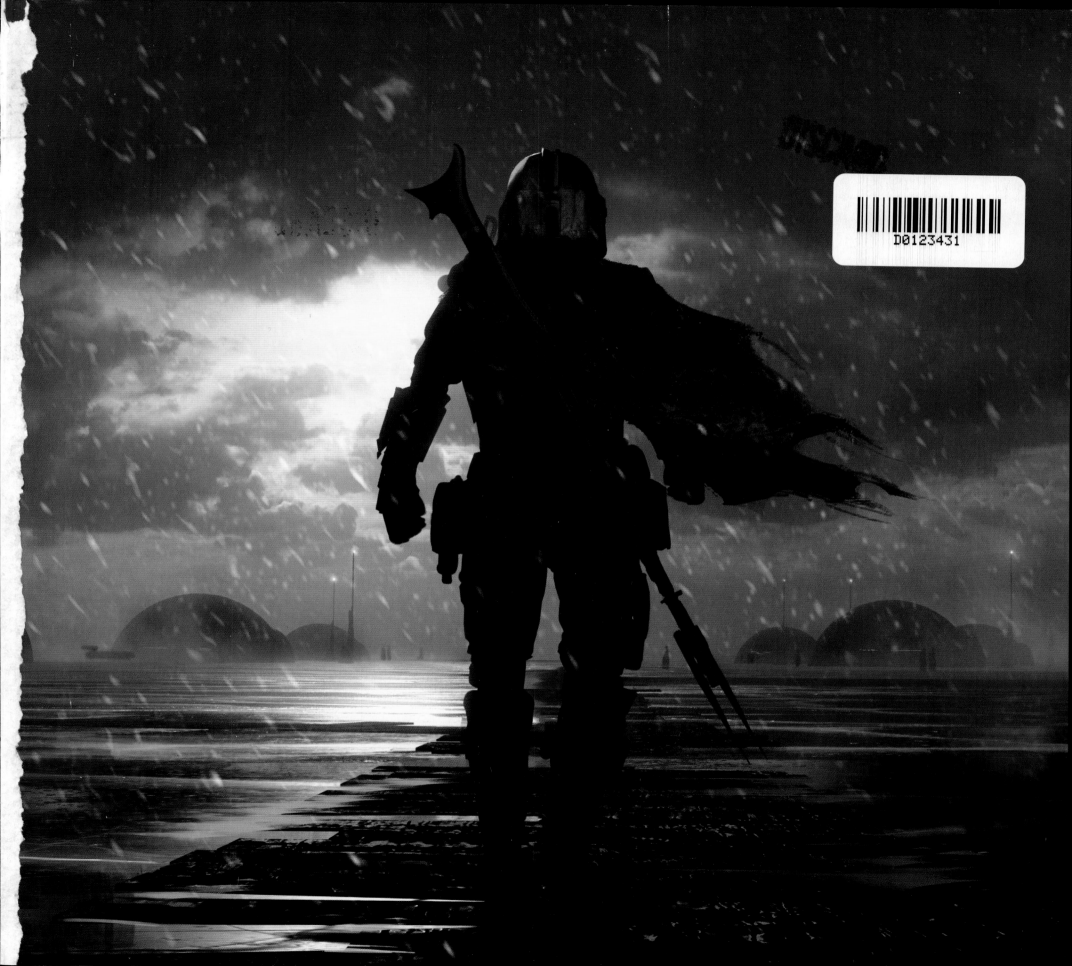

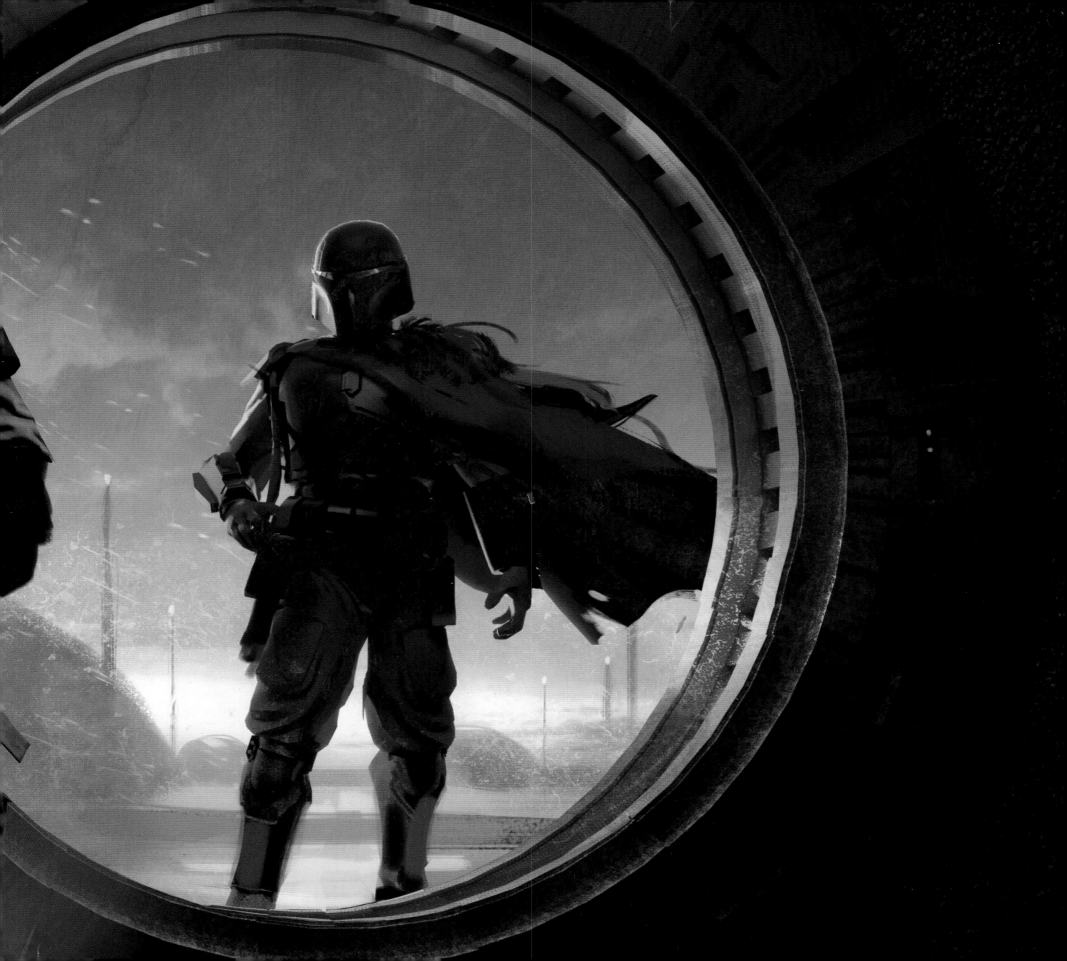

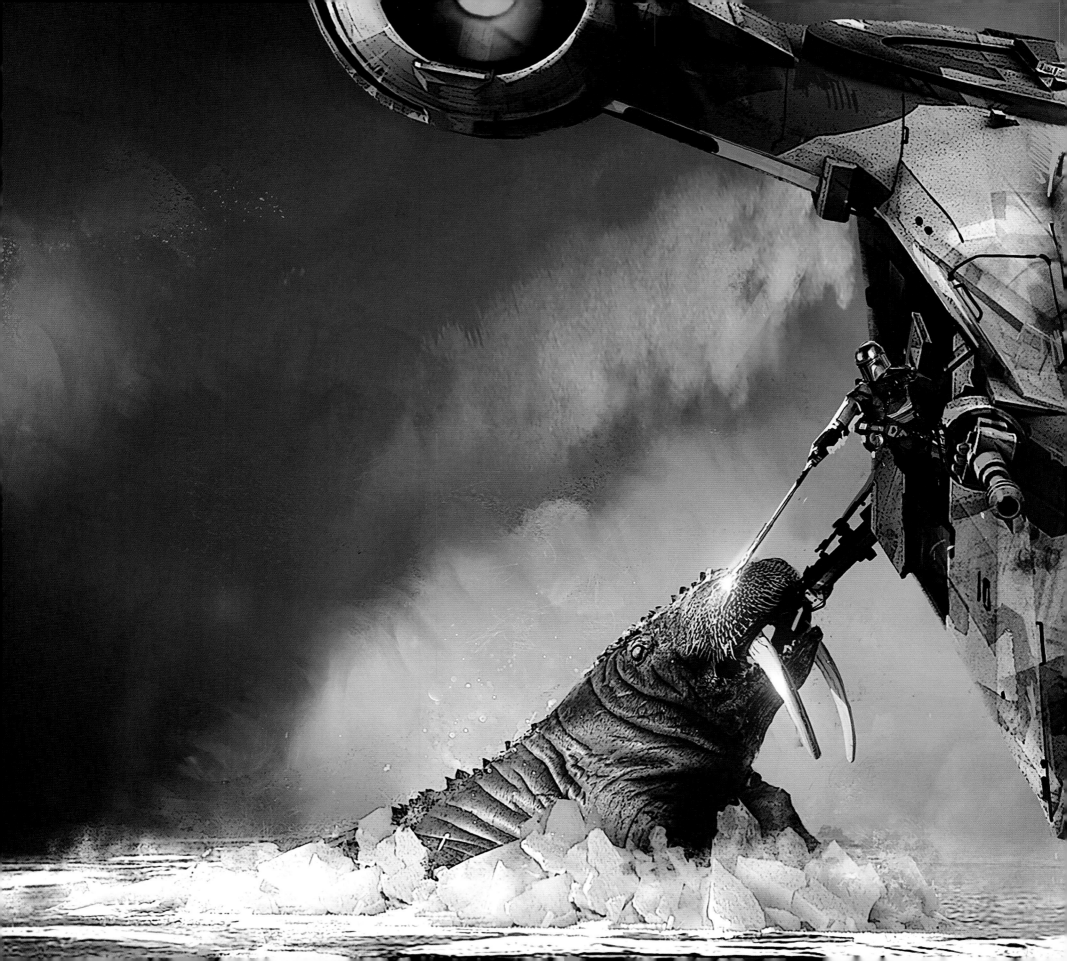

THE ART OF

STAR WARS
THE
MANDALORIAN

Written by Phil Szostak
Foreword by Doug Chiang

ABRAMS, NEW YORK

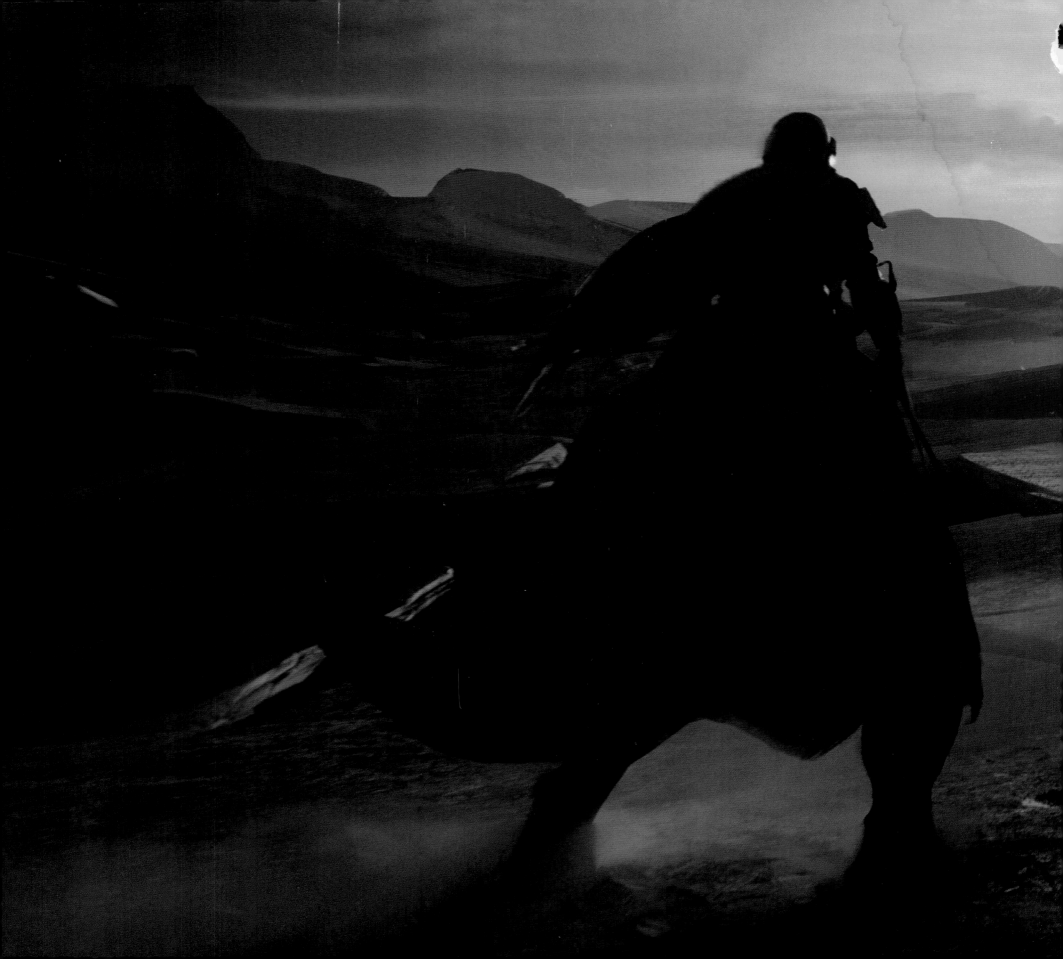

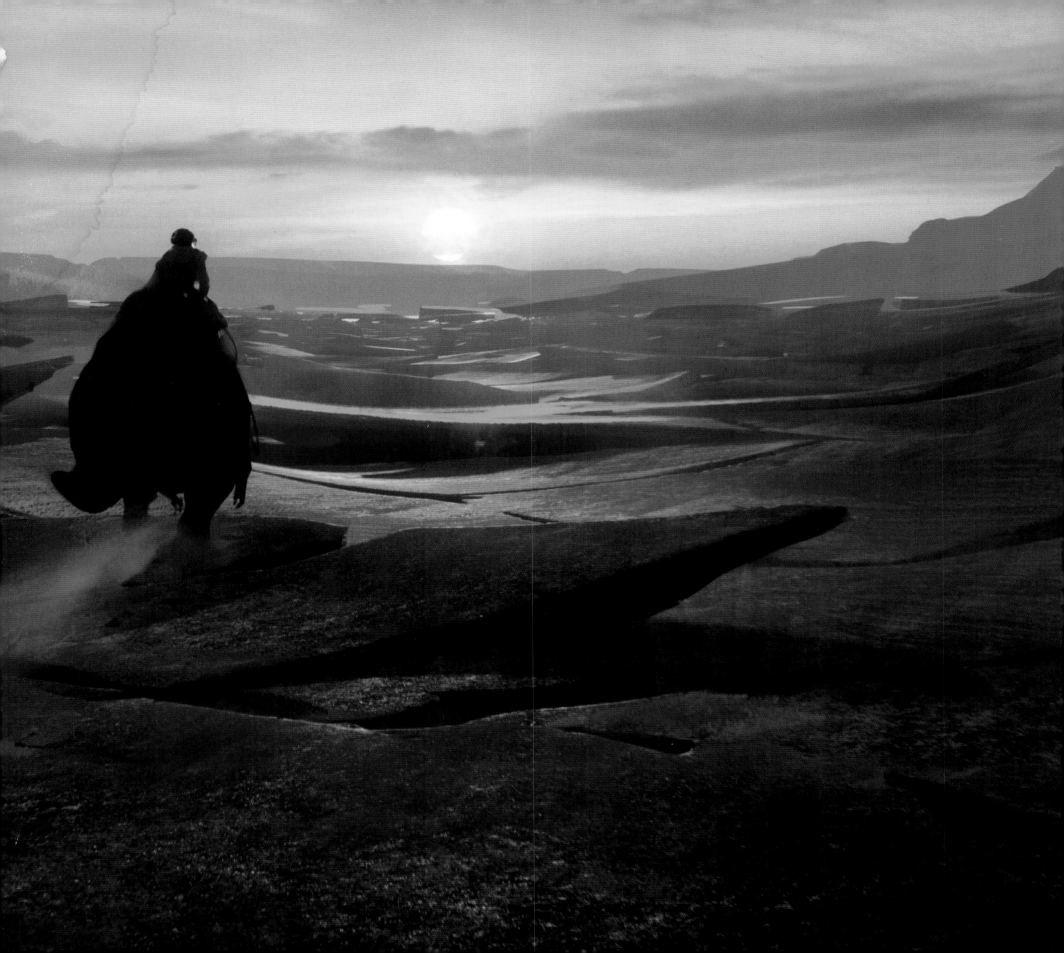

CONTENTS

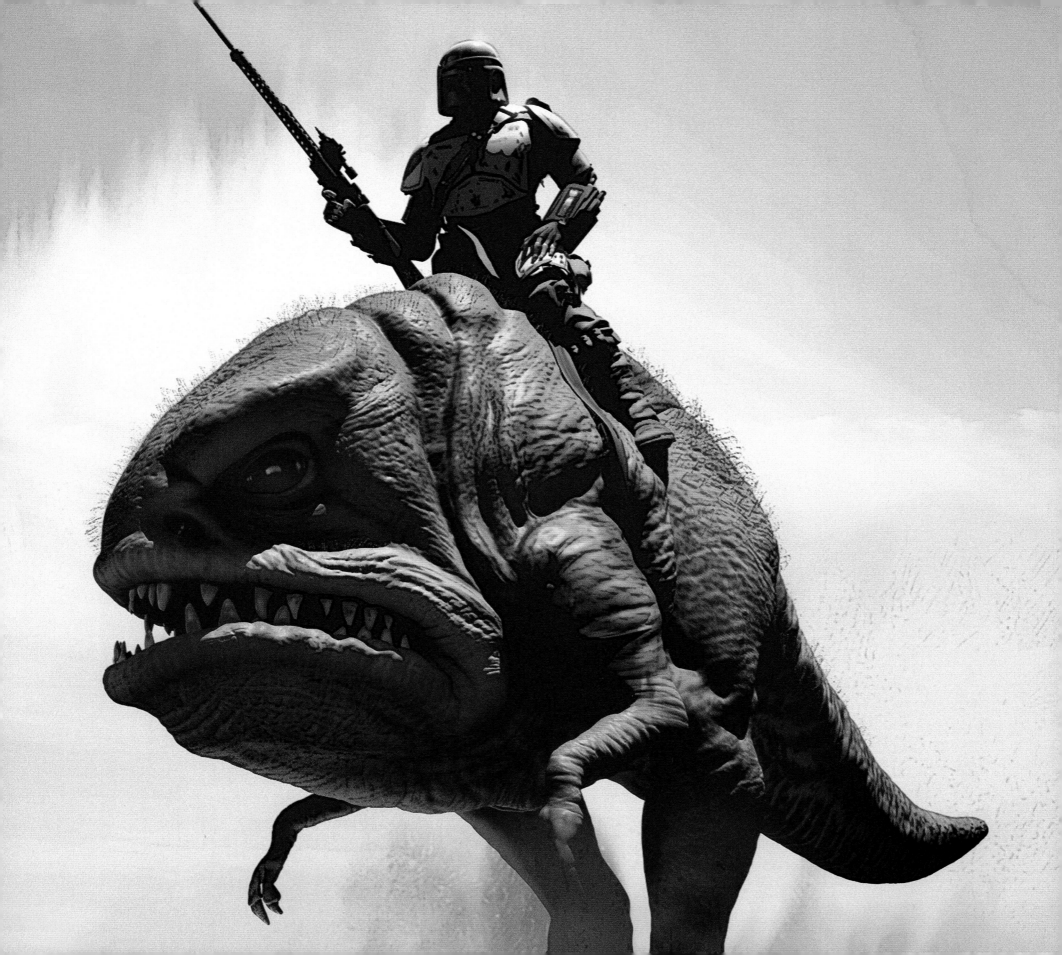

FOREWORD BY DOUG CHIANG

In 1977, *Star Wars* (later subtitled *A New Hope*) premiered in movie theaters and captivated a generation of fans. At the age of fifteen, I was among those whose lives were indelibly changed and, like many aspiring young artists, I dreamt of one day creating artwork for the *Star Wars* universe. Fast-forward eighteen years to 1995, when that childhood dream was fulfilled when George Lucas hired me to head up the new art department for the *Star Wars* prequel films. I spent the next seven years working alongside George, learning directly from the source about what makes a design *look Star Wars*. Twenty-three years later, in 2018, I was challenged to apply everything I had learned to design the rich new worlds of Jon Favreau's *The Mandalorian*.

Set five years after *Return of the Jedi*, *The Mandalorian* hits the sweet spot of *Star Wars* design. Jon Favreau and Dave Filoni expanded upon the characters and worlds that George Lucas created while inventing memorable new ones like the Child and the titular Mandalorian himself as well as a new cast of misfit characters and underdogs from the *Star Wars* galaxy.

When I first started working on *The Mandalorian* back in January of 2018, Jon charged the Lucasfilm art department with staying true to the spirit of the original 1977 film. George always considered *A New Hope* to be a period film and not science fiction; it was more of a Western than a fantasy film. He wanted it grounded in reality, to look like it was filmed on location in a real place. Nothing should look like it had been designed—even though everything had to be created.

From the classic World War II bomber influences for the *Razor Crest* spaceship to the odd IG-11 assassin droid reminiscent of *The Empire Strikes Back*'s IG-88 to the whimsical blurrgs from the *Star Wars: Ewok Adventures* films, Jon insisted on retaining the charm of the original designs that inspired us as kids. He encouraged us not to be afraid of creatures that looked like rubber puppets from the 1980s or spaceships that looked like practical miniature models. With the advent of computer graphics, almost anything we can imagine can be realized, but the key to successful *Star Wars* design is restraint. The hands of the artist should remain hidden. Our creations should be reflections of the characters in the story and not a showcase for the art director. The sets shouldn't look designed, even though they are. Our creations need to disappear into the background. The solution to achieving that quality is simplicity. Some of the concepts may look simple and obvious in hindsight, as good ideas often do. We strived to avoid self-conscious creations that would call attention to themselves unnecessarily. In order to do this, it was essential to give the designs a foundation in history. After all, *Star Wars* isn't about designing the future—it is creating a past from "a long time ago, in a galaxy far, far away. . ."

Within the first weeks of development I knew we were making something special. *The Mandalorian* channels more than forty-three years of *Star Wars* storytelling and designs to create something fresh while honoring what came before. Jon's pioneering approach combined new technologies with old-fashioned storytelling. His initial story pitch made me smile; he said all the things that made me excited as a *Star Wars* fan, from 1977 to the present. I remember thinking, "That's awesome. That's something I want to see in a *Star Wars* film." Over the next several months, art development formed a symbiotic relationship with the writing process. Jon's words informed the art, and the art inspired his words. Ideas were amplified in a process that mirrored my first years working with George Lucas back in 1995.

In my nearly fifteen years of designing for the *Star Wars* universe, *The Mandalorian*'s development process was the most demanding because of our aggressive production schedule. We had a third of the time and half the budget of a typical *Star Wars* film, and yet we were tasked with designing more than 300 minutes of content—enough for two feature films. The art department rose to the challenge in order to fulfill Jon's vision. Remarkably, designs were often approved in only two or three rounds.

The Art of Star Wars: The Mandalorian commemorates this intensive creative process. While flipping through these pages I am transported back in time, not just to 2018 but all the way back to 1977. We've honored George Lucas's design philosophy in order to realize Jon Favreau's bold new vision. This book is more than a compilation of beautiful artwork and designs; it is about the power of images as storytelling devices. None of the design decisions were arbitrary, and in this book you'll have the opportunity to uncover the results. You'll hear directly from the artists to understand the thinking behind their beautiful paintings, the reasoning beneath these creations, and the stories that go with each concept.

INTRODUCTION

*"When one chooses to walk the Way of the Mandalore,
you are both hunter and prey. How can one be a coward
if one chooses this way of life?"* —The Armorer

With his Disney+ television series *The Mandalorian*, executive producer and writer Jon Favreau (*Iron Man*, *Chef*, *The Lion King* [2019]) has crafted the first live-action *Star Wars* story to feature the proud warriors most often associated with the unmistakable armor of Boba Fett. But Mandalorians have been a part of *Star Wars* in one form or another since the very beginning of the now four-decade-old mythology. They have played as integral a role in shaping the history of that galaxy far, far away as the Jedi and Sith, whose conflict between the light and dark sides of the Force has traditionally been at the center of *Star Wars* storytelling. As such, *The Mandalorian* is, both in front of and behind the camera, a broadening of perspective, exploring a lesser-known but still vital thread in the rich fabric of *Star Wars*.

The origin of *The Mandalorian* begins with *Star Wars* creator George Lucas. In his May 1974 draft of "The Star Wars," Imperial general Darth Vader (not yet the masked dark side disciple of future drafts) hires Prince Valorum, "a Black Knight of the Sith" clad in black armor, to track General Luke Skywalker. This bounty hunter archetype was revived for *Star Wars* sequel *The Empire Strikes Back*. Lucas introduced a mercenary figure to collect dues from Han Solo at Jabba the Hutt's behest, and so Boba Fett was born.

"There were quite a few films made about bounty hunters in the Old West," Lucas explained. "That's where that came from. He is also very much like the Man with No Name [famously played by Clint Eastwood] from the Sergio Leone Westerns." Fett began his life encased in the white armor and T-visor helmet of "a squad of supercommandos, troops from the Mandalore system," according to *The Empire Strikes Back Sketchbook*, published in 1980. Designed by Industrial Light & Magic concept masters Ralph McQuarrie and Joe Johnston, that stark Mandalorian armor was soon somewhat reimagined, worn and dented, to better befit a lone gunslinger on the galactic frontier.

Despite decades of inclusion in the *Star Wars* galaxy, it wasn't until the second season of *Star Wars: The Clone Wars* animated TV series in 2010 that Mandalorian lore truly began to be canonically established by Lucas and supervising director Dave Filoni. Coincidentally, that second season also marked the starting point of Favreau and Filoni's working relationship, with Favreau lending his voice to the villainous Mandalorian leader of Death Watch, Pre Vizsla. Mandalorian history developed further in Filoni's animated follow-up to *The Clone Wars*, *Star Wars Rebels*, which debuted in October 2013 and revealed that a disastrous initial encounter with the Jedi pushed ancient Mandalorian warriors to develop new technology, specifically the type of gadget-filled armor Boba Fett wears in *The Empire Strikes Back*, to neutralize the Jedi's paranormal powers. Thus, decades of devastating conflict between the Jedi and Mandalorians began. But one Mandalorian warrior, Tarre Vizsla, ancestor to Pre Vizsla's clan, broke off from his brethren, joining the Jedi Order and forging a unique, black-bladed lightsaber known as the Darksaber.

Ultimately, Mandalorians emerged as the third superpower in the *Star Wars* galaxy, alongside the Jedi and Sith.

Favreau came in with a story about a very different Mandalorian than the one he played in *The Clone Wars*, a bounty hunter forever changed by his encounter with a mysterious child of the same species as master Yoda. Given Dave Filoni's history with Mandalorians, Lucasfilm president Kathy Kennedy brought Favreau and Filoni together to collaborate on what became the first-ever live-action *Star Wars* TV series.

The dynamic between the eponymous Mandalorian and his young charge was inspired by writer Kazuo Koike and artist Goseki Kojima's wildly popular *Lone Wolf and Cub* manga, as well as the film adaptations, from the 1970s. In the manga, ronin (or masterless samurai) Ogami Ittō wanders the countryside of Edo-period Japan, seeking vengeance on those who brutally murdered his wife and family, all the while pushing his son Daigorō's baby cart. The shogunate leadership puts a price on the heads of father and son, akin to the actions of Bounty Hunters' Guild agent Greef Karga, and Ittō is forced to defend his child from any and all willing to claim the bounty. The nobility of the ronin's cause, in righting a grievous wrong and defending the helpless, absolves the violent brutality with which he carries it out.

In director Akira Kurosawa's *Seven Samurai*, another massive influence on *Star Wars* (including *The Mandalorian* "Chapter 4: Sanctuary"), one of the seven, Kikuchiyo, is a blustery, self-styled ronin who secretly started his life as a peasant. Against the backdrop of a burning mill, he clutches a peasant child, the lone survivor of a bandit attack. "This baby. It's me! The same thing happened to me!" Kikuchiyo sobs.

Those who become "lone wolves" are often thrust into it by tragic circumstances: the senseless slaughter of Ittō's family, Kikuchiyo's orphaning at the hands of bandits, Boba Fett witnessing his father's brutal decapitation in *Star Wars*: Episode II *Attack of the Clones*, and the Mandalorian's equally traumatic childhood, in which his home planet was attacked and his parents murdered by Separatist battle droids during the Clone Wars. They remain in constant motion in an effort to outrun the psychological and emotional demons that haunt them. To reckon with a chaotic past, these people seek control and order. The hunted become the hunters.

Throughout the series, the Mandalorian finds other lost souls, namely IG-11, Kuiil the Ugnaught, Greef Karga, and Cara Dune, forming a motley family of mercs otherwise adrift in a lawless time after the fall of the Galactic Empire. But the initial and brightest spark in the Mandalorian's journey of self-discovery through connectedness is the Child. The Mandalorian sees the boy that he once was in this creature: helpless; alone, and desperately in need of rescue.

In exploring the women and men behind the masks of Mandalore and the themes that arise with telling their stories, the filmmakers behind *The Mandalorian* cut to the very heart of *Star Wars*, while exploring relatively unknown aspects of its lore. "It sounds strange to say this, but being in that trope world of Westerns and samurai films allowed

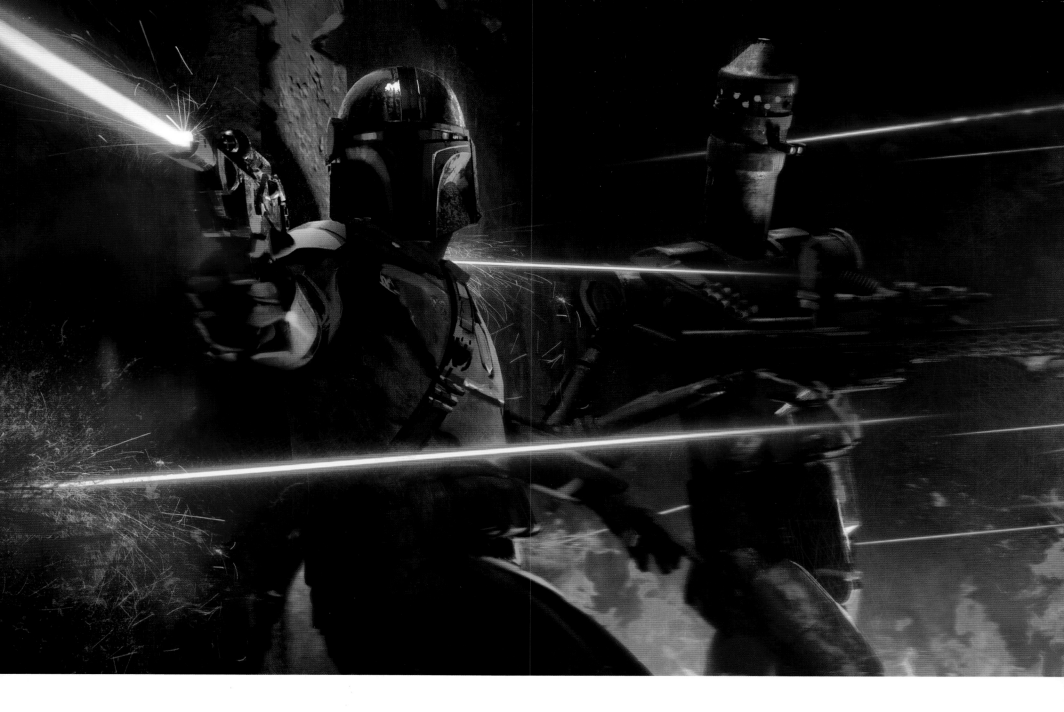

↑ **HIDEOUT STANDOFF VERSION 1B**
Gindraux

↘↘ **LONE WOLF AND CUB VERSION 2A**
Ryan Church and Gindraux

us to be less concerned with the *Star Wars* of it all and more concerned with the character journey," Filoni said. "It's not like we're solving for how the Force works or the bigger movements of the galaxy. That's been pushed away to the background again." As such, *The Mandalorian* represents a big, bold step beyond the larger Skywalker saga that has dominated *Star Wars* storytelling.

To meet this task head-on, *The Mandalorian* creator Jon Favreau has assembled his own motley family of filmmaking mercs who are more than up to the task. This dream team includes Dave Filoni and Lucasfilm vice president and executive creative director Doug Chiang (*The Phantom Menace, Attack of the Clones, Rogue One*), both of whom bring unparalleled instincts for *Star Wars* storytelling honed through years of work with its creator, George Lucas.

Combining forces with production designer Andrew L. Jones (*Avatar, Alice in Wonderland* [2010], *Green Lantern*), a "Murderers' Row" of top-flight directors—Deborah Chow (*Better Call Saul, American Gods, Mr. Robot*), Rick Famuyiwa (*Dope, The Chi, The Wood*), Bryce Dallas Howard (*Jurassic World, The Help, Gold*), and Taika Waititi (*Hunt for the Wilderpeople, Thor: Ragnarok, JoJo Rabbit*)—plus hundreds of seasoned film artists and craftspeople, the next chapter in the annals of *Star Wars* blasts off with a fresh and audacious vision, one worthy of its great legacy.

"This is the Way."

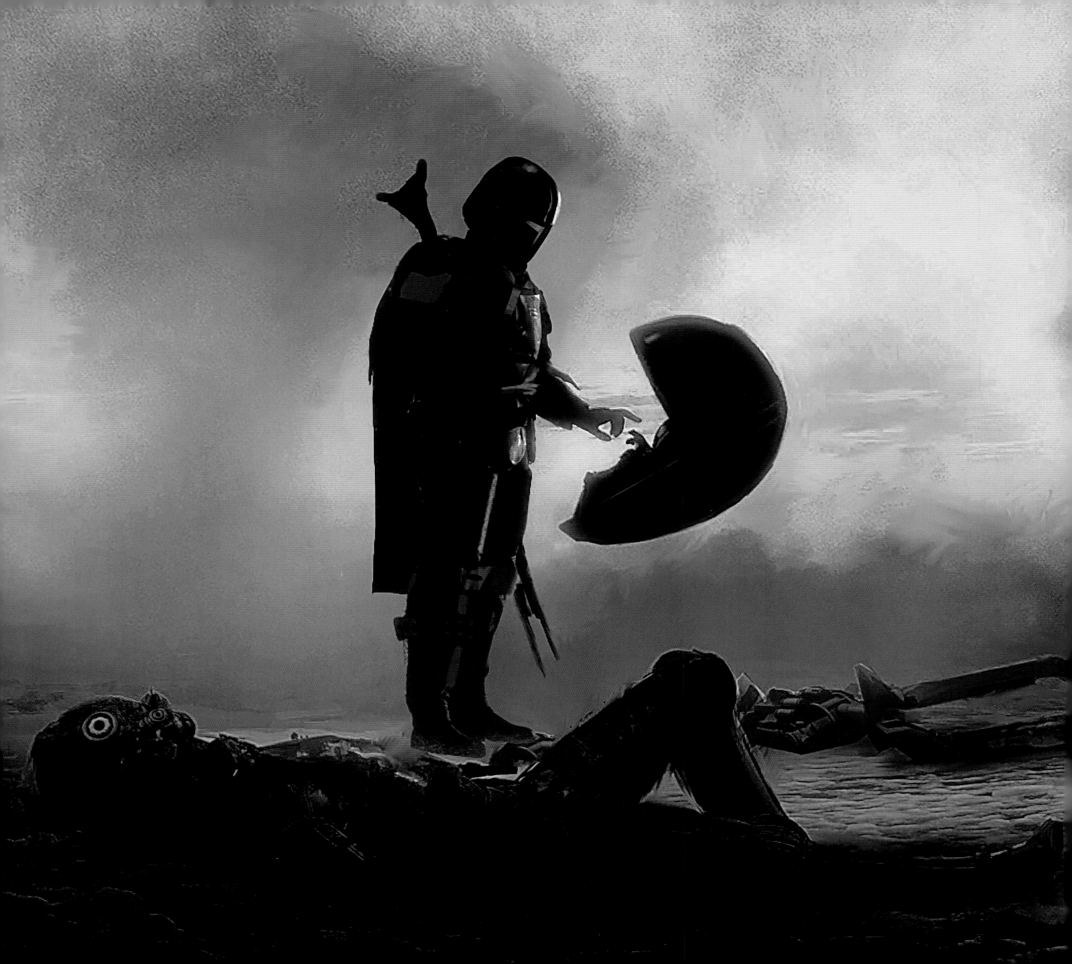

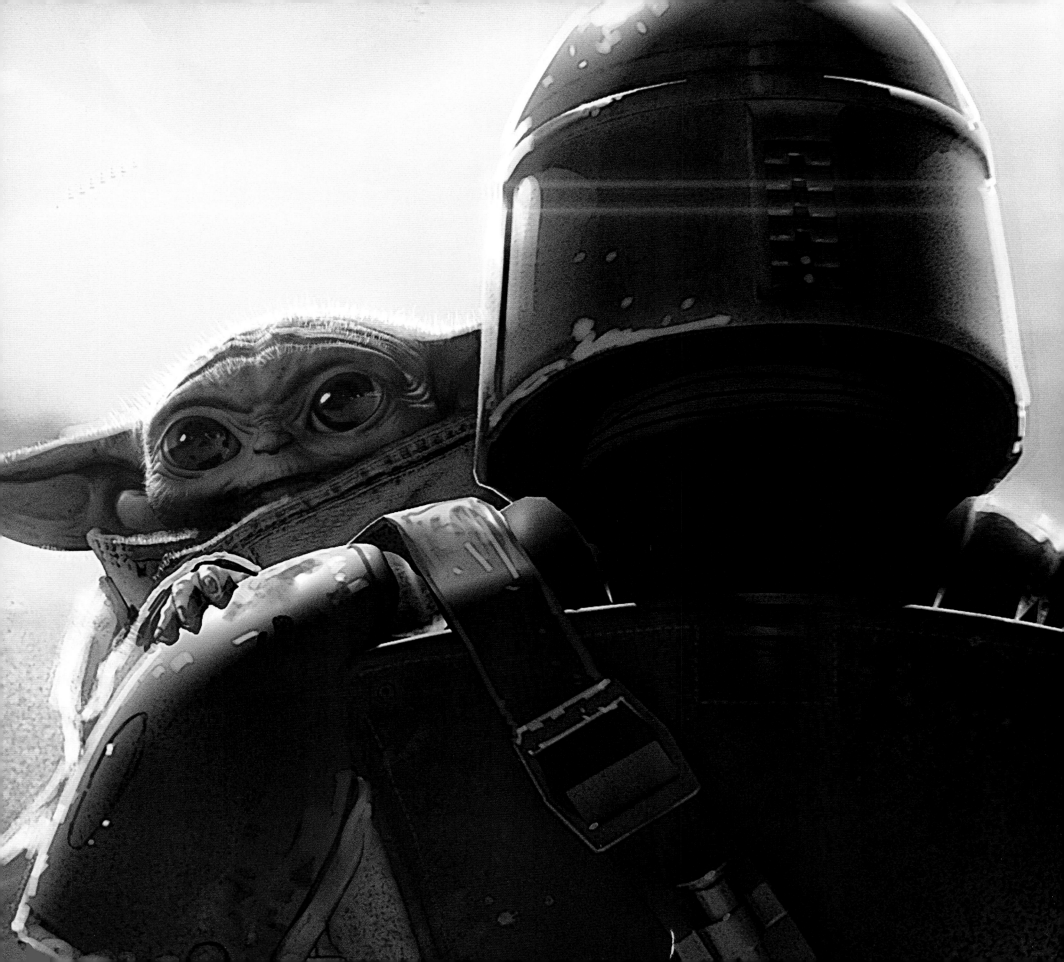

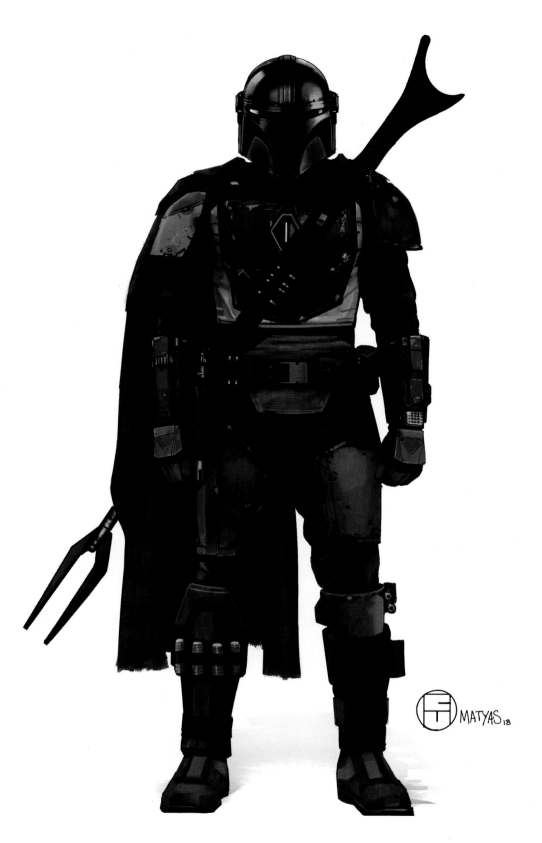

← **BABY VERSION 11** Alzmann

↑ **MANDO REVISION 03 VERSION 11** Brian Matyas

WHO'S WHO

CHRISTIAN ALZMANN
Concept supervisor

MATT ALLSOPP
Rogue One: A Star Wars Story concept artist

JOHN BARTNICKI
Co-producer

CARRIE BECK
Co-producer/ Lucasfilm VP live action development & production

RICHARD BLUFF
VFX supervisor

ROY CANCINO
Special effects supervisor

DOUG CHIANG
Co-producer/Design supervisor/Lucasfilm VP/Executive creative director

DEBORAH CHOW
Director

RYAN CHURCH
Concept supervisor

DAVID DUNCAN
Storyboard artist

SETH ENGSTROM
Concept artist

RICK FAMUYIWA
Director/Screenwriter

JON FAVREAU
Creator/Executive producer/Screenwriter

LANDIS FIELDS
Virtual art director

DAVE FILONI
Executive producer/ Director/Screenwriter

GREIG FRASER
Co-producer/Director of photography

RENE GARCIA
Concept modeler

KAREN GILCHRIST
Co-executive Producer

NICK GINDRAUX
Concept artist

MARISSA GOMES
ILM VFX producer

JOHN GOODSON
Concept model maker

ANTON GRANDERT
Concept artist

BEN GRANGEREAU
ILM concept artist

KIRI HART
Former Lucasfilm senior vice president of development

HAL HICKEL
Animation supervisor

PABLO HIDALGO
Lucasfilm creative executive

DAVE HOBBINS
Concept artist

BRYCE DALLAS HOWARD
Director

BAZ IDIONE
Director of photography

JOE JOHNSTON
Star Wars original trilogy ILM art director

ANDREW L. JONES
Production designer

JAMA JURABAEV
Concept artist

ABBIGAIL KELLER
VFX producer

KATHLEEN KENNEDY
Executive producer/ Lucasfilm president

GLORIA KIM
Costume illustrator

JOHN KNOLL
ILM VFX supervisor

FABIAN LACEY
Concept artist

JANET LEWIN
Co-producer/Lucasfilm VP production

RICHARD LIM
Concept artist

DAVE LOWERY
Head of storyboards

GEORGE LUCAS
Star Wars creator

BRIAN MATYAS
Concept artist

JASON McGATLIN
Co-producer/Lucasfilm senior VP of physical production

RALPH McQUARRIE
Star Wars original trilogy production illustrator/ Concept artist

TONY McVEY
Concept sculptor

PHILLIP NORWOOD
Storyboard artist

PAUL OZZIMO
Prop illustrator

JOHN PARK
Concept artist

RUSSELL PAUL
Concept modeler

JOSEPH PORRO
Costume designer

JASON PORTER
VFX supervisor

CHRIS REIFF
Star Wars Illustrator

JULIE ROBAR
Costume supervisor

JOHN ROSENGRANT
Legacy Effects supervisor

JOSH ROTH
Prop master

AMANDA SERINO
Set decorator

ERIK TIEMENS
Concept supervisor

PHIL TIPPETT
Star Wars original trilogy makeup designer/ Creature designer/Stop motion animation

TAIKA WAITITI
Director

COLIE WERTZ
Concept modeler

COLIN WILSON
Executive producer/Unit production manager

JEFF WISNIEWSKI
Supervising art director

CHRISTOPHER YOST
Executive consultant/ Screenwriter

THE PITCH

Like millions of other children in the summer of 1977, ten-year-old Jonathan Favreau of Flushing, Queens, the Dungeons & Dragons-playing son of New York City public school teachers, saw *Star Wars* with his dad. "I was right there in the sweet spot, the right age at the right time. And *Star Wars* surprised me. I didn't know it was coming. I didn't know what to expect. I went to the theater with my dad and got my mind blown. And there's something really transcendent about different generations watching movies together, when you're loving it and your parents are loving it too. You're downloading a whole set of tastes. As you're forming who you are, you imprint upon those experiences."

Even prior to *Star Wars*, the cinema of *Star Wars* creator George Lucas made a big impact on Favreau. "[My experience in 1977] was coming off of also being completely enthralled by *American Graffiti*, which helped forge my taste in music and in hot rods and nostalgic culture that echoes in *Swingers* [Favreau's 1996 breakthrough movie as a writer-actor]. I wouldn't be who I am without the films of George Lucas, by any stretch."

In January of 2008, with three directorial turns of his own under his belt, including the 2003 critical and commercial smash hit *Elf*, Favreau found his path intersecting with *Star Wars* once more. His first Marvel superhero film, *Iron Man* for Paramount Pictures, was mixed at Skywalker Sound, Lucasfilm Ltd.'s audio post-production facility located on the grounds of George Lucas's fabled Skywalker Ranch in Marin County, California. "*Iron Man* was very much influenced by *Star Wars*," Favreau recalled. "And it taught me about the relationship with source material, that there is a way to honor the people who have been the fans, who know everything about it, and still invite new people in. While I was mixing at the ranch, [*Iron Man* producer and Marvel Studios president] Kevin Feige gave me *The Making of Star Wars* book [by J.W. Rinzler, 2007]. I remember reading how precarious everything felt on *Star Wars* and what it turned into. And I remember how precarious *Iron Man* felt at the time and thinking, 'What if it's the same type of thing, where we actually start something big from this?'

"I was trying to get invited into the archives [on Skywalker Ranch, where all of the original and prequel *Star Wars* trilogy props and costumes are stored]. I was [at the Ranch] for weeks and couldn't get an invitation. Eventually, I heard word that they were going to let me come to the archives. And I went with Kevin Feige, who, by the way, knew every single thing in there. The curators were really impressed by him."

Simultaneous to Favreau's time at Skywalker Ranch, Lucas and supervising director Dave Filoni were putting the finishing touches on the first season of *The Clone Wars* animated series. "I remember being invited over to Big Rock Ranch [the property adjoining Skywalker Ranch where Lucasfilm Animation was headquartered] to meet Dave," Favreau said. "And I showed Dave *Iron Man*. And he showed *The Clone Wars* to me and my son, Max, which we thought was so cool. I think he was one of the first people, certainly the first outside of Marvel, to see *Iron Man*. And I said, 'Hey, if you ever want a voice …'" Favreau would go on to play the villainous Pre Vizsla, Mandalorian leader of the violent Death Watch faction who wields the ominous black-bladed Darksaber, for seven episodes of *The Clone Wars*.

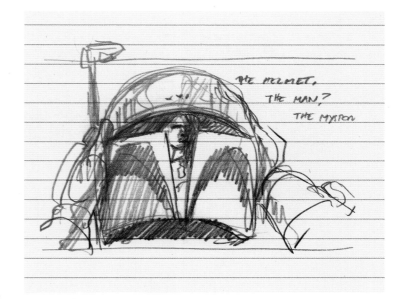

A series of acquisitions soon brought Disney, Lucasfilm, and Jon Favreau together under one roof. On August 31, 2009, while Favreau was in the midst of production on *Iron Man 2*, his second film in the burgeoning Marvel Cinematic Universe (or MCU), the Walt Disney Company announced a deal to acquire Marvel Entertainment. Three years later, Disney acquired Lucasfilm Ltd., a deal that culminated in the massive success of *Star Wars: The Force Awakens* in December 2015. Jon Favreau's live-action adaptation of the 1967 animated classic *The Jungle Book* was another big hit for Walt Disney Pictures the following April.

The lead-up to the 2019 launch of Disney+ made it possible to investigate and pursue new creative directions for *Star Wars*, including live-action television shows. On September 25, 2017, Lucasfilm President Kathleen Kennedy reached out to Favreau, whose continued passion for both *Star Wars* and new and emerging technologies made him the perfect choice for exploring the future of the franchise in the series space. Expressing an interest in Mandalorians in his reply, Favreau met with Kennedy and Lucasfilm executive Carrie Beck on November 9 at the Kennedy/Marshall Company in Santa Monica, California.

"I dusted off some old ideas and characters from when I heard that Disney might be doing more *Star Wars*," Favreau recalled. Those ideas included an intimate, character-driven narrative, disconnected from the larger wars of *Star Wars*, featuring a lone Mandalorian gunfighter redeemed by the child that he must protect. Its straightforward storytelling would echo the Western and samurai films that Favreau enjoyed with his father in his formative years. "After Kathy heard the pitch, she mentioned that Dave Filoni was thinking about doing something with the history of the Mandalorians. And I said, 'I know Dave. I love Dave.'"

Finally, on November 14, 2017, Kennedy, Favreau, Filoni, Beck, and *Star Wars Rebels* writer Chris Yost gathered at Kennedy/Marshall to hear Favreau's *Star Wars* TV show pitch. "Those stories were something that I had been working on for a long time. I didn't know it would be for television. But I loved the idea of doing a story [after the fall of the Empire in *Return of the Jedi*]." The Lucasfilm art department, led by executive creative director Doug Chiang, were conscripted the following day to complete several pieces of concept art for Favreau's pitch.

← **FETT HELMET VERSION 02** "You [Phil Szostak] brought down a replica Boba Fett helmet that I took some pictures of. I even brought in some gloves [laughs]. At first, I was thinking, 'They're not going to reveal this character's face for a while? How is that going to be interesting?' And, of course, now, it's amazing. But that little hint of the face [in this piece], the character looking back into the helmet is a neat tease." **Erik Tiemens**

↗ **MANDALORIAN SKETCH 02** "This was a way to build the mystery of not knowing who the Mandalorian was and to communicate what this story was about. That's why he looks like Boba Fett. We hadn't yet figured out how to make ourselves separate." **Dave Filoni**

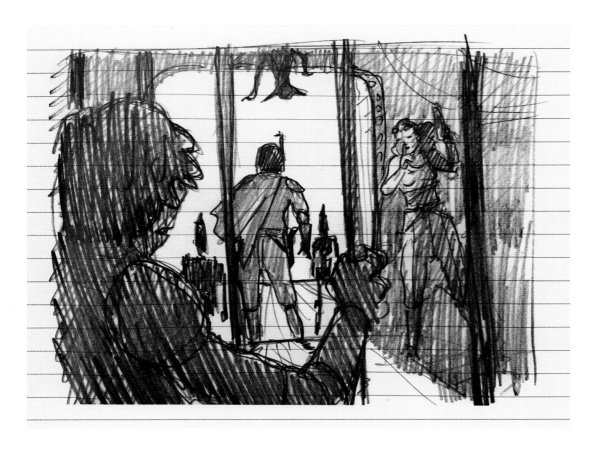

↑ **MANDALORIAN SKETCH 03** "I tended to do a lot of little sketches on the plane, trying to figure out interesting moments for the pitch. Jon loves this one, the first drawing of the pram. And the ball floating and the baby. That's the whole thing. I need to get that framed for Jon. This was the drawing that, dare I say, really sold the idea of the show. It was the image that made everybody go, 'Even if I don't know what a Mandalorian is, I get what this is.' And I like his posture, kind of leaning in and leaning out at the same time. And you wonder, 'Is the kid floating that ball? What does that mean?'" **Filoni**

← **MANDALORIAN SKETCH 01** "We were just riffing off of Westerns. Here, it's the view from inside a jail cell. And the idea that maybe the Mandalorian has more of a crew." **Filoni**

↓ **NEGOTIATION** Church

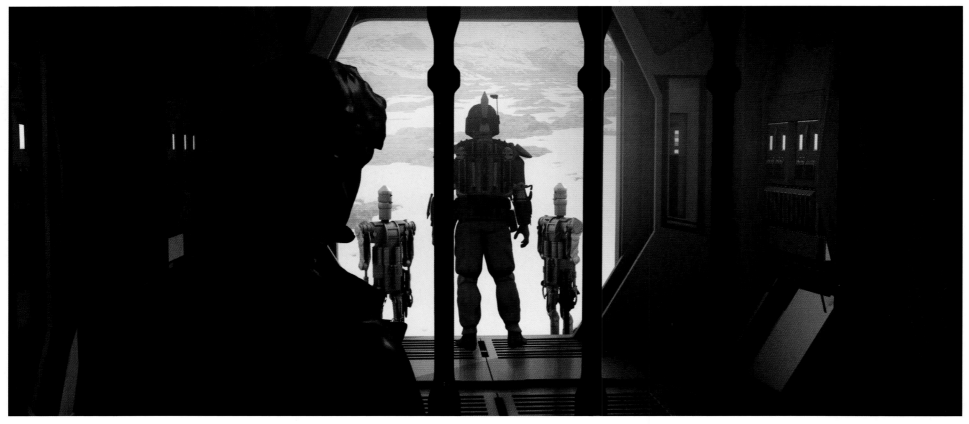

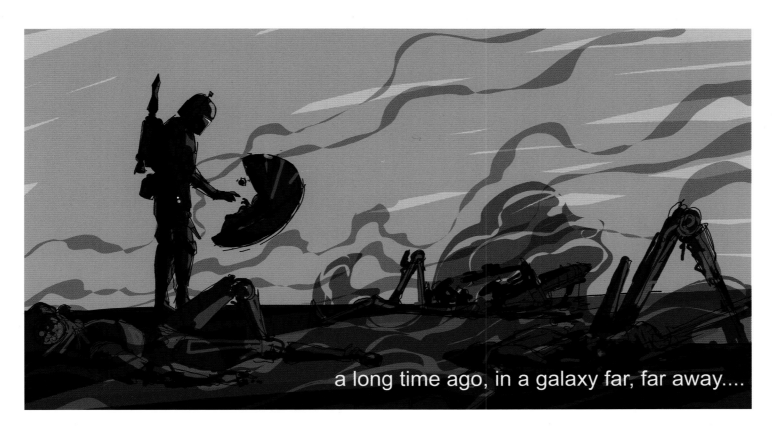

a long time ago, in a galaxy far, far away....

← **LONE WOLF AND CUB SKETCH** Filoni

↓ **LONE WOLF AND CUB 02** "I remember getting Christian [Alzmann]'s 4-LOM and IG-88 CG models, piecing them together. I always loved IG-88. So, my main early attraction to the project was, 'Oh my God, we're going to see him fighting IGs? That is awesome no matter what else happens.'" **Church**

→→ **HORSE CHASE VERSION 02** "This was just a rough idea, a Mandalorian rescuing a young teenage girl. At that point, I was imagining a *True Grit* type of story." **Alzmann**

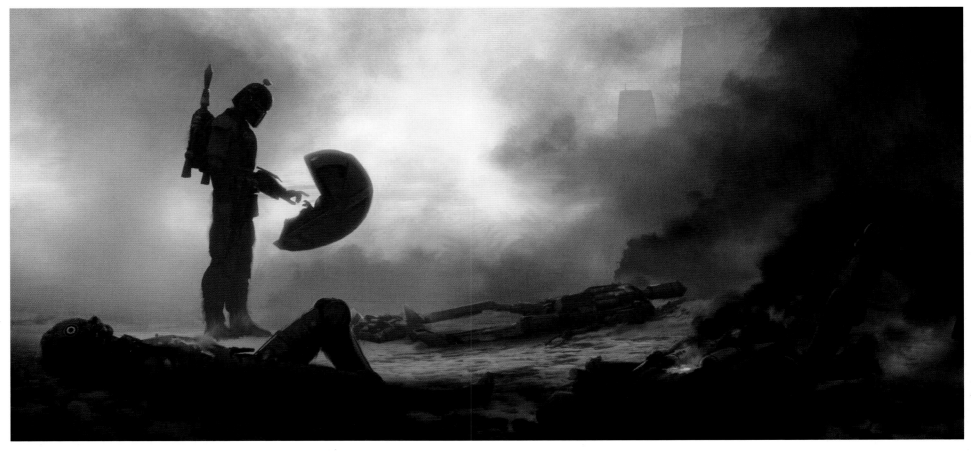

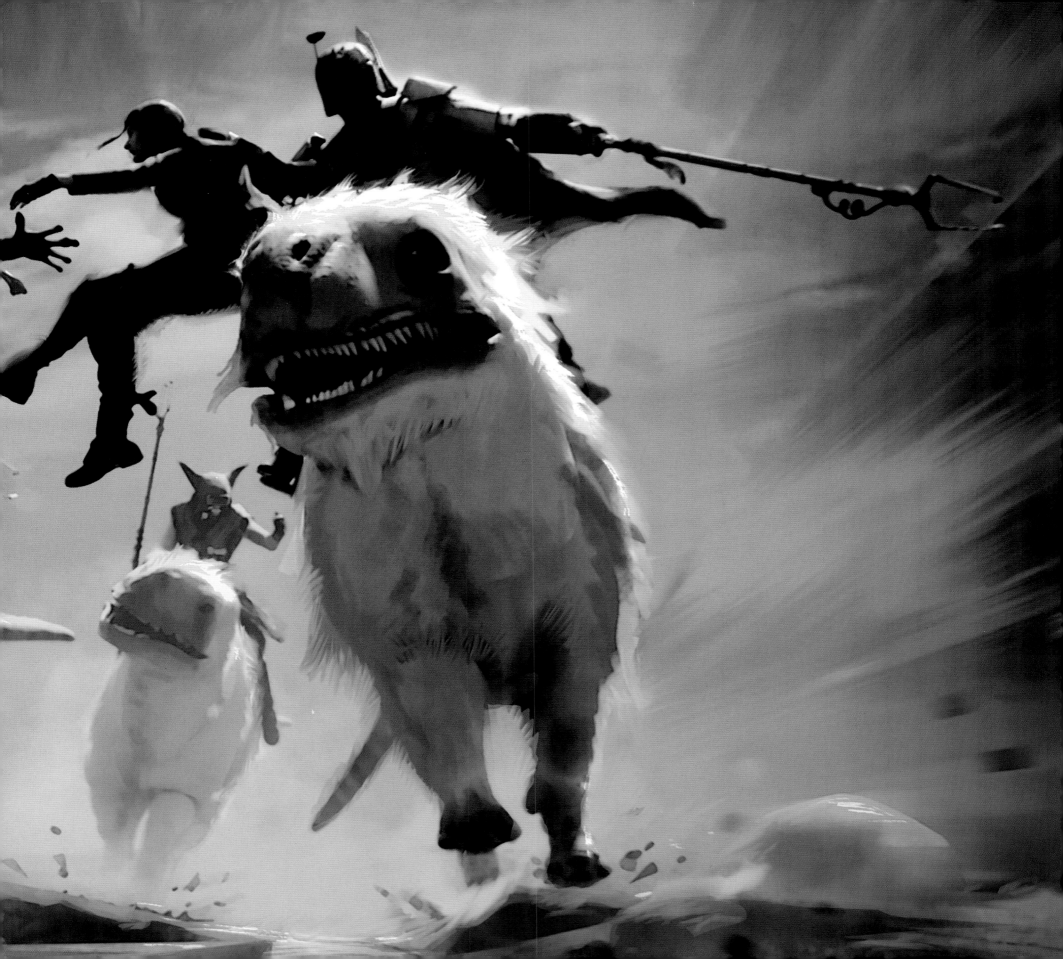

↑ **MANDALORIAN SKETCH 04** "We wanted to do some kind of creature chase, the stealing of a hostage while on horseback kind of thing. And the forked gun was already coming into play in the very earliest of days. The gun was Jon's idea, something he really liked from *The Star Wars Holiday Special*." **Filoni**

↓ **MANDALORIAN SKETCH 05** "We wanted some way of communicating that there were a bunch of Mandalorians. And here you see my early attempt to cross the mythologies of *The Clone Wars*-era Mandalorians and our Mandalorian. This is also a little riff on Simba from *The Lion King* for Jon." **Filoni**

→ **FETT IMAGE REVISION** "The Mandalorian cosplay culture, how colorful, unique, and artful they are, was a really good reference point for me: the shapes of the T-visor, the chest armor, pushing some things so that it's not just a different spray paint on the same exact armor set. I had no idea that soon I would be in deep with Mandalorians. It's definitely testing the limits of how much I actually like Mandalorians [laughs] but I am getting pretty proficient at them." **Matyas**

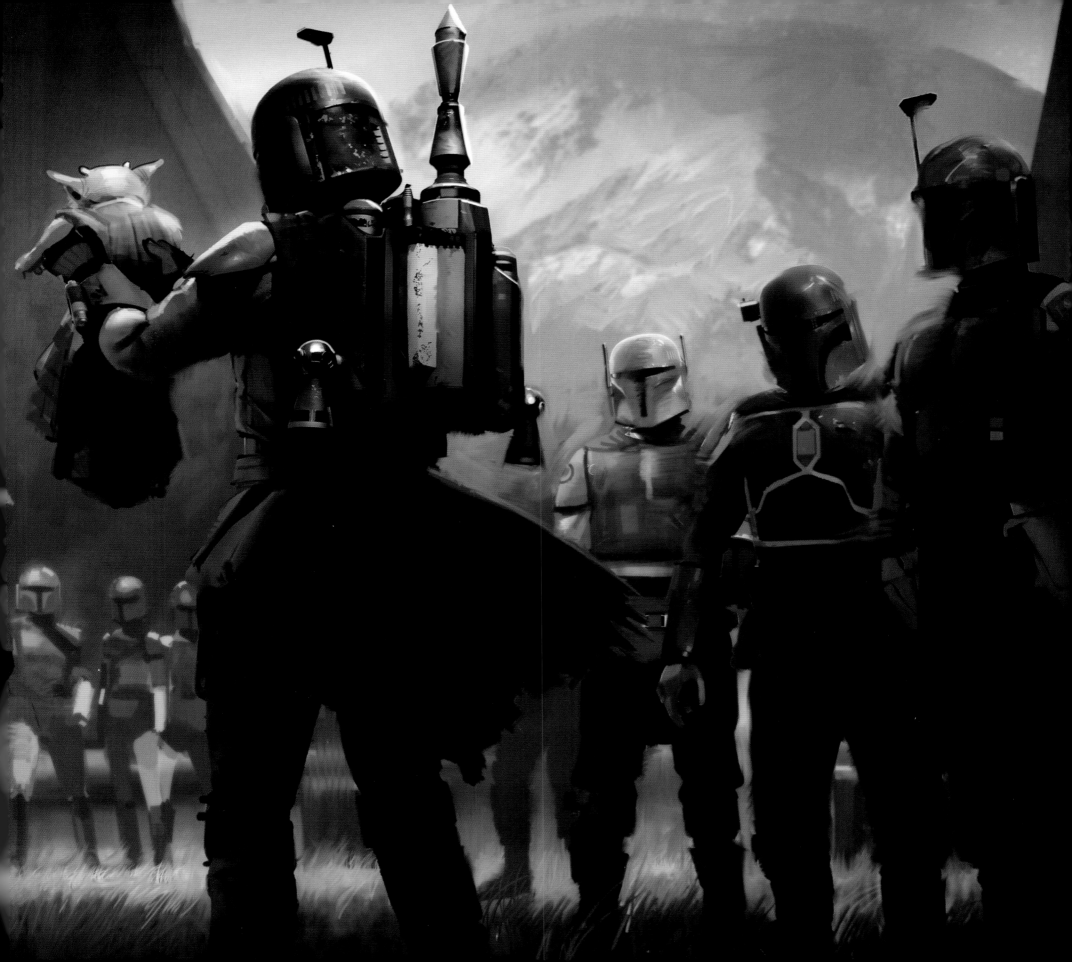

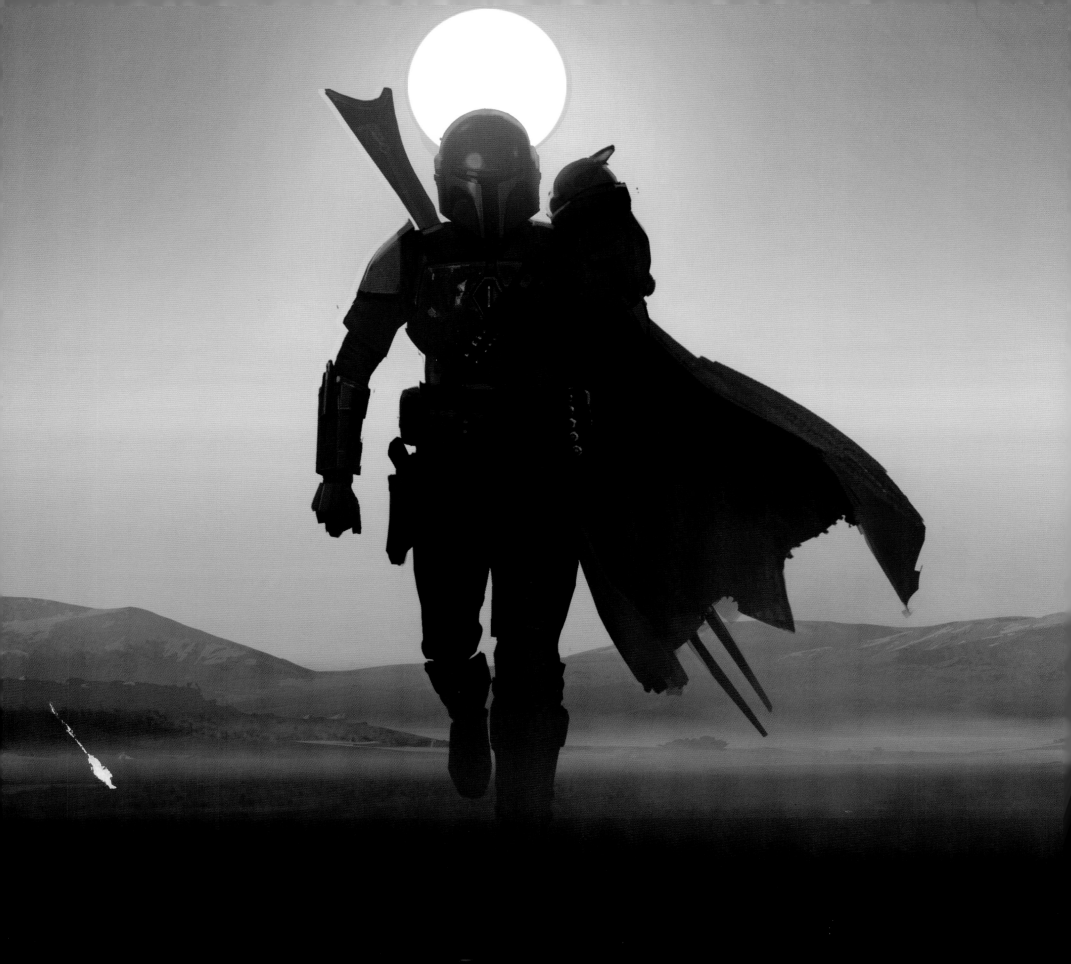

THE MANDALORIAN

Almost three years prior to his fateful meeting with Jon Favreau at Skywalker Ranch, *Avatar: The Last Airbender* director Dave Filoni was hired by *Star Wars* creator George Lucas, Lucasfilm Animation vice president and general manager Gail Currey, and executive producer Catherine Winder to serve as supervising director for the animated television series that would evolve into *Star Wars: The Clone Wars*. "I didn't expect to get the job, because George had worked with so many amazing artists over the years, like Ralph McQuarrie, Joe Johnston, Dennis Muren, and Phil Tippett," Filoni remembered. "It was really bizarre. Suddenly, I was in charge of bringing this thing to life." In fact, Filoni's first week on the job, brainstorming story ideas with writer Henry Gilroy, coincided with the May 2005 theatrical release of *Star Wars*: Episode III *Revenge of the Sith*, Lucas's final *Star Wars* film as writer and director.

Both *The Clone Wars* animated series and the very first live-action *Star Wars* television series were announced by Lucas in late April 2005 at the perennial Lucasfilm-sponsored fan convention, *Star Wars* Celebration, in Indianapolis, Indiana. These projects marked a turn toward television as *Star Wars'* primary storytelling medium.

Design work on the then-unnamed live-action television series set in Coruscant's criminal underworld (with bounty hunters appearing in secondary roles) began, in earnest, with the hiring of concept artists Jonathan Bach and David Hobbins to JAK Films (Lucas's production company, named for his children Jett, Amanda, and Katie) in late November 2006. Bach and Hobbins were later joined in Skywalker Ranch's Main House by concept artists Fabian Lacey and Kinman Chan, design supervisor Erik Tiemens, and art department coordinator Phil Szostak, with Ryan Church contributing concept art remotely. Over a decade later, Hobbins, Lacey, Tiemens, Church, and Szostak would reunite to work on another live-action *Star Wars* television series, *The Mandalorian*.

Given the two shows' concurrent development, story seeds and designs from the live-action series, including Level 1313 of Coruscant's underworld, militant rebel Saw Gerrera (later added to 2016's *Rogue One: A Star Wars Story*), droid bounty hunter C-21 Highsinger, and the alien Pyke Syndicate (also seen in 2018's *Solo: A Star Wars Story*), were planted in *The Clone Wars*, intended to pay off later. The first few episodes of the animated series were combined and restructured into an animated feature film also titled *Star Wars: The Clone Wars*, released on August 15, 2008. *The Clone Wars* series itself, which, under Lucas and Filoni's supervision, greatly expanded the lore of the Mandalorian people and continued *Star Wars*: Episode II *Attack of the Clones*'s story of a young Boba Fett, debuted two months later on the Cartoon Network, running for six multiple Emmy Award-winning seasons.

But by mid-2010, with fifty scripts drafted by a writer's room led by Lucas and thousands of pieces of concept art generated, the live-action series was put "on hold" due to budgetary concerns. And production of *The Clone Wars* wound down in late 2012, as Lucasfilm pivoted toward an original trilogy–focused *Star Wars* storytelling initiative under the Walt Disney Company and new president Kathleen Kennedy, spearheaded by a sequel to 1983's *Star Wars*: Episode VI *Return of the Jedi*.

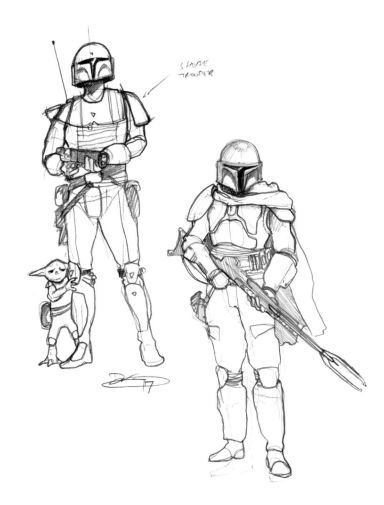

In an effort to retain the core of his seasoned Lucasfilm Animation team, Filoni brainstormed ideas for a new animated series. "The current idea of *Star Wars Rebels* started with my friend, Carrie Beck, who works with the story team at Lucasfilm," Filoni said in 2014. "One of the ideas that Carrie had was for this *A-Team* group that went around righting wrongs. I told her it was really similar to an [early] idea that I had for *Clone Wars*" in which a Jedi Master and his Padawan Ashla (who would inspire *The Clone Wars* beloved Ahsoka Tano) join the crew of a "*Millennium Falcon*-style smuggling ship" for adventures across the galaxy. After a period of development, during which Beck and Filoni were joined by writer/director Simon Kinberg (*Mr. and Mrs. Smith*, *Sherlock Holmes*, *X-Men: Days of Future Past*), *Star Wars Rebels* went into full production in early 2013. Over time, ideas from Lucas's live-action series, such as the formation of the nascent Rebellion, would also be folded into *Rebels*.

Prior to this shift into the sequel trilogy, Kennedy met with Filoni (and others in the company) to ask how he envisioned his future with Lucasfilm. "'Well, I want to continue in animation, but I am really interested in live-action,'" Filoni answered. "She said, 'OK. Live-action is a very different medium but let's set you up to see if you'd really like it.' And I wanted to take it slow. I respect the medium and the people so much that I didn't want to just jump into it and be in over my head. So, Kathy orchestrated sending me to set [Pinewood Studios, where the modern *Star Wars* films were shot] and is therefore instrumental in all of this for me. I can't say enough supportive and good things about her."

← **MANDO BABY VERSION 03** "I'm so inspired by Frank Frazetta. I do mentoring on the side and the thing that I always drive home is simple shape language and how powerful it is. Triangles communicate something. Circles communicate another thing. There's something so visually pleasing about framing characters, especially with triangles and circles. And Frazetta used it all the time." **Matyas**

↗ **Left MANDO SKETCH 06** "What types of pieces make up the Mandalorian's armor? How does the rifle play into his silhouette but also still maintain that evocative gunfighter? One thing that Jon and I both felt was that Boba Fett is a lot slighter-of-build, almost graceful-looking [instead of] the armored linebacker that we wanted. Boba looks like found armor and Jango looks like he belonged to a group. So, we were trying to smash those things together with somebody that was more imposing, altogether.

"Just how knowledgeable is the kid? How active? He devolved a little bit into more of a baby, which is fine. But here, there was something about him ankle-biting that we liked." **Filoni**

↗ **Right MANDO SKETCH 01** "One of the things that Jon and I both thought would help distinguish Mando from Boba was to lose the rangefinder stalk on his helmet. It immediately starts to change his silhouette. And then deciding what type of cape he would have. We were also playing with asymmetry." **Filoni**

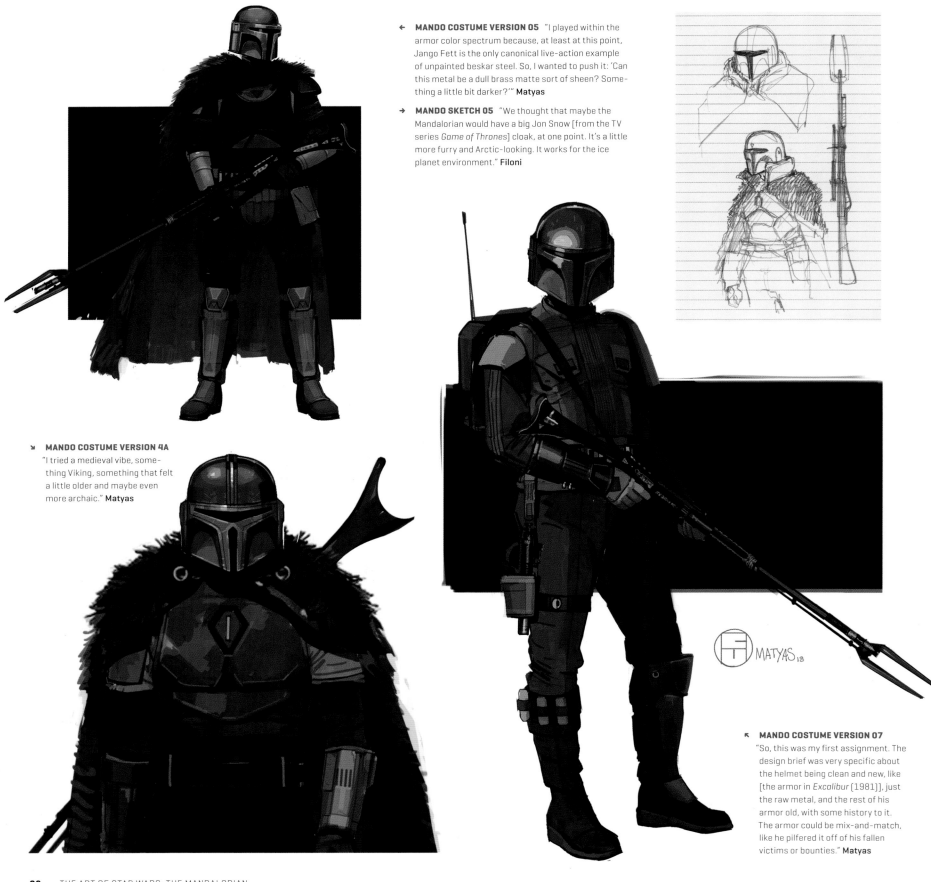

MANDO COSTUME VERSION 05 "I played within the armor color spectrum because, at least at this point, Jango Fett is the only canonical live-action example of unpainted beskar steel. So, I wanted to push it: 'Can this metal be a dull brass matte sort of sheen? Something a little bit darker?'" **Matyas**

MANDO SKETCH 05 "We thought that maybe the Mandalorian would have a big Jon Snow [from the TV series *Game of Thrones*] cloak, at one point. It's a little more furry and Arctic-looking. It works for the ice planet environment." **Filoni**

MANDO COSTUME VERSION 4A "I tried a medieval vibe, something Viking, something that felt a little older and maybe even more archaic." **Matyas**

MANDO COSTUME VERSION 07 "So, this was my first assignment. The design brief was very specific about the helmet being clean and new, like [the armor in *Excalibur* (1981)], just the raw metal, and the rest of his armor old, with some history to it. The armor could be mix-and-match, like he pilfered it off of his fallen victims or bounties." **Matyas**

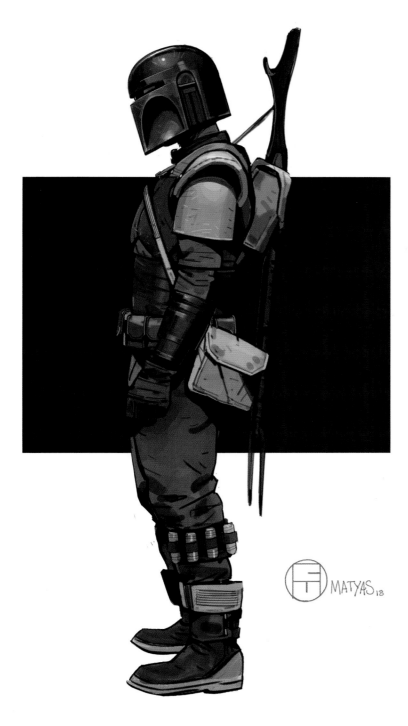

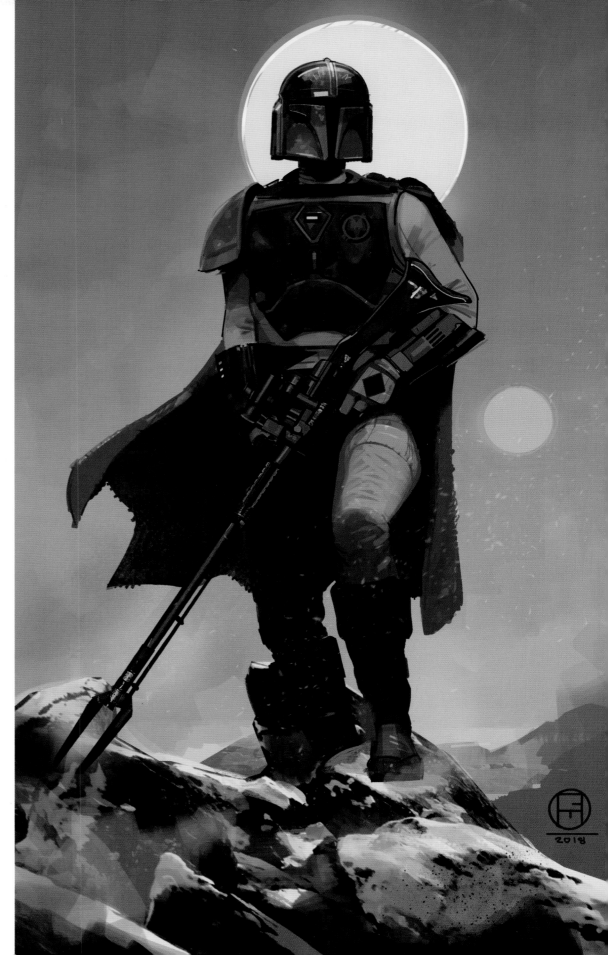

↑ **MANDO COSTUME VERSION 04**
"I was really trying to play down his early armor set here while playing up his attitude, the personality of the gesture. I was looking at the African theater of World War II for a lot of this costuming, how they layered satchels and a lot of leather and backpacks." **Matyas**

→ **MANDO COSTUME VERSION 01** "That was the first image [of the Mandalorian that I worked on]. I wanted something really classic, almost Frank Frazetta-like, or the old 1970s/80s pulp science-fiction covers, like Isaac Asimov. This was also a piece that was really helpful in determining what kind of Mandalorian this is and what's going to separate him from Boba Fett." **Matyas**

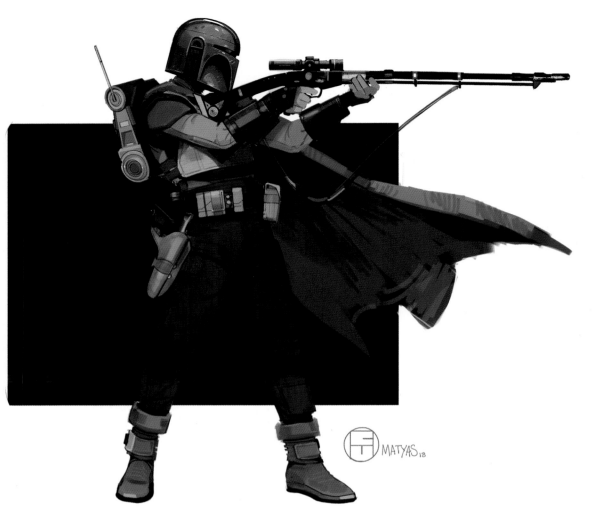

↑ **MANDO COSTUME VERSION 12** Matyas and Chiang

"I was still changing up some of the armor, like the chest pieces being more classic Mandalorian and then playing with a different color for the T-visor, which I'm actually glad they didn't go with. There's something about gold and silver together, even with jewelry, that doesn't quite work for me." **Matyas**

↖ **MANDO COSTUME VERSION 03** "I was thinking of something like a flight outfit for him, with maybe a communication backpack. He's sort of like Anton Chigurh [from *No Country for Old Men*] in that he only brings what he needs. I was doing a lot of contrapposto [a visual arts term for when the human figure is posed with its weight on one leg] characters so I wanted to draw something with a little more energy. On top of the desert earth tones, very military, I was playing with some very muted primary colors, as well: blues, yellows, and maybe some reds." **Matyas**

← **MANDO BAR VERSION 02** Matyas and Chiang

"Looking through the script, someone asks, 'Do you ever take your helmet off?' He says, 'No.' And I'm like, 'How do you eat?' [Laughs] When he goes to a bar, do they give him a sippy straw or something?" **Matyas**

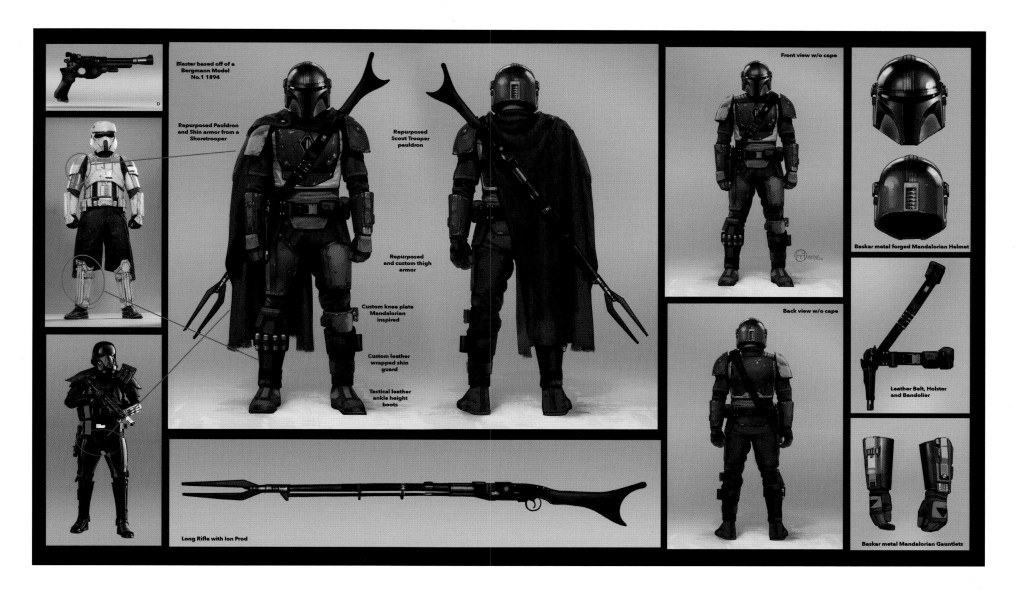

Blaster based off of a
Bergmann Model
No.1 1894

Repurposed Pauldron
and Shin armor from a
Shoretrooper

Repurposed
Scout Trooper
pauldron

Repurposed
and custom thigh
armor

Custom knee plate
Mandalorian
inspired

Custom leather
wrapped shin
guard

Tactical leather
ankle height
boots

Long Rifle with Ion Prod

Front view w/o cape

Back view w/o cape

Baskar metal forged Mandalorian Helmet

Leather Belt, Holster
and Bandolier

Baskar metal Mandalorian Gauntlets

↑ **MANDO COMPONENTS VERSION 04** "I started pilfering from some pieces of designs that I really liked, like the shoretroopers and death troopers, Essentially, we've only seen them in *Rogue One*. I would think they're rare. So, if he has a bounty where he kills one, it's like a trophy.

"They wanted to call back to the forklike cattle prod rifle that Boba Fett has in *The Star Wars Holiday Special*. So, I was looking at a lot of those like Moroccan/African long rifles, which were the inspiration for the Luke and Tusken Raider rifles in *A New Hope*. They are such cool and bold shapes, especially when the're mounted on a character's back. It really breaks up the silhouette." **Matyas**

→ **MANDO BLASTER VERSION 03** "The Mandalorian's sidearm is based on the Bergmann model 1894. I just flipped open a weapons book and on the first page, there it was. I always liked how the original trilogy used real-world firearms and modified them. But this one, apart from the handle, rear sights, and the muzzle, is pretty much the Bergmann 1894, a really unique-looking, already very *Star Wars* firearm. It feels Western. And it's a contemporary of the Mauser C96, which inspired Han Solo's DL-44 blaster." **Matyas**

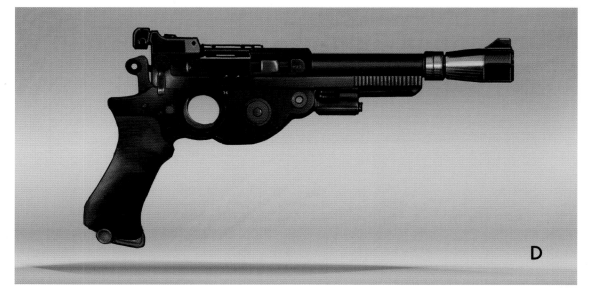

D

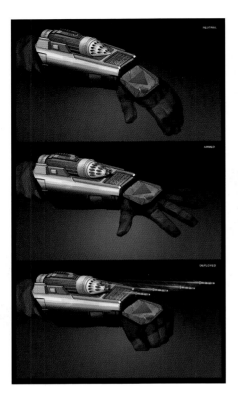

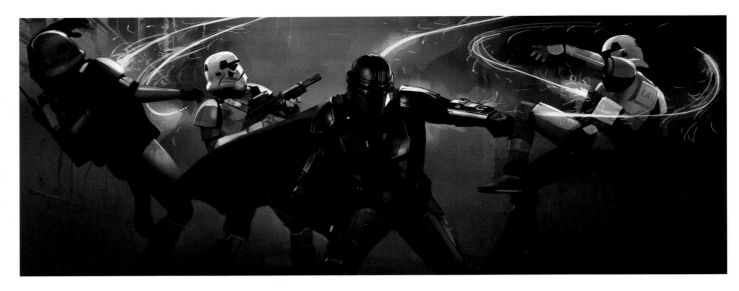

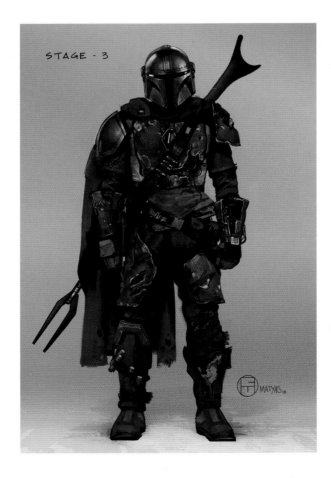

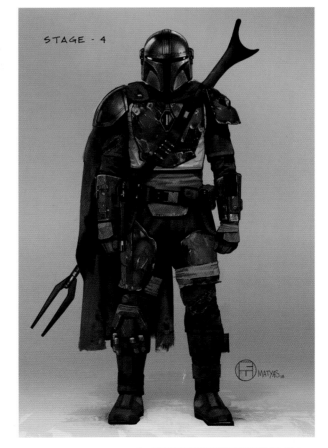

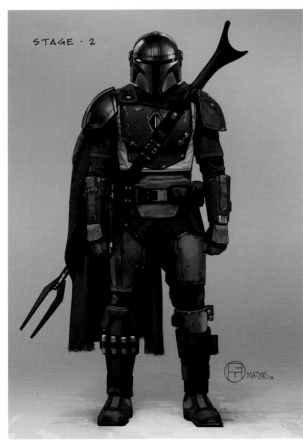

← **MANDO GAUNTLET G** Matyas and Chiang

"I thought of this sort of like a honeycomb rocket or fighter jets when they fire off multiple rockets in quick succession. And all he has to do is expand his fingers to arm it and close his hand to deploy it." **Matyas**

↓ **MANDO DAMAGED NEW** "When I found out about the damaged state of his armor, it was a very 'murder your darlings' situation. 'Oh, okay. This is early and he's going to get new armor.'

"For what was underneath the beskar armor, they just said 'techie bits.' What does that mean? I was thinking of the repair work on Luke's arm or Vader's severed hand, 1980s kind of tech." **Matyas**

↑ **WHISTLING BIRDS VERSION 02**
Matyas

In illustrating the Mandalorian's "whistling birds" weaponry, concept artist Brian Matyas was inspired by fireworks, such as Roman candles and sparklers.

STAGE - 2

STAGE - 3

STAGE - 4

↑ **MANDO NEW SHOULDER VERSION 02** Matyas

↑ **MANDO BANDAGED VERSION 4B** Matyas

STAGE - 1

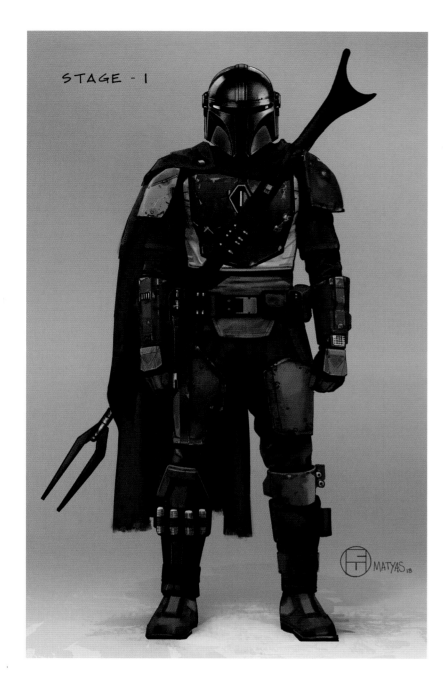

STAGE - 5

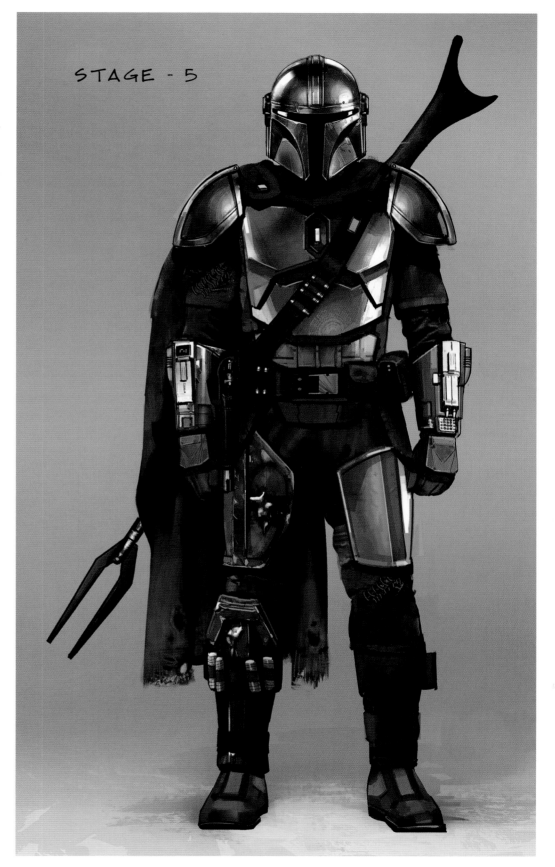

↑ **MANDO STAGE 1 VERSION 01** "I did a collection of a dozen different sketches, and from those they pulled the pieces that he liked and that helmet really resonated, the type of metal and the aggressive angular look, especially the T-visor and how it tapers and points a little more. The thing about Boba Fett's helmet is that it's rather large and square, in terms of its proportions, and the T-visor is quite wide. For Mando, I was thinking a lot about medieval helmets." **Matyas**

→ **MANDO REPAIRED VERSION 05** "In the final stage, there are still some remnants of repair work on the thigh and shin guard, like he used a soldering iron or some sort of liquid metal to fill in the holes for a quick repair, versus some of the armor being so obliterated that it needed to be completely replaced." **Matyas**

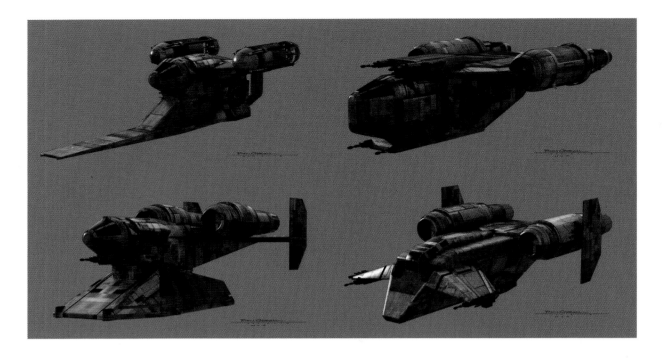

SHIP VERSIONS 02–05 "Jon's design brief was the A-10 Thunderbolt 'Warthog,' which I know extremely well. That's my favorite plane. When I was a kid, I would steer the family vacation to the Tucson air show, the main A-10 pilot training base. I got to sit in the cockpit and everything. The Warthog almost looks like a *Star Wars* vehicle, if you painted [it] the right color, because it doesn't have anything compound about it. It's all simple shapes. And that's the difficult thing about using the A-10. It's so conventional: wings, fuselage, and engine. It ends up looking like a toy if you're not careful.

"It's got to look at least as distinctive and odd as the *Slave I*. Is this the *Slave I*'s brother vehicle? Is this another Mandalorian vehicle? But, by then, I knew I couldn't do those big weird shapes because that's not very A-10." **Church**

SHIP TOP QUARTER VERSION 01 "The ships that I drew in this first pass turned out to be the first and last, because it was chosen very quickly. I just painted over the one sketch that Jon liked. And this is close to the final design, down to the markings. I just threw those markings in." **Church**

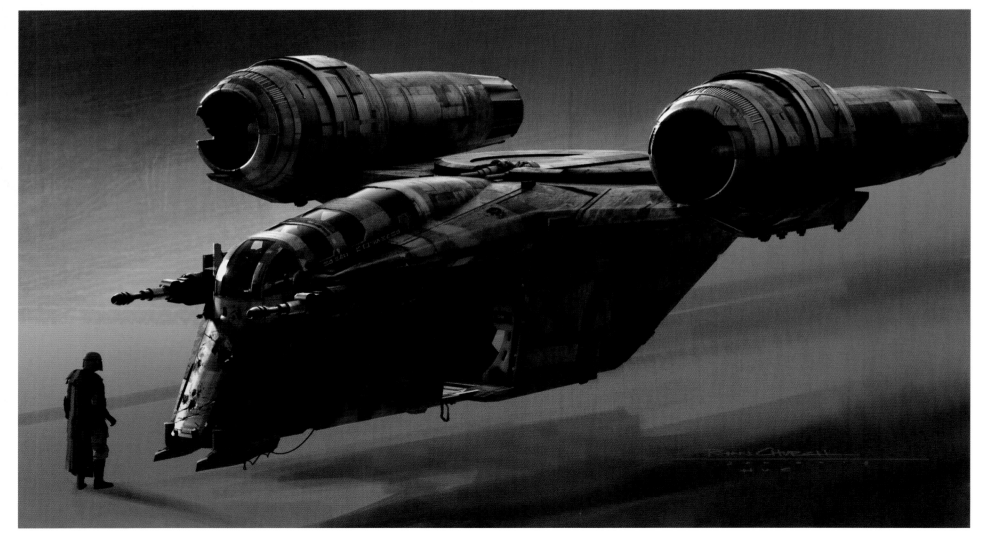

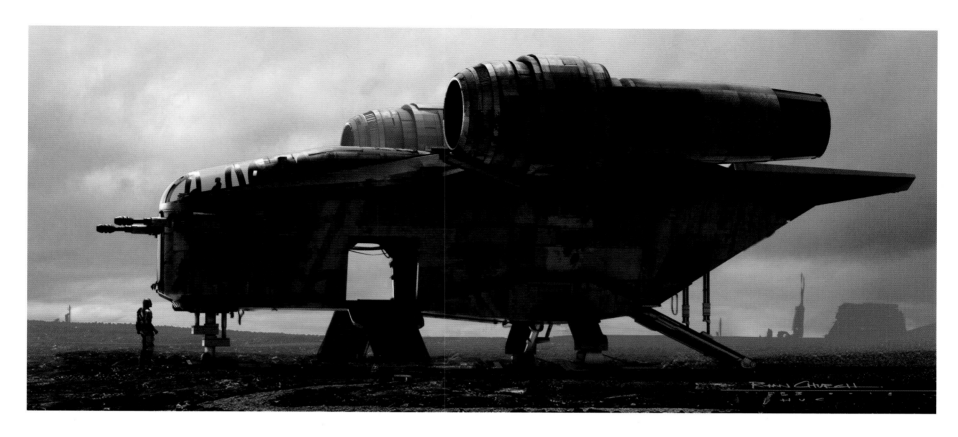

↑ **RAZOR CREST LANDED SIDE VERSION 01** "Jon only said that the *Razor Crest* is smaller than the *Millennium Falcon*. There's something about the A-10's fuselage that appears taller than it is wide. A lot of airplanes are very low and sleek. And the A-10 is definitely not that. So, I accentuated those proportions, in order to get that A-10-ness." **Church**

↓ **RAZOR CREST ICELAND VERSION 2C** Tiemens and Chiang

"The shininess was also harkening back to the World War II aircraft that Doug was referring to. We definitely wanted the specularity [how much light reflectivity a surface has] to be broken up in patches. There is also a purity to how its surface matches the Mandalorian's bare metal helmet. I like its contrast with the coldness of the ice planet or space. You're in this metal hunk and then you've got the tenderness and backlit peach fuzz of the little baby." **Tiemens**

↓ **RAZOR CREST TEXTURE NOTES**

"We went back and forth for a long time on the *Razor Crest*'s exterior finish. If you're going to have a ship, then you should make it shiny. Shiny is cool. But then how *Star Wars* does it really look in the end?" **Church**

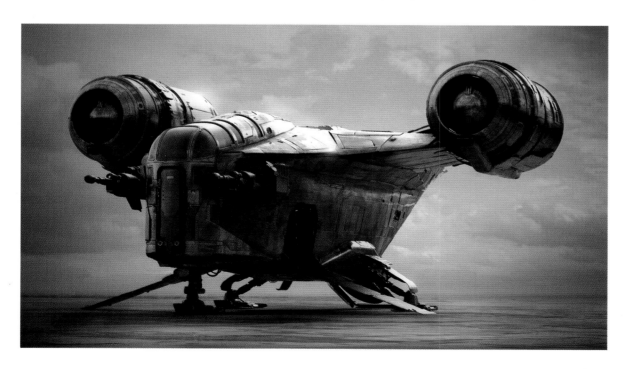

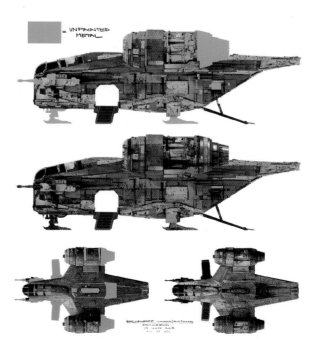

= UNPAINTED METAL

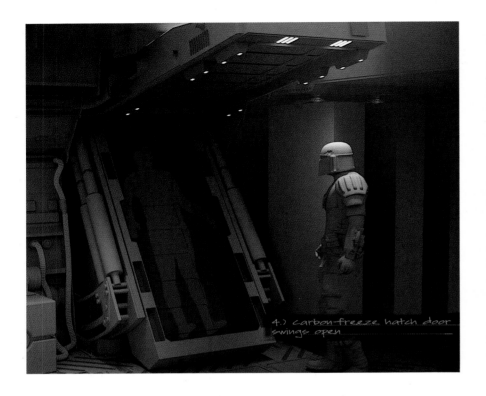

4.) carbon-freeze hatch door swings open

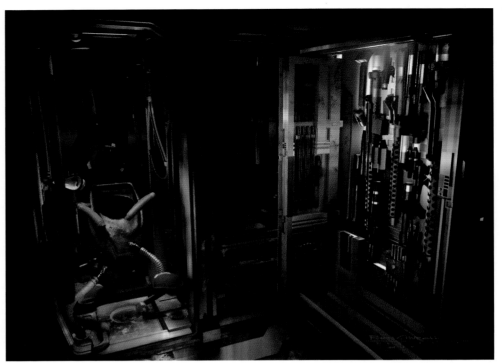

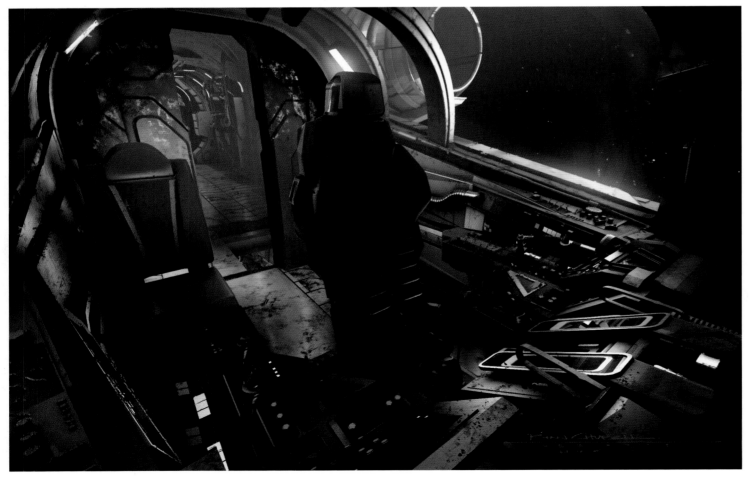

↖ **CARBON FREEZE UNIT OPTION 04**
David Hobbins

↑ **GUN RACK OPEN VERSION 1A** "Jon was very specific about the refresher. We were looking at International Space Station equipment. And then getting more and more gross with it, and literal, and odd. It doesn't matter what kind of alien you are [laughs]. This has all the attachments. And his single bunk tells you a lot about the guy. That's the Mandalorian's sad existence. Nobody is sleeping over." **Church**

← *RAZOR CREST* **INTERIOR AFT VERSION 02**
Church and Chiang

"The Mando is a loner so his cockpit has a single central seat. Early on, we added a jump seat for the kid. After that, it was a matter of how much *Millennium Falcon* to put in the cockpit, how much Harry Lange [original trilogy art director, who brought a mid-century aerospace aesthetic to *Star Wars* set dressing], all that stuff was in the mix. Cool ways of interacting with the ship that feel like they work (but don't really) so it doesn't just become an airplane, which would be super boring." **Church**

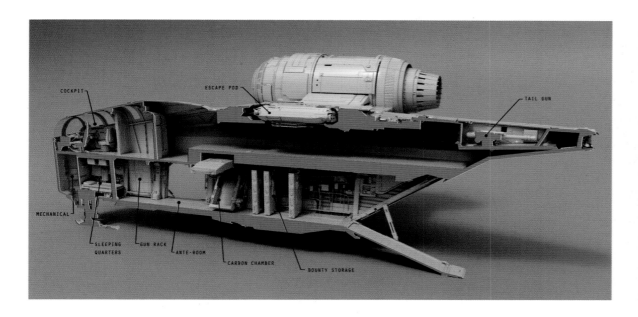

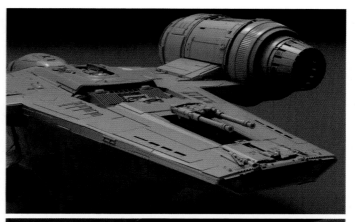

↑ *RAZOR CREST* SECTION VERSION 2A Colie Wertz

"Immediately after the exterior was approved, we got the list of interior needs: a carbonite thing, a refresher, a bunk. And the ship grew: a full two stories. Doug and [production designer] Andrew Jones and those guys got out the tape measure and [said], 'Well, that's how big it is. So, that's where we're going to build.' That never, ever happens. It's usually like, 'Can we do a contraction phase? Let's consolidate some things.' So, it was refreshing to not go through that process." **Church**

↗ *RAZOR CREST* VERSION 1H Wertz

→ ESCAPE POD VERSION 1H Wertz

"There was great detail in the finished exterior model that Jon really liked. And one day, he asked what it was. 'That's a life pod.' He goes, 'Well, we don't have a scene for that. Let's just finish it anyway because we may eventually.'" **Chiang**

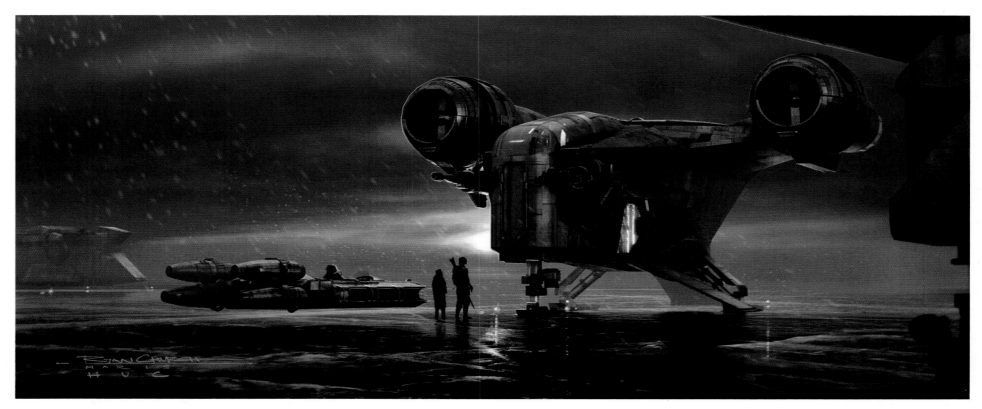

↑ ICE TOWN PARKING VERSION 1A Church and Chiang

→→ MYTHROL IN HANDCUFFS VERSION 03 Jurabaev and Chiang

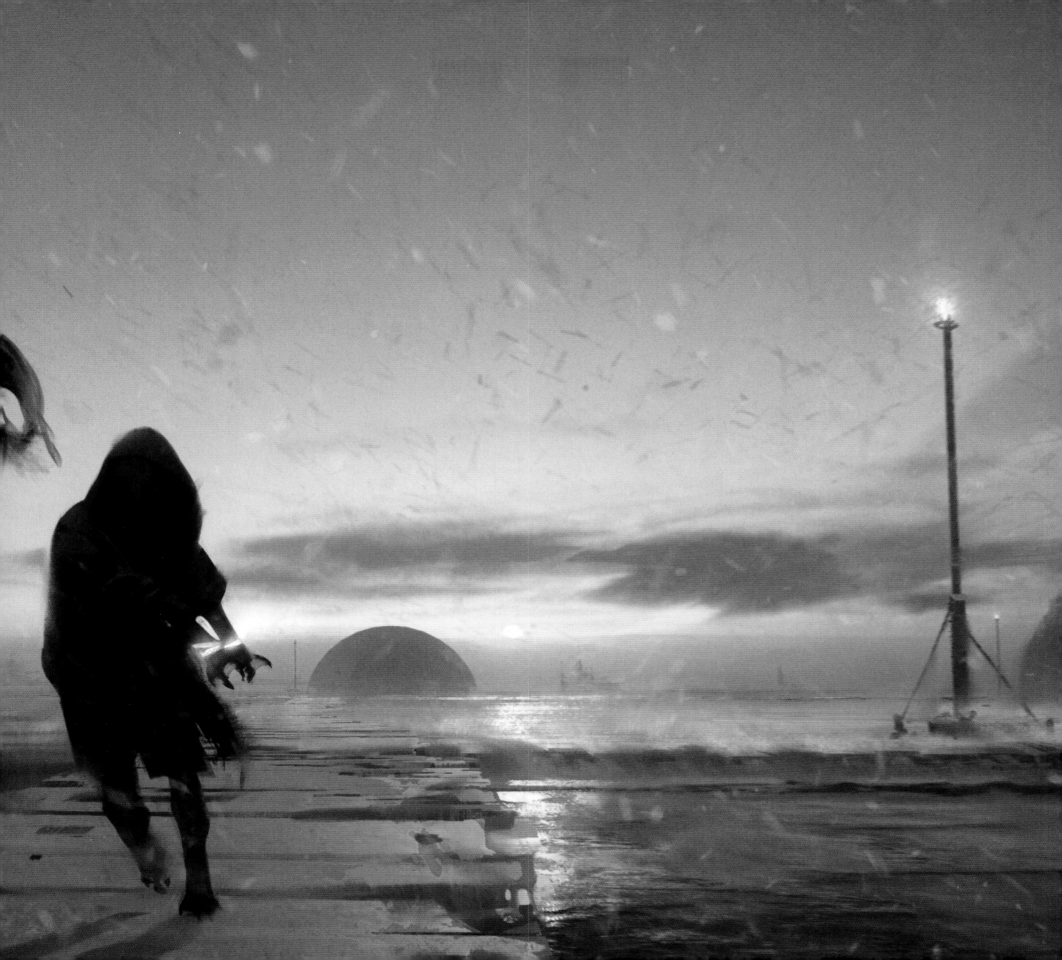

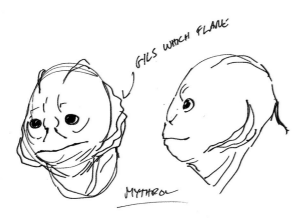

GILS WHICH FLAKE

MYTHROL

↑ **MYTHROL SKETCH 01** Filoni

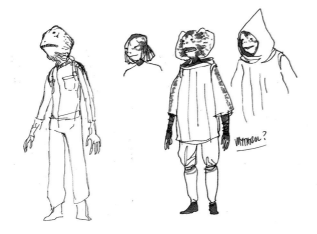

MYTHROL?

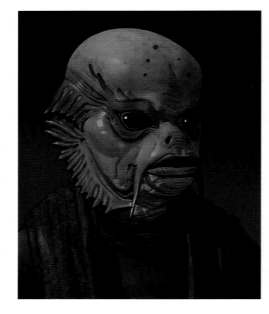

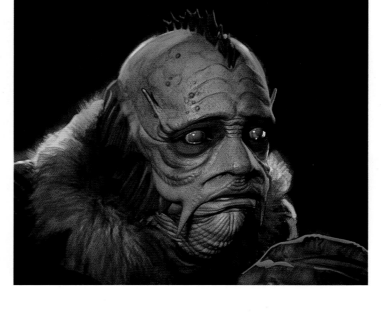

↑ **MYTHROL 01** Alzmann

← **MYTHROL SKETCH 02** Filoni

"If we were doing this for a saga film, we could go to town in terms of creature design, without really worrying too much about execution. This was slightly different because we knew that the Mythrol and other creatures were going to be actors in masks. So, how do we create an effective mask without it looking too cheap? There was a charm that Jon wanted to embrace, that they should look like the world's best rubber masks." **Chiang**

↙ **MYTHROL GRAY VERSION 03** Gloria Kim and Joseph Porro

↓ **MYTHROL 13B** "They kept simplifying the Mythrol makeup more and more, which is that razor's edge. Jon comes from an acting background and probably wants to reassure his actors that their performances will come through. But honestly, I still don't know that we have cracked that yet. Makeups are limiting because you can't cut forms off. It's only additive. So, it was tough." **Alzmann**

↑ **MYTHROL 02** "The Mythrol is weasely. When we read the script, I was totally thinking of Joe Pesci in *Lethal Weapon 2*. Or Charles Grodin in *Midnight Run*. From what I remember, the design brief from Favreau was for a gill man. So, on this particular design, I was looking at Vizzini, the character from *The Princess Bride* who can outthink everybody. I even used the gills to make it look like he's got the same balding pattern [laughs]." **Alzmann**

↓ **MYTHROL SCULPT** Tony McVey

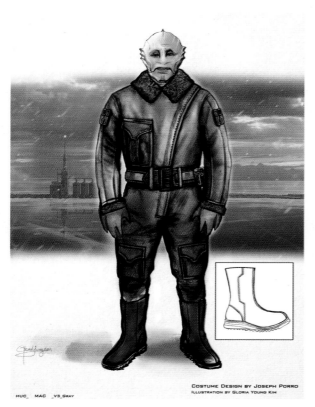

COSTUME DESIGN BY JOSEPH PORRO
ILLUSTRATION BY GLORIA YOUNG KIM

HUC_MAC_V3_Gray

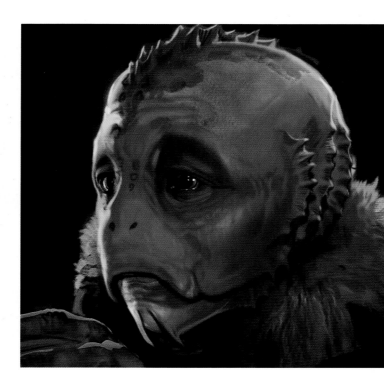

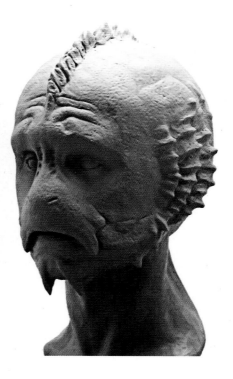

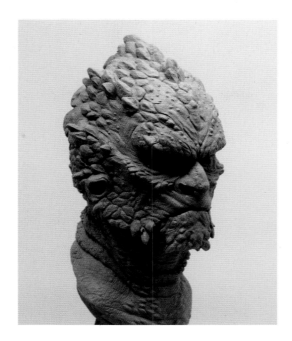

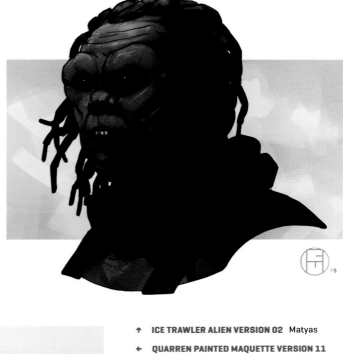

↑ TRAWLER SKETCH Filoni

"Filoni did sketches of these characters that looked like a mix between Prune Face and Walrus Man. Those really felt like classic *Star Wars* to me. So these guys would be larger-than-life, seven-foot-tall aliens." **Matyas**

→ TRAWLER SCULPT "This was something I came up with, inspired by *The Hideous Sun Demon* [1958], which features a reptile man. He only turned into a reptile when he was exposed to the sun. So, I bounced off of that design." **McVey**

↓ ICE TRAWLER VERSION 02 "I love drawing Nauto-lans, especially this one, since he had an accident and one of his tentacles got ripped off. They're also the perfect alien to modify the body type of. And to add a Canadian hat to." **Matyas**

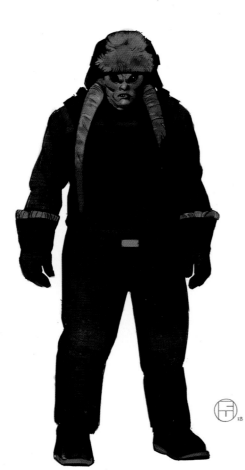

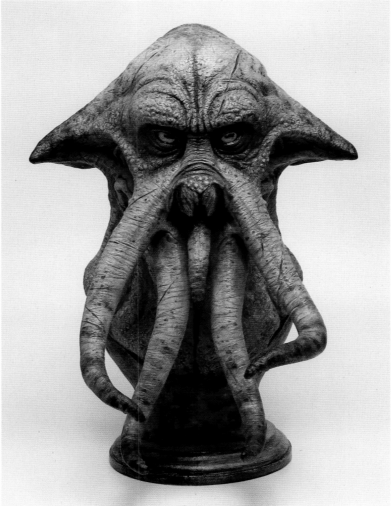

↑ ICE TRAWLER ALIEN VERSION 02 Matyas

← QUARREN PAINTED MAQUETTE VERSION 11
"He does look mean. I actually had him looking a lot meaner than that. At Doug's request, I changed his expression somewhat. The Quarren is an odd design. I tried to tone down the weird-ness a bit. My team did the original Quarren sculpt back on *Jedi*." **McVey**

↓ ICE TRAWLER SQUIDFACE VERSION 01 Matyas

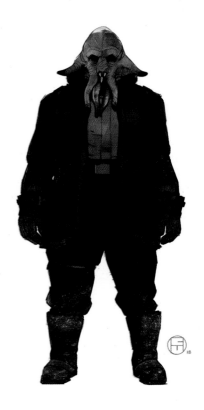

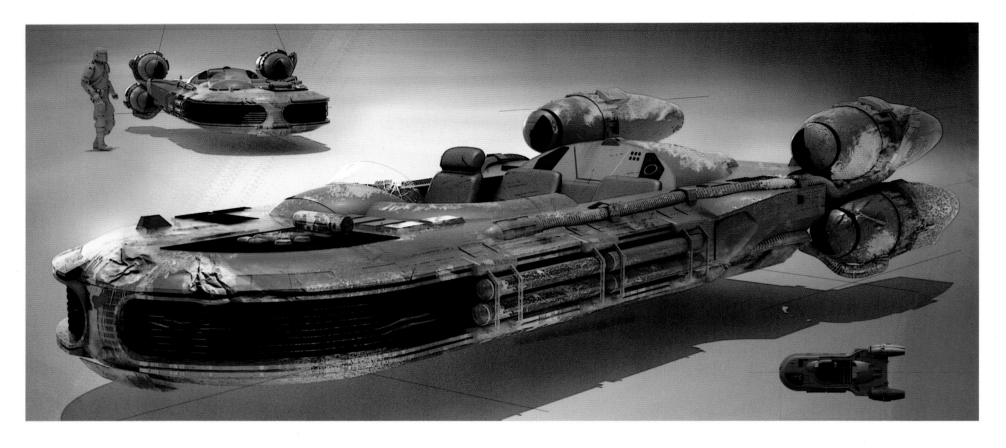

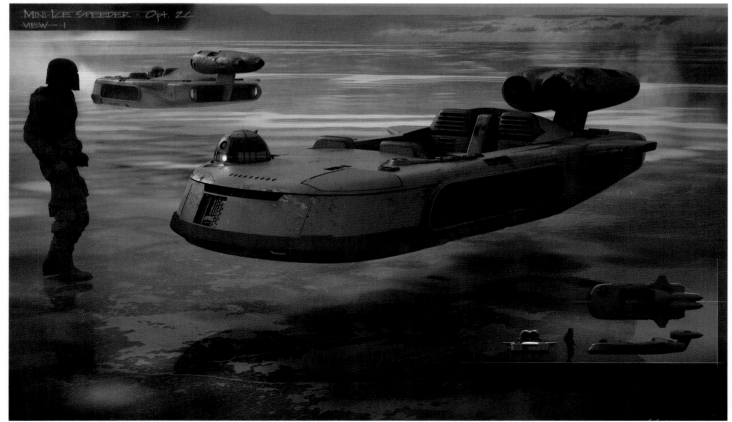

↑ **ICE SPEEDER OPTION 1B** Hobbins and Chiang

"The original Luke's landspeeder from *A New Hope* was tiny, even though it seated three or four. Initially, when we designed this speeder in the abstract, it was almost limousine-sized, which is ridiculous. So after a reality check, the final version scaled down to be almost half of what it was originally. And it's still a really big speeder." **Chiang**

← **MINI ICE SPEEDER OPTION 2D** Hobbins

↓ **FERRYMAN FLUTE VERSION 02** Matyas

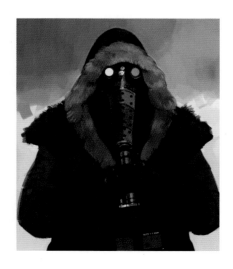

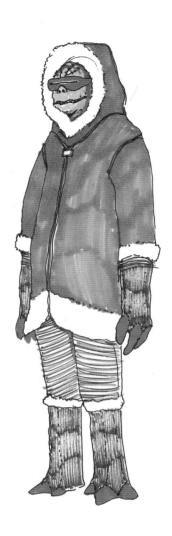

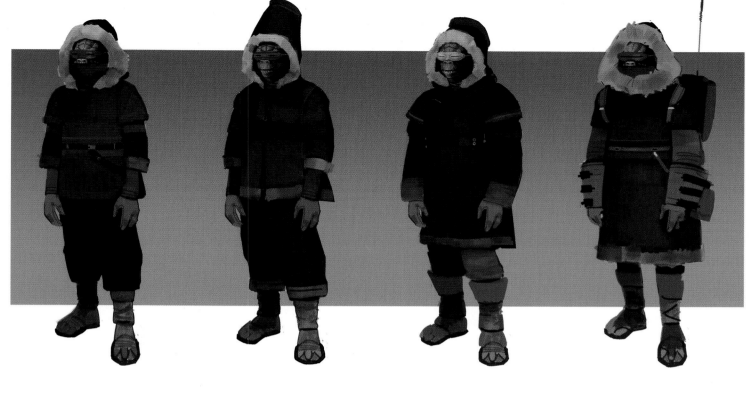

↑ **SPEEDER DRIVER SKETCH** "We loved and held on to the idea of the ferryman being a Trandoshan." **Filoni**

↗ **TRANDOSHAN SKETCHES VERSION 02** "Those snow goggles are from the Yup'ik Eskimo people. There are so many different designs and a lot of them are made out of actual whale bone, which is really cool. With that last sketch, I was thinking, 'Well, maybe he has some sort of warming backpack.' That didn't really gain traction. But there are a ton of other Trandoshans in the show." **Matyas**

→ **MANDO ICE PLANET VERSION 01** Matyas and Chiang

↓ **MANDO DRIVER STORYBOARD SKETCH** Filoni

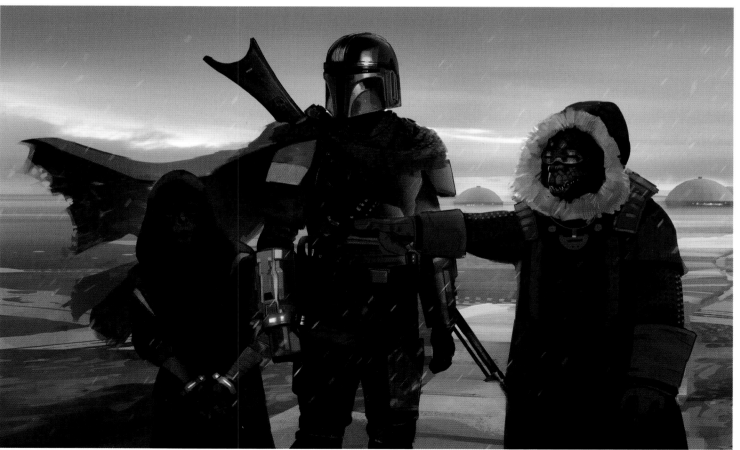

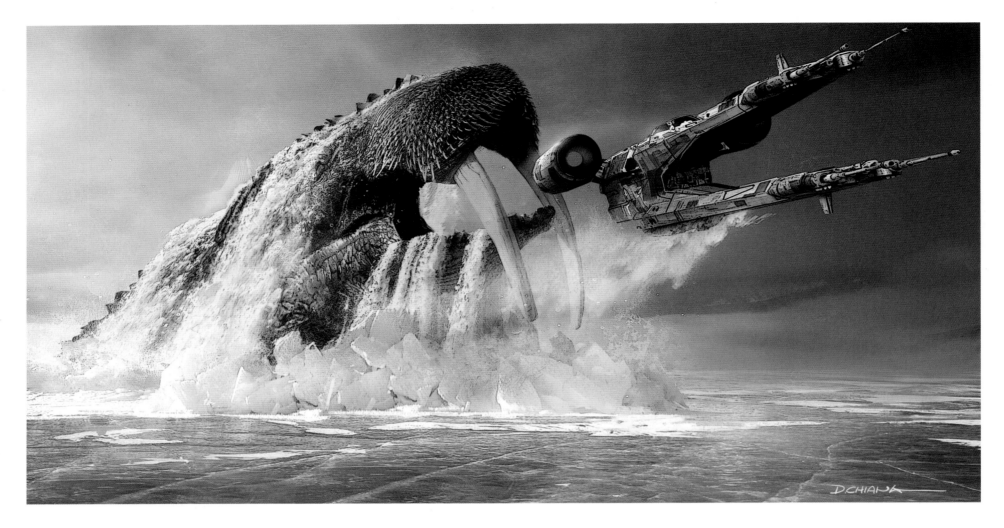

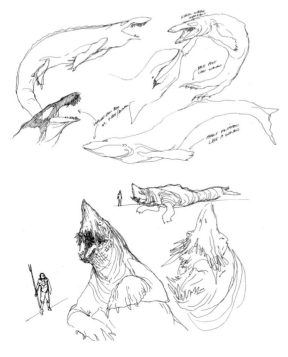

WALRUS ATTACK VERSION 01 "Jon Favreau and I both love old Ray Harryhausen movies. He came up with the idea of having this crazy walrus monster. And I immediately thought of *Sinbad and the Eye of the Tiger*, which I saw at the same time as *Star Wars*: Episode IV *A New Hope*. Those are the two films that had the greatest influence on my career.

"In some of the early pieces, I made the walrus huge because I just wanted a big monster moment. And Jon said, 'No, this is a small creature. It's not really a menacing thing. Mando is not threatened by him. In fact, he's more annoyed.'" **Chiang**

WALRUS SKETCH 02 **Filoni**

WALRUS SKETCH "When the first episode took place in the desert, the creature was going to be a worm of some kind. When it changed to an ice planet, I asked, 'Well, what about a big walrus?' And we started to explore what that might look like." **Filoni**

WALRUS VERSION 01 "It was Dave's idea to have the creature be a walrus. As we kept iterating, Jon pushed for it to be walrus-based, but much less one-to-one than this was." **Alzmann**

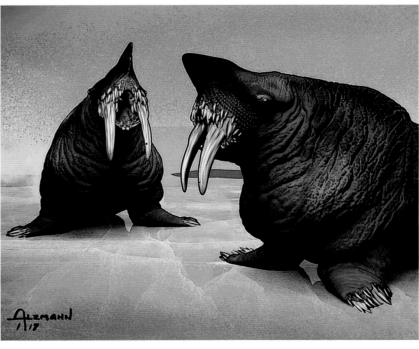

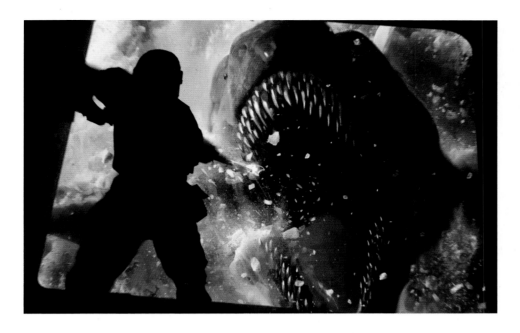

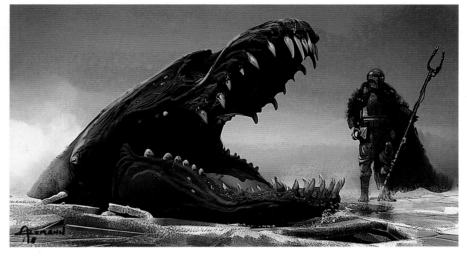

↖ **WALRUS MONSTER ATTACK VERSION 04** Jurabaev

↑ **ICE MONSTER VERSION 01** "I'm always thinking about something from *Star Wars* past. For the little pin eyes, I was thinking of the space slug. I figured if we're only going to see the top part of it, then let's make it all about the mouth." **Alzmann**

← **WALRUS CREATURE VERSION 01** Gindraux

→→ **LURKING WALRUS VERSION 04** Gindraux and Chiang

"One of the [LED screen] volume tests was of this moment, just to see how clear the ice should be and what kind of practical effects we should do for the boards." **Chiang**

↓ **RAVINAK SCULPT** "I was introduced to oil clay when I worked on *Gremlins*. I had never used it before. You can melt it down to a liquid, pour it into a rubber mold and make a clay casting, pull it out, and then rework it. The claws are just pieces of a plastic rod that I filed into shape. The tusks are epoxy putty." **McVey**

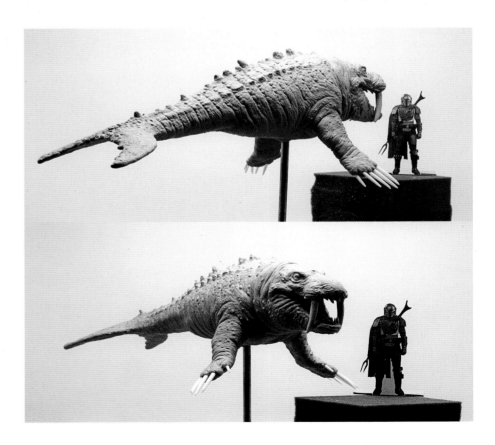

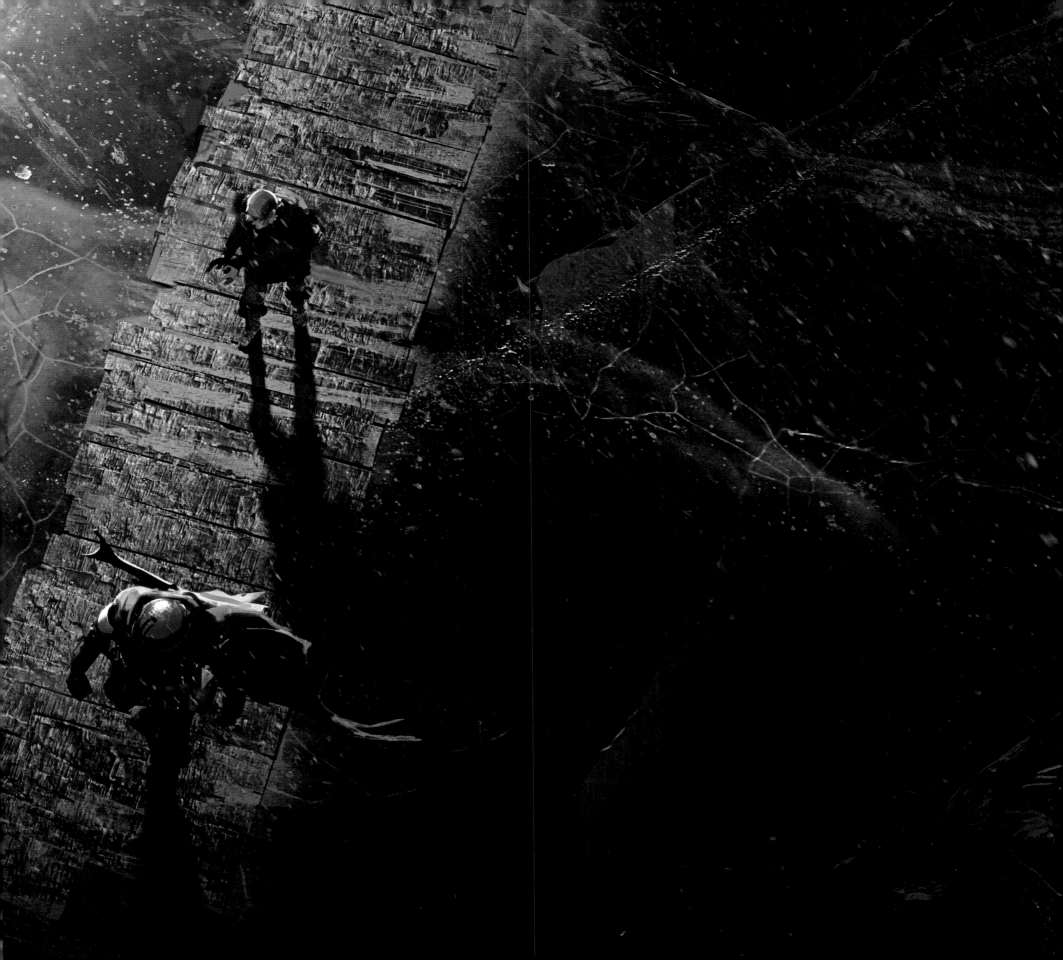

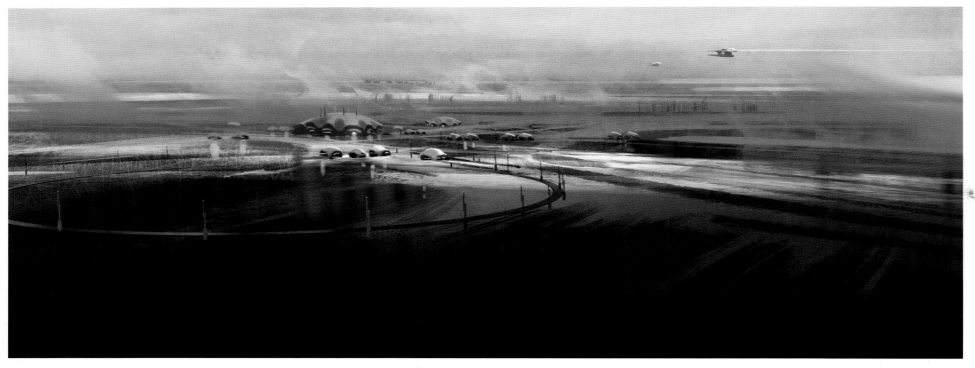

↑ **ICE PLANET WIDE VERSION 01** Gindraux

↑ **ICE PLANET SKETCH 02** Filoni

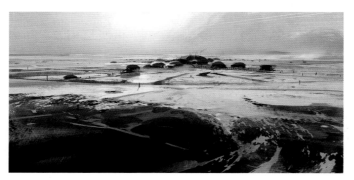

↑ **ICE PLANET VERSION 01** John Park

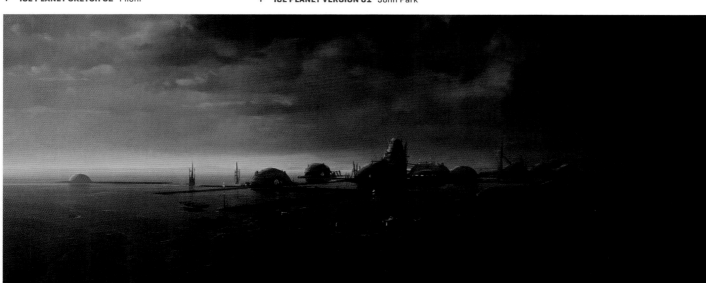

"I said, 'Let's just do something on ice.' I don't know if that was the best choice. It's very hard to do an ice environment. But our ice planet is unique and doesn't look like Hoth." **Filoni**

↑ **ICE PLANET VERSION 02** Park

"We thought that a whaling or trapper town on this outskirt planet would be really interesting to play around with. So, we leaned into wood, quite a bit. That was something really fresh for us, keeping the *Star Wars* form language of domes but changing the material." **Chiang**

← **ICE PLANET VILLAGE VERSION 02** "I always want to give a feeling of hope in the horizon to any place that's isolated, so that compression of tones, top and bottom, creates a little more tension and draws your eye into the center line area. I would imagine that a gray day gets a lot more interesting if there's a little bit of break in the horizon and something lights up, like an old volcanic cliff. Then it becomes dramatic." **Tiemens**

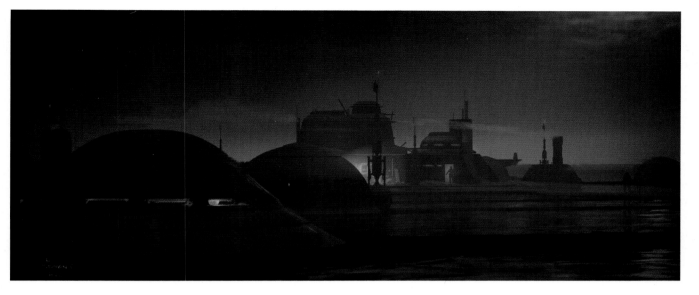

↑ **ICE PLANET SKETCH 01** Filoni

→ **ICE WHARF VERSION 01** "This was early exploration of an igloo metaphor with added *Star Wars* gack. I was intrigued with how flat this planet was. Even the planks were frozen into that surface layer. And it being a windy place, maybe the igloo forms could be aerodynamic, clinging on almost like mollusks or barnacles, something that can handle the elements." **Tiemens**

→ **EXTERIOR BAR DOOR** Seth Engstrom

↓ **ICE PLANET STORYBOARD SKETCH 01** "If you clearly understand the environment you're shooting, the shots become iconic. Everybody has got to be on the same page, telling the same story, making the same movie. If you are, then the shots become self-evident because you, the director of photography, the first assistant director, the art director are all saying, 'This is the best place to see this set from.' It's been like that forever but the shots from these sketches are in the final episode." **Filoni**

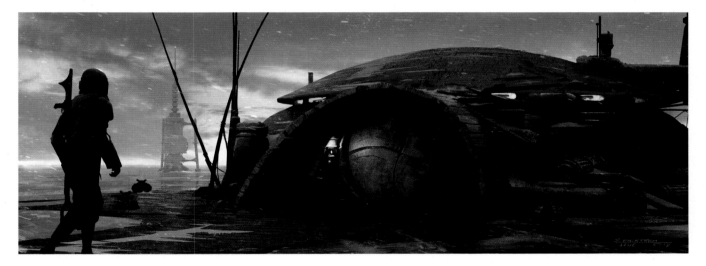

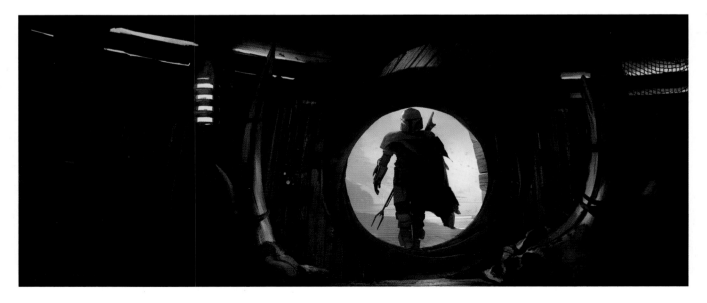

↑ **BAR DOOR SKETCH** Filoni

→ **BAR DOOR VERSION 05** Engstrom

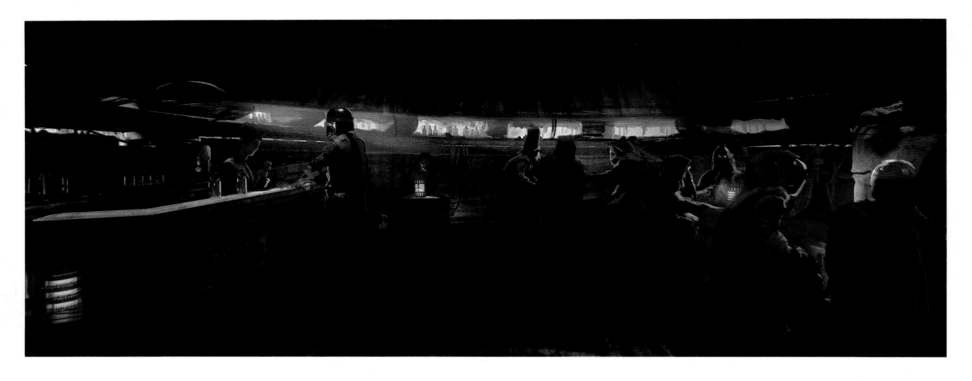

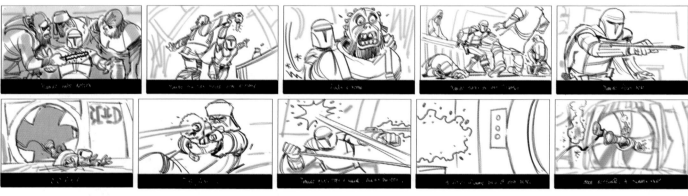

"The interior of the bar was made to resemble Quint's shack from *Jaws*. The set dressing brought it to life, all the traps and nets and things." **Chiang**

"So many people touched this interior. I did one of the first paint-overs of this space and added aliens. Then Anton added more bar patrons and this last revision was pulling down the windows so that they would do a better job of framing anyone who stood up." **Alzmann**

← **ICE BAR STORYBOARDS** Dave Lowery, Phillip Norwood, and David Duncan

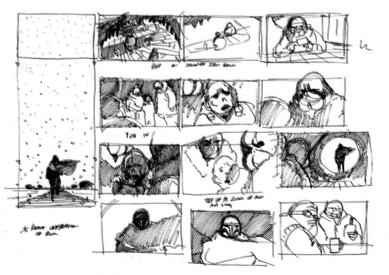

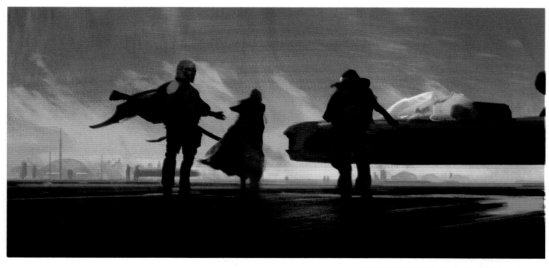

↑ **ICE PLANET STORYBOARD SKETCH 02** Filoni

↑ **TRANDOSHAN DRIVER VERSION 01** Gindraux

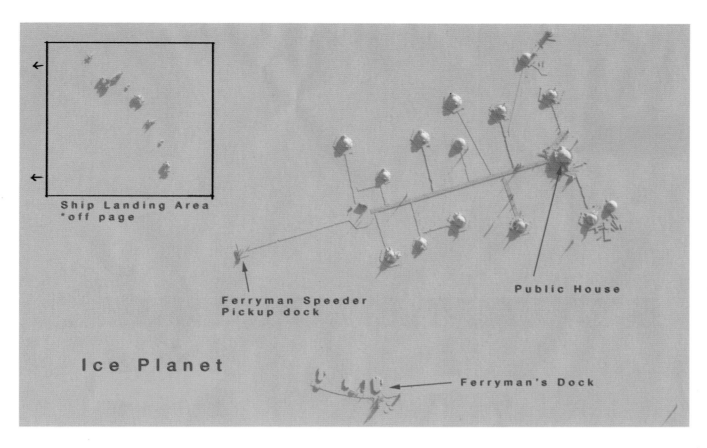

Ship Landing Area
*off page

Ice Planet

Ferryman Speeder
Pickup dock

Public House

Ferryman's Dock

↑ **ICE TOWN LAYOUT SKETCH** Filoni

← **ICE PLANET MAP VERSION 1A** "This is really close to Filoni's sketch. I loved this approach of keeping things like they're little foam-core card models, just purely layout and not getting bogged down with texturing. More and more, we've been doing that, just looking for clarity and what kind of action is going to play out—laying it out in 3D, visiting those areas with the camera, and seeing potential compositions." Tiemens

↓ **MYTHROL IN HANDCUFFS VERSION 4A** Park

→→ **MAIN HALL VERSION 04** Tiemens and Chiang

"Our *Star Wars* version of crab shacks were fun to set dress, to add stuff poking out of the ice. If we were spending more time here, it would be interesting to play with the effects of moonlight and artificial light and how it dances across the ice. And then the reverberations of this creature below that we might see now and then. That adds to its beauty, sense of isolation, and potential peril." Tiemens

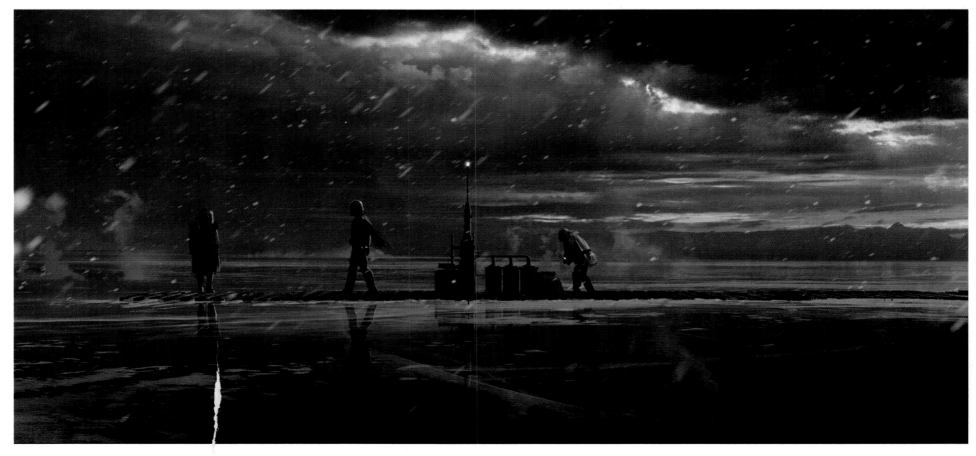

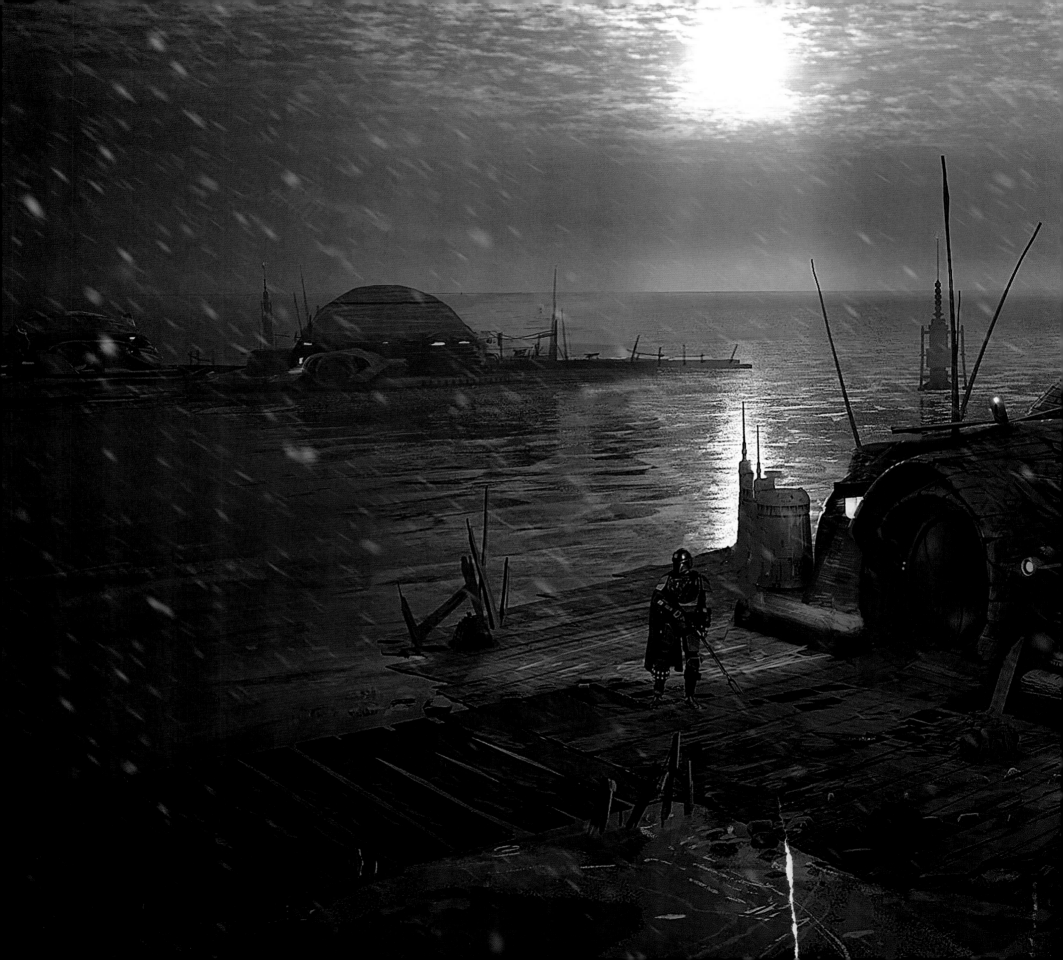

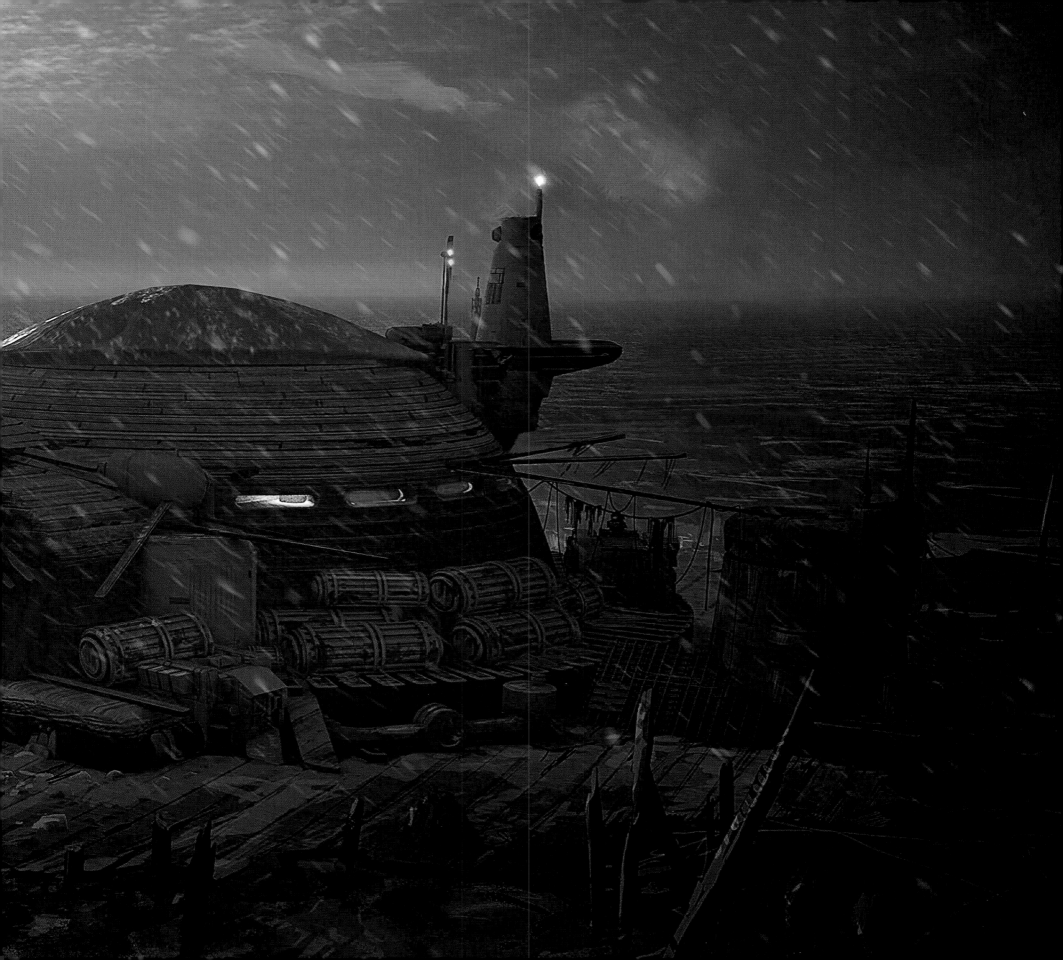

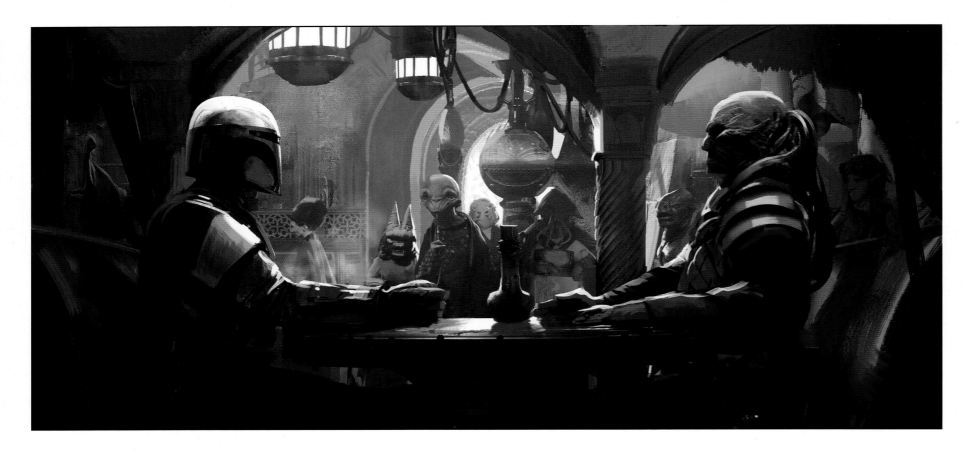

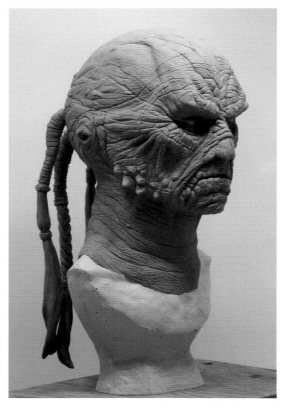

↑ **WEEQUAY VERSION 1A** Park and Chiang

→ **PUBLIC HOUSE INTERIOR VERSION 02**
Park and Chiang

"Before Carl Weathers was cast, Jon wanted the Mandalorian's boss to be a Weequay. So, we came up with that sculpt and it worked really well. Then, when Carl Weathers came on board, we tried to adapt that mask to him. I believe it was like a week or two later, Jon was asking, 'Gosh, why are we hiring Carl if we're going to hide his face? No, let's just save that for another character and embrace Carl as Carl.'" **Chiang**

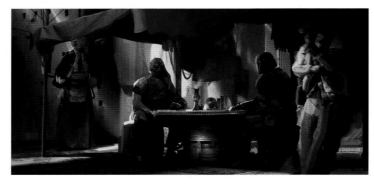

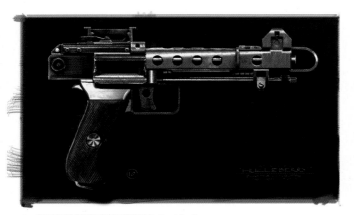

↑ **GREEF BLASTER VERSION 10** Paul Ozzimo

↑ **TRACKING FOB** Ozzimo

↑ **WEEQUAY SCULPT** McVey

- → **CLIENT MEDAL VERSION 02** Kim and Porro

- → **GREEF VERSION 07** "I did a design based on fifteenth-century French half-capes, where you stick your arm through it, for a Chapter 7 bounty hunter. And then that design stuck for Greef Karga. I just put Carl Weathers's head on there [laughs]. I don't find myself to be the best at portraiture. If I don't have enough time, I'll use a Drew Struzan technique where I'll put a photo on low opacity and draw over it." **Matyas**

- ↓ **CLIENT VERSION 01** "I was just thinking Italian mob boss for the Client. I was shocked that they got Werner Herzog, because he's such an iconic actor and director." **Matyas**

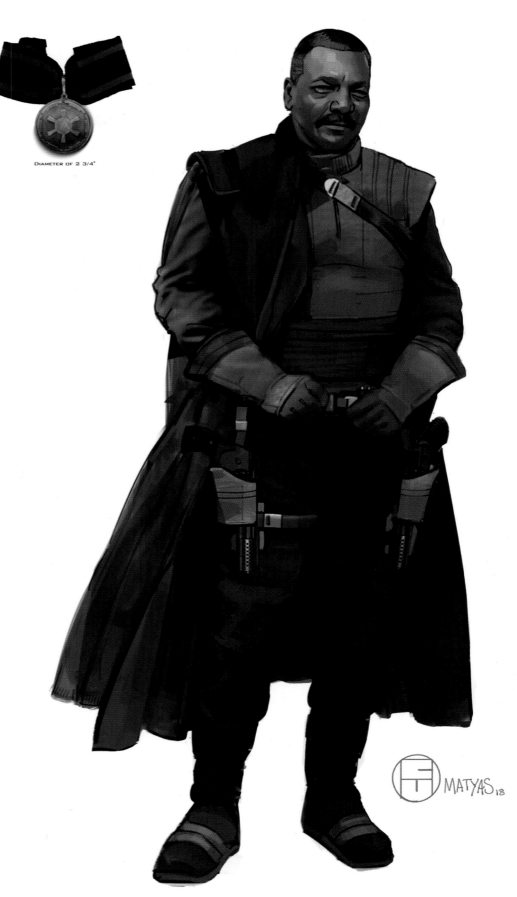

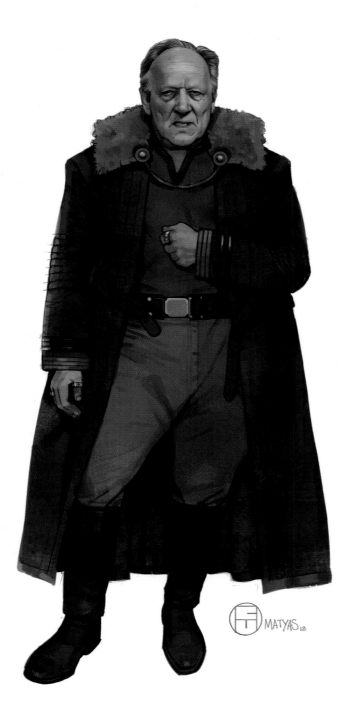

DIAMETER OF 2 3/4"

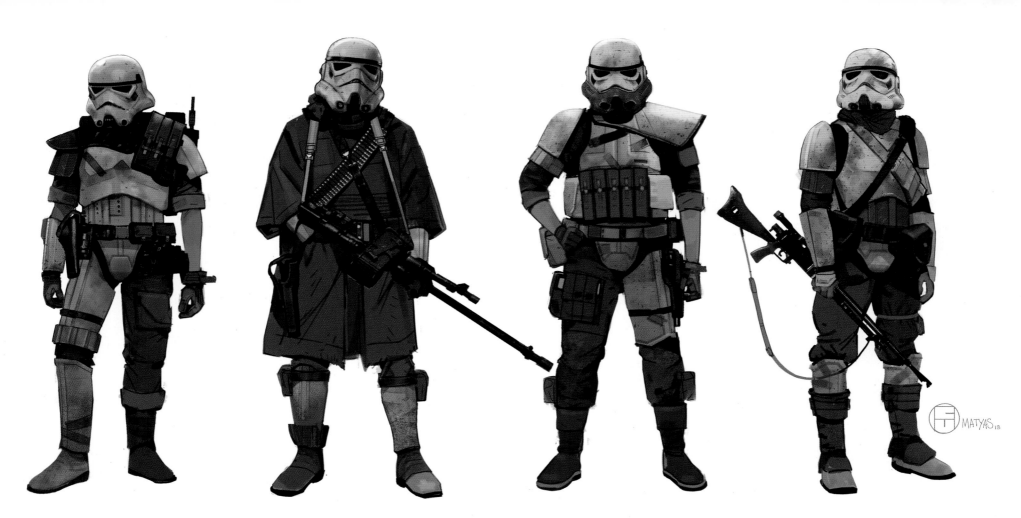

→ **DECOMMISSIONED STORMTROOPERS VERSION 05** "I might try and reintroduce these decommissioned stormtrooper designs in some way for Season 2. I would still love to see some of the layering, the guerrilla fighter idea." Matyas

← **EX-STORMTROOPERS VERSION 01** "I was thinking that these storm-troopers are kind of tribal, having taken to whatever the culture of this lava city is and painted themselves in the reds of an Imperial shock trooper. Maybe they weren't ever shock troopers but they have a certain class and clout within Nevarro that have branded themselves as such." Matyas

→ **DECOMMISSIONED STORMTROOPERS VERSION 05** Matyas

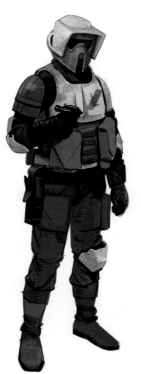

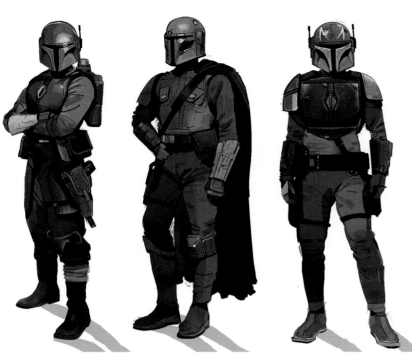

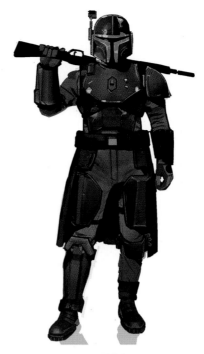

"Jon wanted to explore the idea that once we go into the Mandalorian covert [in the sewers under Nevarro], we will see other Mandalorians. Who should they be?" **Chiang**

← **BACKGROUND MANDOS VERSION 2A** Matyas

↓ **FEMALE MANDOS VERSION 2A** Matyas

↑ **BACKGROUND MANDOS VERSION 6A** Matyas

↓ **BACKGROUND MANDOS VERSION 5A** Matyas

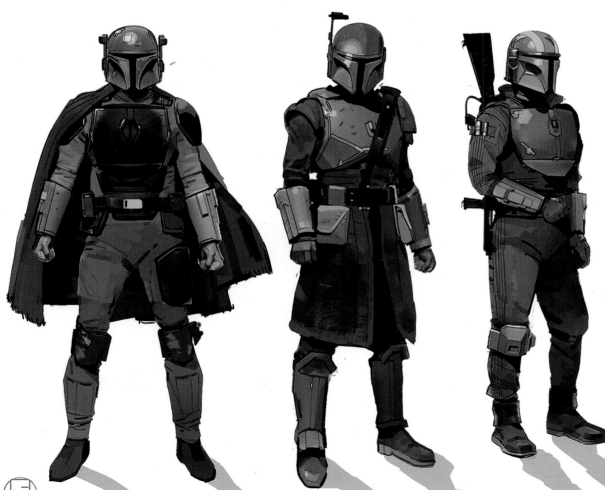

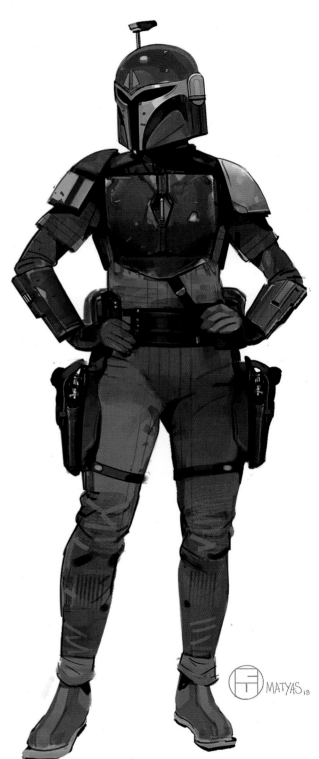

↑ **BESKAR ILLUSTRATION** Ozzimo

← **MANDO ENCLAVE VERSION 02** "An idea for what Mandalorians would do when they are hanging out at their base, playing a tactical game to sharpen their senses for battle." **Anton Grandert**

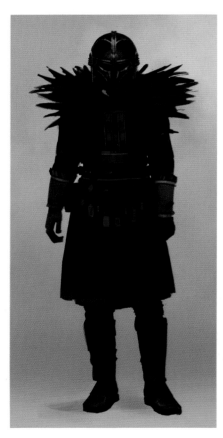

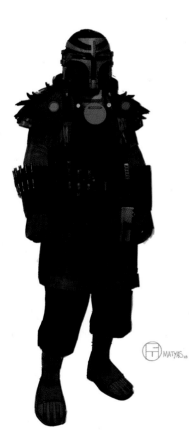

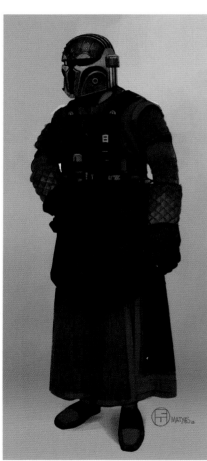

↑ **BLACKSMITH VERSION 02** Matyas

 BLACKSMITH VERSION 3A Matyas

"The Armorer's design was pretty open for me to create. They gave me enough context, that she represents an ancient culture of blacksmithing. I wanted something that felt like a costume that is passed down to the Armorer. I was playing with the helmet being a little more opulent and ornate in a ceremonial way. She's not a warrior and they didn't want her to come off as a warrior. But, at first, I was thinking of more of a shaman kind of look. And then it got more practical, as the designs progressed." **Matyas**

↑ **BLACKSMITH VERSION 01** "The design started getting a little more utilitarian with the leather apron, thinking that she keeps her tools in there. I tried to work in a couple of the tools that Boba Fett keeps on his shin guards." **Matyas**

↑ **BLACKSMITH VERSION 9A** Matyas and Chiang

"I explored some kind of weird saber-toothed tiger jaw attached to the helmet that riffs off of the mythosaur skull, something more barbaric and intimidating. Although I think it was getting a little too barbaric. But it did create an interesting silhouette." **Matyas**

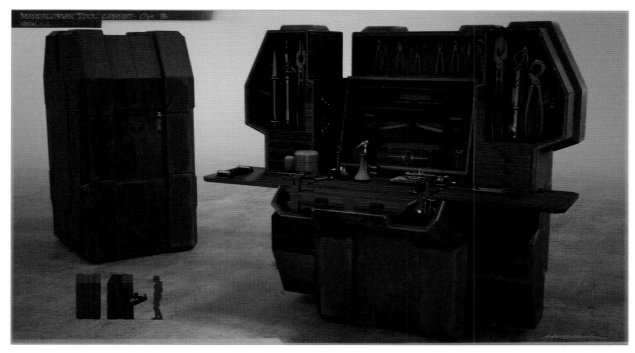

↓ **BLACKSMITH VERSION 4B** Matyas ↑ **TOOL CABINET VERSION 1B** Hobbins

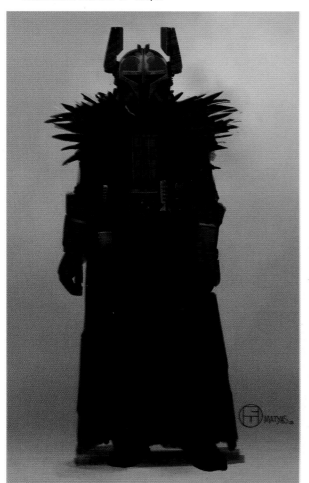

↑ **BLACKSMITH VERSION 3B** "The leather apron became a little more encompassing, like a skirt. Everything's really thick and protective. It's a good balance between the ancient, the ceremonial, and the Mandalorian, and practical for her job. I wasn't even aware of the Armorer when I was designing the Mandalorian. But she was perfect for retaining those medieval elements from his [the Mandalorian's] early designs. It's weird how the horns don't quite look devilish. Between the visor, the horns, and all of that, it could have gone so differently [laughs]." **Matyas**

Barn owl–shaped eyes on Mandalorian helmets first appeared in the 2012 *Star Wars: The Clone Wars* episode "A Friend in Need," on Bo-Katan Kryze's Nite Owl faction of the sinister Death Watch.

← **BLACKSMITH VERSION 02** "I played with bones and hides, a lot of leather stripping that's painted, and draping, trying something wacky knowing that it's probably not going to stick. But maybe it would be a good conversation piece. And then also wrapping the forearm so she's protected from the hot molten metal." **Matyas**

↑ **LAVA PLANET VERSION 02** Park

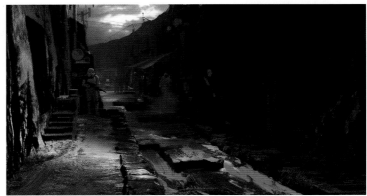

↑ **LAVA PLANET VERSION 03** Park

"Jon was very aware that each of these environments needed to be very distinct. So, he immediately was drawn to the idea of a lava planet. But he didn't want it to look anything like Mustafar. In fact, he said it should be more like Kona, Hawaii. And so, some of the early designs had this very hard packed dried lava." **Chiang**

↓ **LAVA PLANET VERSION 1A** Jurabaev

→ **LAVA CITY STREET VERSION 02** Park

"This settlement has been here for many generations. The first layer was very much like Pompeii, an old town that a volcanic eruption had laid ruin to. The next settlement came in with the Empire and built on top of that, infusing a little bit of their aesthetic into it. The goal was to set up a place with that kind of richness, so that if you look down the street, you can dissect the layers of history." **Chiang**

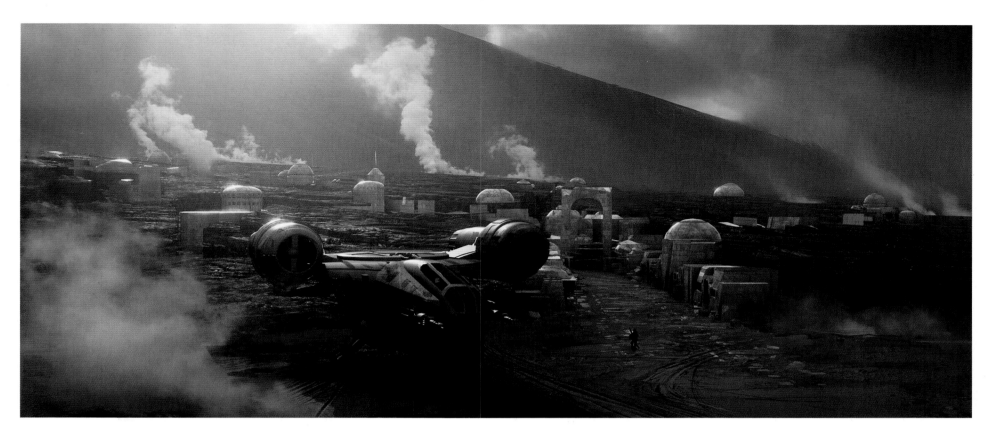

↑ **LAVA PLANET VERSION 04** Jurabaev and Chiang

← **NEVARRO SKETCH 01** Filoni

→ **WIDE STREET AERIAL VERSION 01** Church

↓ **NEVARRO MAP VERSION 1A** "I worked with Ryan's model to break down the areas of Nevarro, just so we get our bearings. And of course, things got adjusted and changed. But the essence is there: the T-line through town and the Pompeian arch and then the public house." **Tiemens**

↓ **SAFE HOUSE ROOFTOP VERSION 02** Landis Fields

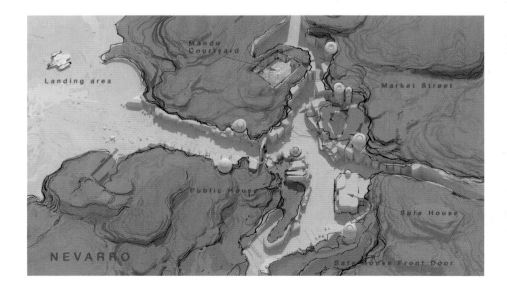

↑ **NEVARRO SKETCH 01** Filoni

→ **NEVARRO MARKET VERSION 06** Park

↓ **NEVARRO MARKET VERSION 04** Park

"We leaned into Middle Eastern/Moroccan for the architecture, as an initial inspiration. And then we changed some of the materials, trying to find the distinguishing architectural and textural quality of this place. Very quickly, we started to come up with this graphic: white stucco walls to contrast the black lava on the floors and roofs, creating this rich black-and-white contrast. Then we added accents of color from awnings and the marketplace." **Chiang**

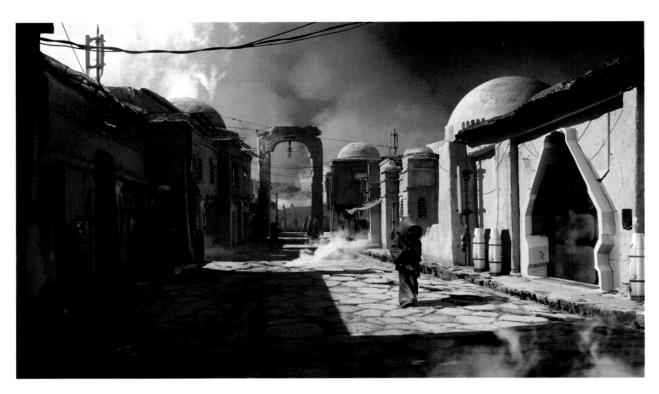

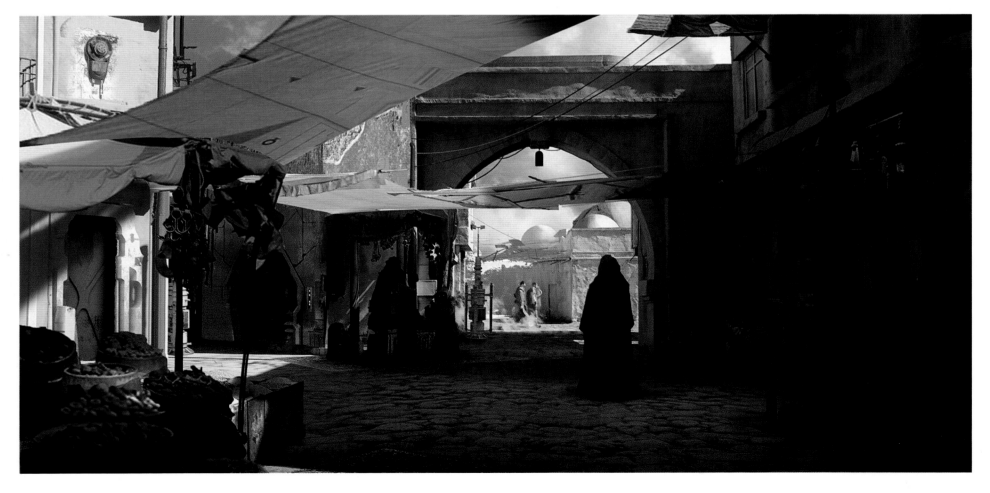

↑ **IMPERIAL BUNKER VERSION 01** Gindraux

↑ **NEVARRO DOORWAY VERSION 02** Church and Chiang

"Just that white outline around the door makes it visually distinct. When you come back, you know where you are. It doesn't take much." **Church**

← **NEVARRO SAFE HOUSE VERSION 01** Fields

→→ **PUBLIC HOUSE INTERIOR VERSION 02** Park and Chiang

"For the initial interiors of the main public house, we completely embraced mixing a Middle Eastern market with *Star Wars*. It was the right idea, the right tone." **Chiang**

↓ **OFFICE INTERIOR VERSION 02** Gindraux

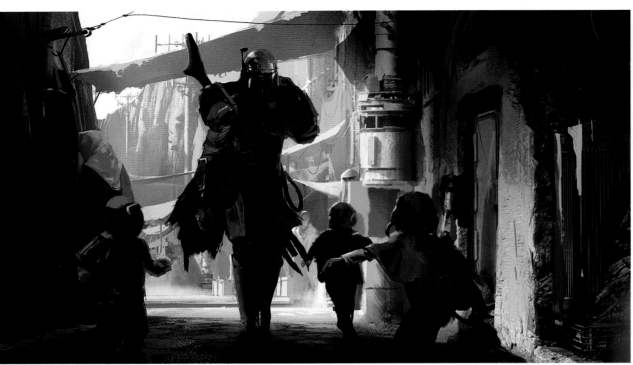

↑ **STREET KIDS VERSION 02** "John Park scribbled some Mandalorian kids into his piece. And Favreau liked the feeling of that. So, I used it as inspiration and did these pretty quick costume designs." **Matyas**

→ **MANDO KIDS STREET SCENE VERSION 03** Park and Chiang

↓ **SHOP INTERIOR VERSION 02** Park and Chiang

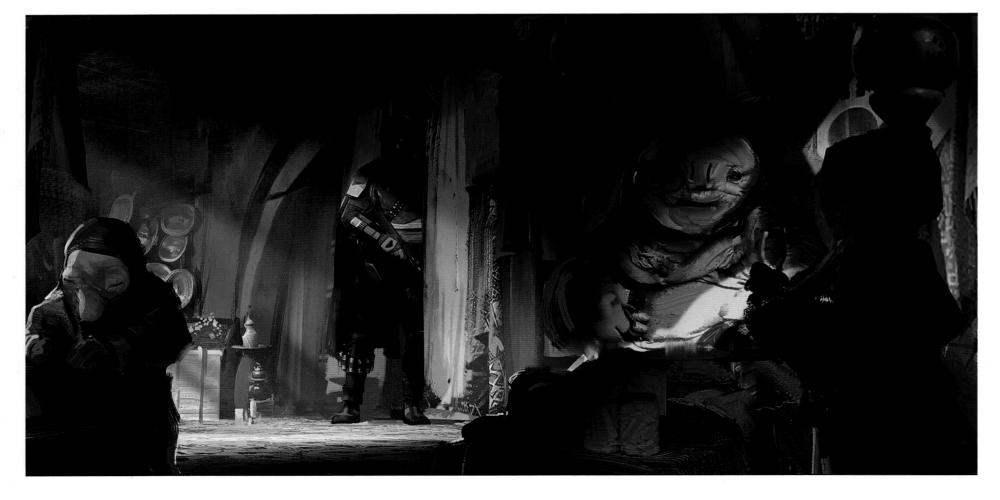

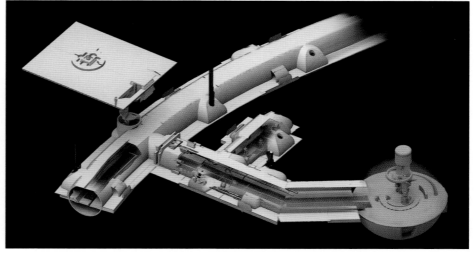

↑ COURTYARD OVERVIEW VERSION 02 Grandert

"Some of our initial ideas were quite grand, multistory courtyards and things. But it's really helpful to establish that aspirational high bar." **Chiang**

↓ ENCLAVE ENTRANCE VERSION 02 Grandert

The mythosaur skull emblem on Boba Fett's left shoulder pauldron, which also appears on a flag outside of Maz Kanata's castle in *Star Wars: The Force Awakens*, was the inspiration for the sculpted mythosaur skull hanging over the entrance to the Armorer's subterranean workshop.

↑ ENCLAVE OVERVIEW VERSION 02 Grandert

"The Mandalorian den underneath the city, in the sewer systems, was all figured out. You got a sense of why they were there and how the space functions." **Chiang**

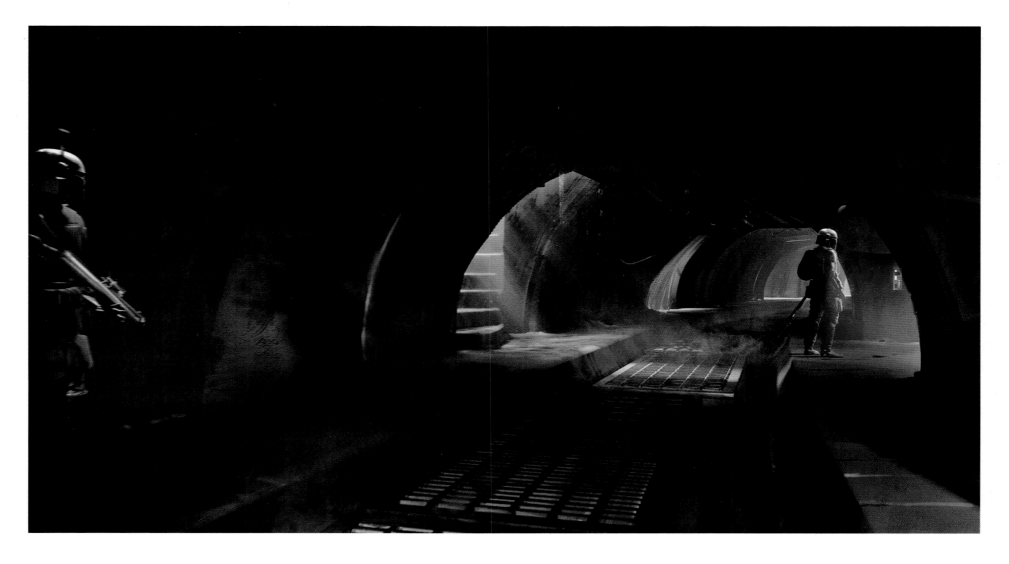

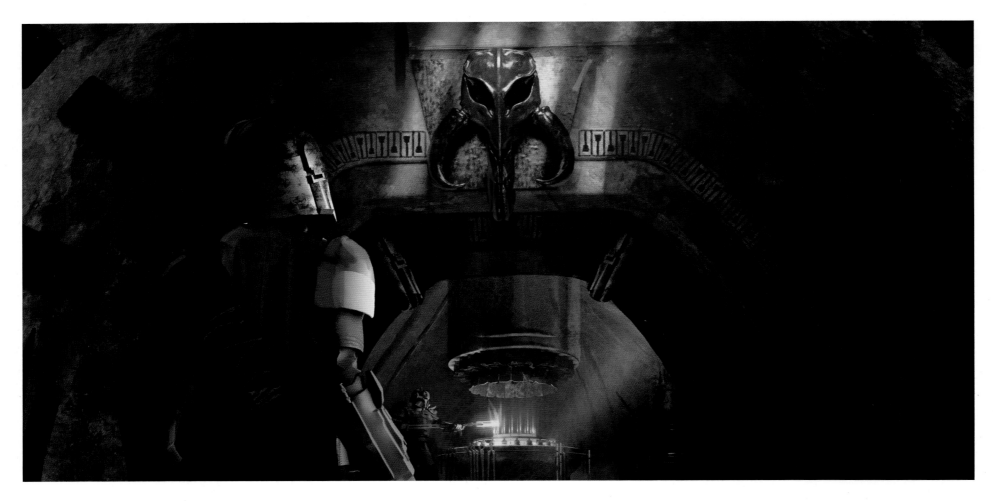

"The form factor for where the Armorer chose to set up her workshop came from the fact that they were hiding in the sewers. So, maybe this is one of the main sewer chambers, with open access to a manhole cover, a place to vent while still remaining hidden." **Chiang**

↑ **ARMORER ENTRANCE VERSION 02** Gindraux

→ **ARMORY VERSION 02** Jurabaev

↓ **WORKSHOP SKULL 01** Fabian Lacey

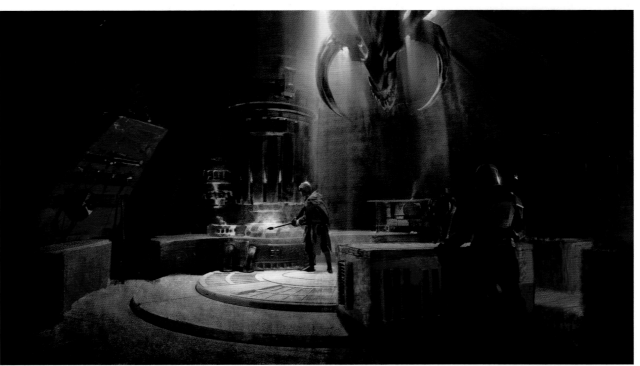

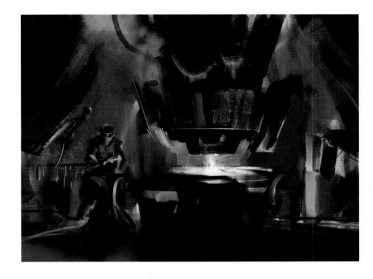

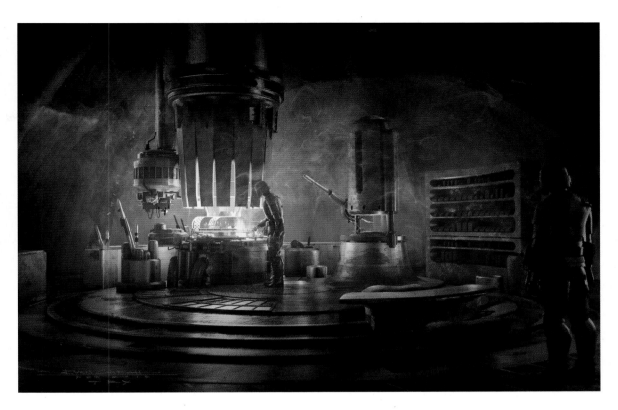

The traditional art of Japanese steel swordsmithing, dating back thousands of years, as well as other forms of blacksmithing, were referenced by the Lucasfilm art department for the Armorer's forging of beskar steel into Mandalorian armor.

↑ **ARMORY SKETCH VERSION 01** Grandert

→ **ARMORY SIDE SHOT B** Church

↓ **ARMORER MOOD VERSION 3A** Gindraux

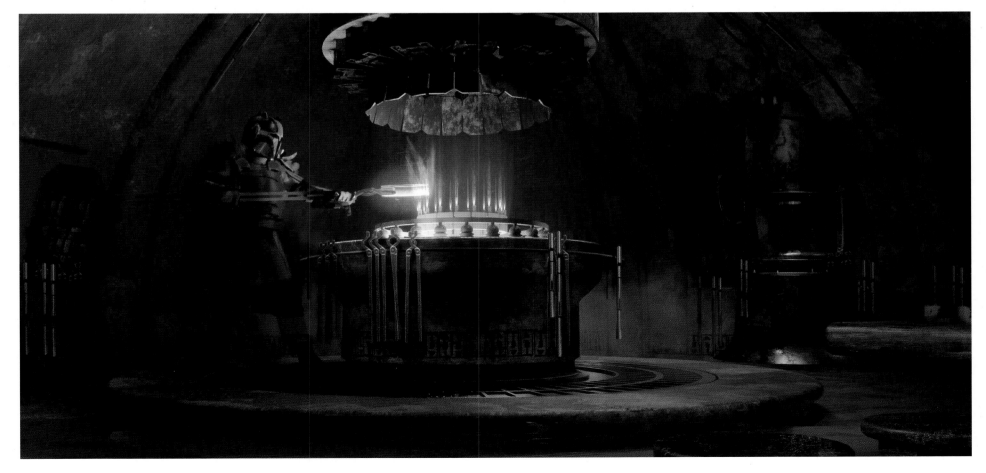

I Have Spoken

At Lucasfilm president Kathleen Kennedy's behest, Dave Filoni began visiting the Pinewood Studios sets of the new live-action *Star Wars* films, starting with *Star Wars: The Force Awakens* in mid-2014. "I'd only go for a week at a time because I was still doing *Rebels*," Filoni recalled. "And I would just sit there quietly and watch. I'll never forget that when I visited Episode VII, [co-writers] Larry Kasdan and J.J. Abrams, who had such tremendous weight on their shoulders, looked up and said, 'Hey, Dave, congratulations on *Rebels*.' That kind of thing just floors you. I always appreciate those small moments."

The following year, Filoni visited the set of *Rogue One: A Star Wars Story*. "That had a dual purpose because I was more involved with the story, which [due to overlapping in-universe timelines] was way more relevant to the work I was doing on *Rebels*," Filoni said. "Certainly in developing the third act battle [in which *Rebels*' starship the *Ghost* appeared] with John Knoll and Hal Hickel. And I had to make sure that [*Rebels*' droid] Chopper was Chopper in *Rogue One* and, frankly, wasn't in the way. But I talked to [director] Gareth Edwards and [writer] Gary Whitta so much throughout the process that Gary wrote on *Rebels*. He's so fun and we get along as two *Star Wars* fans. I also met Greig Fraser, *Rogue One*'s director of photography, and Baz [second unit cinematographer Barry Idoine]." Fraser and Idoine would return to *Star Wars* as cinematographers for *The Mandalorian*.

But Filoni's greatest education as a live-action director may have come on the set of *Star Wars: The Last Jedi* in early 2016. Filoni recounted that "[director] Rian Johnson had me right up next to him with the camera. He shoved lenses in my hand and said, 'Look through here.' He would bring me along to show me how to block a scene. Rian was so supportive of my interest in doing live-action, as was his producer, Ram Bergman. They really made me feel like this was something that I could do."

On September 25, Jon Favreau replied to Kennedy's email gauging his interest in a live-action TV series, expressing interest in Mandalorians, a subject Filoni also wished to explore further. Favreau and Filoni, sharing a mutual history in Mandalorians from their time on *Clone Wars*, were reunited by Kennedy to collaborate on the subject in the November 14 meeting at the Kennedy-Marshall Company, culminating in the creation of pitch art that same month. Filoni quickly fed sketches of potential moments in the series to Doug Chiang's Lucasfilm art department. "Through my sketches, Jon and I can instantly communicate," Filoni said. "And when we talk to Doug, hopefully we're on a symmetrical page. Then, the art department make it something you could never have dreamed of. I love working with them. But [in late 2017], I was still learning how. My *Clone Wars* and *Rebels* sketches end up pretty one-to-one [with the final designs]. Whereas in live action, it's a more fluid evolution."

After nine full months of design, fabrication, and prep work, *The Mandalorian* "Chapter 1" marked Dave Filoni's live-action debut as a director, shot concurrently with director Deborah Chow's "Chapter 3: The Sin," as the two episodes share much of the same cast and sets,

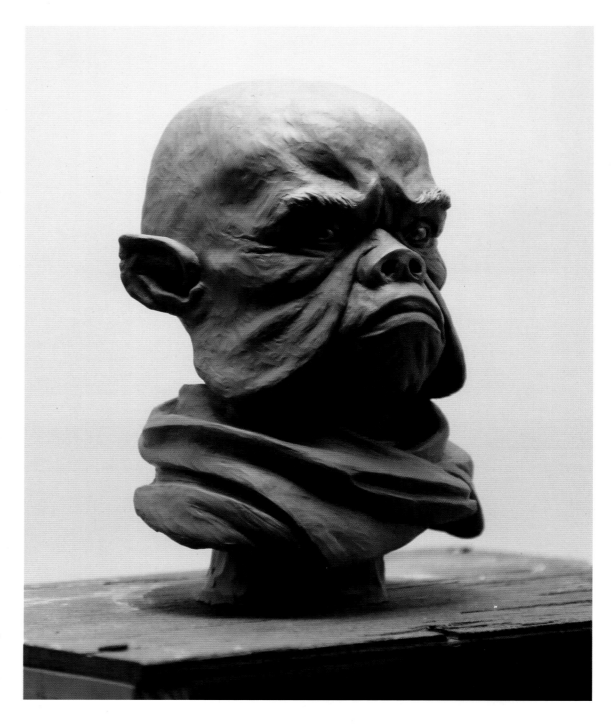

from October 1 to 26, 2018. Filoni's *Star Wars* creative mentor, George Lucas, visited the set on October 19, which coincidentally was Favreau's birthday, with a snapshot of the two *Star Wars* creators taken to commemorate the occasion.

"I hadn't directed something that I hadn't written in years," Filoni reflected. "I would do my own pass on every episode of *Clone Wars* or *Rebels*, to get it ready to shoot. But to have somebody like Jon be supportive and instructive, with the amazing amount of technical knowledge that he has, was instrumental in my own rapid learning curve."

↑ **UGNAUGHT SCULPT** McVey

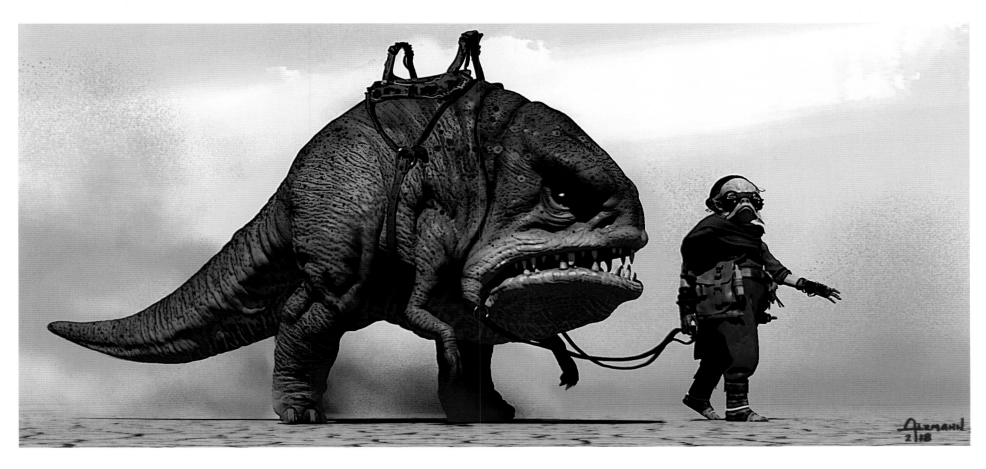

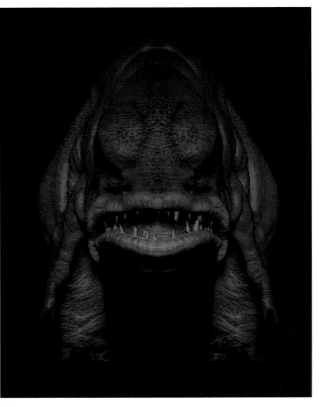

↑ **BLURRG VERSION 02** "I thought the blurrg would be computer generated, that we'd get the skin textures and animation as realistic as possible. But all the forms still look like they did in *Ewoks: The Battle for Endor*. The tricky part was designing the blurrg so that he could turn his head. The shoulder and head are so close together.

"Why don't we make Ugnaught a little more heroic and kind of a badass? What if he had a bit of a swagger to him? So, I gave him goggles and this scarf-like cape. I added jewelry and adornment, just to give a little color to the outfit. This was the first pass on the Ugnaught and it got immediate approval." **Alzmann**

→ **BLURRG VERSION 03** Alzmann

"I love the charm of the original Phil Tippett design from *Ewoks: The Battle for Endor*. You could easily go full CGI, make it look extremely real. But it would lose the *Star Wars* charm. There's a funkiness to it. So, our design approach was, 'In the old days, the mid-1980s, how would this have been created?' It would be a combination of a hand and stop-motion puppet. That material limits how much dexterity and fidelity you can get into the musculature. We backed into that to give our blurrg that old-school charm." **Chiang**

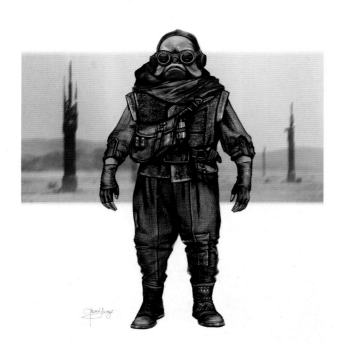

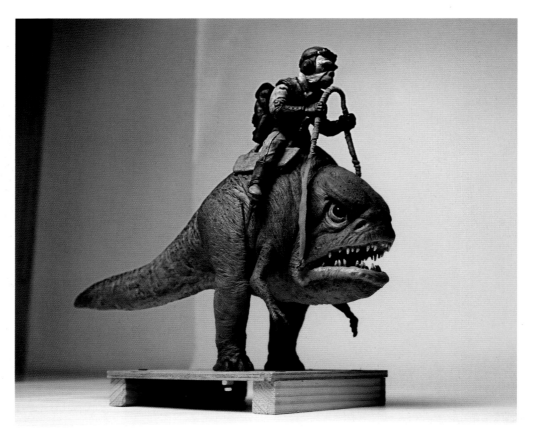

↑ **UGNAUGHT VERSION 02** Kim and Porro

→ **BLURRG AND UGNAUGHT STOP-MOTION PUPPET** McVey and Chiang

↓ **BLURRG RIDE VERSION 01** Gindraux

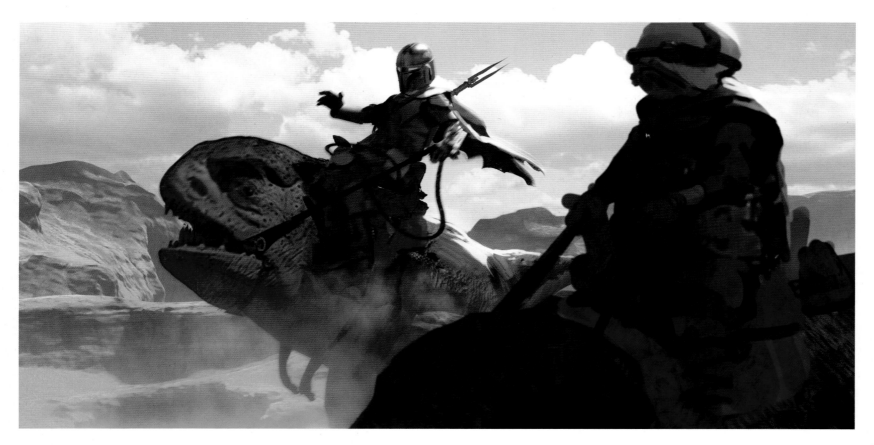

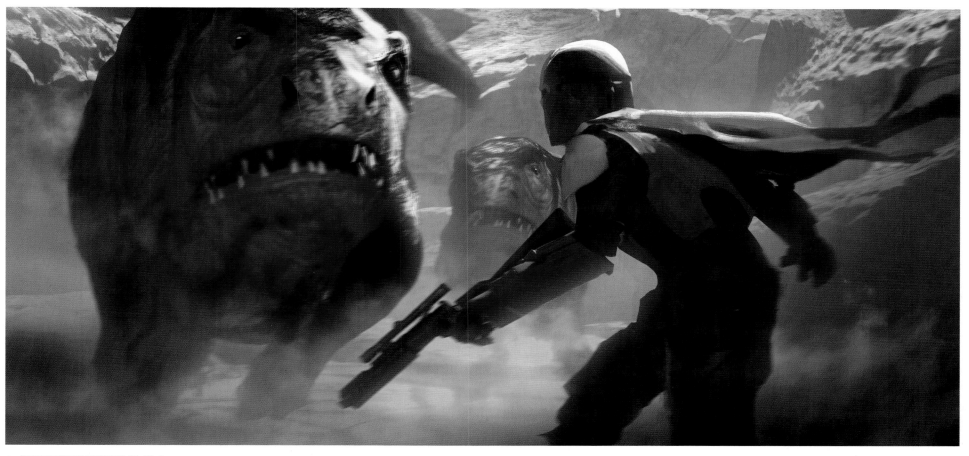

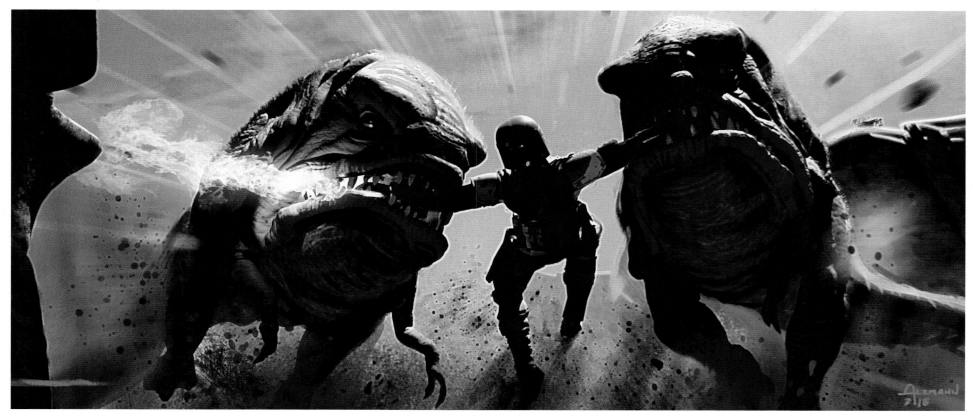

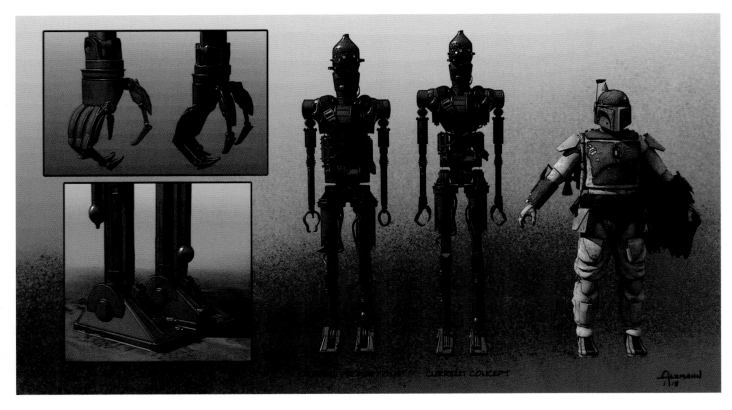

"How do we take that very simple-looking robotic assassin and actually make him into a really cool character? Hal Hickel's execution on his animation was spot-on, giving him the personality and the movement that he needed so we believe this simple tin man can be an amazing assassin." **Chiang**

"Doug and I were talking about it early on, 'Let's break the human anatomy guidelines.' So, we made the model so that he could spin his chest and shoulders separately from his abdomen, separately from his hips if he needed to." **Alzmann**

↑ **IG-11 VERSION 01** "He has to hold different guns. So, we went through a few iterations of hand designs to get it to work. At one point, I made them too human, even though I gave him a double thumb. But I love Jon's sensibility, 'No, he's a clunky robot. Let's go back.'" **Alzmann**

↖ Behind the scenes photo of IG-88 on the control deck of the Super Star Destroyer *Executor* during production of *The Empire Strikes Back*.

← **STANDOFF VERSION 02** Gindraux

"We were wrestling with the height of IG-11. Do we have him at six feet tall? Should he be closer to seven? We added his orange-colored stripes and his double bandoliers so that he's not IG-88. John Knoll has this quote on *Rogue One* about trying to capture what you remember as opposed to what it actually is. Because sometimes, what it is won't fit into a modern-day film." **Alzmann**

The heads of both IG-11 and IG-88 are taken from World War II airplane scrap of Rolls-Royce Derwent jet-engine flame canisters, also seen on the Mos Eisley cantina set of *Star Wars*: Episode IV *A New Hope* and *The Mandalorian* "Chapter 5: The Gunslinger."

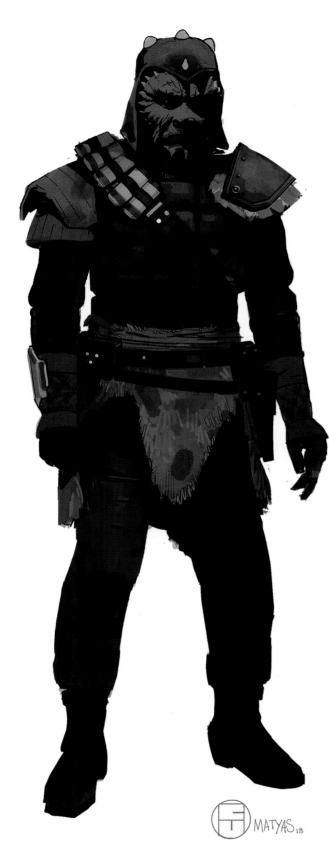

NIKTO BANDITS VERSION 01 "The Nikto were supposed to look rough and like Western bandits, essentially. I was riffing off of the typical bandito bandoliers. Another good reference for these was the old Kenner *Star Wars* toys. I like how charmingly simplistic a lot of those, like, '70s and '80s action figures are. They were great references for the palette and layering on these guys." **Matyas**

→ **NIKTO SCULPT** "I just took Ken Ralston's design and varied it a little. But it's essentially the same thing. I try to make it look like there's a personality behind the face with everything that I do." **McVey**

↑ **ORANGE NIKTO SKULPT** McVey

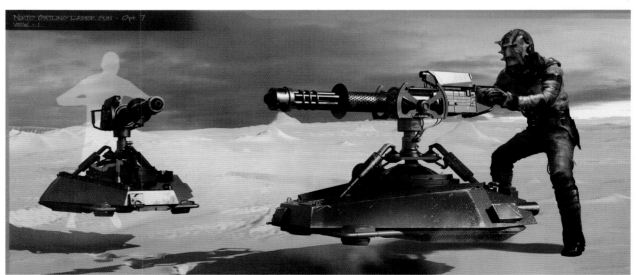

↑ **NIKTO BANDIT VERSION 04** Matyas

→ **GATLING LASER GUN OPTION 07** Hobbins

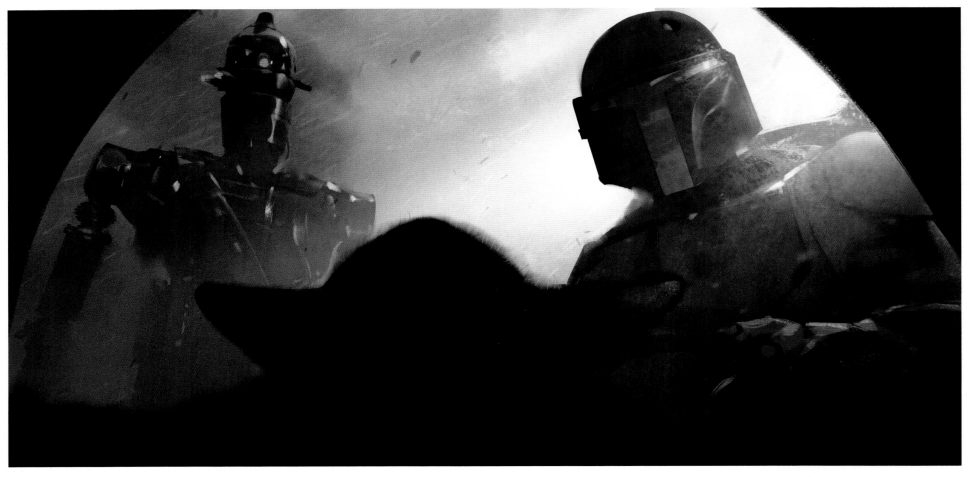

↑ **BABY YODA VERSION 01** Jurabaev

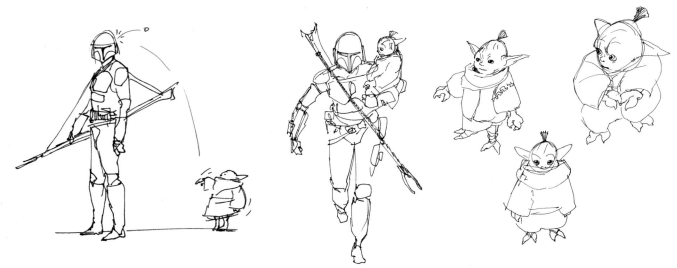

↑ **BABY YODA SKETCH 01** Filoni

↗ **BABY YODA SKETCH 02** Filoni

"The baby was a really tough challenge. We knew were stepping into dangerous territory. Dave was great because he could always capture the spirit of the character very quickly. Our task then was to take the essence of what Dave was thumbnailing out and turn it into a real character. Make it very believable while still retaining the features that Jon wanted. Jon was very keen on making sure that he wasn't too cute. How do we make a character that's cute but not too cute?" **Chiang**

→ **BABY VERSION 02** "The first one I did looked almost like a human toddler in makeup. We were just groping around in the dark. And it seemed like Favreau had such a strong negative reaction. Not that he hated it, but he's like, 'No, I want this thing to look like a *Dark Crystal*/ Henson-style puppet.'" **Alzmann**

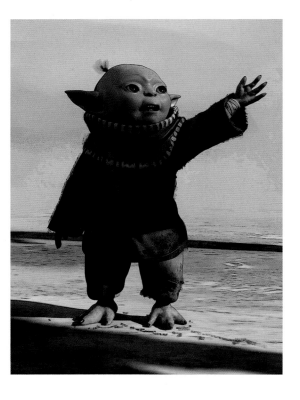

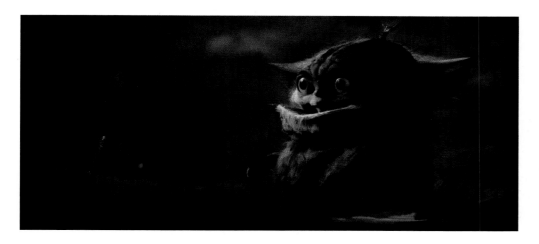

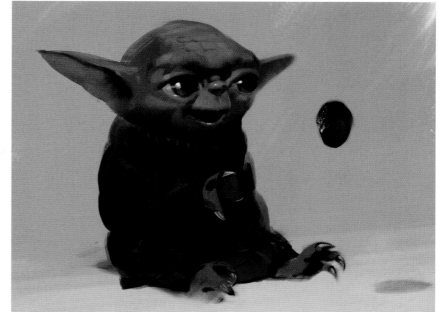

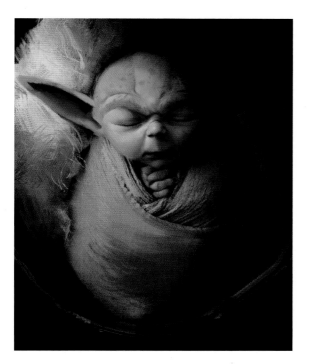

BABY VERSION 01 "I was working with Christian Alzmann's model, which was fantastic. The opportunities in the lighting and finding some interest here with this new character. And then the innocence, even though he's got some years on him, in contrast to the technology on the left side of the piece." **Tiemens**

BABY YODA VERSION 04 Jurabaev and Chiang

"Jon was adamant that we don't see much of the sclera in the eyes. They are mostly giant pupils, to keep it more animallike. You can easily tip over into a little cute baby with giant eyes. And Jon didn't want to do that. So, our task was: What should the proportions be? How big should the ears be? How much of the Yoda-ness do you want to embrace versus not?" **Chiang**

BABY YODA VERSION 01 Jurabaev

"They threw everyone at it, for a good couple of weeks there were tons of babies coming through the door." **Alzmann**

YODA BABY VERSION 01 Park

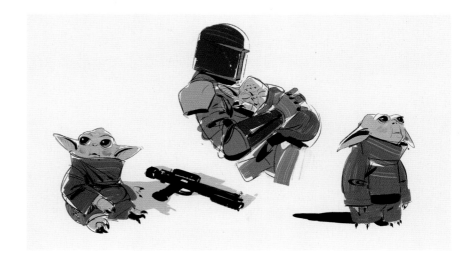

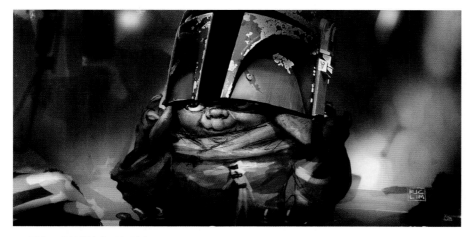

↑ **PEEKABOO VERSION 1A** Richard Lim

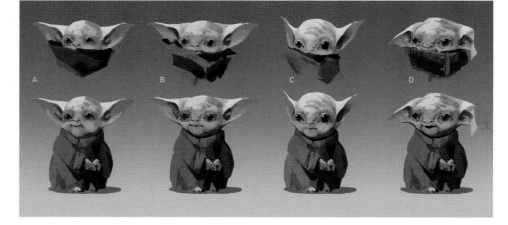

↑ **BABY YODA VERSION 01** Gindraux

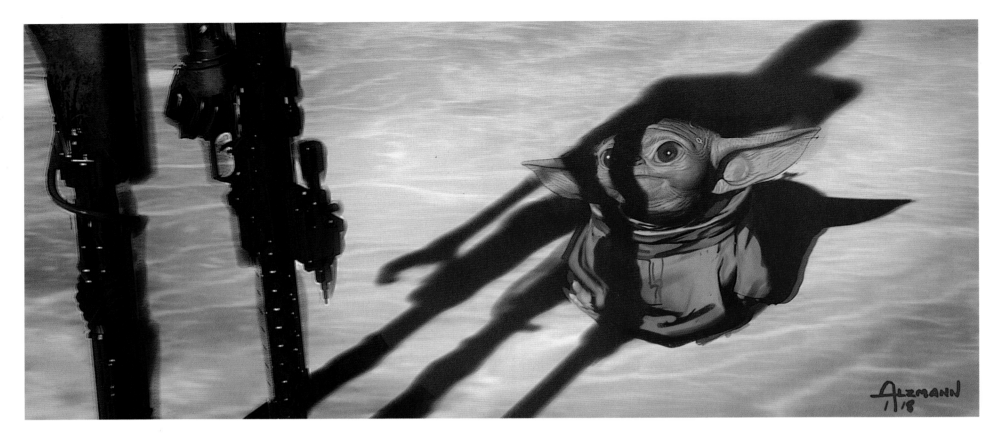

BABY VERSION 09 "I did two versions of this realistic kid-baby. And the third was the one. I immediately had an idea when Jon said he wanted it to be more puppetlike, one of those rare lightning-strike moments. I looked a lot at J.C. Ley-endecker's babies. He has this certain way of doing massive cheeks on babies. I was also thinking about old Warner Bros. cartoon characters, which had those same cheeks." **Alzmann**

"Christian totally nailed it, in terms of the proportions. There's just enough Yoda. And yet, the design was fresh enough to make him our own character." **Chiang**

→ **BABY VERSION 12** "Kids look so much cuter when their clothes are too big. There's a sketch Dave did of this big collar. The baby could sink his head down into it and almost hide or cower. But we didn't end up keeping the hood, which, in a lot of ways, became the pram. You just couldn't get his ears in there." **Alzmann**

↓ **BABY YODA SKETCH 03** Filoni

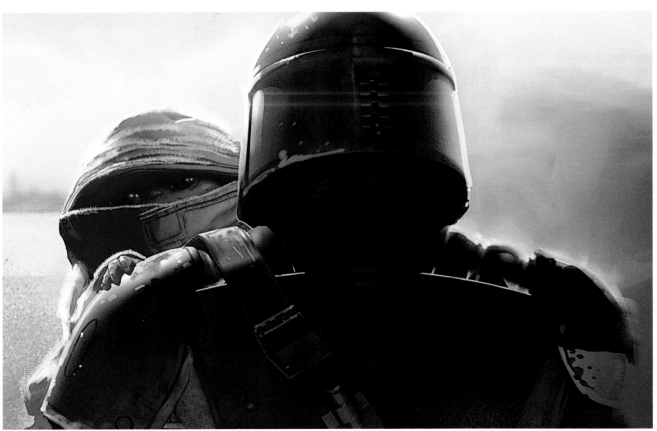

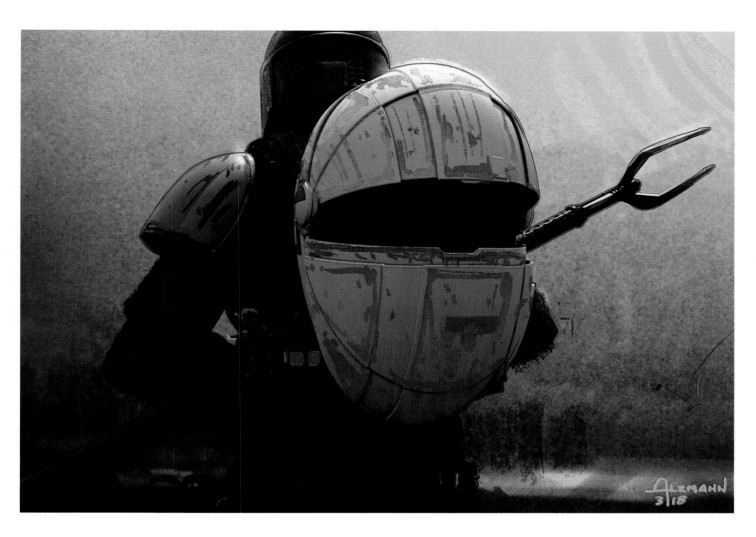

↑ SPACE BASSINET OPTION 01 Hobbins

→ BABY PRAM VERSION 2A
Alzmann and Chiang

"We were thinking that if you made the pram like a backpack, there'd be a way to copy the vibe of the hood. But then you lose the *Lone Wolf and Cub* quality." **Alzmann**

↓ BABY PRAM VERSION 03 Alzmann

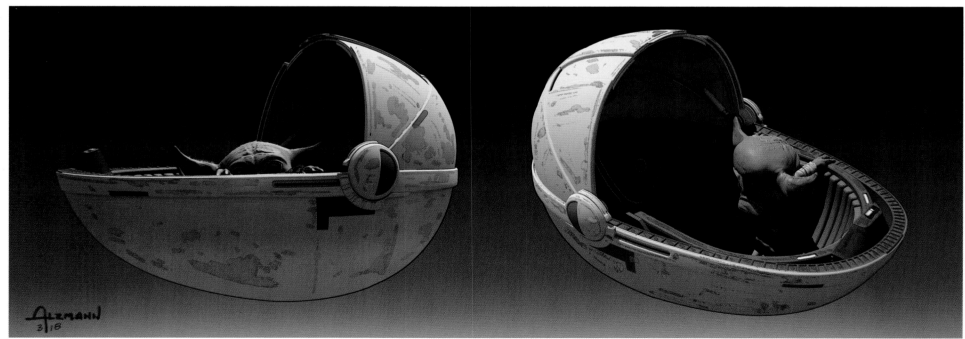

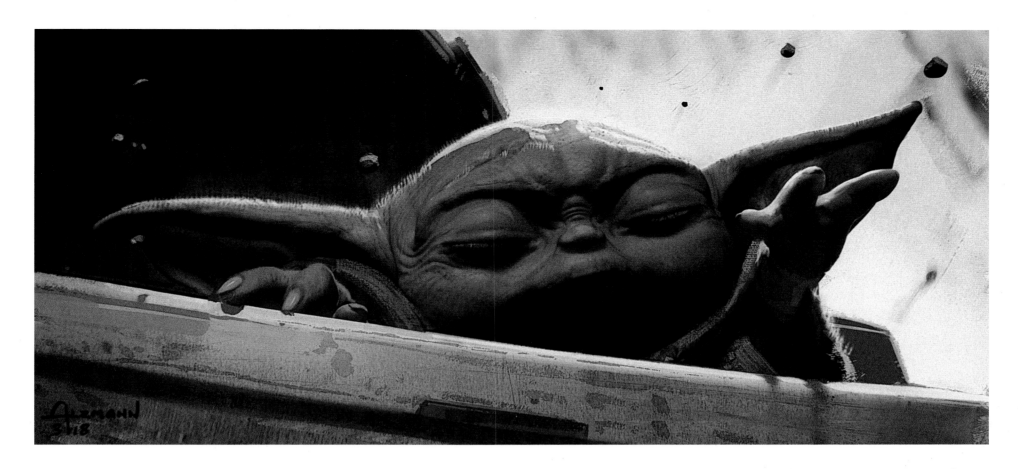

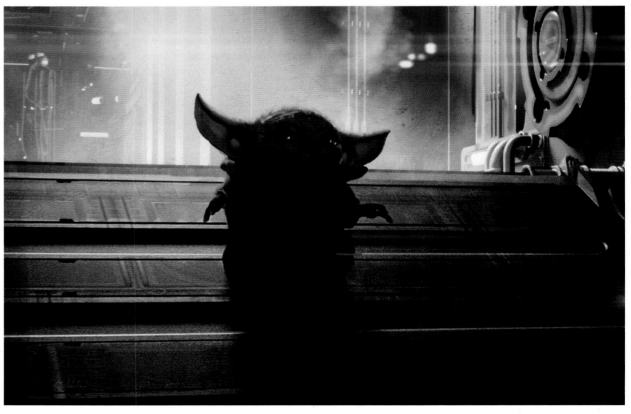

↖ **BABY VERSION 13** "For me, it's all about the mouth and cheeks, getting that little bit of an overbite and almost no chin. Almond-shaped eyes feel alien and rotating them seemed really cute. That plus his scale is the Gizmo [from 1984's *Gremlins*] flair. It's part of that early-'80s aesthetic. You can't get away from it." **Alzmann**

"It happened with *Iron Man*, happened with *The Lion King*. You get one image that just clicks, and you say, 'Okay, this is it. This is the one.' Although the Child was a character that popped out of my imagination, it really didn't come to life fully until you had all of these artists collaborating and finding the essence of what that character was. When it works out well, it's just magical." **Jon Favreau**

← **BABY YODA COCKPIT VERSION 04** Gindraux, Alzmann, and Chiang

↑ **MUDHORN LEVITATION VERSION 02** "Eyelashes are cuter if they are really light and blond, like baby hair. Jon wanted a lot of wrinkles and bumps, all of that stuff makes someone look old. And here we are trying to make a baby. So, there was a bit of wrestling with that. But if you keep the scale of the eyes to the face like a baby's, then you can add all of the detail. I had to look a lot at Yoda to make sure they felt like they were in the same family of . . . whatever he is [laughs]. We still don't know what he is!" **Alzmann**

→ **BABY ON RAMP VERSION 2A** "You see him waddling down, that way young babies and toddlers do, with arms splayed out because they know that they're probably going to end up falling. When babies walk, they lean their head in the direction that they're going and just pray their feet catch up [laughs]. This was also the first pass at teeth. I always love when you get those really gummy smiles from kids and they only have a few really well-placed teeth. That makes him so much cuter." **Alzmann**

→→ **BABY GOBBLE VERSION 1A** Alzmann

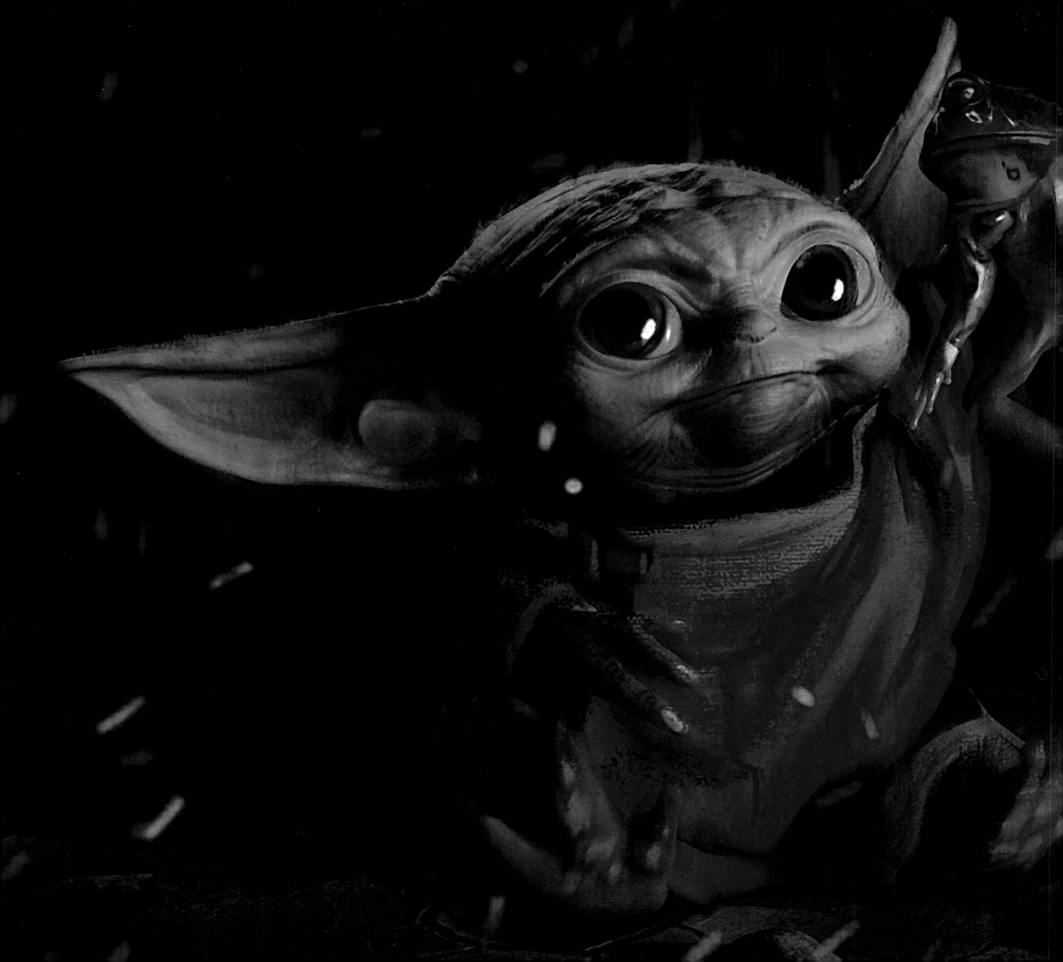

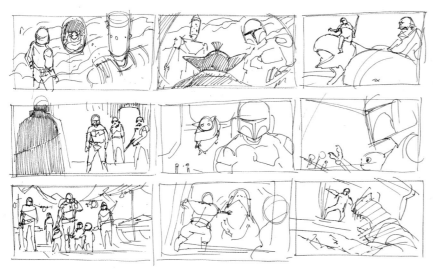

↑ **ARVALA-7 STORYBOARD SKETCH 01** Filoni

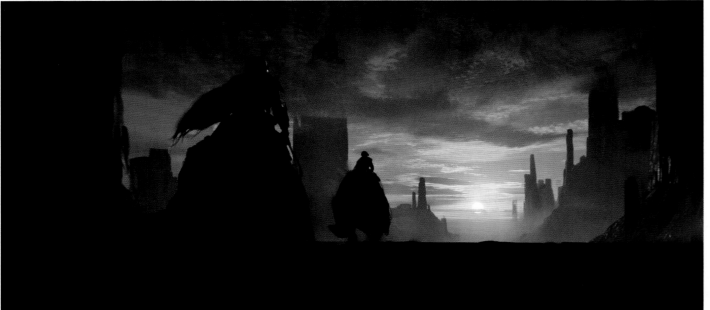

↑ **ROCKY PLANET SUNRISE VERSION 02** Jurabaev

← **ROCKY PLANET SUNRISE VERSION 06** Jurabaev

↓ **MUD PLANET VERSION 05** Jurabaev

"With Arvala-7, we were trying to find a different take for a new planet. We thought about taking dried mud and scaling it up so features that were normally a couple of meters across are now hundreds of meters, if not even bigger. We take something that's very familiar and just change the scale, which is very *Star Wars*." **Chiang**

↓ **MUD PLANET VERSION 07** Jurabaev

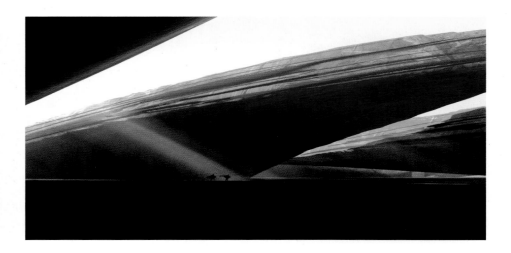

"The original brief was that it rained very rarely, like every five years or seven years, and we're between rainy seasons. When Rick Famuyiwa came on board, he wanted to make it wetter and give it a little more texture, which I thought was really helpful because it explains the geology of this planet. It also made the world a little bit more visually interesting, with some nice reflections." **Chiang**

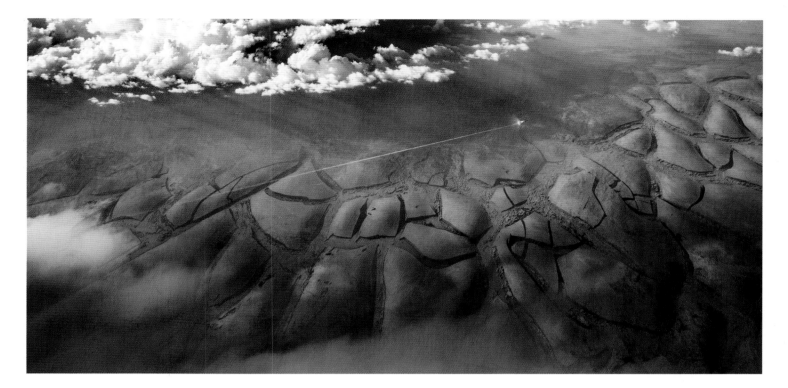

→ **MUD PLANET SUNRISE VERSION 02**
Jurabaev

↓ **MUD PLANET SUNRISE VERSION 01**
Jurabaev

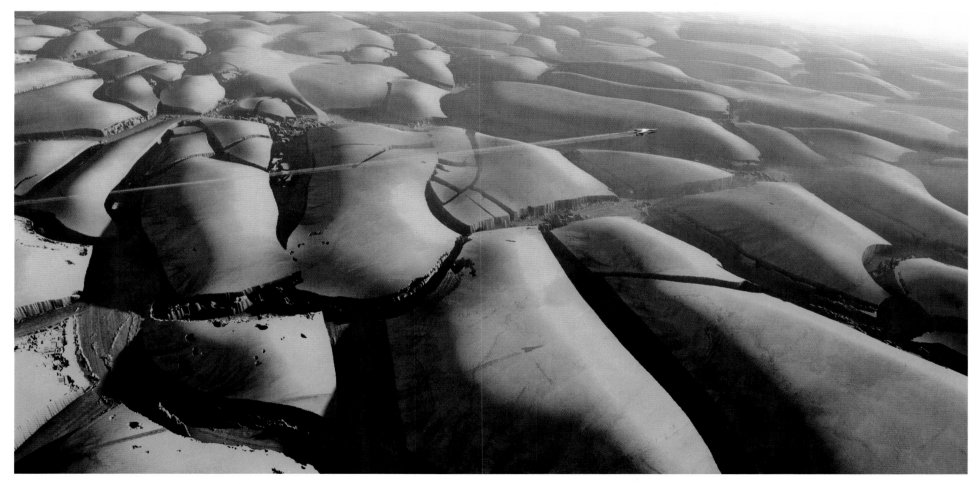

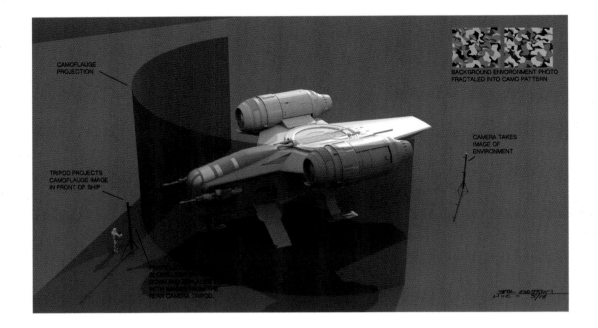

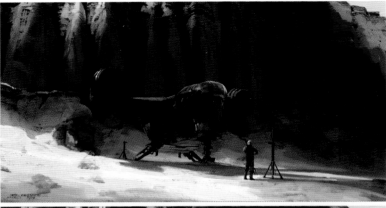

BACKGROUND ENVIRONMENT PHOTO
FRACTALED INTO CAMO PATTERN

CAMOFLAUGE
PROJECTION

CAMERA TAKES
IMAGE OF
ENVIRONMENT

TRIPOD PROJECTS
CAMOFLAUGE IMAGE
IN FRONT OF SHIP

In early versions of Jon Favreau's "Chapter 1" script, the Mandalorian camouflages the *Razor Crest* upon arrival on Arvala-7. The camouflage is depicted here as a high-tech projection system or as an adhesive sprayed into the mud, which is then lifted up and leaned on the ship as camouflaging walls. In spite of his efforts, the *Razor Crest* is still stripped clean by Jawas.

↑ **CAMO SCHEMATIC VERSION 01** Engstrom

↗ **CAMOUFLAGE STAGE 1** Engstrom

→ **CAMOUFLAGE STAGE 4** Engstrom

↓ ***RAZOR CREST* CAMOUFLAGE VERSION 01** Engstrom

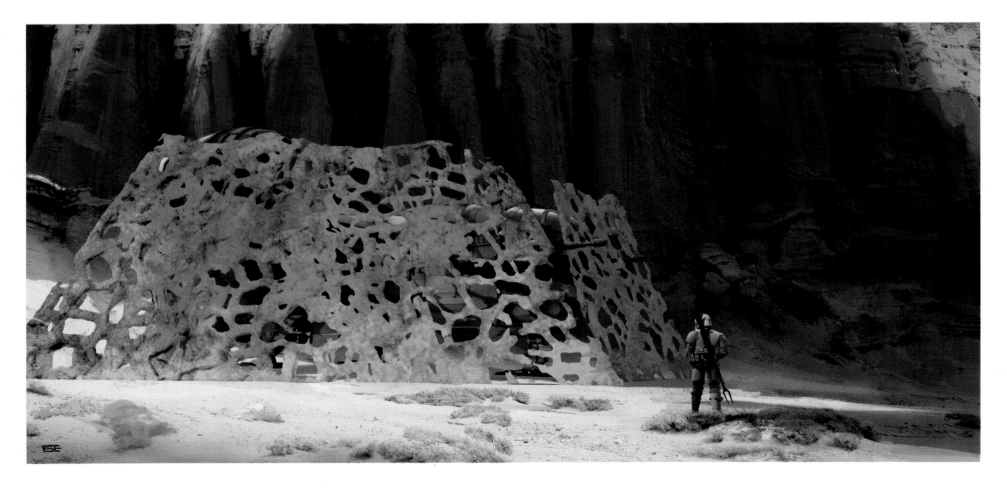

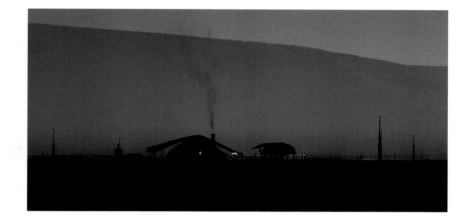

↑ **UGNAUGHT RANCH 02** Engstrom

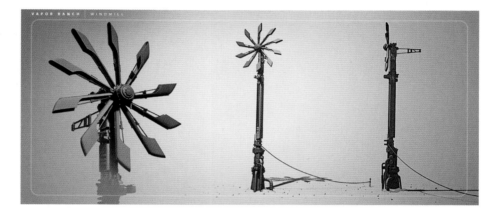

↑ **RANCH AERIAL VERSION 02** Jurabaev

"The inspiration for this environment was your typical ranch out in Montana. Very iconic Western imagery, to the point that we even added our own *Star Wars* windmill." **Chiang**

"The Ugnaught chooses to live simply, off the land, outside the system, and raising animals." **Alzmann**

↑ **VAPOR RANCH VERSION 02** Jurabaev

← **WINDMILL DESIGN A VERSION 01** Fields

↓ **RANCH VERSION 01** Jurabaev

→→ **RANCH VERSION 02** Jurabaev

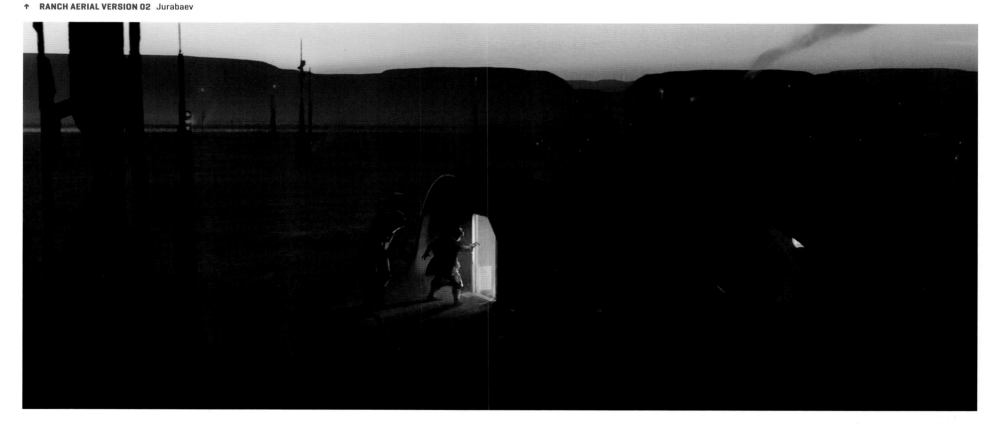

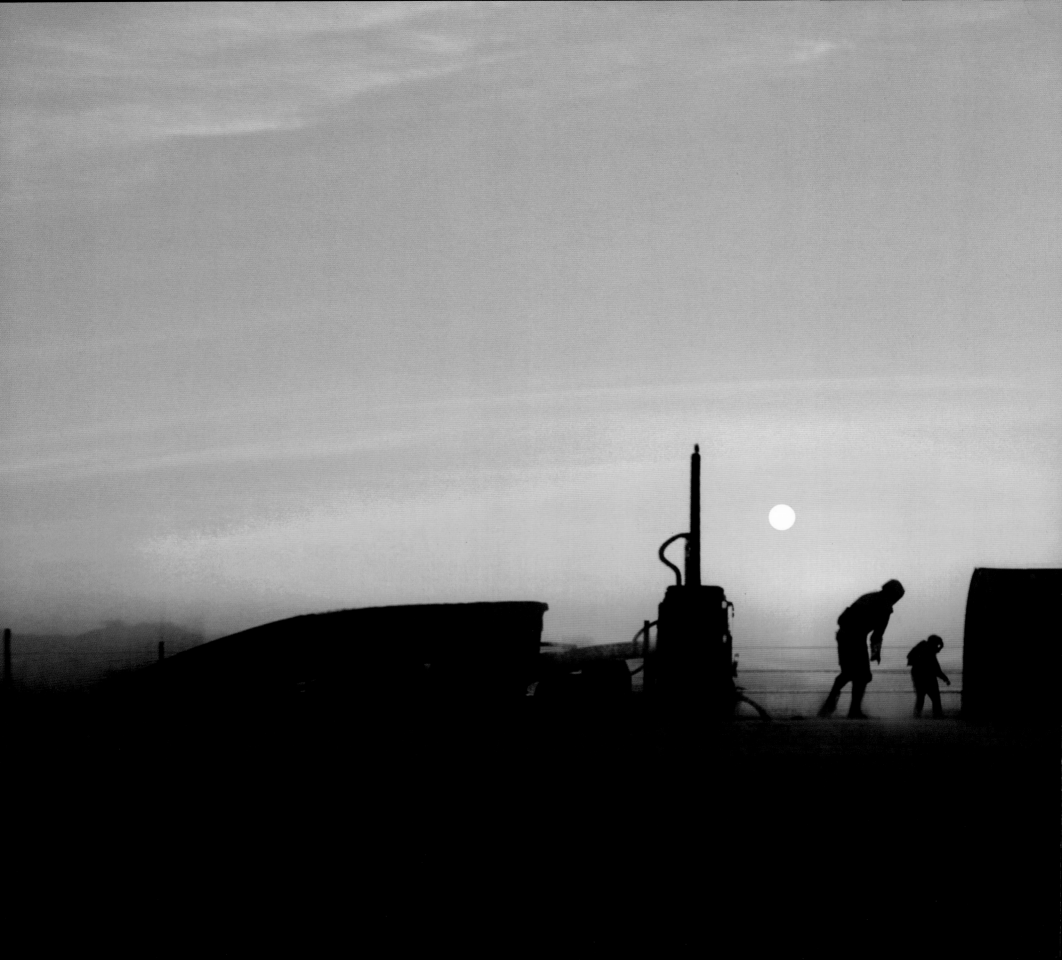

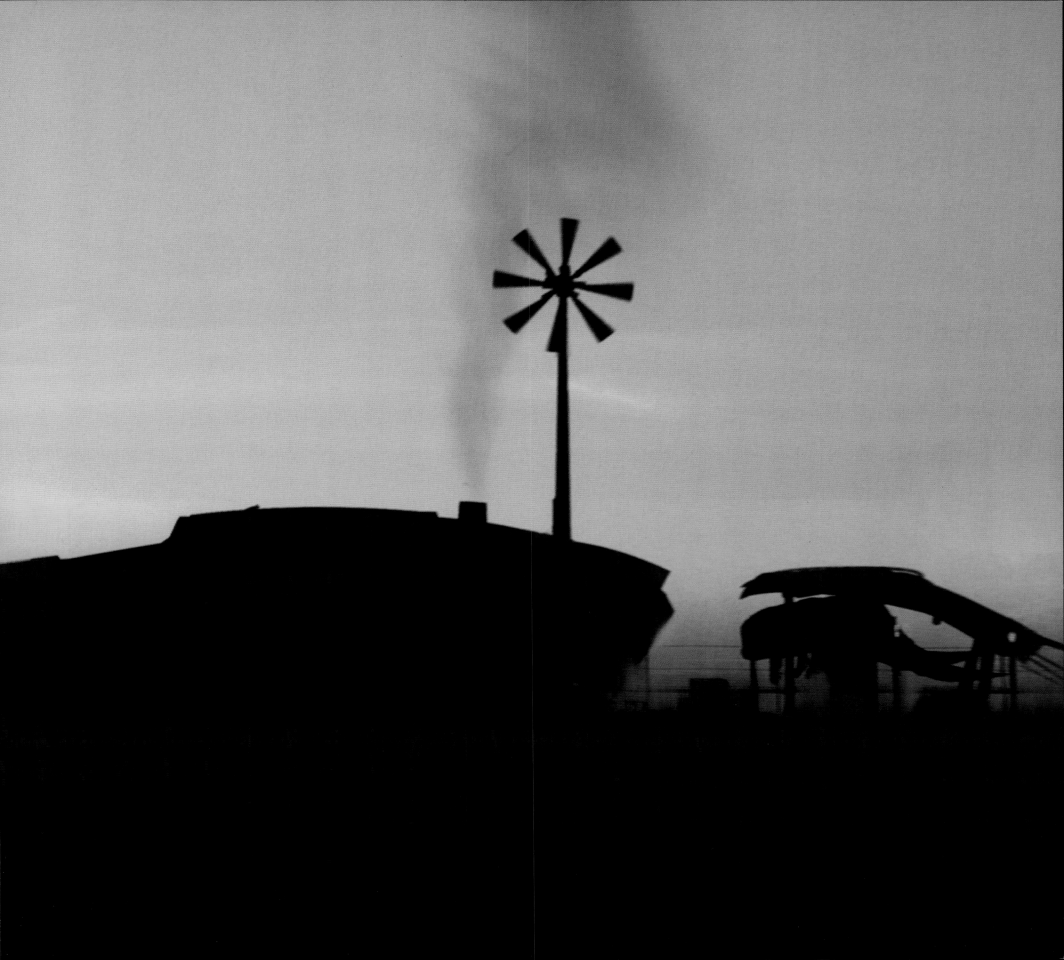

↑ **SEAT VERSION 02** Jurabaev

← **BLURRG PEN VERSION 02** Grandert

↓ **RANCH INTERIOR VERSION 01** Jurabaev

"Knowing that this was for a very short character, we deliberately scaled everything down. Part of the charm and the humor of this set design was that when Mandalorian goes inside, he doesn't fit." **Chiang**

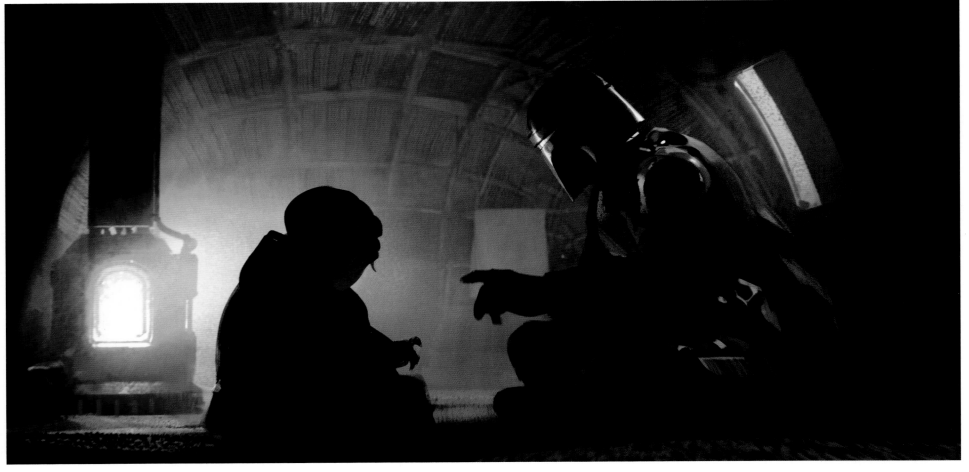

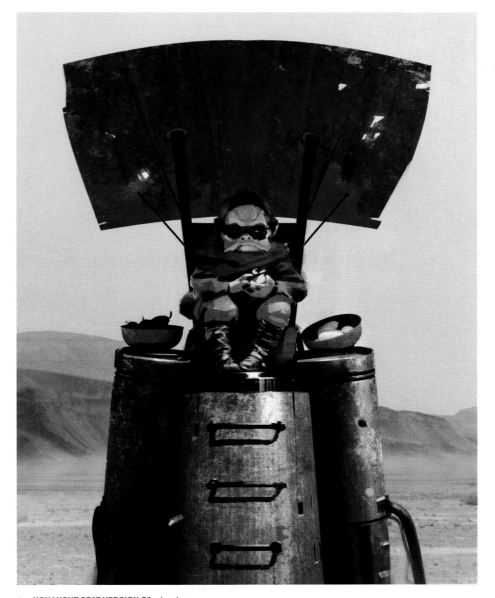

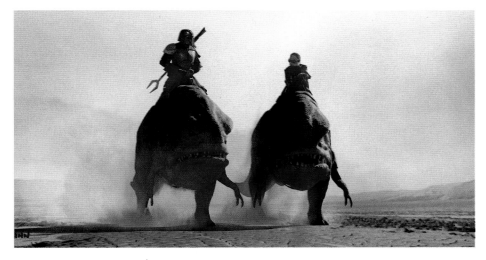

↑ **RIDING VERSION 01** "These were to sell that Western vibe and a hero moment of the two of them riding together. To me, the story drives everything, including all the design. So, I love thinking about posing and lighting and color. And I'm hearing the music in my head as I'm doing it." **Alzmann**

↓ **MUD PLANET VERSION 04** Jurabaev

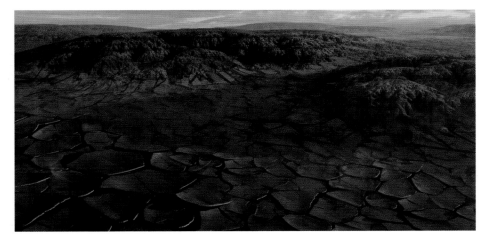

↑ **UGNAUGHT SEAT VERSION 01** Jurabaev

↑ **BLURRGS CLIMBING VERSION 01** Jurabaev

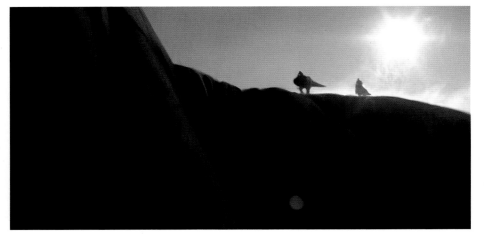

↑ **BLURRGS CLIMBING VERSION 02** Jurabaev

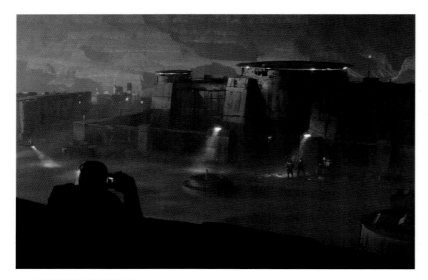

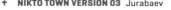
↑ **NIKTO TOWN VERSION 03** Jurabaev

↑ **MANDO VISION B** Ben Grangereau

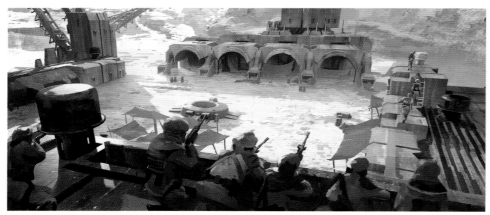

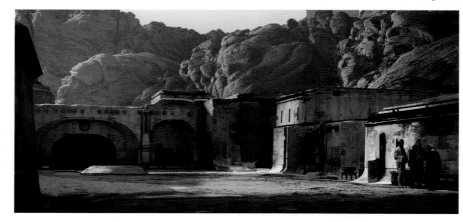

↑ **NIKTO TOWN VERSION 1A** Church and Chiang

↑ **NIKTO STANDOFF** Engstrom

"Basically, this was the bandits' hideout. But I wanted to give it a little more of a history, a reason why this town was there. So, we came up with the idea that this was an old abandoned mining town nestled into these canyons. The bandits found it very convenient because, strategically, it was hidden and easier to defend. We anchored the design in *Butch Cassidy and the Sundance Kid* and old Spanish missions. Once you place that very loose idea down, the story starts to evolve." **Chiang**

→ **STANDOFF ENTRANCE VERSION 02** Gindraux and Chiang

"*Butch Cassidy* was our point of reference, which I watched for the first time. There's something about how straightforward Doug's art direction and Jon's direction was. It's not frilly. It's not fancy. This is a very traditional adobe structure. And it totally works. The repeated cues evoke an old hacienda but a *Star Wars* version of it, abstracting it." **Church**

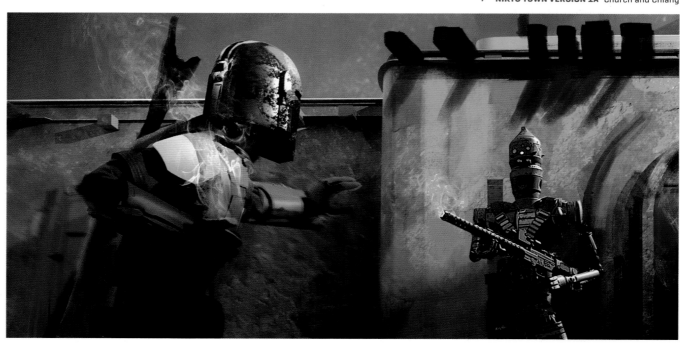

↑ **STANDOFF VERSION 1A** Engstrom

→ **NIKTO TOWN INTERIOR VERSION 02** Church and Chiang

"This is set design and shot design at the same time. Fire is difficult to do in an interior set. And that's why we built in a little walkway on the exterior and pillars for them to hide behind." **Church**

↓ **ACTION OVERVIEW VERSION 03** Russell Paul

→→ **STANDOFF TURRET VERSION 01** Gindraux

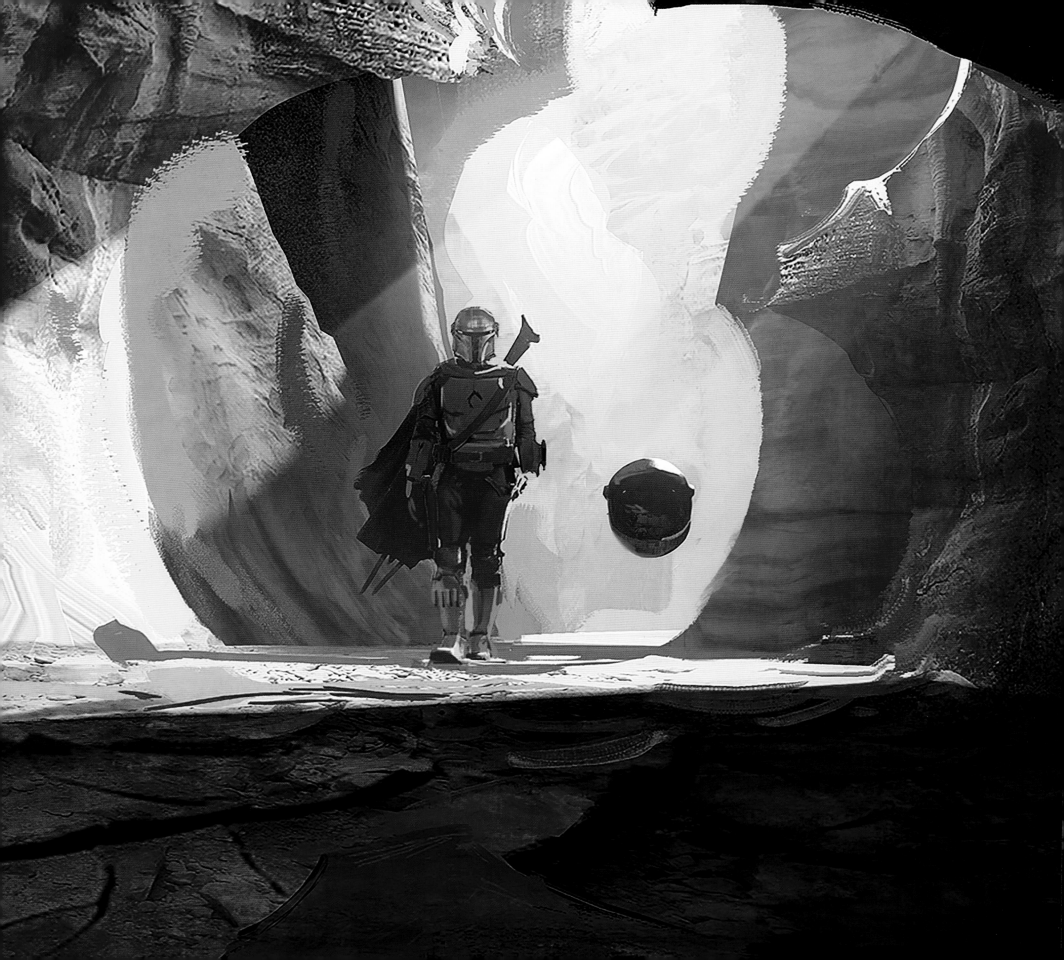

THE CHILD

Concept design for *The Mandalorian* began two days after Jon Favreau first pitched his ideas at the Kennedy/Marshall Company on November 14, 2017. Doug Chiang recalled, "Working with Dave, the fact that he's an artist and a director, is visually very aware, and knows what he wants was really great."

By mid-November, Doug Chiang's Lucasfilm art department were also a month and a half into full-time design work on "Trixie," the code-name for *Star Wars: The Rise of Skywalker*. "We're always juggling multiple projects," said Chiang. "Even though there was more on our plate to design than was really realistic, I felt energized because the ideas in *The Mandalorian* were exciting. And that helped to fuel both shows."

Lucasfilm art department members working on both *The Mandalorian* pitch and *The Rise of Skywalker* in November included concept supervisors and *Star Wars* design veterans Christian Alzmann, Ryan Church, and Erik Tiemens; Church and Tiemens having started their *Star Wars* careers on Episode II: *Attack of the Clones* and co-concept design supervising Episode III: *Revenge of the Sith*.

But *The Mandalorian* was not the first time Church had worked on a Favreau project. Church recalled: "For six months in 2007, I was in the *John Carter* art department [under Favreau, attached to direct the film at the time] with Ryan Meinerding and Phil Saunders, who went on to do all the *Iron Man* stuff, and [*Star Wars* prequel and *The Force Awakens* designer] Iain McCaig," Church said. The film, based on Edgar Rice Burroughs' 1912 science-fiction classic *A Princess of Mars,* was ultimately helmed by Pixar Animation Studio's Andrew Stanton and released in 2012. "Jon would have us over for lunch in his house. They weren't Cubanos [as seen in Favreau's 2014 film *Chef*] but he made sandwiches for us."

Joining the Lucasfilm art department for the pitch was character/costume concept artist Brian Matyas, who had his own history, both with Doug Chiang and *Star Wars*. "Doug hired me as a production assistant at ImageMovers Digital [a former Disney-owned animation studio not far from George Lucas's Skywalker Ranch] in 2007, right out of college. [Episode II: *Attack of the Clones* concept artist] Dermot Power was also working there, and I wanted a mentor, someone to hone my professional process. *The Art of Episode I* and *II* were some of the first art books that I owned, besides Ralph McQuarrie's work from the originals. So, I was a superfan of Dermot's work, in particular for characters."

"When IMD closed in 2010, I did a lot of freelance and worked in the gaming industry, specifically *Star Wars: Uprising* at Kabam, which became a huge chunk of my portfolio. In January of 2017, Doug gave me some costume and creature work with Erik Tiemens and Walt Disney Imagineering on Star Wars: Galaxy's Edge and Star Wars: Galactic Starcruiser. Working with them was some of the most fun that I've ever had."

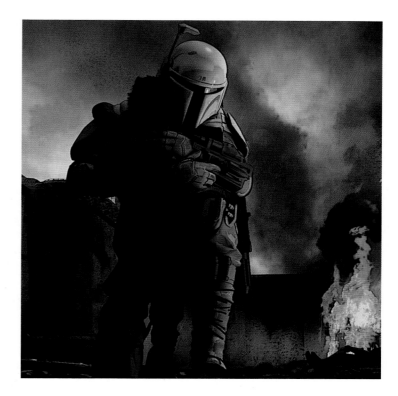

As a child, Matyas revered Boba Fett, coveting Kenner's twelve-inch Collector Series action figure of the bounty hunter. "After hernia surgery in the eighth grade, I was resting up and my dad was like, 'I'm going to go get that Boba Fett.'" Matyas's father ended up fighting for the doll with the comic shop clerk, who had his eyes on it too. "[Ever since,] one of my professional goals has been to have an action figure of something that I've designed."

Pitch art for *The Mandalorian* was completed from November 16 to 20, 2017. "After we produced those pieces, Jon and Dave pitched it to Kathy," Chiang remembered. "And it was almost an immediate, 'This is a very intriguing idea. Let's go for it.' Then, right around the holidays was when I first heard that Jon had written two scripts. And they were spot on. The characters and the emotions really shined through. For me, it was, 'Okay, let's really dissect and figure out how we approach this, in terms of design.'"

One of the pair of scripts Jon Favreau wrote over that 2017 holiday break, "Chapter 2: The Child," would not be lensed by director Rick Famuyiwa for almost another year. "*Star Wars* was the first film I saw in a theatre," Famuyiwa said. "And I made a couple of coming-of-age films inspired by *American Graffiti*. The spirit of *Star Wars* has always been about young dreamers. And Jon has given *The Mandalorian* a spirit of collaboration where the directors are in this together, telling the same story but each bringing their unique perspectives to it." With Favreau's shooting draft in hand on November 26, 2018, "The Child" was in production from November 30 to December 13, the fifth of eight episodes shot during the first season's production schedule.

← **CANYON VERSION 03** Park

↗ **MANDO FLASHBACK VERSION 08** Alzmann

CANYON VERSION 09 Engstrom

"At the beginning of 'Chapter 2,' Mando is in between those mud cracks [that he and the Ugnaught rode over on their blurrg mounts] from 'Chapter 1.'" Chiang

TRANDOSHAN HUNTERS LINEUP VERSION 01 "I tried to push their designs. I really like that orange-and-black-faced Gila monster one with a mohawk. I was hoping that would stick because that look would be unique among Trandoshans." Matyas

FIGHT VERSION 04 Park, Chiang and Gindraux

"How do we take the Trandoshan and turn it into a character mask that stunt actors can wear? That demanded that the eyes have to be lined up with human eyes and we can't be too big with the heads. They can't have a real lizard's snout. And so we slowly backed into a hybrid design, where we kept the essence of a Trandoshan while still making it effective for stunt players." Chiang

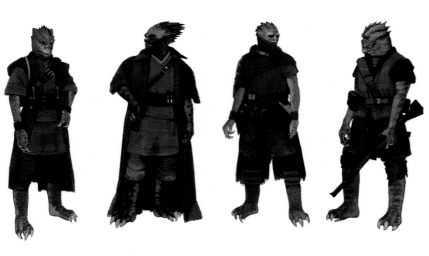

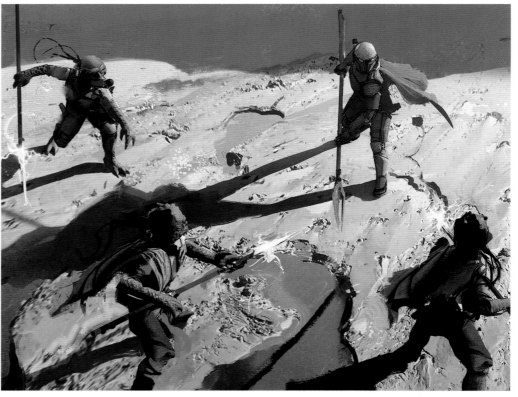

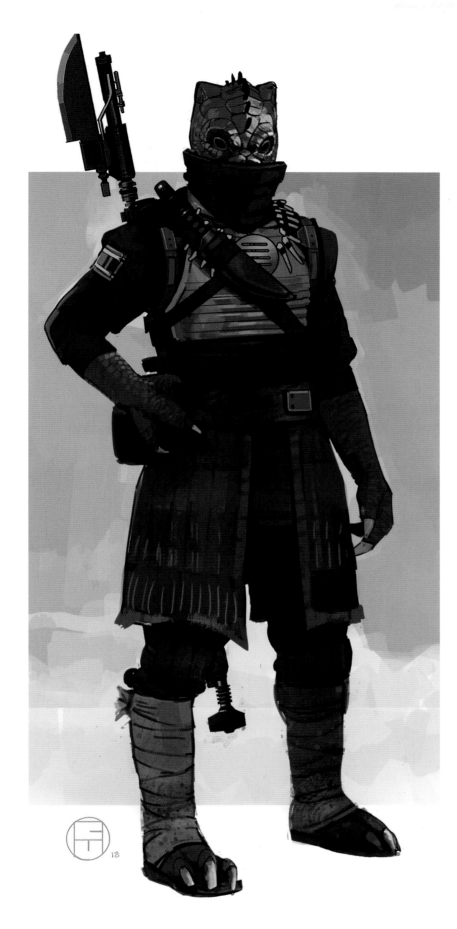

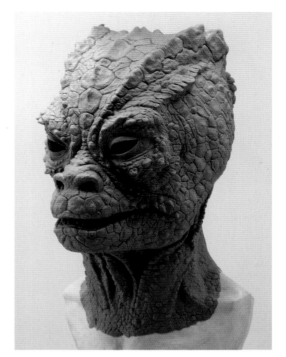

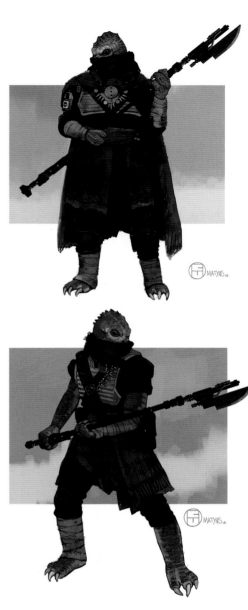

↑ **TRANDOSHAN SCULPT** "Doug said that he's a reptile man. So, I went to town with it. But he wanted me to stay pretty close to the original. It didn't have much texture and was very much a background character. So, I had to do quite a bit of enhancement, you might say." McVey

↗ **TRANDOSHAN HUNTER VERSION 01** Matyas

→ **TRANDOSHAN HUNTER VERSION 02** Matyas

← **TRANDOSHAN HUNTER VERSION 03** "They wanted the Trandoshans more layered, disguising their faces with cloth. A lot of teeth and layered bits, and the palette too works pretty well for him. He could very well have stolen that flight vest off of a pilot." Matyas

↓ **AMBUSH VERSION 01** Park

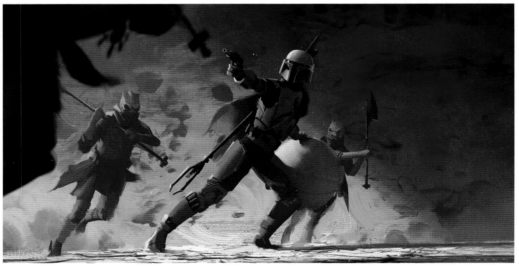

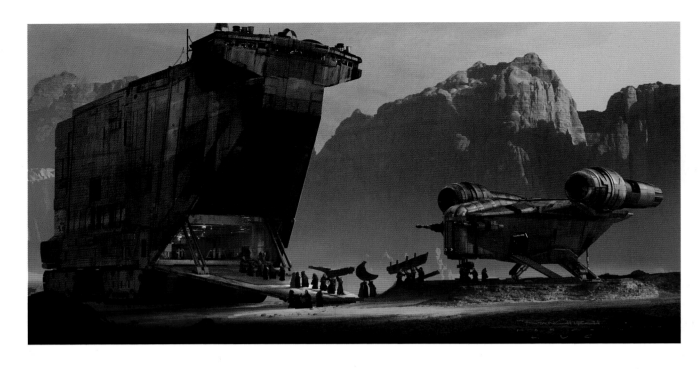

↑ **SANDCRAWLER DETAILS VERSION 02** Rene Garcia

← **JAWA STRIPPERS VERSION 1A** Church

↓ **SANDCRAWLER VERSION 1A** Church

"At first, I was a little reticent because I thought that the audience was going to confuse this world with Tatooine. So, to distinguish our sandcrawler, we made it gray versus rust brown. To distinguish them further, we thought that even the Jawas' robes should be gray. But we kept the sandcrawler shape pretty much one-to-one to what was in *A New Hope*." **Chiang**

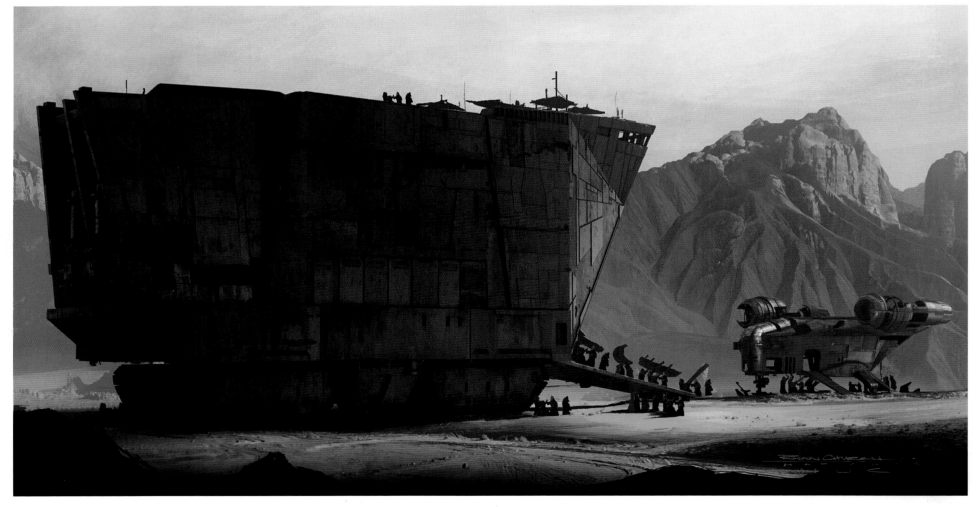

↑ **SANDCRAWLER VERSION 01** Jurabaev

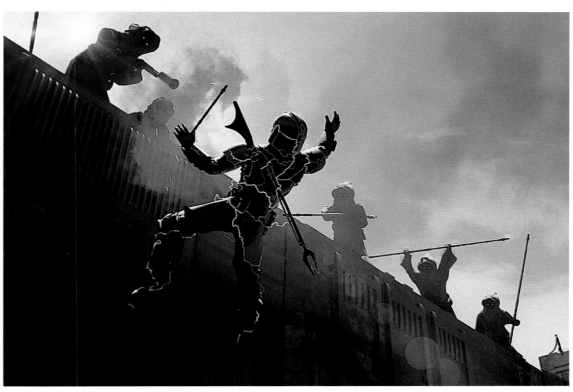

↑ **SANDCRAWLER CLIMB VERSION 01** Gindraux

↑ **SANDCRAWLER ASSAULT VERSION 01** Alzmann

↓ **SANDCRAWLER VERSION 02** Jurabaev

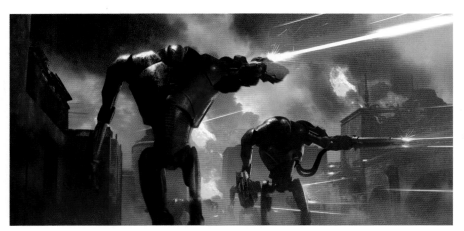

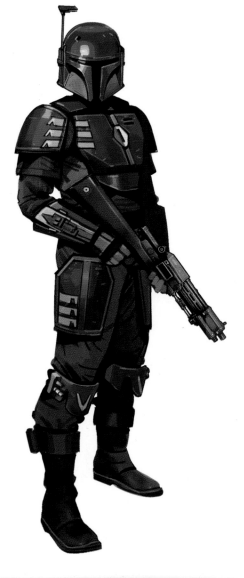

↑ **DROID INVASION VERSION 01** Gindraux

← **DROID GROUND ATTACK VERSION 1A** Gindraux

"Jon liked the original super battle droid but he thought that ours should be more badass and stronger, as if they were the next generation. So, we cleaned up the design a little bit, made them beefy and more threatening." **Chiang**

→ **CLAN MANDO VERSION 3A** "I did a blue Mandalorian and a red one, which I quite liked. And then a white one, which I also liked because it felt the most retro, very '70s/'80s. This one felt the most action figure-y, I think." **Matyas**

↙ **FLASHBACK BATTLE DROID VERSION 01** Church

↓ **MANDALORIAN RESCUE VERSION 03** Gindraux

↑ **MANDO FLASHBACK VERSION 05** "I was trying to make this one feel a little dreamy with the vignette, like it's through the eyes of the young Mandalorian. It's sort of angelic, like a Biblical painting." **Alzmann**

↓ **MANDO FLASHBACK VERSION 07** "I thought it would be really fun to make the Mandalorian that rescued him the Ralph McQuarrie white version. If this guardian in white reaches down for you, you're going to go with him." **Alzmann**

→→ **MANDO FLASHBACK VERSION 10** "It's all about hitting that second highlight on the lower lid, where the tears are just about to spill over and roll down the cheek. I wanted a very flickering fire-lit feeling on this too, which adds to its memory-dreamy vibe." **Alzmann**

↑ **CAMPFIRE VERSION 02** Gindraux and Chiang

↑ **HOVER CART OPTION 4A** Alzmann and Hobbins

↑ **HOVER CART VIEW 2** Alzmann and Hobbins

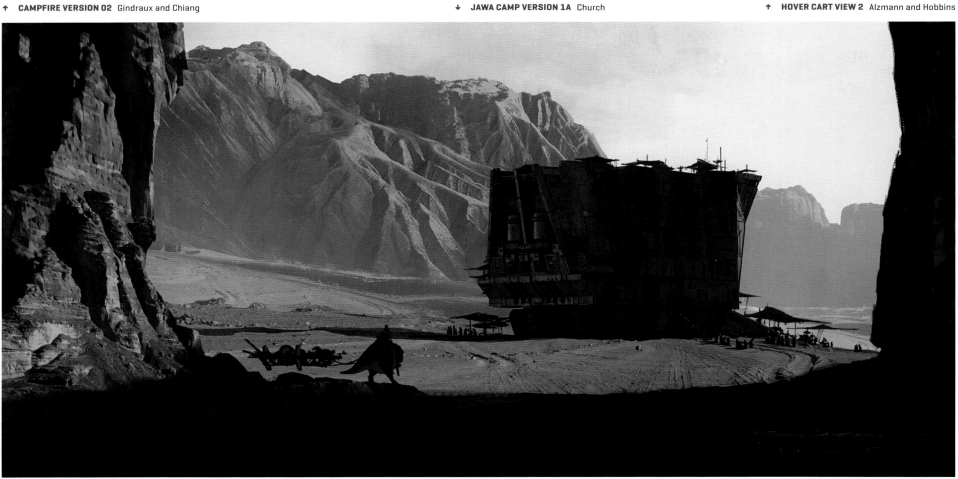

↓ **JAWA CAMP VERSION 1A** Church

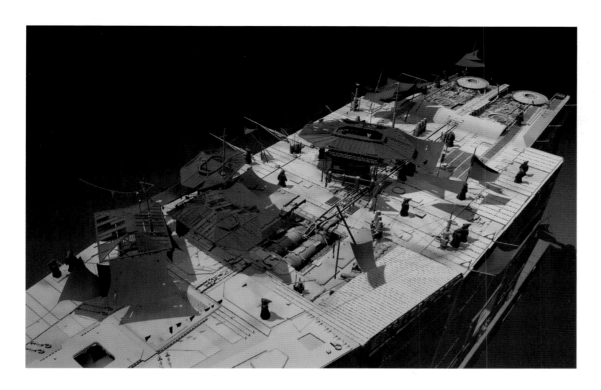

↑ **JAWA SANDCRAWLER VERSION 2A** Grandert

← **SANDCRAWLER DETAILS VERSION 06** Garcia

"We decided to have some fun and put some activity up on top of the sandcrawler, just to give it a different flavor, a little bit of mystery, a little bit of backstory." **Chiang**

↓ **JAWA CAMP TRADING VERSION 8A** Grandert

"The more I thought about it, the more I realized that we don't know anything about Jawa culture. They could be nomadic, and they emigrate to all sorts of systems. And these will have red eyes and not orange eyes. 'OK, maybe they're eating something different in the native diet here.'" **Alzmann**

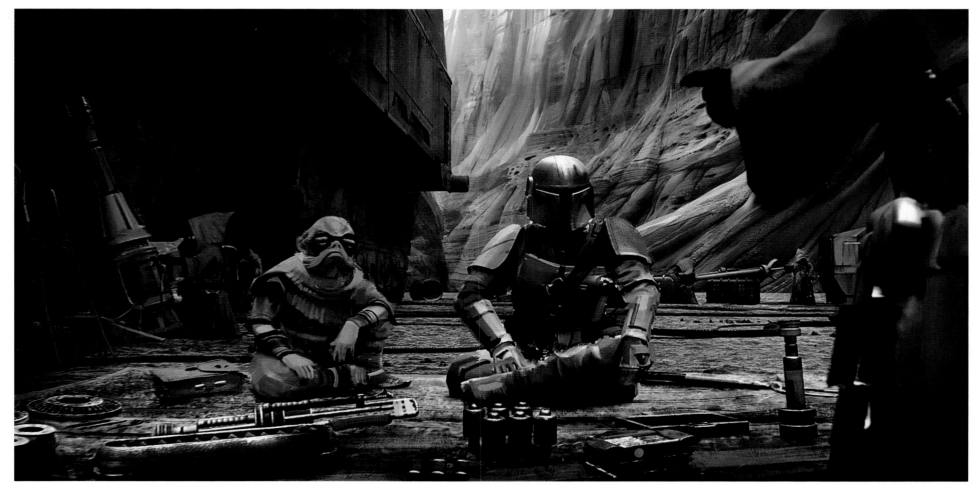

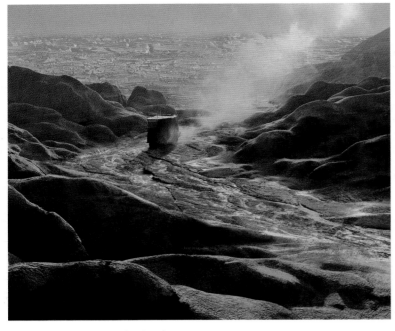

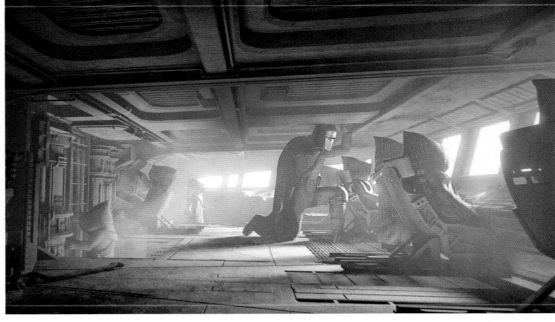

↑ **JAWA LANDSCAPE VIEW 4A** Grandert

↑ **SANDCRAWLER BRIDGE** Fields

↓ **JAWA LANDSCAPE VIEW 5A** Grandert

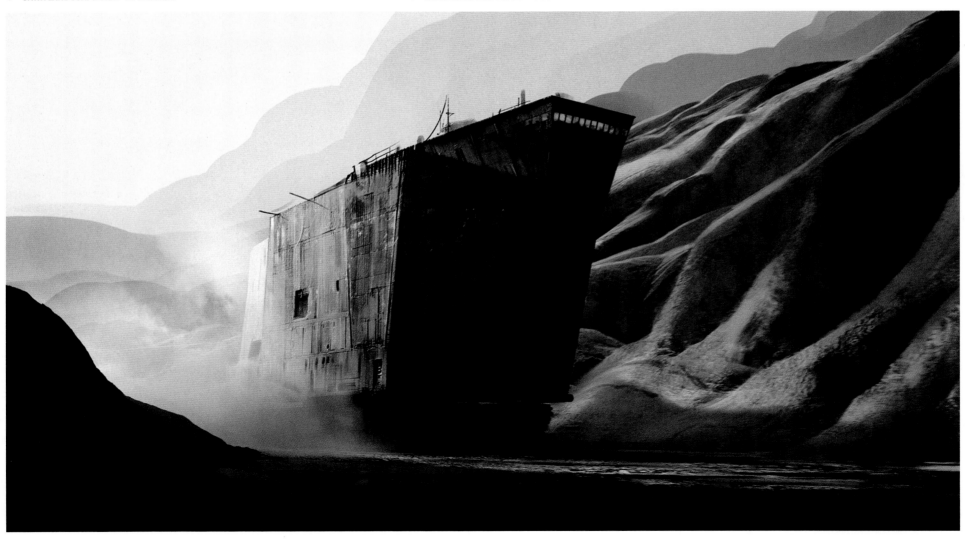

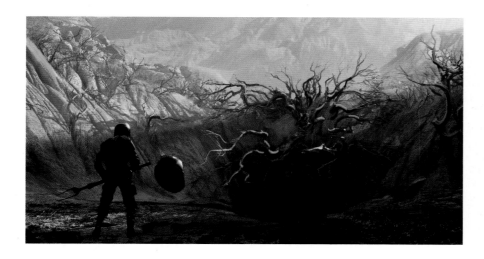

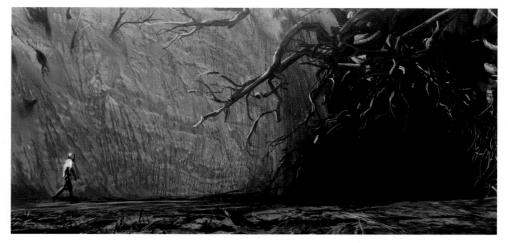

↑ **MUDHORN CAVE VERSION 2A** Jurabaev

"At one point there was a big old tree right above the entrance to the mudhorn cave. I ended up shooting the scene where he goes down to the cave. I shot second unit on every single episode in Season 1. My perspective on how the cave should be shot hadn't changed from my early storyboards. But I talked with Rick Famuyiwa and he was all for it. The clarity of what Jon wrote leads us all to the same ideas." **Filoni**

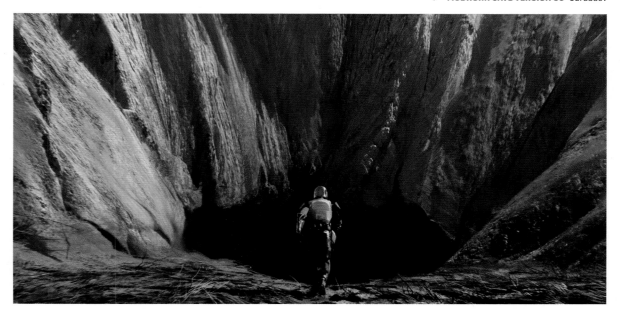

↑ **MUDHORN CAVE VERSION 03** Jurabaev

"Initially, the way I interpreted what Jon had written, was that the mudhorn was going to be a giant beast, bigger than a brontosaurus. When Jon saw the initial maquette studies, he felt that we were going too big. He wanted to keep it more realistic, more down-to-earth." **Chiang**

↑ **MUDHORN CAVE VERSION 01** Jurabaev

← **MUDHORN CAVE VERSION 03** Jurabaev

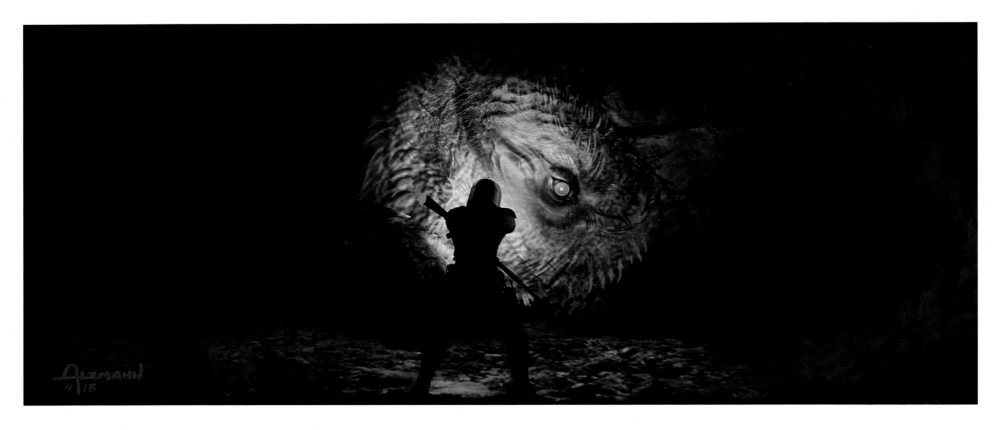

↑ **MUDHORN DISCOVERY VERSION 3A** "It would be so cool if the mudhorn has that nictitating membrane, making that retroreflective pink or green color that dogs and cats have. If its eye opened and you got a flash of red, reflecting the light back, for a sec?" **Alzmann**

← **MUDHORN SURPRISE VERSION 1A** Engstrom

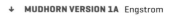↓ **MUDHORN VERSION 1A** Engstrom

"Ultimately, the mudhorn became an oversized rhino, which made our Mandalorian having a one-on-one fight with it more believable." **Chiang**

↓ **MUDHORN SKETCH 01** Filoni

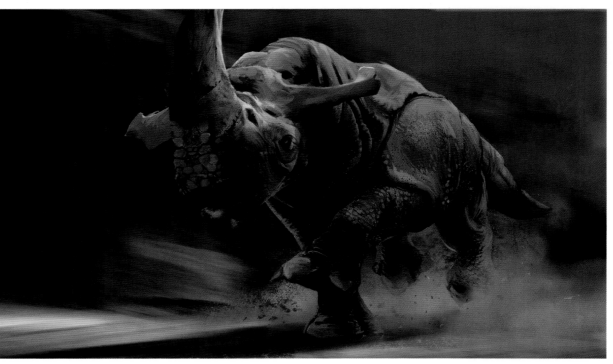

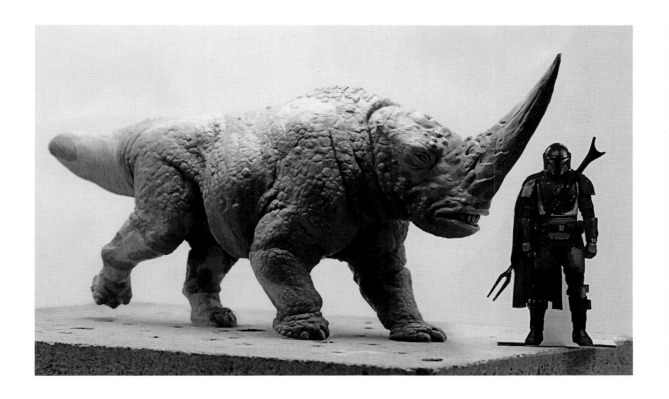

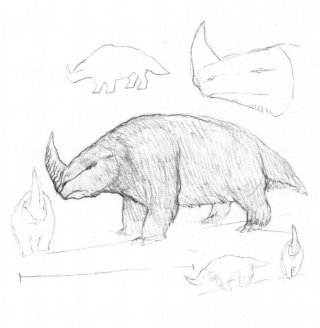

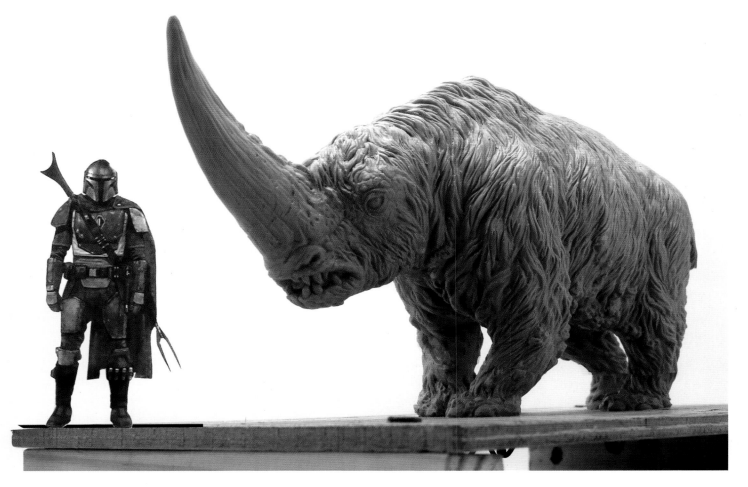

↖ **MUDHORN SCULPT REVISED** McVey and Chiang

"The mudhorn started off as like a big Indian rhino-type thing with a naked skin but heavily textured. And then we went to a furry version with shorter legs and a longer head." **McVey**

↑ **MUDHORN SKETCH 02** "Jon was inspired by this big prehistoric creature, [the giant rhinoceros Elasmotherium, specifically a recreation of one in the Museum of the City of Ústí nad Labem, Czech Republic]. So I started drawing some stuff, just to get us on the same page." **Filoni**

← **MUDHORN SCULPT** McVey and Chiang

"Now there is a more of a slope to the back, going up to a point on the back of the neck. If it's really outlandish and they try and animate the thing, it just isn't going to look right. So, you have to bear its anatomy in mind all the time." **McVey**

"Graphically, with this design, we were going simplistic: a hairy rhino with a large horn. Not overthinking the design, not overdesigning it, not putting too many creature elements into it. Jon instinctively understood what worked with the creatures in the original trilogy and brought those same sensibilities to ours." **Chiang**

→→ **MUDHORN LEVITATION VERSION 07** Alzmann

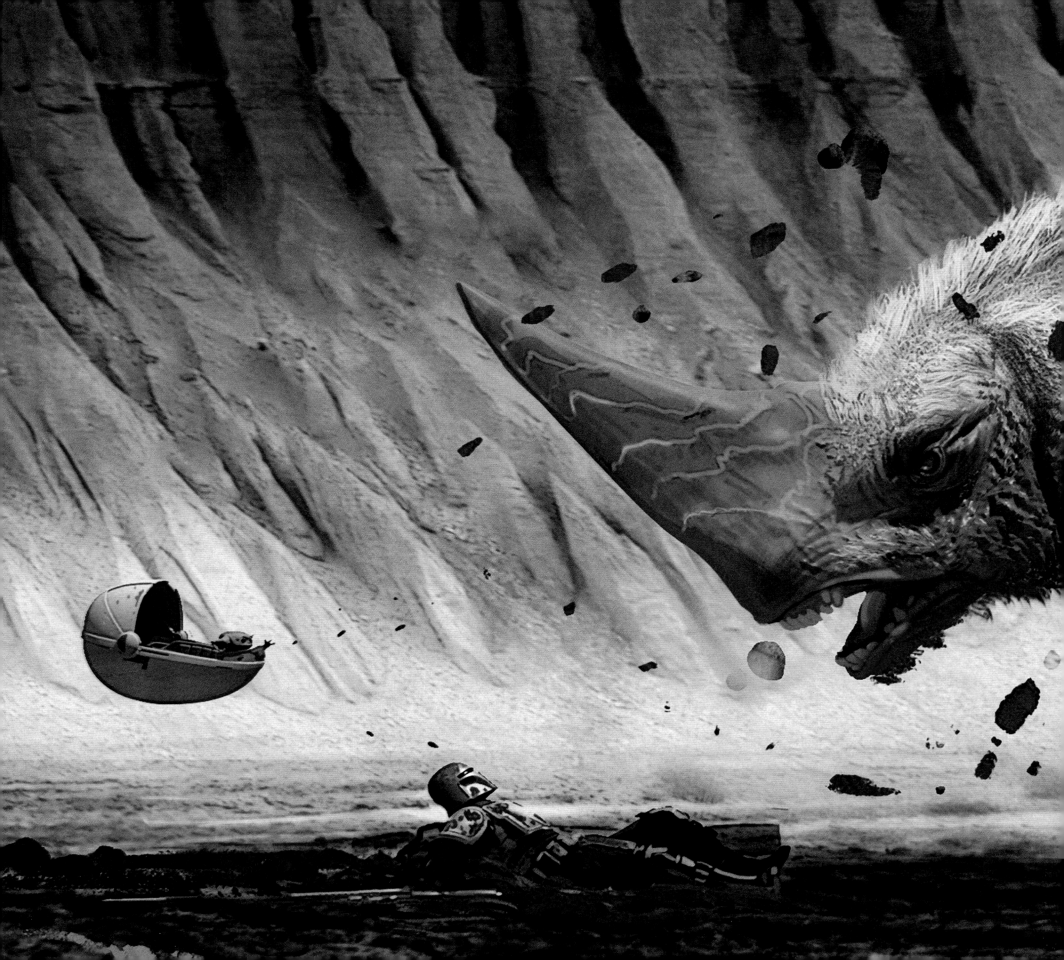

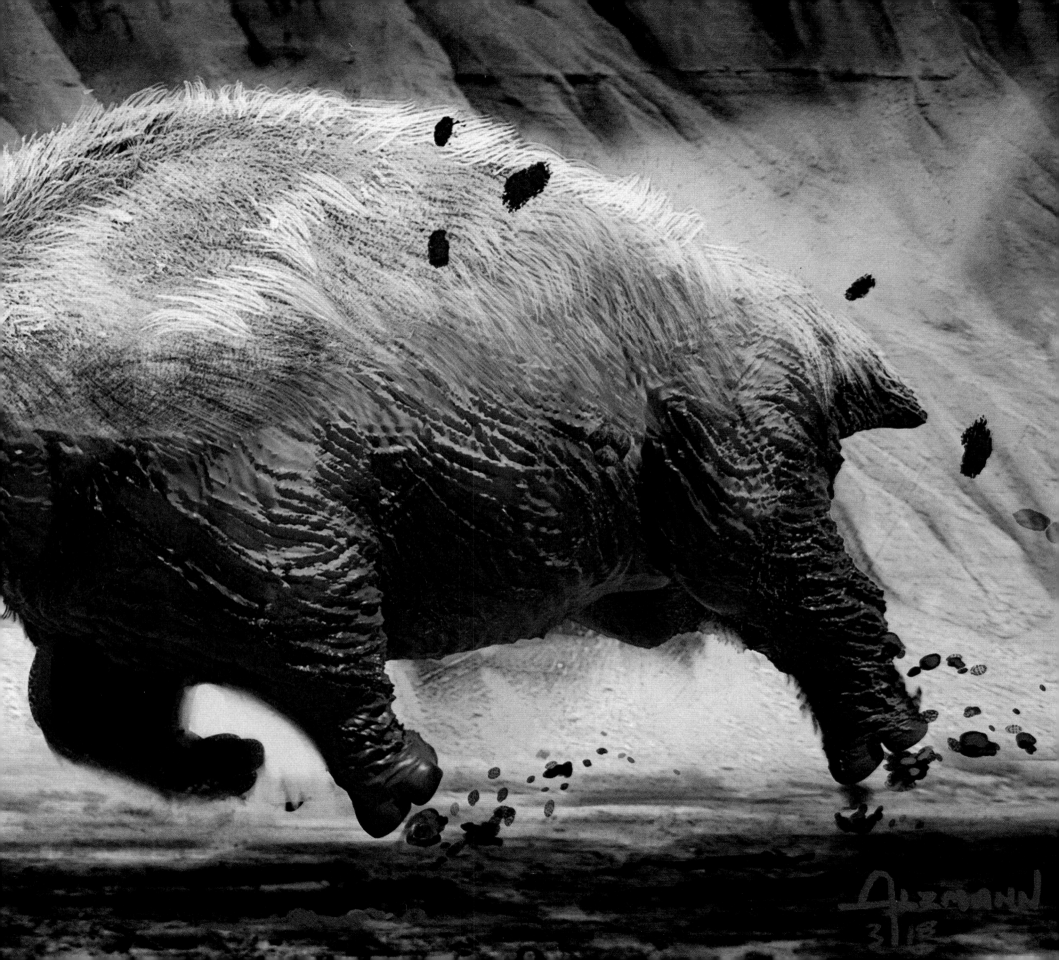

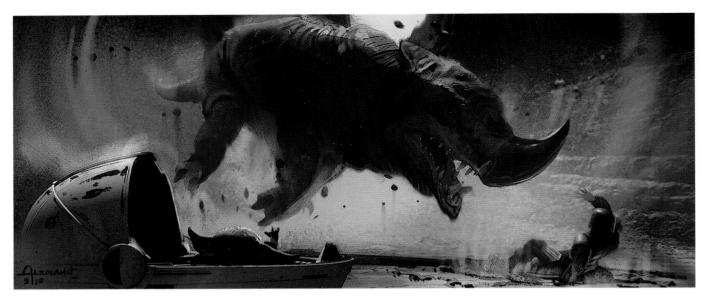

↑ **LEVITATION SKETCH 01** Filoni

→ **MUDHORN LEVITATION VERSION 01** Alzmann

↓ **MUDHORN STALK VERSION 04** "We didn't want to make the mudhorn too sympathetic, since the Mandalorian has to kill the beast. And yet, it needed to look like a real creature. So, we gave an ugliness and menace to its face, so that the mudhorn was a threat but we didn't sympathize too much when it was killed." **Chiang**

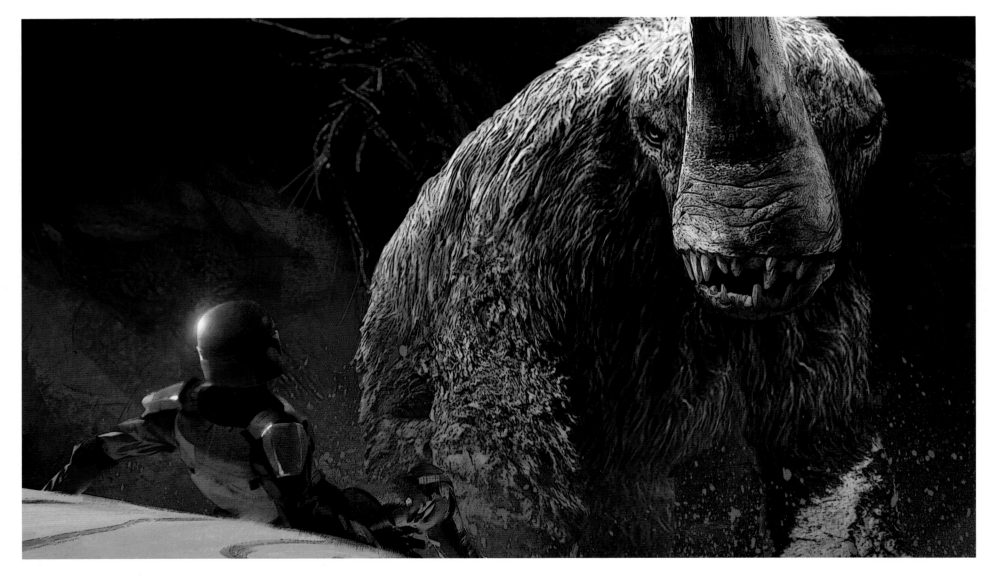

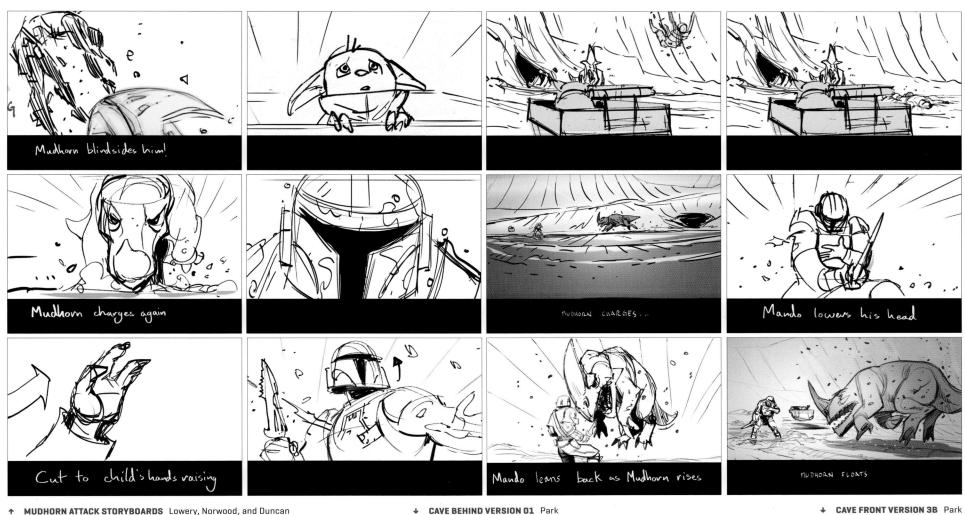

Mudhorn blindsides him!

Mudhorn charges again

MUDHORN CHARGES...

Mando lowers his head

Cut to child's hands raising

Mando leans back as Mudhorn rises

MUDHORN FLOATS

↑ **MUDHORN ATTACK STORYBOARDS** Lowery, Norwood, and Duncan ↓ **CAVE BEHIND VERSION 01** Park ↓ **CAVE FRONT VERSION 3B** Park

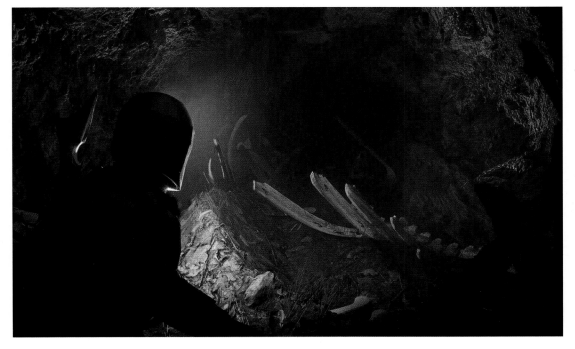

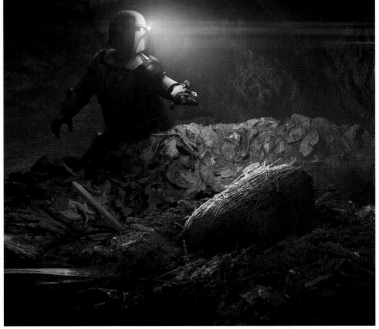

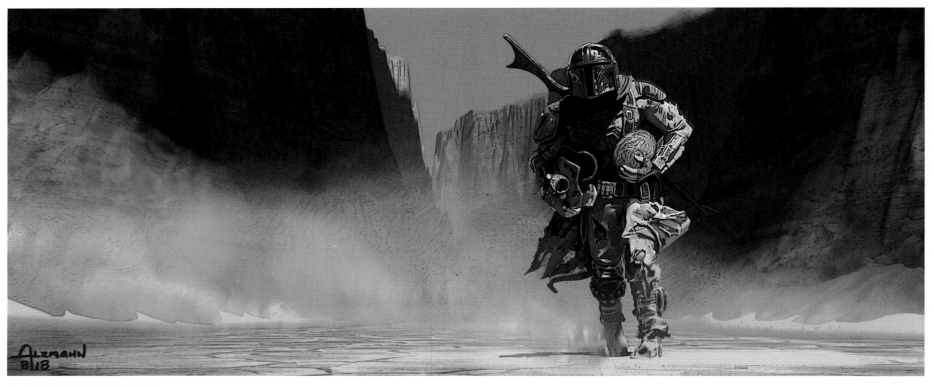

↑ **MANDO WITH EGG VERSION 03** Alzmann

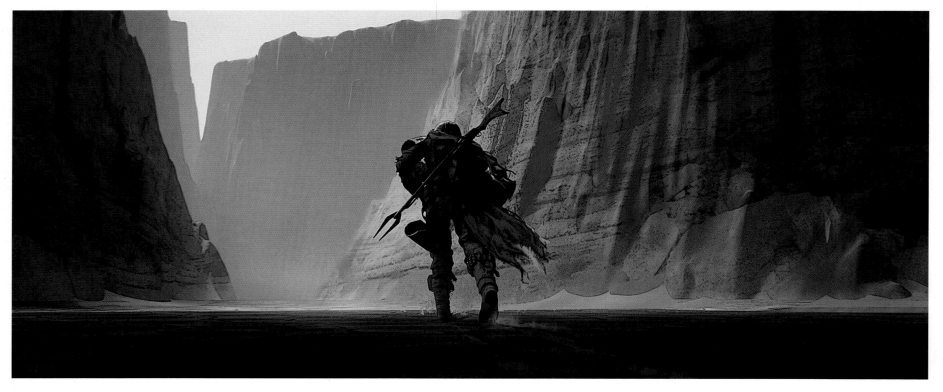

↑ **MANDO WITH EGG VERSION 01** "How can you show how mangled he got in a rear silhouette? Covering him in mud, tattering the cape, having all the armor hanging off of it. And it's such a Frazetta pose, having that leading foot just off-center. It's duck-walked in, meaning that he screwed up his hip or knee. Plus, all of the dust kicking up from him dragging his back foot." **Alzmann**

→ **UGNAUGHT REPAIRS VERSION 1A** "In one single night, the Ugnaught, the best builder in the galaxy, puts it all back together. But what does he really need for that? He would need some generators and lights." **Church**

↑ **JAWA EGG VERSION 02** Park and Chiang

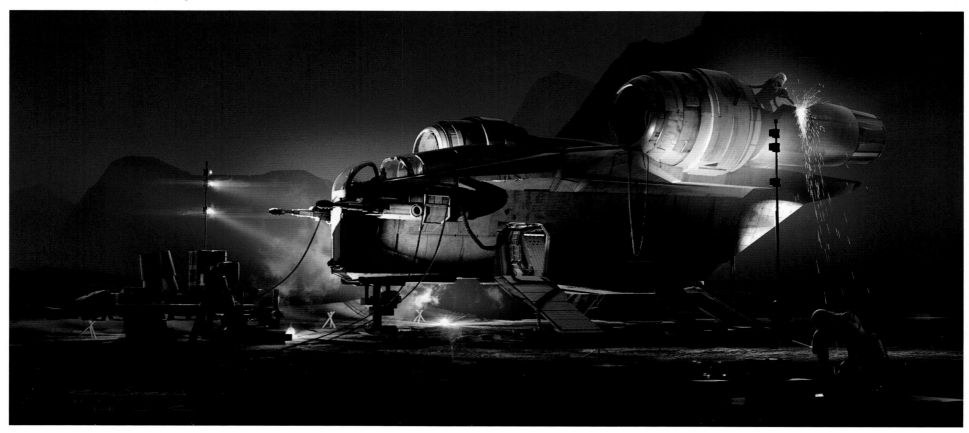

THE SIN

Doug Chiang's Lucasfilm art department commenced full-time design on the first season of *The Mandalorian* on January 9, 2018, work that would continue unabated until early September of that same year. "I approached *The Mandalorian* like it was a regular film, with the scope and visual drama inherent in those saga films," Chiang said. "I wasn't restricting myself in any way, at that point. In the initial design phase, I like to keep it very aspirational, setting the bar really high." Two weeks of pick-up shooting on *Solo: A Star Wars Story* (a film in which Jon Favreau supplied the voice of four-armed alien pilot Rio Durant) at Pinewood Studios outside of London began that same winter day.

Designers joining *The Mandalorian* team remotely in January included ILM London concept artist Jama Jurabaev; Star Wars: Galaxy's Edge designers Nick Gindraux, John Park, and David Hobbins; and ILM Vancouver's Richard Lim, with Brian Matyas returning for character and costume design work. Chiang recalled, "I've known John Park for a long time, but we didn't get to work together until *Rogue One* and Galaxy's Edge. I was trying to get Jama on a show for a long time, but he was tied up with ILM London. When he left, I grabbed him."

By early April 2018, concept artist Anton Grandert, *Star Wars* sequel trilogy veteran Seth Engstrom, and ILM concept modelers Colie Wertz, Russell Paul, and Rene Garcia would shore up the art department's growing workload. "I met Anton at DICE [a.k.a. EA Digital Illusions CE AB, a Swedish video game developer] for *Battlefront II,* and we stayed in touch," Chiang said.

Jon Favreau had completed first drafts of the first four chapters of *The Mandalorian* by early February 2018. From those scripts, the most challenging designs facing the Lucasfilm art department were the titular Mandalorian himself, his ship the *Razor Crest*, and a child of Yoda's unnamed alien species, around whom the plot of the entire series revolves.

"I had an image in my mind for what I wanted it to be," Favreau explained. "I had done some exploration on a character with big eyes and very expressive ears, for a VR project called *Gnomes and Goblins*, based on some drawings I had done many years ago. But you don't have a tremendous amount of resolution in VR and can't really see facial expression on a small character. So, you have to use very simple shapes to express emotion. We were looking at [Japanese animation director] Hayao Miyazaki's little soot balls in *Spirited Away* and *My Neighbor Totoro*, how expressive characters that are just eyes can be. And learning how expressive you could be with ears. I didn't want to have too much expression in the face

because it's just a baby. And big ears imply a character that's receptive and listening and aware and empathetic."

Regarding the Mandalorian: "making somebody who is distinct from Boba Fett yet evokes Boba Fett was a big challenge," Chiang said. "We wanted to keep the silhouette but create a more powerful, more iconic Mandalorian, almost like the idealized, aspirational version of Boba Fett. For Jon, it was about getting away from the giant helmets. How do we make the iconic Mandalorian helmet tight as possible to both the stunt performer's and actor's heads so that they're comfortable and don't look like a bobblehead?"

"And we zoned in on the *Razor Crest* pretty quickly because Jon wanted an A-10 'Warthog' design with the giant engines. Story-wise, the ship was an old, refurbished fighter. So, the design challenge was mainly blending those two aesthetics. The bar for us, internally, was wanting as much charm as the *Millennium Falcon*. We wanted it to last."

"Very quickly, within the first two or three months, we outlined the visual look of the whole series," Chiang continued. "So, everybody from the studio side to Kathy to the teams that were coming on board could very quickly understand where we were going. Amazingly, that changed very little. It just got more refined."

Favreau completed his shooting draft of *The Mandalorian* "Chapter 3: The Sin" on September 28, 2018, and it was shot by veteran film and TV director Deborah Chow concurrently with the Filoni-directed "Chapter 1" from October 1 to 26. "In everything that I've ever worked on, it doesn't matter how many robots or zombies there are, it doesn't matter how great the visual effects are, it always comes down to story and character," Chow said. "If you're not engaged with the story and characters, it really doesn't matter how great it looks or how fancy the effects are."

← **LAVA STREET NIGHT VERSION 02** Park and Chiang

↗ **THE SIN STORYBOARD 410** Lowery, Norwood, and Duncan

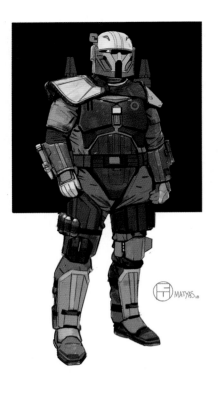

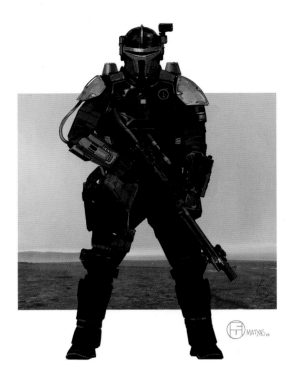

"Jon thought that there should be this heavy-infantry Mandalorian [in the covert], a Mandalorian on steroids with heavy armor. He is going to be our Mandalorian's antagonist." **Chiang**

↑ **HEAVY MANDO VERSION 02** "I was riffing a little too much on the sandtrooper shoulder pauldrons. But, yeah, I was trying to get him chunky and feeling heavy." **Matyas**

↓ **BLACKSMITH CHAMBER VERSION 1A** Matyas

↑ **HEAVY MANDO VERSION 04** "The double pistols are very Western but not appropriate for him. He's definitely a Gatling gun kind of guy. I was also seeing how far we can go with the visor being curvilinear, almost like a Nazi helmet. It does still feel Mandalorian but I went a little too far." **Matyas**

↑ **HEAVY MANDO VERSION 05** "The design was starting to solidify. Dark armor, barrel-chested. 'Intimidating' was the big thing. I was starting to settle on a darker palette for him with very minimal paint variations on his armor." **Matyas**

↗ **HEAVY MANDO VERSION 06** "There was an effort to make his helmet tight, angling everything. Very geometric. art deco and German Expressionism. Something that feels very brutal was important. The helmet gives the impression of a broad-shouldered square character, even the antenna not being this little flimsy, chintzy thing." **Matyas**

↓ **HEAVY MANDO FLYING VERSION 02** "I did a bunch of different jetpack designs. How do you sell this big guy flying through the air? That was hard. He doesn't look like he'd be the Rocketeer or someone nimble in flight." **Matyas**

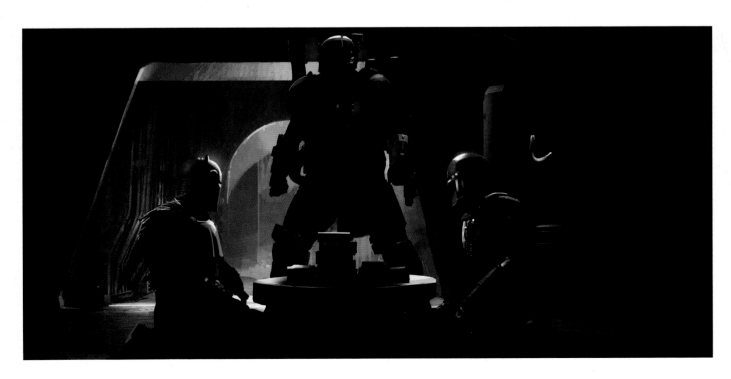

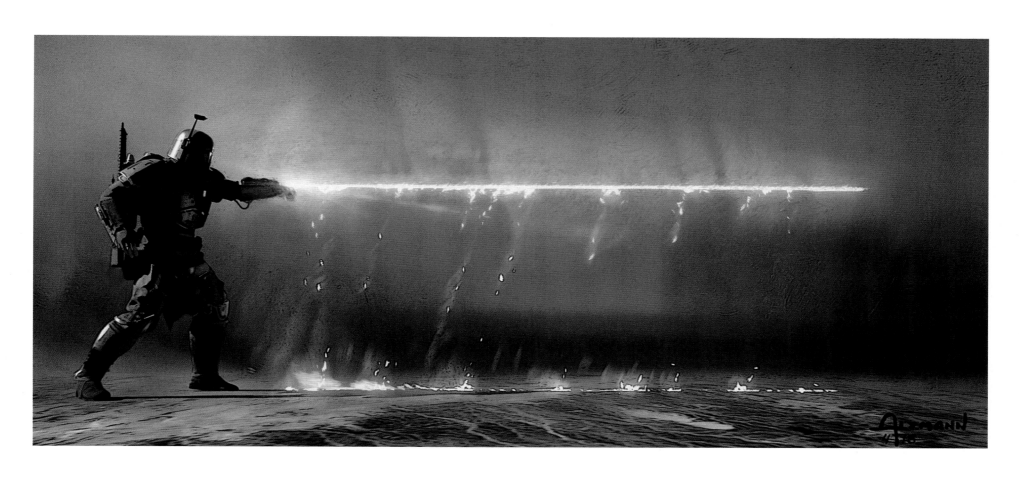

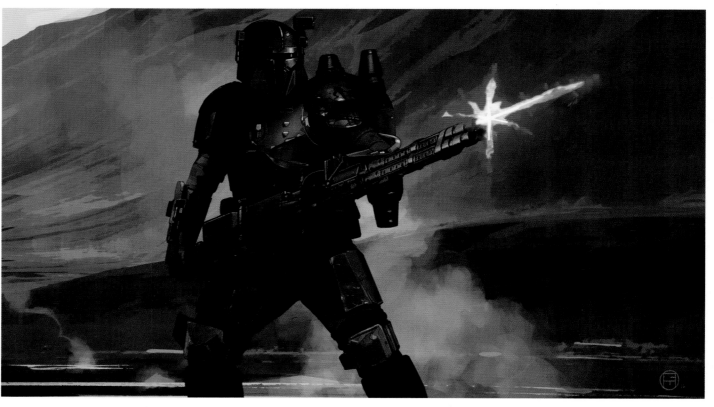

 BRUTE MANDO WEAPON VERSION 1A Alzmann

"Our Mandalorian had the whistling birds and the forked rifle. So, we wanted to give the heavy Mandalorian something different. And we thought, 'What about a plasma laser?'" **Chiang**

"It's sort of a plasma flamethrower. So, when he turns that off, it just falls to the ground into molten pools of lava." **Matyas**

➜ **HEAVY BLASTER VERSION 01** "The giant Gatling gun was a nod to the [M56 Smartgun] *Aliens* blaster rifle that they mounted on a Steadicam rig, although that one would hinge and go around corners." **Matyas**

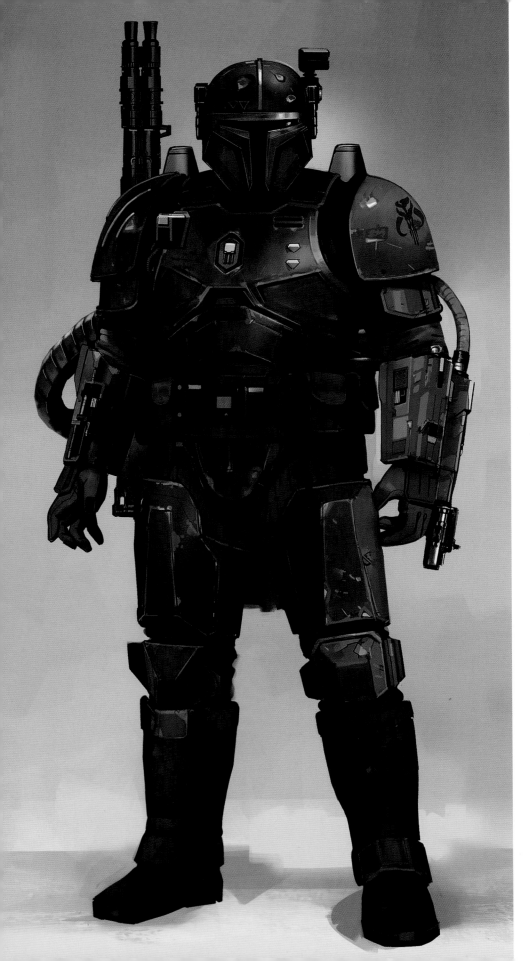

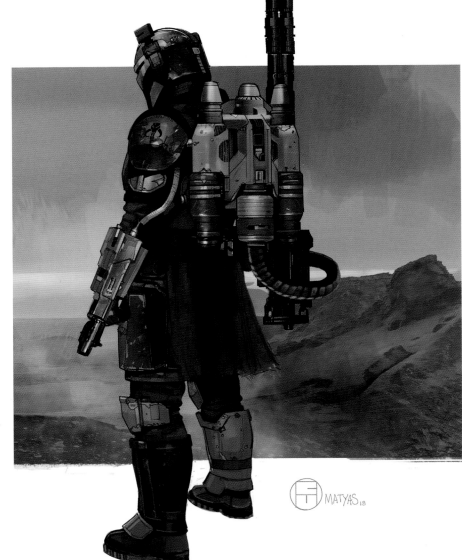

← **HEAVY INFANTRY MANDO VERSION 3B** "I wanted to make the visor even smaller for the big guy because it inadvertently makes him feel larger than he might actually be, just by pushing those proportions a little bit." **Matyas**

↓ **NEVARRO STREETS ALLEY VERSION 02** Engstrom

↑ **HEAVY INFANTRY MANDO VERSION 03** "They wanted the weapon to be fed by the jetpack. And that reminded me of Baze Malbus from *Rogue One*. His hose was real chunky, like square blocks, which informed how to construct the delivery system into Heavy Mando's fuel canister." **Matyas**

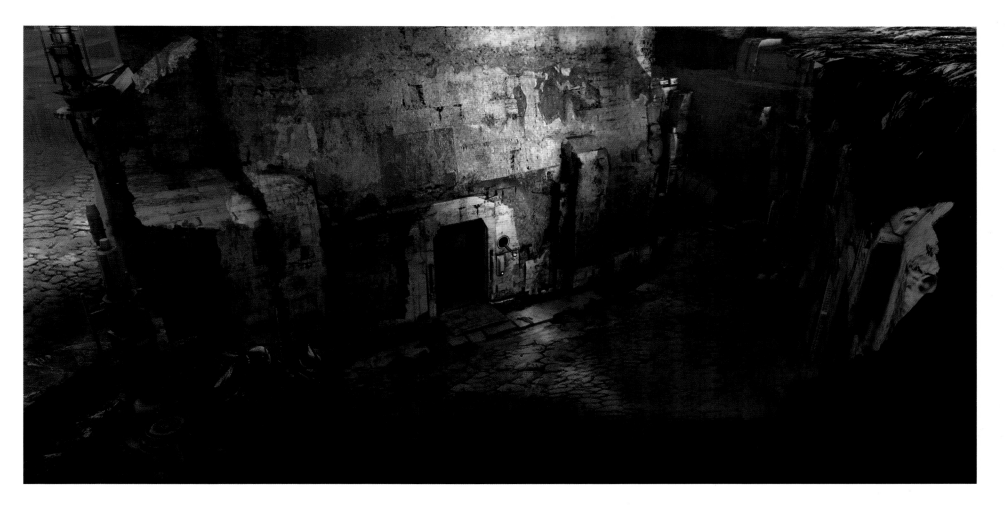

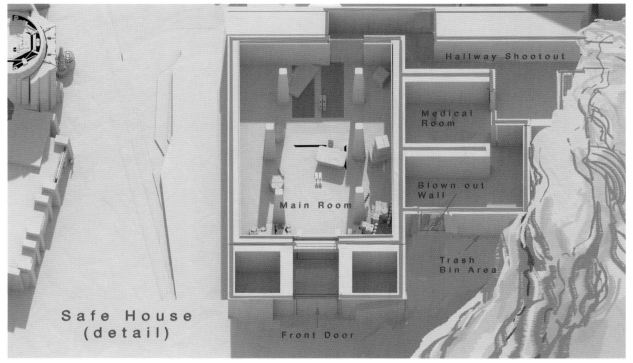

Safe House
(detail)

Main Room

Front Door

Hallway Shootout

Medical
Room

Blown out
Wall

Trash
Bin Area

↑ **NEVARRO DOORWAY DOWN SHOT VERSION 01** Church

← **NEVARRO SAFE HOUSE VERSION 1A** "Mando has to get the little guy back. And works his way through these hallways and medical rooms. So, this was a loose start. Then, the layouts got more refined." **Tiemens**

↓ **NEVARRO ALLEY GRAFFITI VERSION 01** Church

Examples of graffiti in *Star Wars*, including Coruscant Level 1313 street art from *The Clone Wars*, Jedha City symbols from *Rogue One: A Star Wars Story*, and Mandalorian artist Sabine Wren's starbird from *Star Wars Rebels*, were referenced by Ryan Church for this piece.

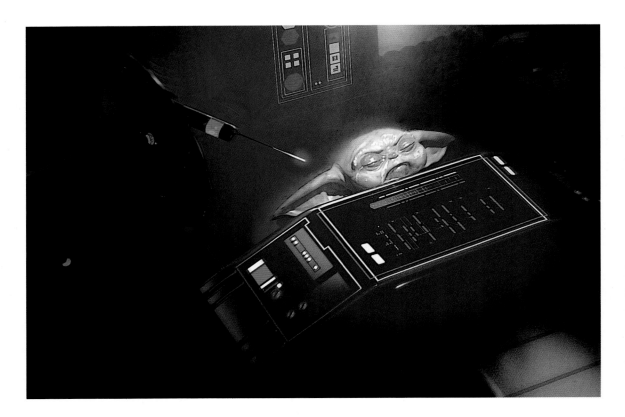

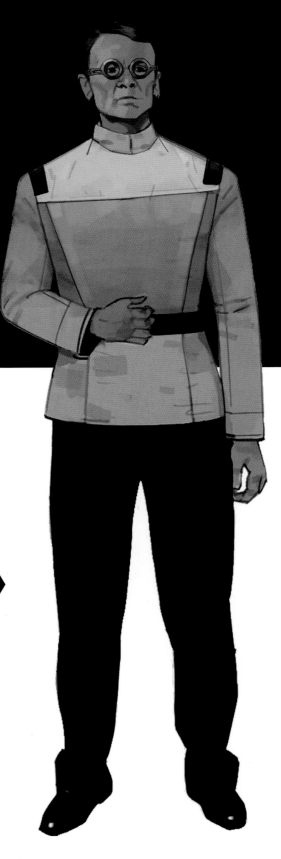

↑ **BABY AND DROID VERSION 02** "The brief was that they wanted the medical bed to come up over and cover his body. And I figured that the readout would be right above him. I wanted to give him a pallor showing that he's obviously unwell, like finding E.T. [from *E.T. the Extra-Terrestrial*] in the riverbed, the dry salami look [laughs]." **Alzmann**

↓ **SAFE HOUSE HALLWAY VERSION 02** Tiemens

→ **DR. PERSHING VERSION 01** "They wanted an Imperial scientist so I looked up a bunch of old Nazi scientists. I wanted the hairstyle, the posture, and everything to be really clean and simplified." **Matyas**

"Jon thought that glasses were the right look for him. I was a little nervous about it, at first. But what is good design if you're not nervous? His outfit was taken from *Rogue One*, from the Imperial scientist outfits." **Chiang**

↑ **PERSHING EMBLEM** Alzmann

The symbol Dr. Pershing has on the right shoulder of his Imperial scientist uniform was inspired by the emblem first seen on the Kamino-based clone soldiers in 2002's *Star Wars: Episode II Attack of the Clones*.

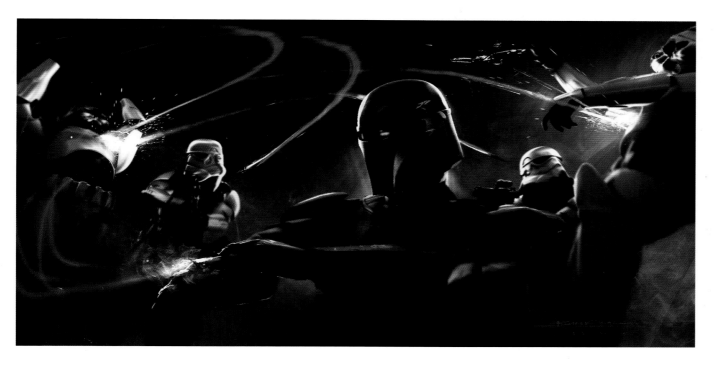

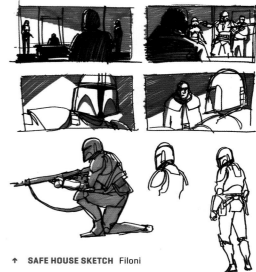

↑ **SAFE HOUSE SKETCH** Filoni

← **SINGING BIRDS VERSION 1A** Church

↓ **STREET BATTLE STORYBOARDS** Lowery, Norwood, and Duncan

→→ **MANDO FLYING COCKPIT VERSION 02** Park and Chiang

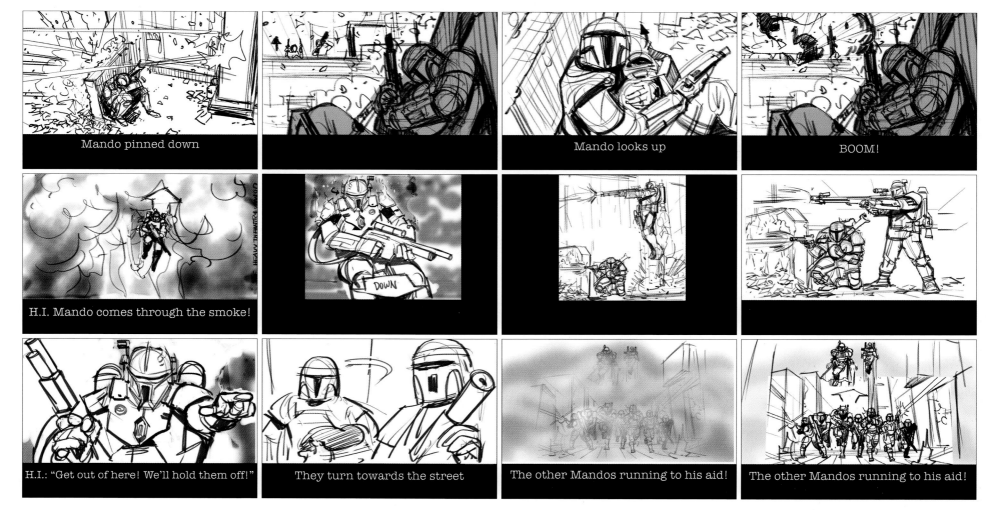

Mando pinned down

Mando looks up

BOOM!

H.I. Mando comes through the smoke!

H.I.: "Get out of here! We'll hold them off!"

They turn towards the street

The other Mandos running to his aid!

The other Mandos running to his aid!

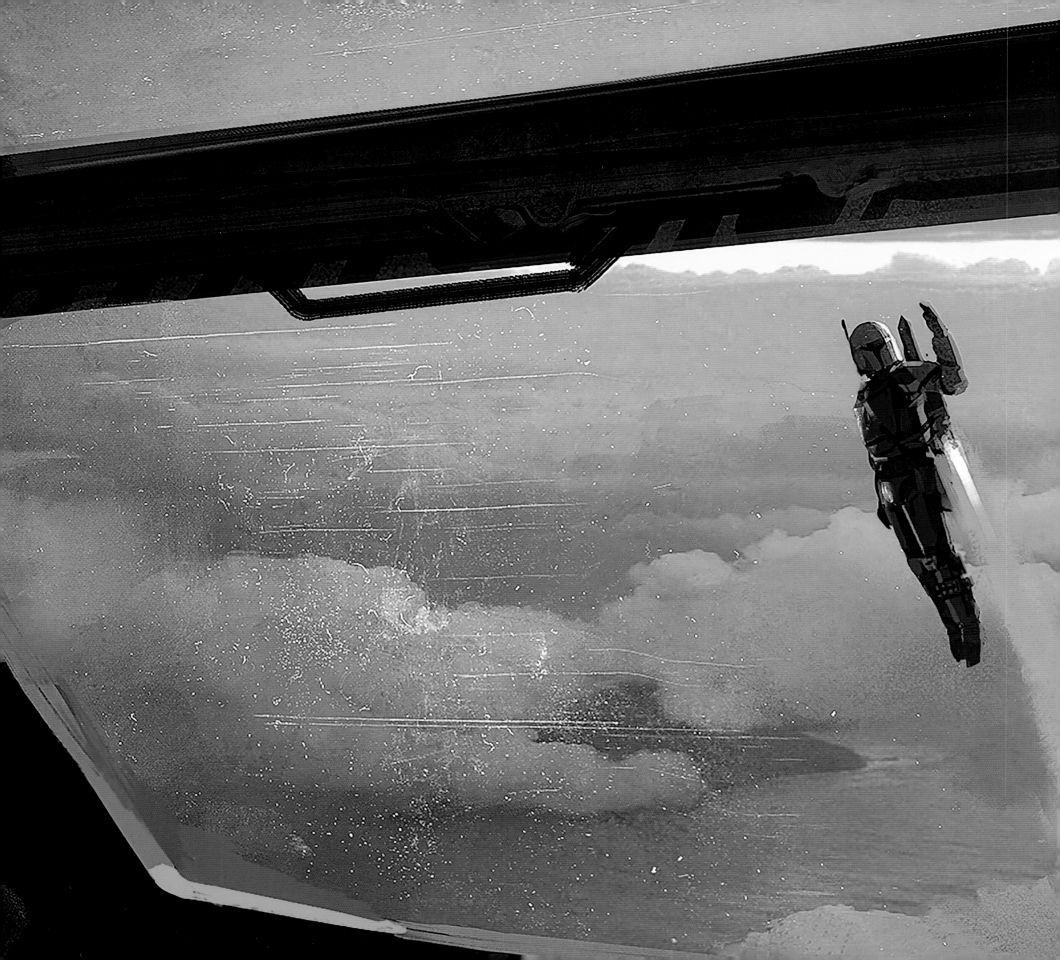

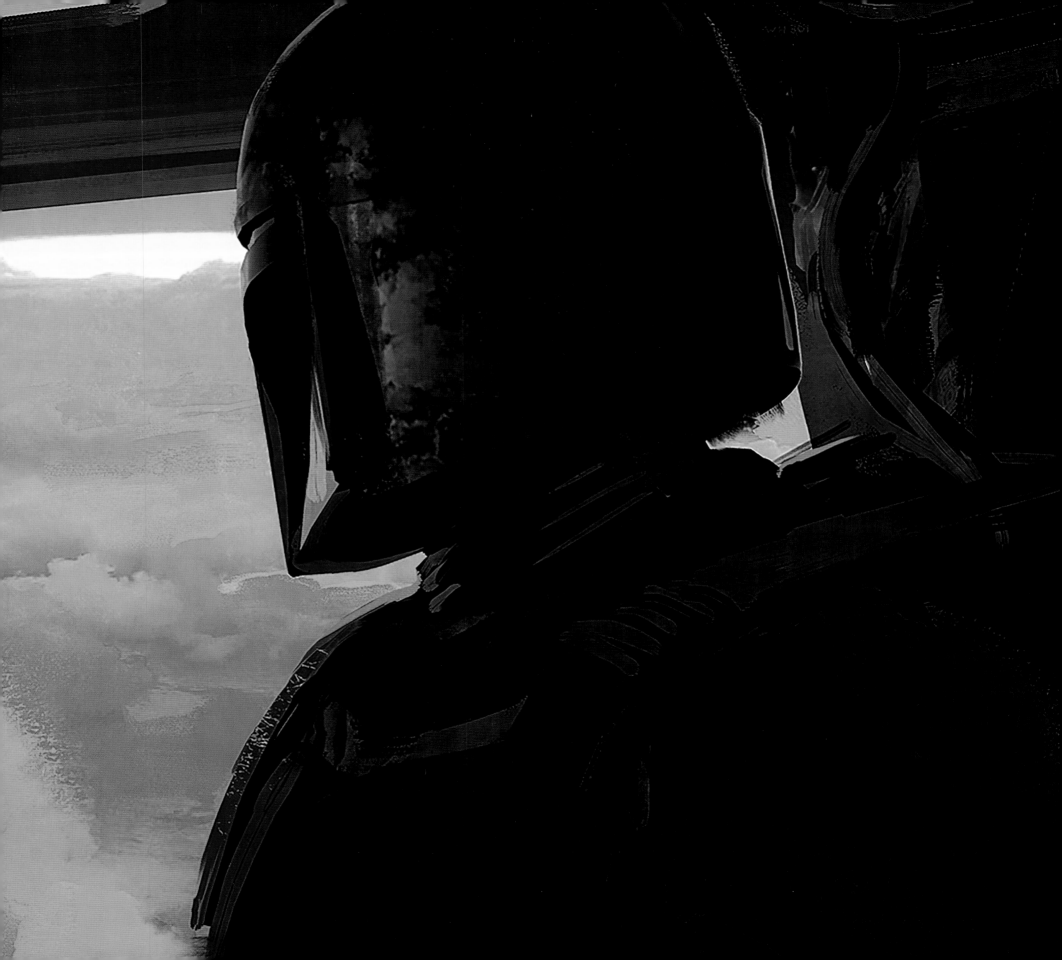

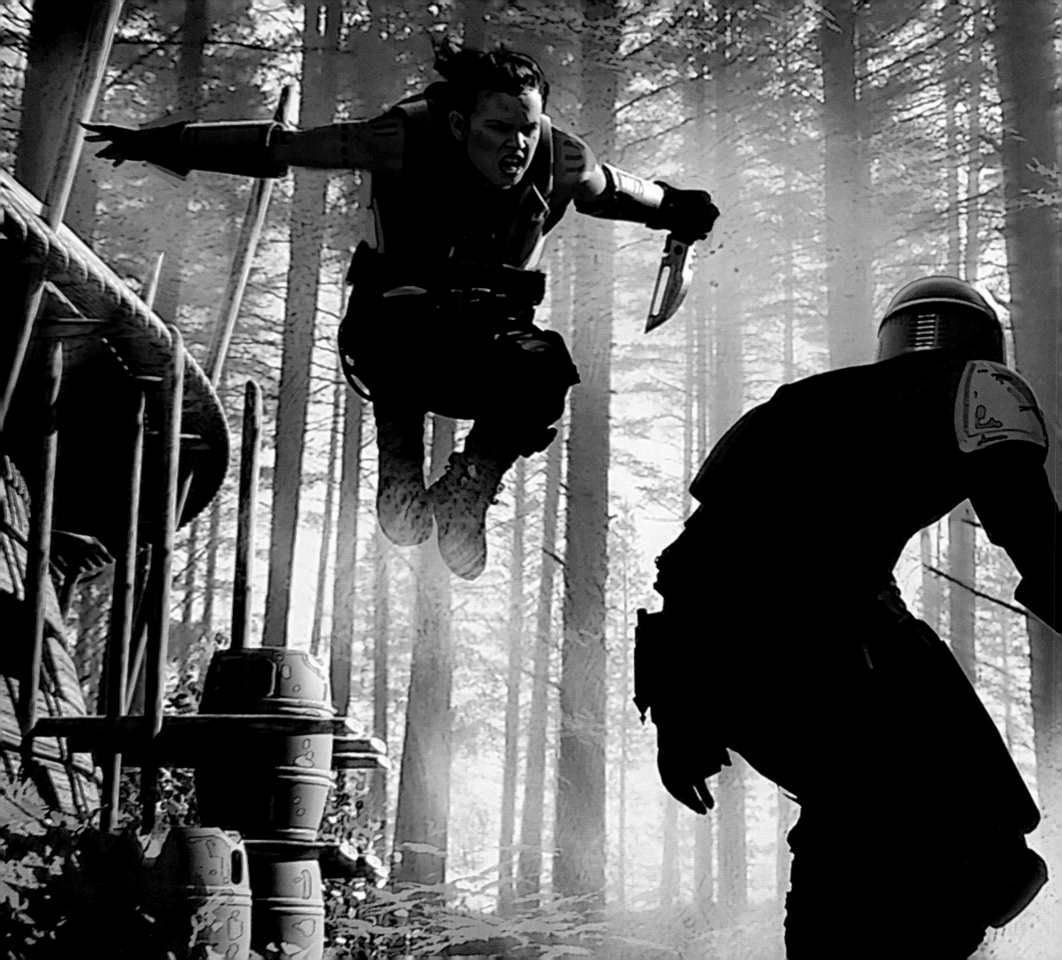

SANCTUARY

The Lucasfilm art department designer with the deepest historical connection to *Star Wars* was concept sculptor Tony McVey, joining the San Francisco-based team on March 12, 2018. A member of ILM creature supervisor Phil Tippett's crew for 1983's *Star Wars*: Episode VI *Return of the Jedi*, McVey is most famous for designing and fabricating Salacious B. Crumb, corpulent crime lord Jabba the Hutt's cackling court jester. "Phil came to me one day and said, 'We need this little pet that is supposed to sit on the arm of Ephant Mon, like a pirate with his parrot. So why don't you go design something?'" McVey remembered. "I went home that night and did a drawing. It took me ten minutes. And that was it. The puppet wasn't even that sophisticated. It couldn't move its eyes. It couldn't blink. It couldn't do anything, really [laughs]. Somebody on the set made the decision to make Salacious a featured character. He did well, my little boy, didn't he? [Laughs]" In September of 2018, McVey recreated the Salacious Crumb puppet from scratch and by hand for *The Mandalorian* "Chapter 1."

"Prior to *Return of the Jedi*, I was working on *The Dark Crystal* for eleven months or so in England, initially at the puppet workshop in Hampstead, right across the street from where Jim Henson lived," McVey continued. "The basement was where all of the foam rubber was run. A couple of big ovens and two people injecting foam rubber into molds all day long. I was doing little bits here and there, pick-up stuff like Aughra's horns and feet and various Podlings.

"I had met a guy named Mike McCormick from Albuquerque when I was working at the puppet workshop. So when our time was up on *The Dark Crystal*, we thought we'd come to L.A. and see what was available. We got a tour of *The Thing* [1982] and *Fright Night* [1985] workshops but didn't get any work. And then somebody suggested we talk to Phil Tippett. Phil said, 'Sure, I've heard of you guys. Why don't you come up to Northern California? We're just gearing up for this new movie, *Return of the Jedi*.' So, I was on that for nine or ten months. I enjoyed myself and did a lot of stuff. I had to make three pig guard bodies, that Ephant Mon costume, and Salacious Crumb, of course."

McVey went on to be a concept sculptor under Doug Chiang for both 1999's *Star Wars:* Episode I T*he Phantom Menace* and 2002's Episode II: *Attack of the Clones*, for which he fashioned the final look of the insectoid Geonosians and sculpted the head of Yoda that was scanned and digitized for the prequel trilogy. Chiang hired McVey again at ImageMovers Digital, where he formed the monstrous Grendel for Robert Zemeckis' 2007 adaptation of *Beowulf*. Upon returning to *Star Wars* in 2018, McVey found that "it has changed quite a bit. It's all digital now. And I'm the only holdover from the old days. I'm still doing what I did in the old days [laughs]. My background is in making models for the Natural History

Museum. They had to look right because they were vetted by scientists before they went into the gallery. So, that's uppermost in anything I design. Is it actually functional? Is it going to work properly when it moves? If it doesn't, then it has to be changed."

In the midst of concept designing *The Mandalorian* Chapters 1 through 3, the Lucasfilm art department kicked off "Chapter 4: Sanctuary" in mid-March 2018, following the February 8 delivery of Jon Favreau's *Seven Samurai*-inspired first draft script. Concept artist Brian Matyas immediately got to work designing ex-Rebel shock trooper Cara Dune. "The main thing was that Cara had to be a worthy opponent to the Mandalorian, so you could believe she could kick Mando's ass," Chiang reflected. "Gina has such a presence already that the challenge was just coming up with an outfit that complemented her."

The sixth of eight episodes shot for *The Mandalorian* Season 1, "Chapter 4: Sanctuary" was in production from December 14, 2018, to January 25, 2019, with a two-week holiday break in the middle. Director Bryce Dallas Howard completed the episode almost a year to the day after her father, Ron Howard (star of George Lucas's second feature film and first box office smash *American Graffiti* and director of Lucasfilm's 1988 fantasy film *Willow*) completed the final pick-up shots for *Solo: A Star Wars Story*.

"*Star Wars* has been a very personal journey because I care very deeply about the man behind the story," Bryce Dallas Howard said. "George honestly feels like family and has been a mentor to my father since he was a teenager. It's incredible to be a part of the continuation of this story. I've always been in awe of *Star Wars* and the magic of that."

← **CARA AMBUSH VERSION 1A** "I just wanted to make this piece as dynamic as possible. Cara's not going to do any old ambush. Plus, I got to design some cool *Star Wars* knives." **Alzmann**

↗ **VIBRO DAGGER** Ozzimo

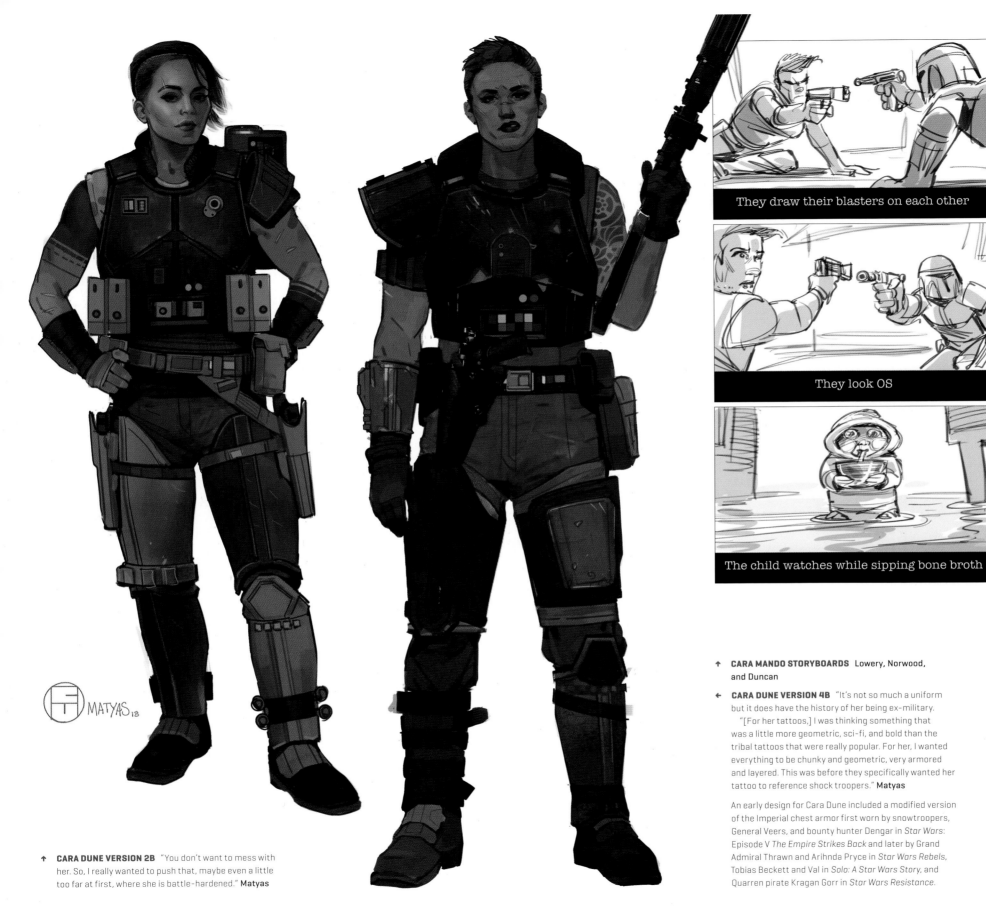

They draw their blasters on each other

They look OS

The child watches while sipping bone broth

↑ **CARA MANDO STORYBOARDS** Lowery, Norwood, and Duncan

← **CARA DUNE VERSION 4B** "It's not so much a uniform but it does have the history of her being ex-military.

"[For her tattoos,] I was thinking something that was a little more geometric, sci-fi, and bold than the tribal tattoos that were really popular. For her, I wanted everything to be chunky and geometric, very armored and layered. This was before they specifically wanted her tattoo to reference shock troopers." Matyas

An early design for Cara Dune included a modified version of the Imperial chest armor first worn by snowtroopers, General Veers, and bounty hunter Dengar in *Star Wars: Episode V The Empire Strikes Back* and later by Grand Admiral Thrawn and Arihnda Pryce in *Star Wars Rebels*, Tobias Beckett and Val in *Solo: A Star Wars Story*, and Quarren pirate Kragan Gorr in *Star Wars Resistance*.

↑ **CARA DUNE VERSION 2B** "You don't want to mess with her. So, I really wanted to push that, maybe even a little too far at first, where she is battle-hardened." Matyas

↑ **MANDO CARA FIGHT VERSION 2A** Park

↑ **CARA DUNE VERSION 05** "So, I did a bunch of sketches and this was the one. It's so rare when you do a bunch of designs and the armor set you really like ends up being the one that really resonates with them." **Matyas**

"In some of the initial ideas, we gave her quite a bit of armor. But we realized that, for her stunt performance, it was going to be too restrictive. So, we start to give the costume more soft armor and the hard armor was left for certain key points like the shoulder, knee pad, and gauntlets." **Chiang**

← **CARA HIDEOUT VERSION 02** Matyas

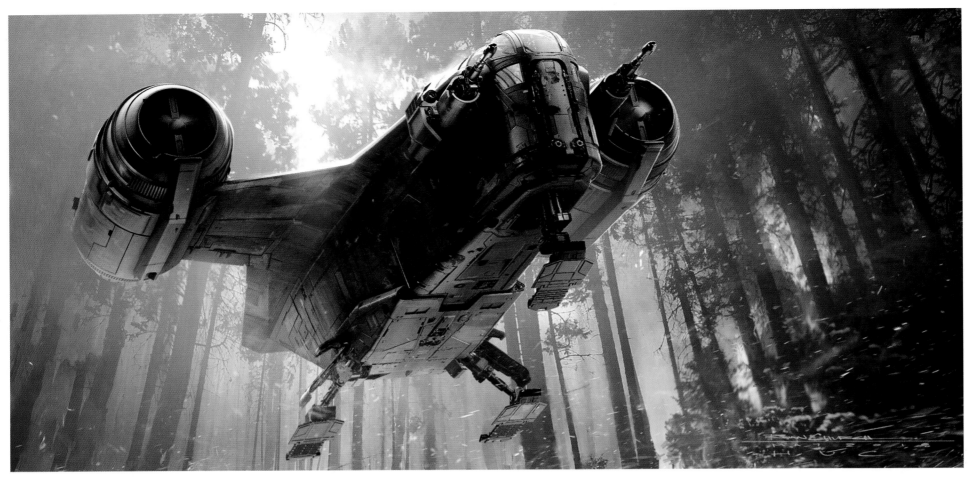

↑ **LANDING SORGAN VERSION 02** Church

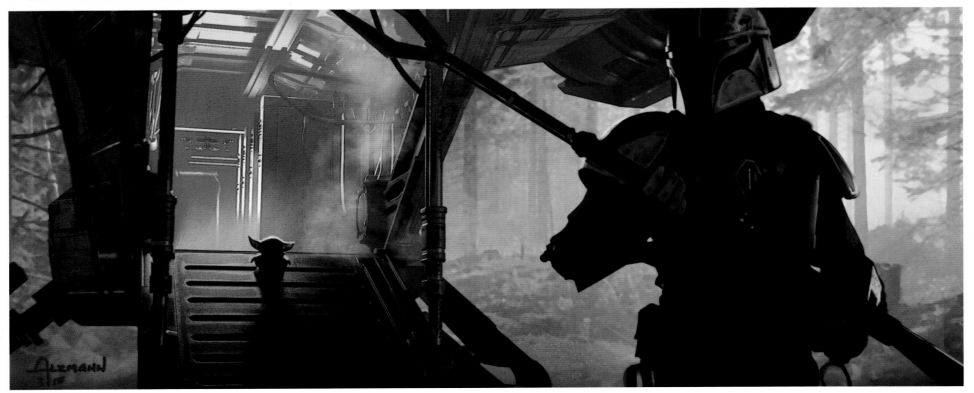

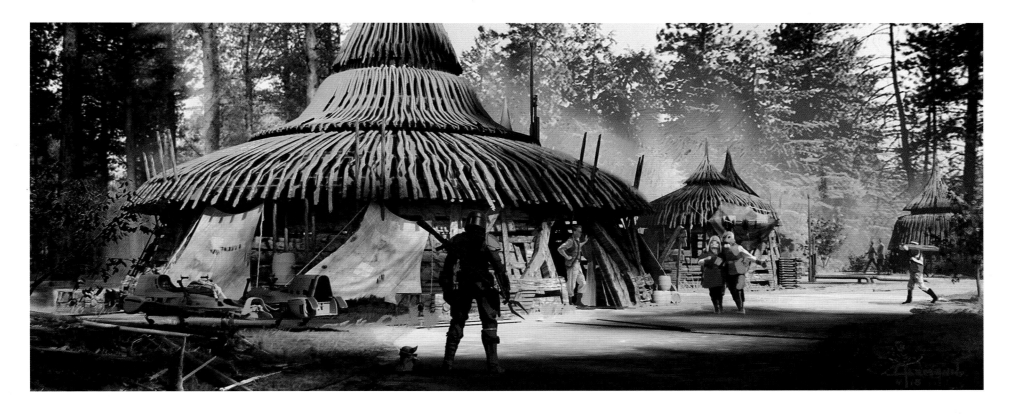

BABY ON RAMP VERSION 2A "What's so great about the whole series is, whenever you show those two, you have that visual juxtaposition and irony of having the baby with this really big scary-looking dude with a gun." **Alzmann**

PUBLIC HOUSE EXTERIOR VERSION 16 "This show is all about being in very remote places and scaling everything down. Jon wanted that *Shane* little town feel everywhere that Mando went. But how little of a town and main street could we get away with? I think this one ended up being too small. If we ever end up in a place like Coruscant, it will be shocking to viewers of *The Mandalorian*." **Alzmann**

PUBLIC HOUSE INTERIOR VERSION 05 "You want this set to feel very homemade and sort of ramshackle but also not super poor and disheveled. It didn't want to feel like a sad or bad place." **Alzmann**

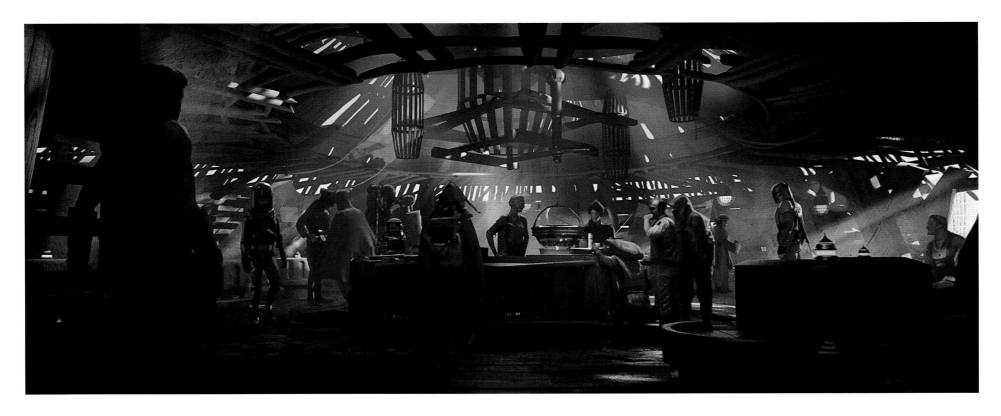

SORGAN PUBLIC HOUSE

↑ **PUBLIC HOUSE PLAN VERSION 05** Alzmann

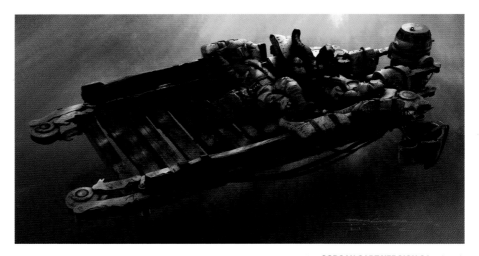

↑ **SORGAN CART VERSION 01** Church

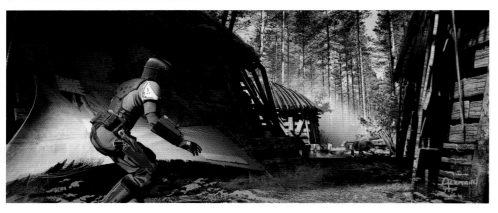

↑ **PUBLIC HOUSE EXTERIOR VERSION 18**
"We were calling this 'the alley.' Well, what constitutes an alley in this kind of town? How many buildings do we need? This was more of a final look for how ramshackle the woodwork was on the exteriors." **Alzmann**

↓ **KRILL FARM DROIDS VERSION 01** Alzmann

→ **KRILL FARM DROIDS VERSION 08** "It's basically an R5 head but I changed the top a little bit. And I gave him really long stork-like legs so he could wade into the pools. It's simple, straightforward.
 "I kept adding a basket that [the droids] would carry their krill haul in, almost like they're panning for gold [laughs] and then tossing them overhead into the basket." **Alzmann**

↘ **KRILL FARM DROIDS VERSION 02** Alzmann

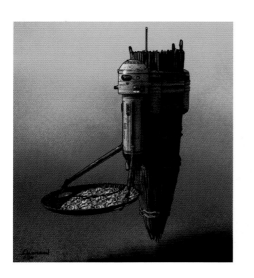

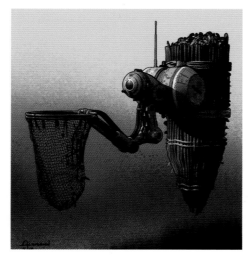

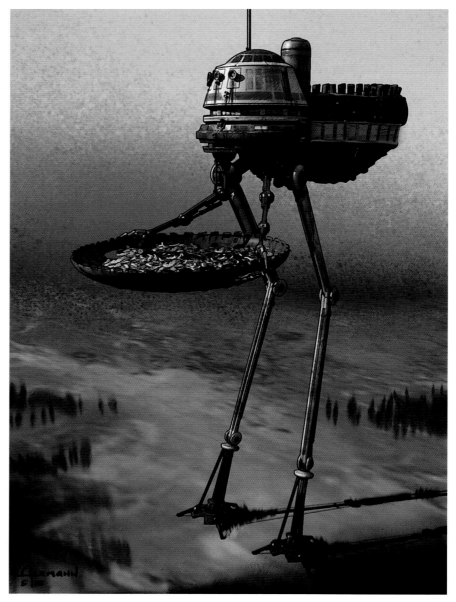

"We wanted to make sure that this village felt very idyllic, a secret paradise hideout. Why are the farmers here? Jon decided there were krill farmers. That informed us to design these ponds." **Chiang**

↑ **KRILL FARMS VERSION 02** Jurabaev

↓ **KRILL FARMS VERSION 03** Jurabaev

→ **KRILL FARMS VERSION 05** Jurabaev

"I loved the idea of this being a forest planet but we had to be very careful that it didn't become Endor. Part of the solution was making the trees normal scale. It's more like the West, in terms of Montana or Wyoming. So, there were flat plains with rivers and lakes and then normal trees perhaps with mountains surrounding them. That became our anchor versus the giant sequoias of Endor." **Chiang**

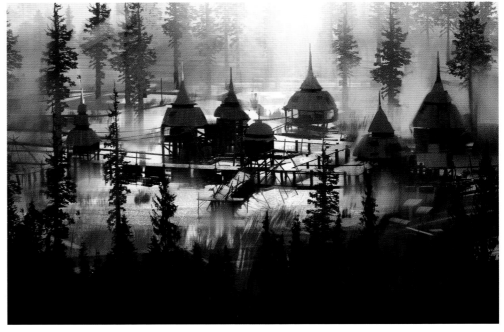

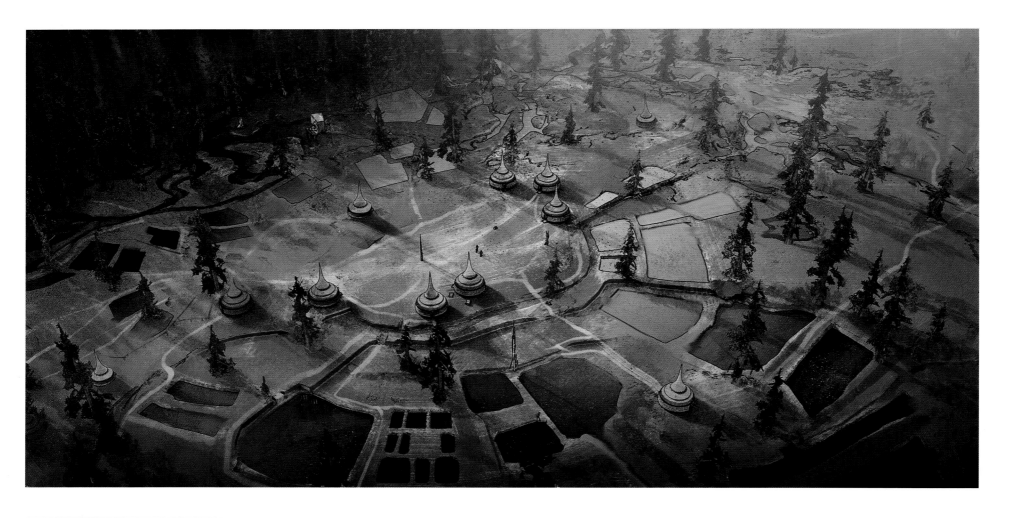

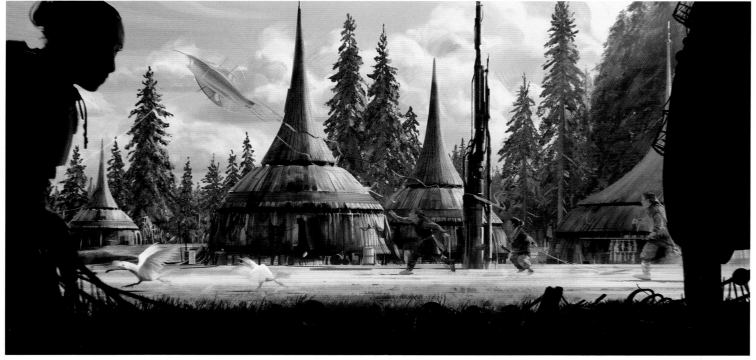

↑ **KRILL VILLAGE OVERVIEW 01** Grandert

"From a high angle view, I really want to create the graphic of this focal point, where the city is surrounded by this central courtyard, which is then surrounded by these krill ponds. The ponds serve a purpose both for farming but also protecting the town itself, giving a barrier of some kind. In this overview, you can see that the ponds go right up against the forest. And that's where the Klatooinians attack." **Chiang**

← **KRILL VILLAGE OVERVIEW 11** Grandert

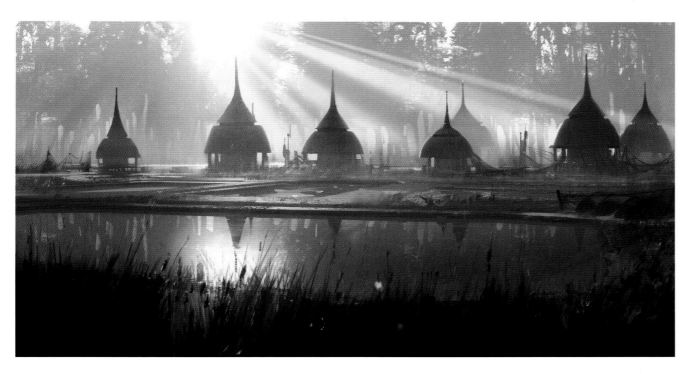

↑ **HUT EXTERIOR VERSION 03** Grandert

"We wanted to give Sorgan a unique form language, a distinct personality. This domed peak shape was something that I've always been really fond of. We tried it on *Rogue One*. It's a form of a roof that's seen on temples. So, we basically scaled it down and changed it to wood. But very quickly, it gave us a graphic quality and really identifiable distinguishing feature, a visual identity, like the dome buildings on Tatooine." **Chiang**

← **KRILL FARMS VERSION 07** Jurabaev

↓ **SORGAN VILLAGE VERSION 02** Engstrom

→→ **KRILL VILLAGE OVERVIEW 02** Grandert

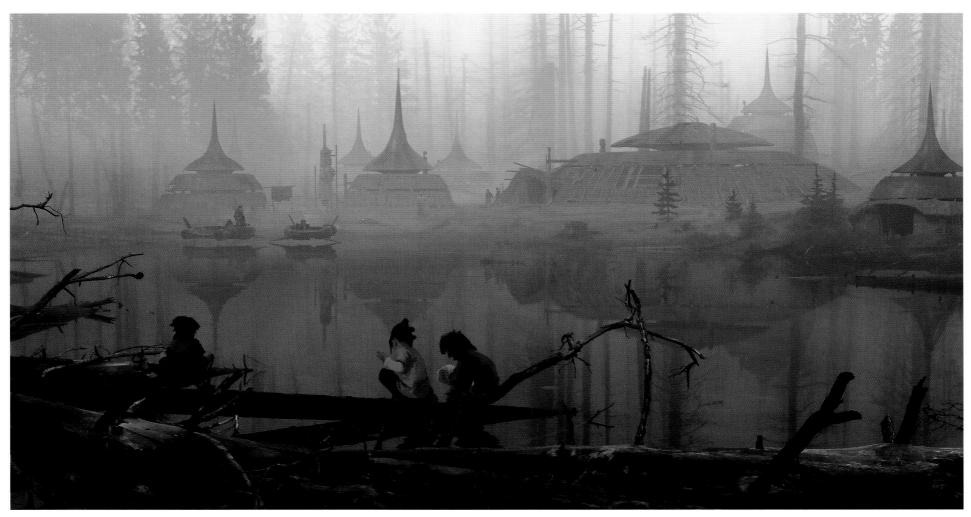

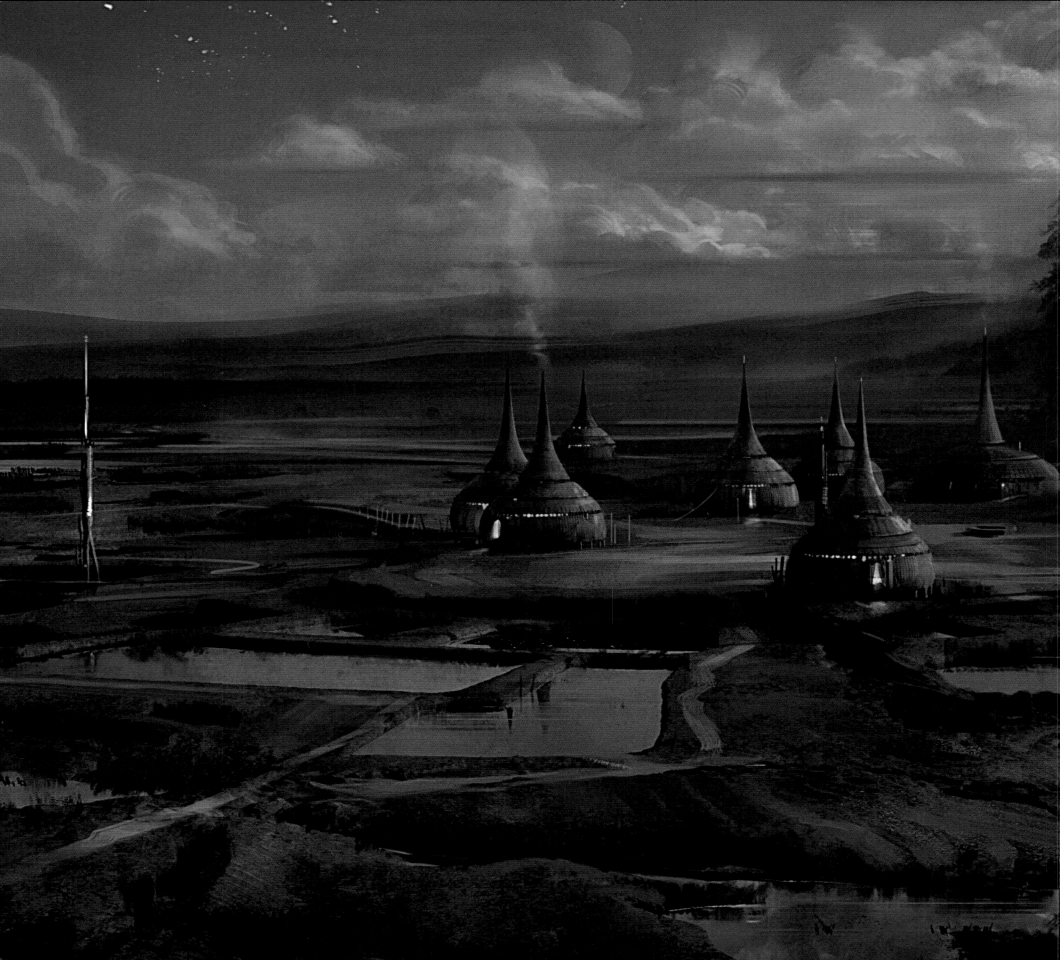

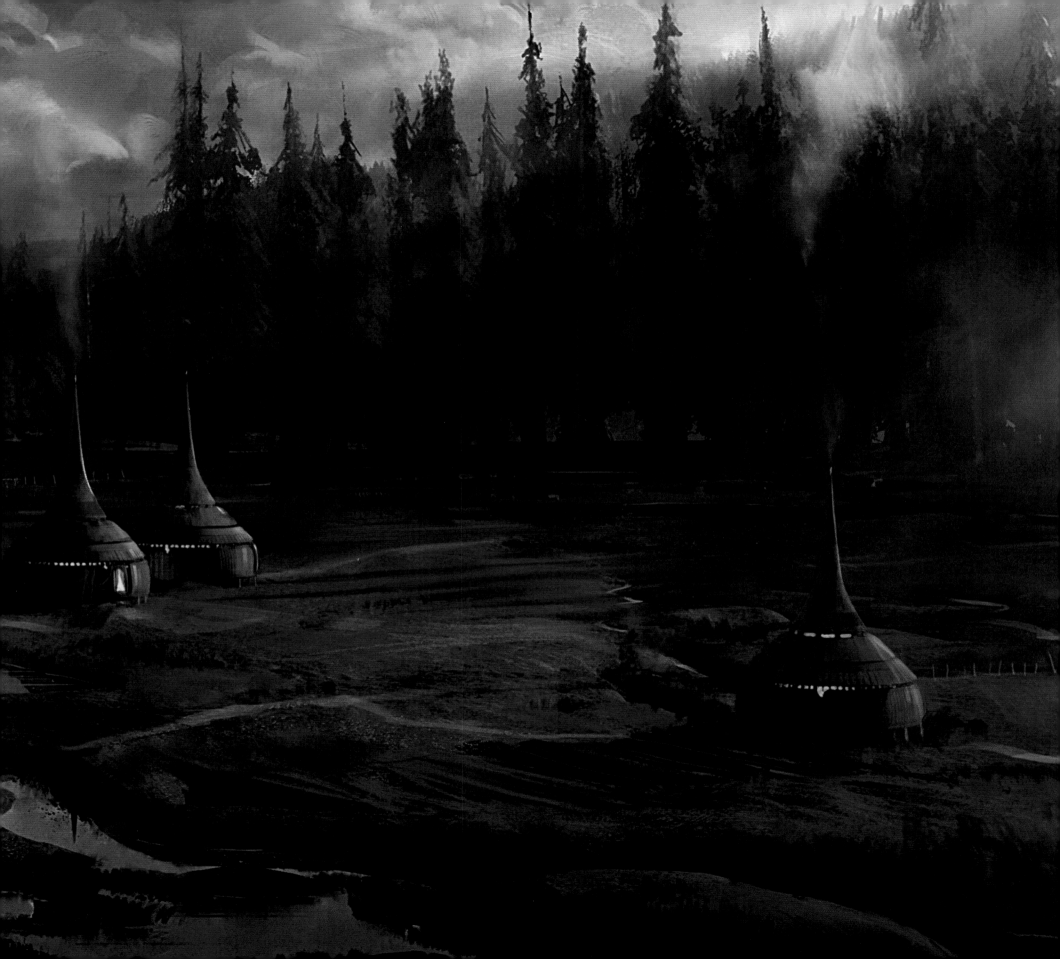

↑ LARGE HUT VERSION 04 Engstrom

"Maybe there are schoolrooms? This was us leaping ahead before this script was finished, trying to find other moments." **Chiang**

← SMALL HUT INTERIOR VERSION 02 Engstrom

↓ SORGAN BARN INTERIOR VERSION 03 "How do we keep Mando as the mysterious unknown figure when somebody's got to see him at some point? This way, we can see him as a silhouette and not give away his appearance to the viewer. I'm always mentally referencing movies I grew up with. This is *Witness* with Harrison Ford. They start to have feelings for one another, but a relationship will never happen." **Alzmann**

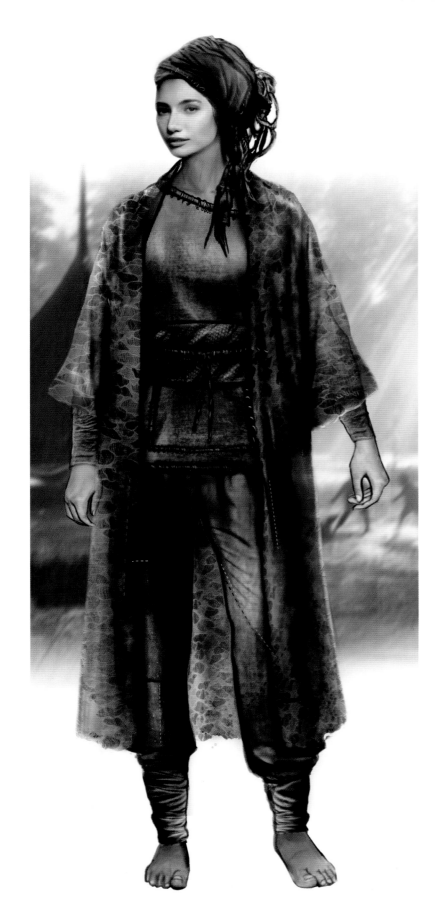

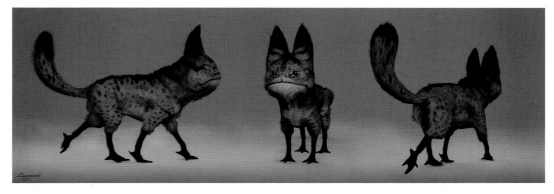

↑ **LOTH CAT VERSION 03** Alzmann

↑ **LOTH CAT VERSION 04** "Dave wanted to put a Loth-cat in the village [in post-production], curled up on the floor of that public house. I'm just thinking the baby's rushing toward it saying, 'Kitty! Kitty!' [Laughs] It was fun to make a realistic version of the Loth-cat. The design is super cartoony, even for Miyazaki. Dot eyes? Whoa, those are just dots. They never change shape, they never move? It was a tough one." **Alzmann**

← **SORGAN MOTHER VERSION 01** Kim and Porro

↓ **KRILL FARMS VERSION 1A** Jurabaev

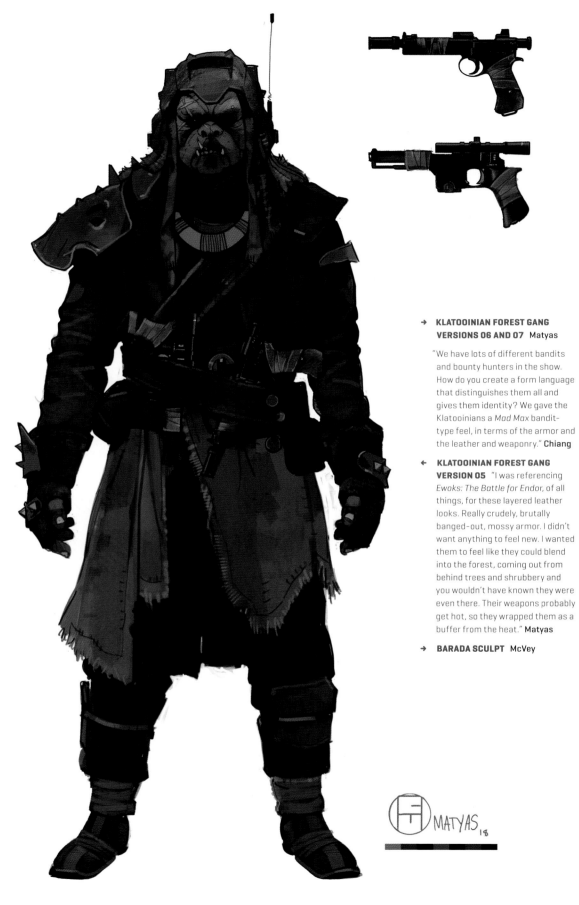

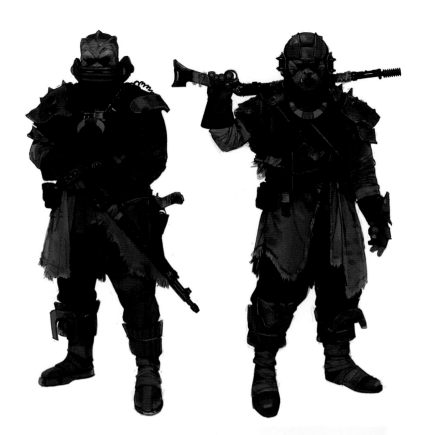

→ **KLATOOINIAN FOREST GANG VERSIONS 06 AND 07** Matyas

"We have lots of different bandits and bounty hunters in the show. How do you create a form language that distinguishes them all and gives them identity? We gave the Klatooinians a *Mad Max* bandit-type feel, in terms of the armor and the leather and weaponry." Chiang

← **KLATOOINIAN FOREST GANG VERSION 05** "I was referencing *Ewoks: The Battle for Endor*, of all things, for these layered leather looks. Really crudely, brutally banged-out, mossy armor. I didn't want anything to feel new. I wanted them to feel like they could blend into the forest, coming out from behind trees and shrubbery and you wouldn't have known they were even there. Their weapons probably get hot, so they wrapped them as a buffer from the heat." Matyas

→ **BARADA SCULPT** McVey

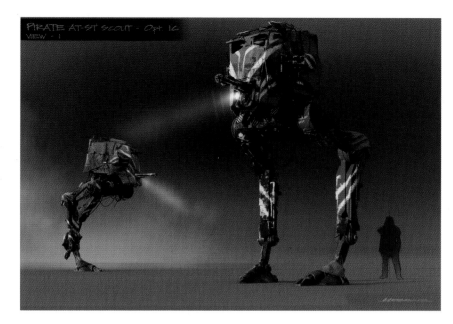

"The idea of a refurbished AT-ST being their main weapon of choice was really fun. They painted it up with tribal markings to give it some personality. I really like taking something that we are familiar with and turning it a little bit on its head." Chiang

↑ **TREE LINE RAID VERSION 02** Engstrom

→ **AT-ST SCOUT OPTION 1C** Hobbins

↓ **AT-ST VERSIONS 5A, 5B, AND 5D** Grandert

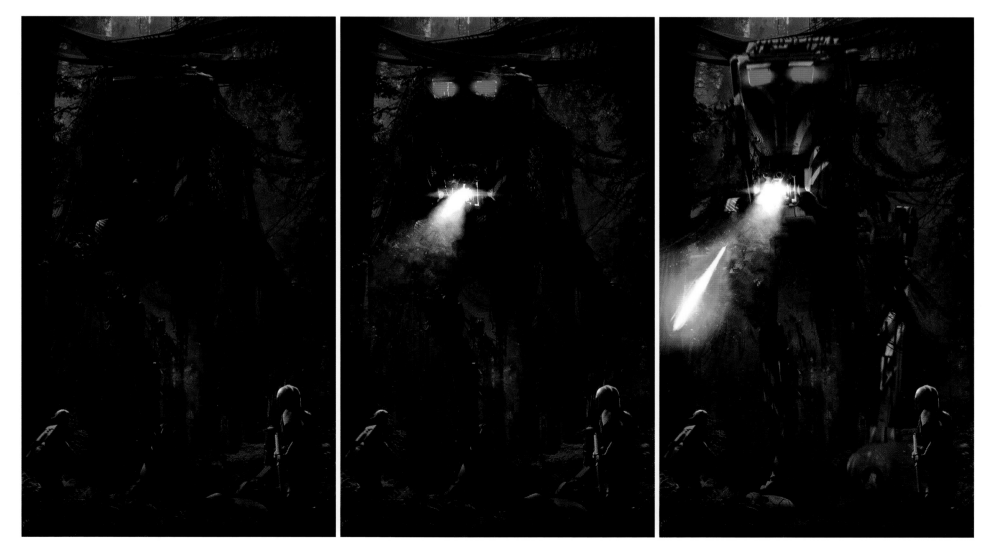

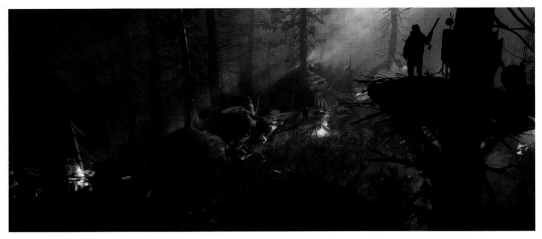

"The goal here was to create a camp that felt quasi-nomadic but try to figure out a reason why they put it here. The idea we came up with is that it's embedded into the hillside so it's a little bit protected, a little bit hidden. That's why the form language of the tents grew out from the tree trunks. It's almost a rougher version of the Sorgan village design." **Chiang**

↑ **KLATOOINIAN CAMP VERSION 02** Grandert

↗ **BANDIT VILLAGE VERSION 02** Jurabaev

→ **KLATOOINIAN CAMP 25** Grandert

← **KLATOOINIAN CROW'S NEST VERSION 01** Grandert

↓ **BANDIT VILLAGE VERSION 04** Jurabaev

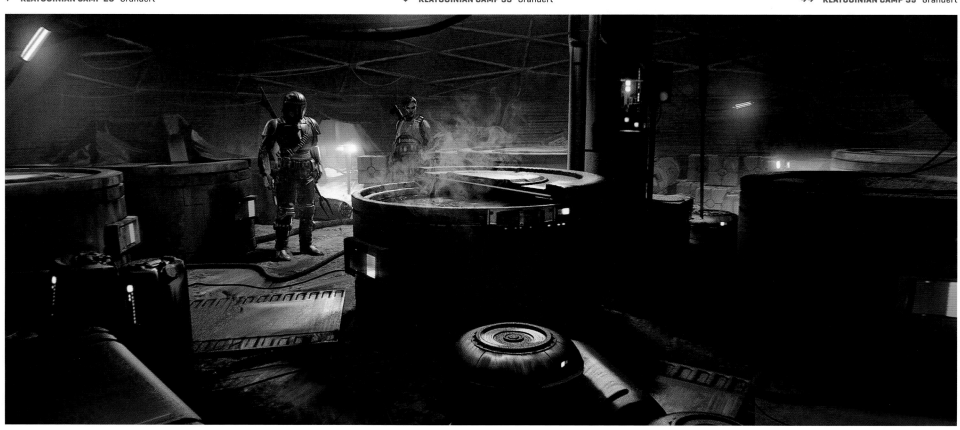

SORGAN BARRICADE VERSION 01 "This was partially just figuring out scale-of-set to set extension. A lot of the discussion was how far the barricades were from the pools. How far are they from the huts? And then what's the distance from the forest to there. So, is it three hundred feet from forest to pond? 'God, they're going to take ten minutes to get there.' [Laughs] It's like on Hoth in *Empire*. 'Oh my God, they're ten miles away! Everybody get out.' On this one, it would be better if, when they come out of the trees, they're in firing range." **Alzmann**

→ **AT-ST ATTACK BOMB VERSION 2A** Grandert

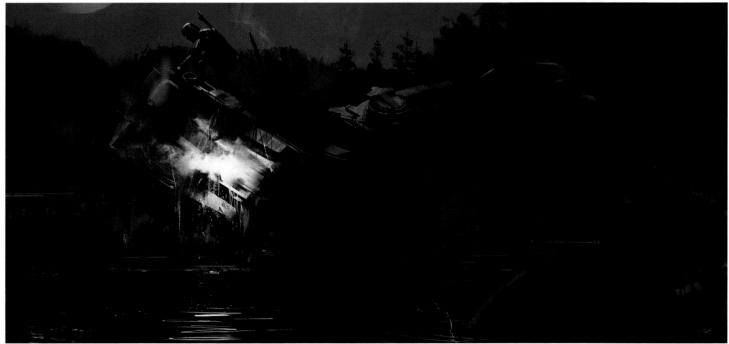

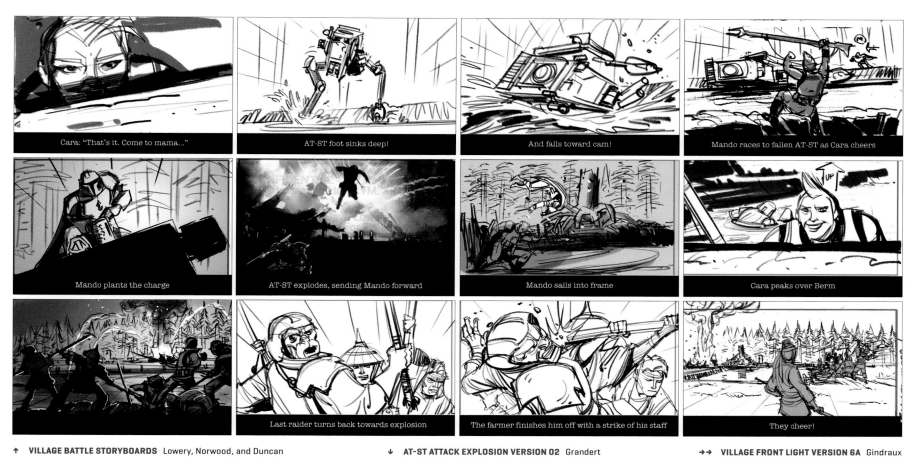

Cara: "That's it. Come to mama…"

AT-ST foot sinks deep!

And falls toward cam!

Mando races to fallen AT-ST as Cara cheers

Mando plants the charge

AT-ST explodes, sending Mando forward

Mando sails into frame

Cara peaks over Berm

Last raider turns back towards explosion

The farmer finishes him off with a strike of his staff

They cheer!

↑ **VILLAGE BATTLE STORYBOARDS** Lowery, Norwood, and Duncan ↓ **AT-ST ATTACK EXPLOSION VERSION 02** Grandert →→ **VILLAGE FRONT LIGHT VERSION 6A** Gindraux

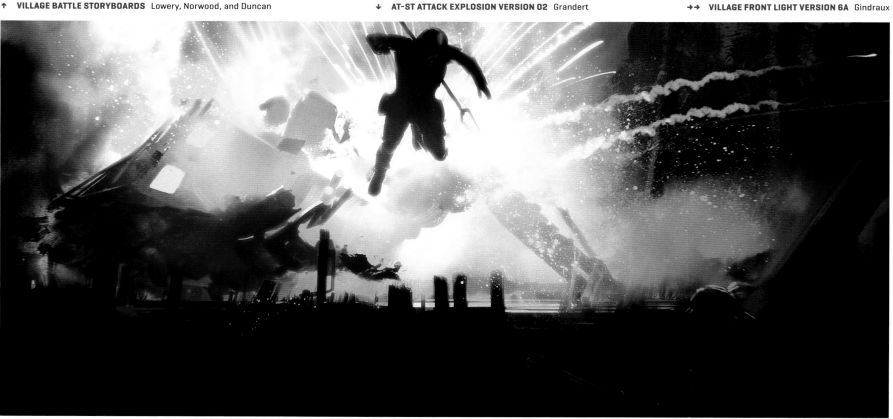

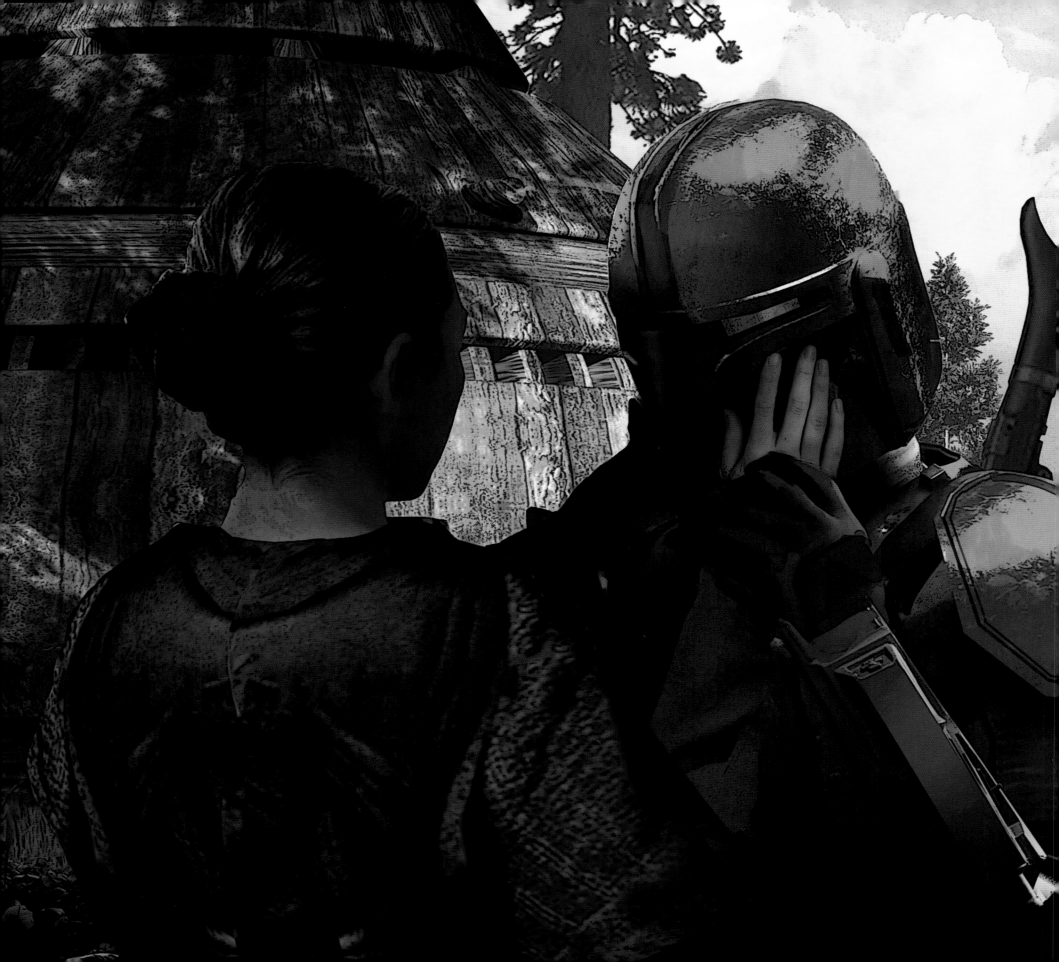

THE GUNSLINGER

Jon Favreau delivered *The Mandalorian* "Chapter 1" rough draft script to his fellow executive producer and primary creative collaborator Dave Filoni on Christmas Day, December 25, 2017, a month after Doug Chiang's Lucasfilm art department completed pitch art for *The Mandalorian* and ten days after the United States theatrical debut of *Star Wars: The Last Jedi*.

"In the early *Mandalorian* episodes, Jon and I were figuring out our writing style and collaboration," Filoni said. "In most story meetings we sit and talk about what we'd like to see in *Star Wars*. We push each other's boundaries and rally to come up with good solves. I can sit with Jon and, in an hour, come up with a whole episode. And then Jon will go off and write it. My process is a little longer. I like to ferment my ideas secretly over time.

"I was trying to learn a slightly different way of writing *Star Wars*. Jon very strongly wanted Western tropes. And Westerns have pretty clear dialogue. The gunslingers don't really say a lot. So, that was different for me."

One Western in particular inspired Filoni's story for "Chapter 5: The Gunslinger," the first *Mandalorian* script written by someone other than Favreau. "Jon had keyed me to a TV series called *The Westerner* [1960] by Sam Peckinpah," Filoni said. "It became a template on how to tell a clear, clean story that was still really compelling. 'Hand on the Gun' is an episode where a young man comes out from the city and is in love with the idea of what it means to be a cowboy. He's got the nice shiny hat and outfit and a polished gun. He understands gunslinging from pulp novels. But he doesn't understand the reality of it: that it's a real job. And that there's a code. Eventually, the character proves to be more and more dishonorable. And in the end, the kid gets gunned down because he's of ill repute and doesn't follow the code of the West. He gets his comeuppance.

"I pitched 'Chapter 5' to Jon. Usually, my first pitch is an overload for him. But out of that, he's challenging me. 'What are you really saying? What's the important thing about this? What do you like about this episode?' And I start to distill it down. You need to find ways to be subtle but still get your point across. And I've worked at that.

"It definitely affected *Clone Wars* this year [referring to the animated show, which returned for a seventh and final season on Disney+ in February of 2020, executive produced, directed, and written by Filoni]. You need to be challenged constantly and Jon's knowledge is a challenge for me, which is good. And there's all kinds of things about *Star Wars* that I can lend knowledge to him about: little subtle tweaks on lines and things that connect it to the broader *Star Wars* universe in a way that might have been missed if I wasn't there."

"Chapter 5: The Gunslinger" was the final episode of the first season of *The Mandalorian* in production, from January 9 to February 12, 2019. Poetically, first-time live-action director Filoni helmed both the first and last of the eight episodes shot.

← **DEWBACK MANDO VERSION 01** "The trick on this one was one: to show the dewback, but two: to show that Mando wrapped the dead bounty hunter and is taking him too. He's not just going to rot in the desert because Mando has a sense of honor." **Alzmann**

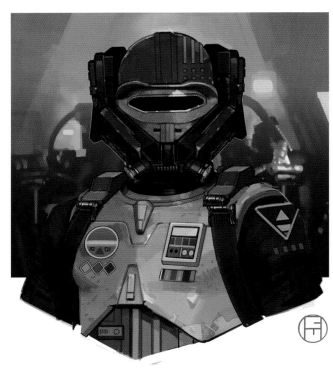

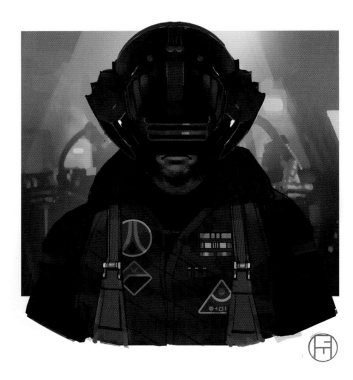

↑ **RIOT MAR VERSION 01** "They described Riot Mar as having a crazy or exotic helmet and a lot of aviation-style patches. It seemed to me like he's like a decorated *Top Gun* pilot. I looked at Cold War-era garments, this one being more World War II bomber." Matyas

↓ **RIOT MAR VERSION 2A** Matyas

↑ **RIOT MAR VERSION 04** "I was thinking of a Boba Fett or mercenary version of a TIE fighter pilot, something like that. That armor was probably too expensive to make for a character that wouldn't last very long [laughs]." Matyas

↓ **RIOT MAR VERSION 07** Matyas

↑ **RIOT MAR VERSION 05** "The Uruk-hai came up, *The Lord of the Rings* kind of stuff. They asked for some intimidating shape language so that was my attempt at doing a *Star Wars* version of that. Rank bars and 1970s-style logos influence those military patches, and some of the really simple *Star Wars* graphic shape-language." Matyas

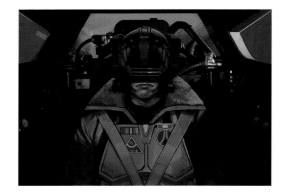

↓ **RIOT MAR VERSION 06** Matyas

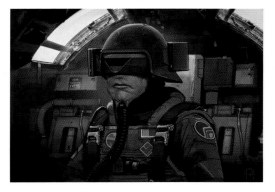

← RIOT MAR TEETH VERSION 01 "Something clicked. I did like a dozen different types of toothy mouths. And it was really hard to adapt it to the respirator design. And then Doug said, 'Try it right around where the muzzle meets the visor.' And that worked so well. Teeth designs are usually on the noses of bombers." **Matyas**

↑ BOUNTY HUNTER FIGHTER INTERIOR VERSION 11 "It's the interior with two big circular shapes [in the control panel]. Something that instantly differentiates it from the *Razor Crest*. You're cutting back and forth between cockpits and you just want it to read as completely different." **Church**

↓ RIOT MAR COCKPIT VERSION 3A Church and Matyas

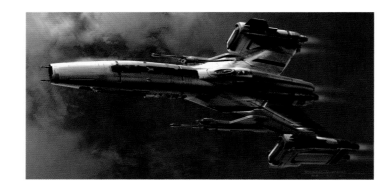

"One of the planes I really like is the F-100 Super Sabre from the Korean War because they had a long thin fuselage with a single cockpit. That was the initial inspiration, the swept wings of a Super Sabre and even the open nose scoop. That slowly evolved to the final design that you see at the bottom." **Chiang**

↗ **BOUNTY HUNTER FIGHTER VERSION 11** "Jon wanted something that looks like it was from a 'zoomy' 1950s comic book. An F-86 or F-104, something like that. But the vertical engines take you away from pure 1950s jet fighters." **Church**

→ **BOUNTY HUNTER FIGHTER VERSION 21** "With that first one, Jon was like, 'Oh, that's too on-the-nose F-100 and 1950s.' So I made it more spaceship-y here. The final version looks like something between the two." **Church**

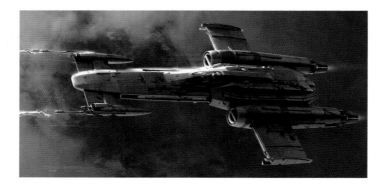

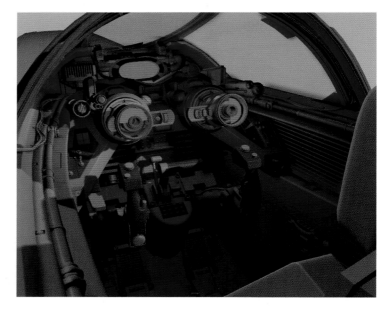

↑ **RIOT MAR SHIP COCKPIT VERSION 02** Garcia

↓ **BOUNTY HUNTER FIGHTER** "In the original design brief, they asked for two back windows [laughs]. 'Let's make sure there's room back there for somebody.' So, it's an X-wing with a bed way down a tube." **Church**

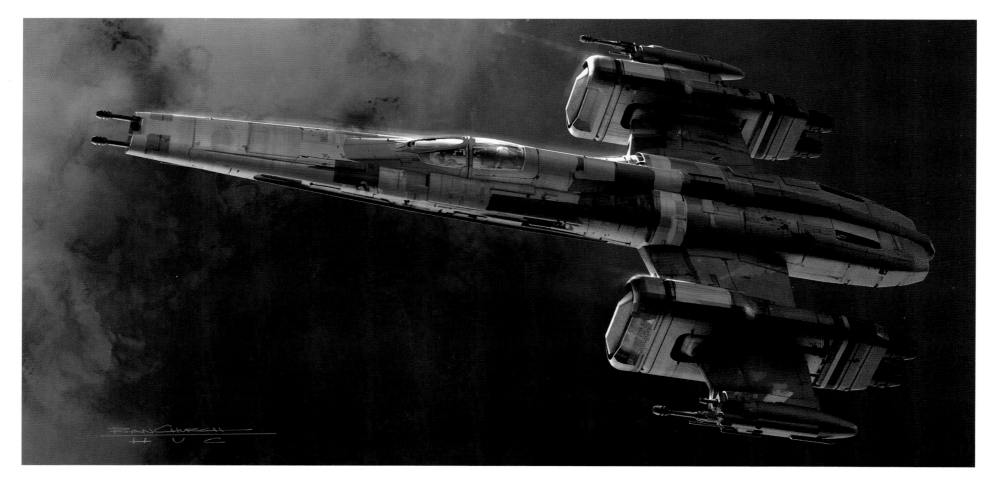

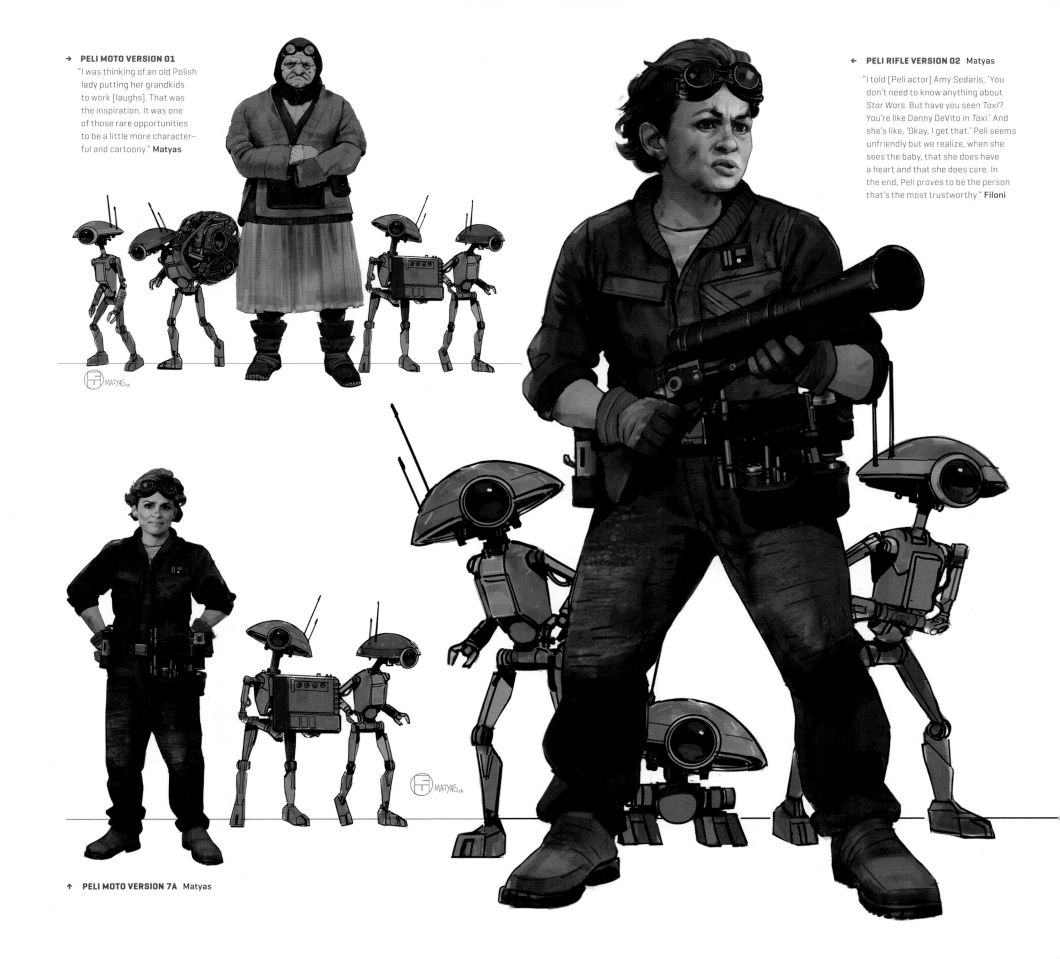

→ **PELI MOTO VERSION 01**

"I was thinking of an old Polish lady putting her grandkids to work [laughs]. That was the inspiration. It was one of those rare opportunities to be a little more character-ful and cartoony." Matyas

← **PELI RIFLE VERSION 02** Matyas

"I told [Peli actor] Amy Sedaris, 'You don't need to know anything about *Star Wars*. But have you seen *Taxi*? You're like Danny DeVito in *Taxi*.' And she's like, 'Okay, I get that.' Peli seems unfriendly but we realize, when she sees the baby, that she does have a heart and that she does care. In the end, Peli proves to be the person that's the most trustworthy." Filoni

↑ **PELI MOTO VERSION 7A** Matyas

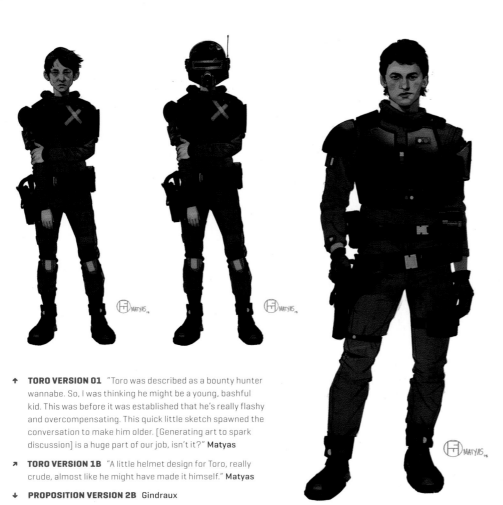

← **TORO VERSION 03** "Toro's getting further along here, a little older. Jon really liked this armor set but they wanted to give it a little more of a Western vibe." **Matyas**

↓ **PROPOSITION VERSION 2A** Gindraux

"I'm also teasing the audience, 'Is Toro going to become an understudy here? Is he the Robin to Mando's Batman?' I'm twisting that archetype of 'the sidekick' to show that he's really evil, that ambition and ego and all the things you warn Jedi not to be, this kid has. And he reveals himself.

"I wanted Tatooine to feel like when you go home after many years. So, places that you knew are similar but different." **Filoni**

↑ **TORO VERSION 01** "Toro was described as a bounty hunter wannabe. So, I was thinking he might be a young, bashful kid. This was before it was established that he's really flashy and overcompensating. This quick little sketch spawned the conversation to make him older. [Generating art to spark discussion] is a huge part of our job, isn't it?" **Matyas**

↗ **TORO VERSION 1B** "A little helmet design for Toro, really crude, almost like he might have made it himself." **Matyas**

↓ **PROPOSITION VERSION 2B** Gindraux

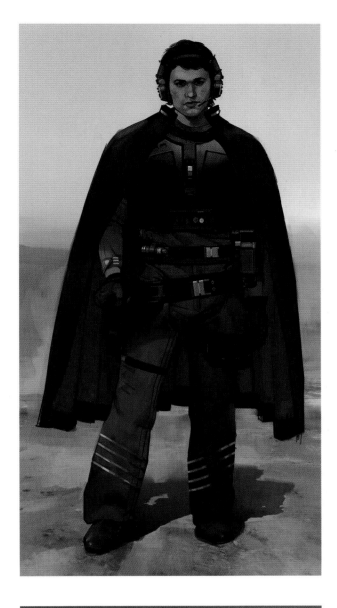

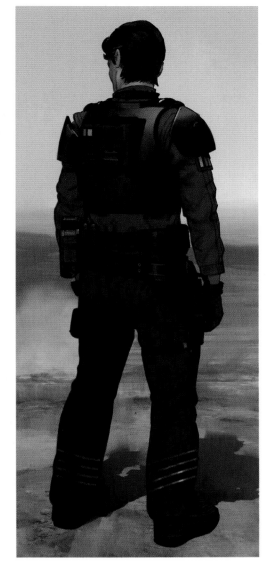

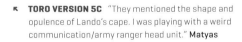

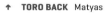

↖ **TORO VERSION 5C** "They mentioned the shape and opulence of Lando's cape. I was playing with a weird communication/army ranger head unit." **Matyas**

↑ **TORO BACK** **Matyas**

→ **TORO VERSION 6C** "Toro's all about flash. We didn't want his pants too overtly like cowboy chaps, but still with a 1970s flaring. So he's got metallic or reflective pin-striping within the thick leather material. There isn't a part on him that doesn't have just a little bit of flash. Like even the cuffs of his sleeves are fancy and the armor is new." **Matyas**

← **TORO GOGGLES VERSION 02** **Matyas**

"I could see Toro as somebody who is from the Core Worlds of the New Republic, growing up at the tail end of the Empire, and he has an ego about what it was like. It's like he's playing a shooter game without ever really understanding that World War II was a real thing, without respecting the fact that people died. Toro knows the old *Star Wars* films but he doesn't understand them." **Filoni**

↑ **SPEEDER BIKE VERSION 13** Church

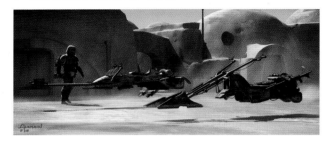

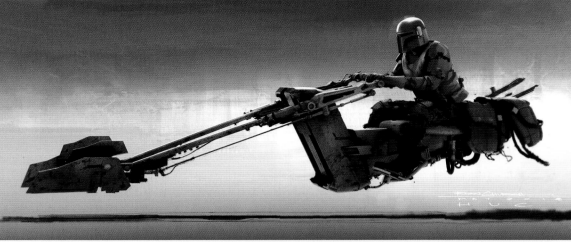

↑ **TATOOINE SPEEDER BIKES VERSION 01** "Doug said, 'Let's try a swoop bike and a standard speeder bike but make them really old and beat up because Mos Eisley has been on hard times.' I tried adding a little windshield. Maybe there's a civilian model that gets stripped down for the Imperial bike. On vehicles like this, I'm always thinking about the body position of the rider and how can we change that a little bit. So, I was hoping, with the really long handlebars, that he's sitting back like [on] a chopper." Alzmann

→ **SPEEDER BIKES SIDE VERSION 12** Church

↓ **SPEEDER BIKE DESERT VERSION 12** "I'm glad Jon gave the speeder bike that he did to the Mandalorian. It's the hog. The other one's more high-tech. Both are based off of Joe Johnston's designs [for speeder bikes from *Return of the Jedi*]." Church

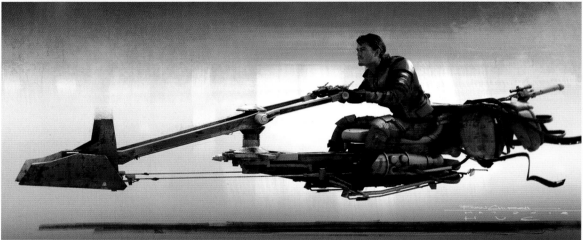

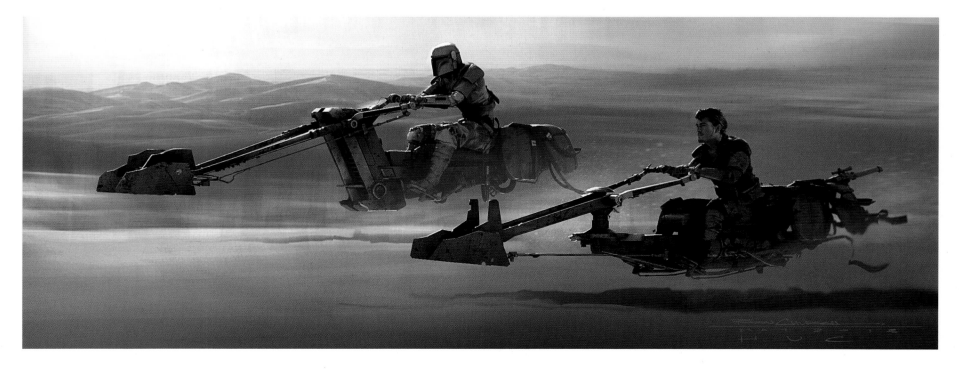

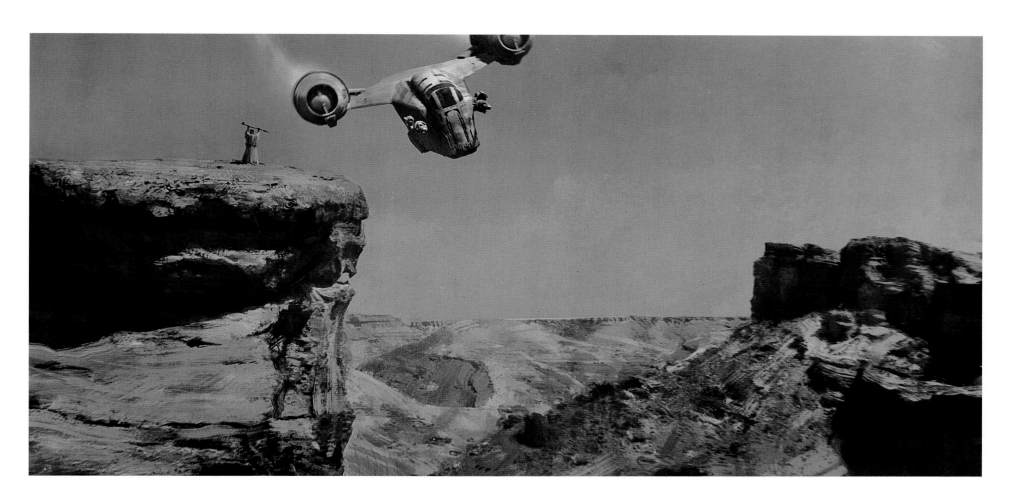

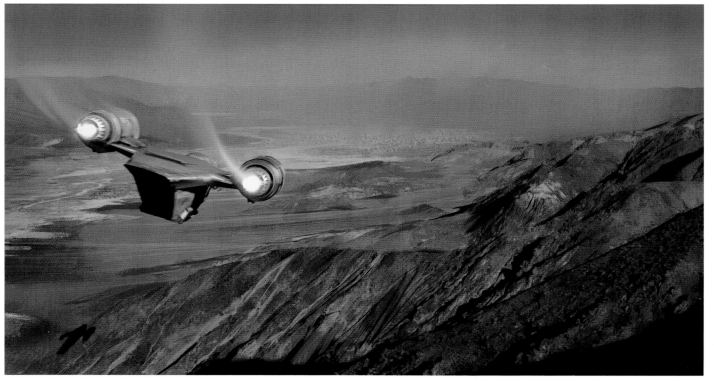

↑ **MOS EISLEY VISTA 1 VERSION 03** Grandert

← **MOS EISLEY VISTA 2 VERSION 03** Grandert

Both Harrison Ellenshaw's Mos Eisley and Ralph McQuarrie's Tatooine planet matte paintings from 1977's *Star Wars: Episode IV A New Hope* were reused for "Chapter 5: The Gunslinger."

"I wanted Tatooine to have all the visual cues it should have. But something I learned from George is that, culturally, it would be different. We were very much selling a Wild West vibe. So I thought, 'Well, maybe the town actually took a downturn. Maybe everybody moved to Mos Espa. Maybe this freedom that they thought they were all going to get, they suddenly couldn't get.'" **Filoni**

→→ **DOCKING BAY 35 VERSION 03** "This was a quick last-minute fix. I had Peli as a [three-eyed Gran alien, as originally scripted]. I always imagined her character as Carla from *Cheers*, which is basically the female version of Danny DeVito from *Taxi*. I was thinking that she'd be diminutive like Carla. But then in her booth, she's up a step in the way that Danny DeVito was, looking down on everyone. What I love about the pit droids is that she found something smaller than she is." **Alzmann**

"People like Peli Moto, who were just trying to live a life on the Outer Rim, didn't have a lot of support and learned not to rely on anybody." **Filoni**

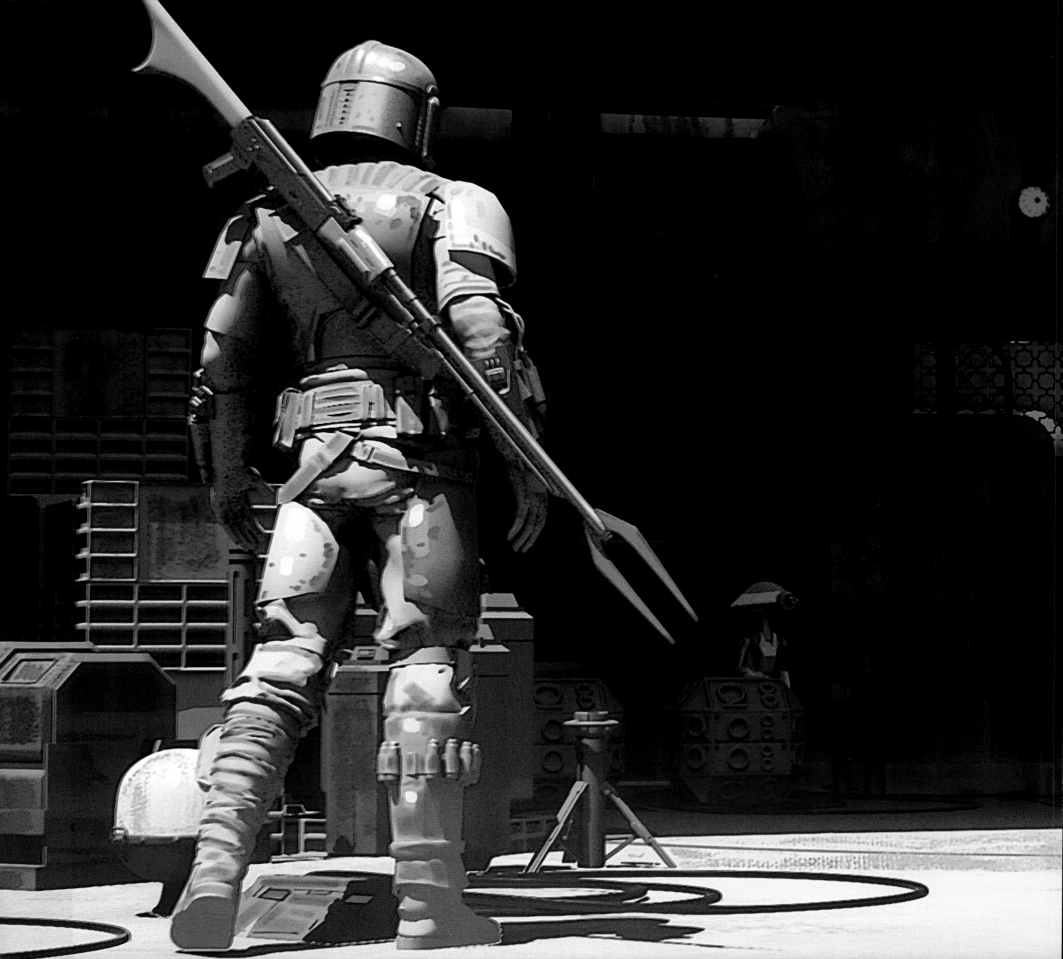

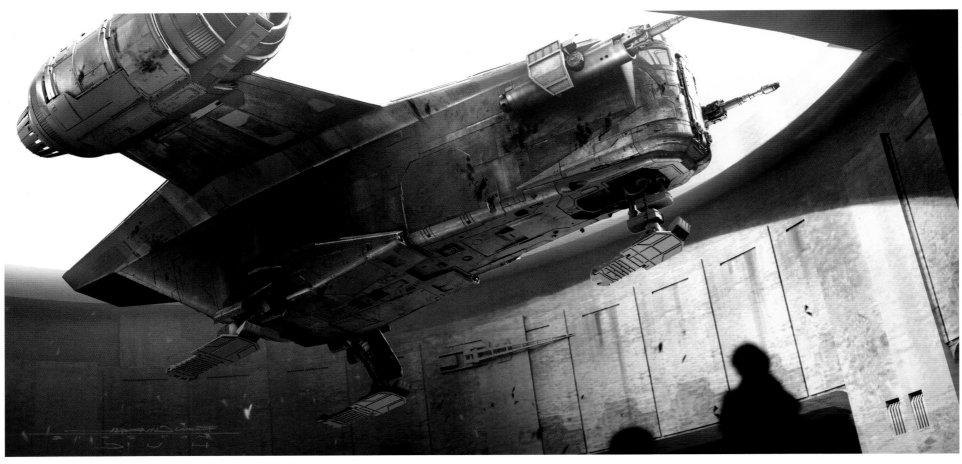

↑ **HANGAR LANDING VERSION 02** Church

↓ **TATOOINE DOCKING BAY VERSION 03** Grandert

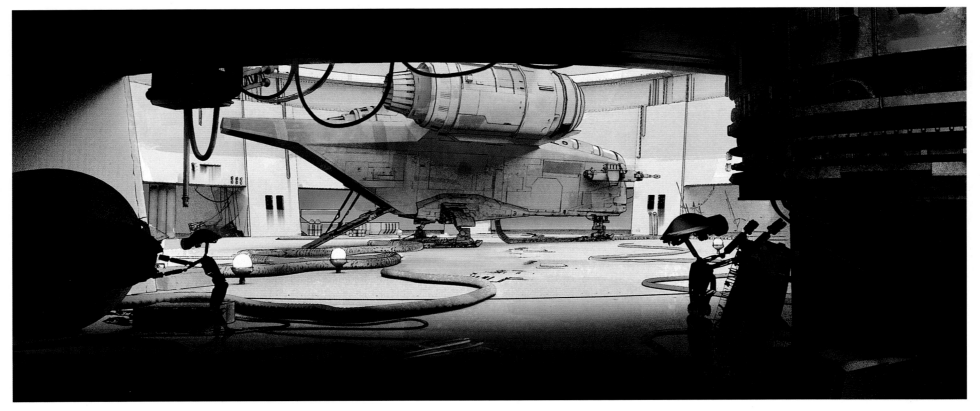

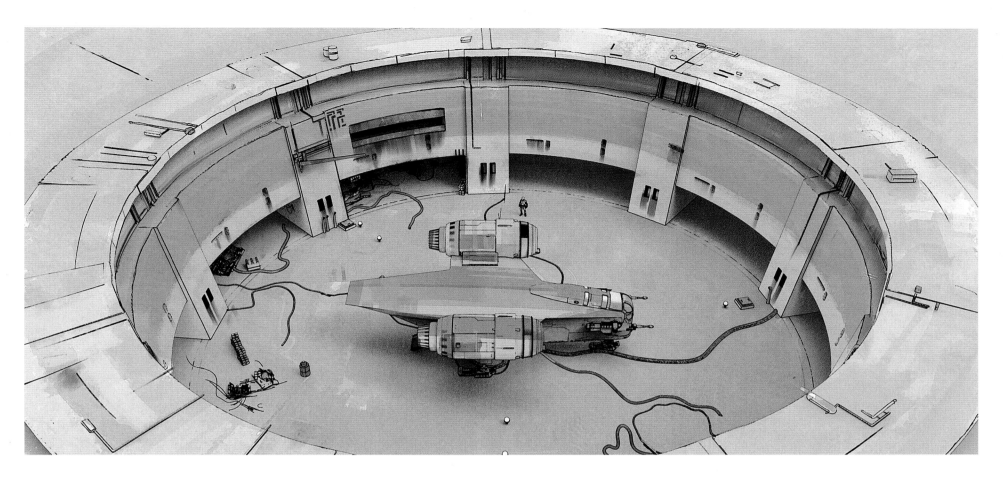

↑ TATOOINE DOCKING BAY VERSION 01 Grandert

"Originally, this was going to be Docking Bay 94, the one that the *Falcon* was in in *A New Hope.* When we made the docking bay the scale to fit the *Falcon*, it was too big for the *Razor Crest.* So, we scaled it down, about two thirds the size of Docking Bay 94. But we kept a lot of the same details, matching the angles that were built into the original hangar." **Chiang**

→ DOCKING BAY STREET ENTRANCE VERSION 5B Grandert

↓ DOCKING BAY STREET ENTRANCE VERSION 1A Grandert and Chiang

"Mos Eisley is not as thriving as it [once] was. I intentionally had less people on the streets. Our feeling was that New Republic organization and civilization was more inward focused on the Core Worlds. Maybe, at first, some people in the Outer Rim thought this was a great victory and that they were all going to be saved. Much to their surprise, the rule of law completely broke down. And now there is just chaos." **Filoni**

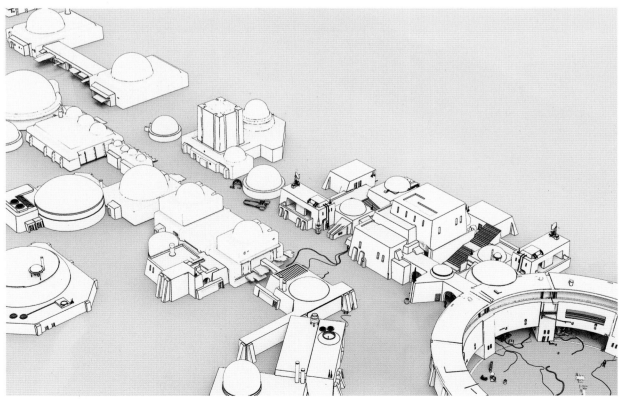

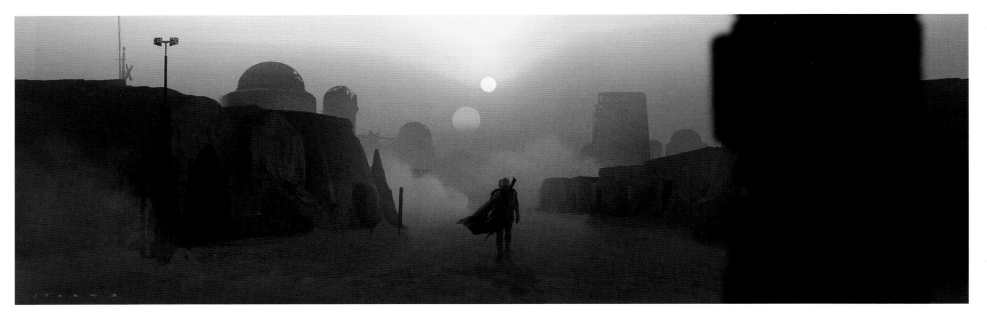

↑ **MOS EISLEY POV STREET VERSION 01** Park

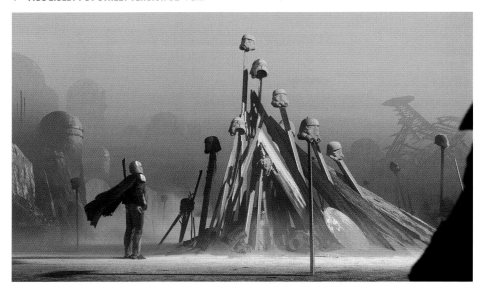

← **MOS EISLEY PIKES VERSION 01** Park

"I figured there was an uprising on Tatooine. So, I always had that image of stormtrooper helmets on pikes in my head. I thought it was a really important image for the entire show, to tell you where we were and what was going on." **Filoni**

↓ **TATOOINE HELMETS VERSION 01** Jurabaev

↑ **CANTINA SIGN GRAPHIC** Chris Reiff

Clear photo reference of the Perspex sign over the front entrance to the Mos Eisley cantina was provided to *The Mandalorian* crew by *Star Wars: Episode IV A New Hope* set designer Roger Christian, via cantina experts Tom Spina, president of Tom Spina Designs, and Lucasfilm creative executive Pablo Hidalgo.

↓ **TATOOINE DAY VERSION 02** Jurabaev

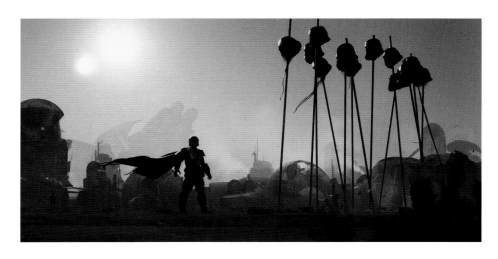

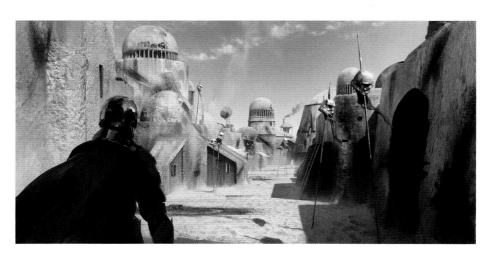

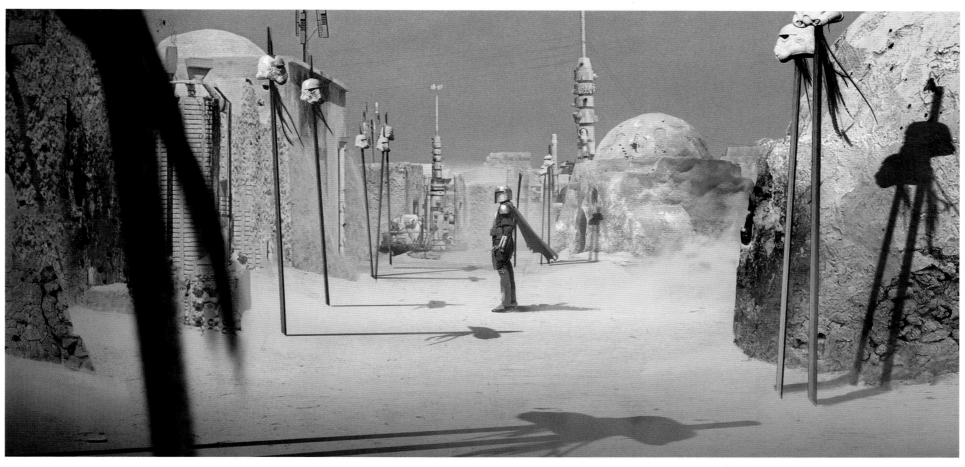

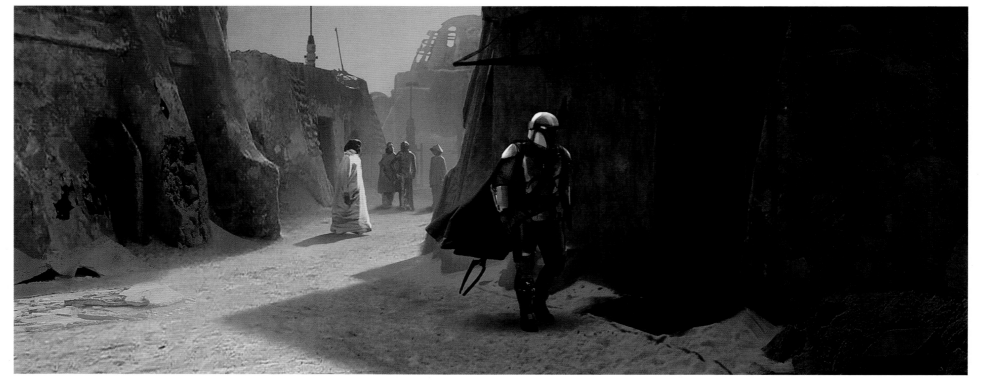

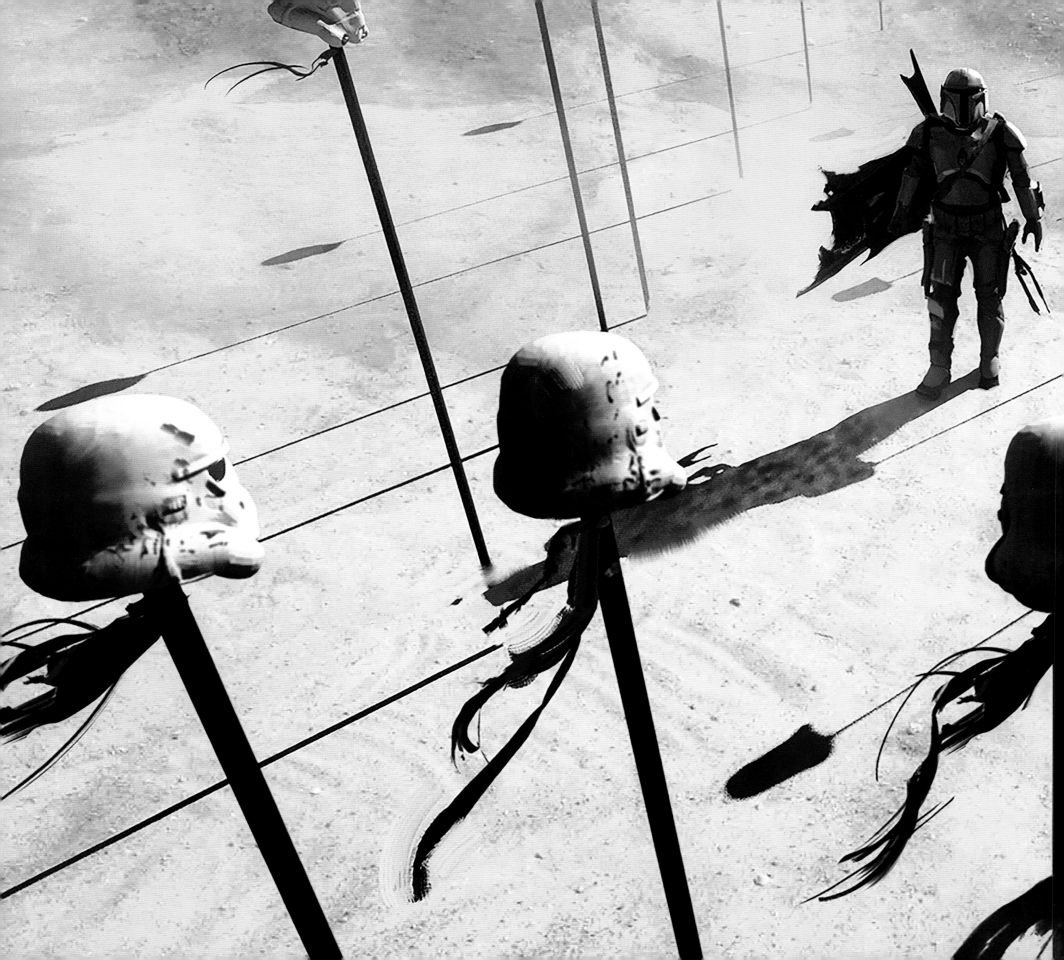

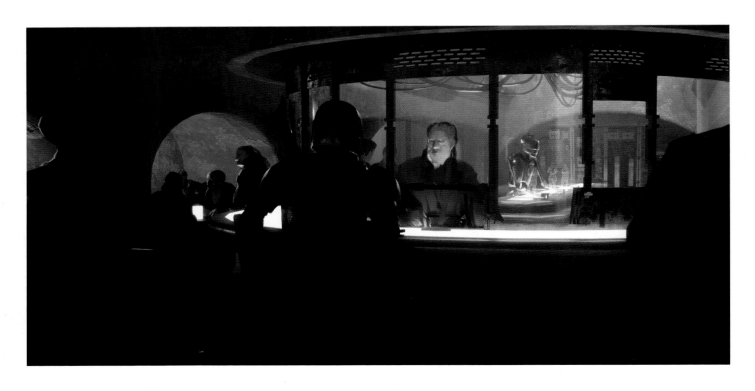

← **BOUNTY HUNTER HIDEOUT VERSION 01**
Gindraux

"We wanted to make sure that there was a clear passage of time. Now, it's owned and operated by droids, which is a fun thing. But structurally, it's the same cantina." **Chiang**

↓ **CANTINA INTERIOR VERSION 02** "Referring to the [original January 1976 blueprint drawings by *A New Hope* assistant art director Alan Roderick-Jones], I built a CG model of the entire cantina, which I later sent to L.A. It was fun to pore over all the details from that blueprints book. 'OK, we'll have this many arches on this side. And here's how the entrance came in.'" **Alzmann**

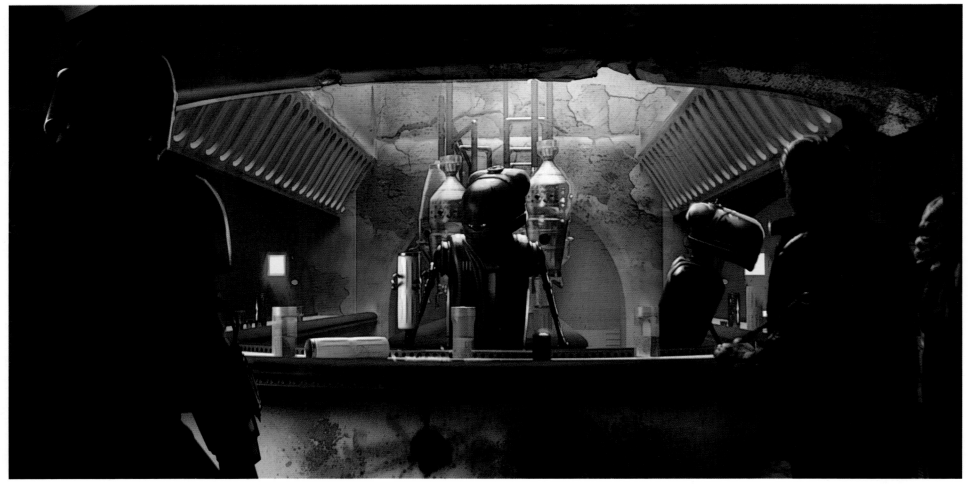

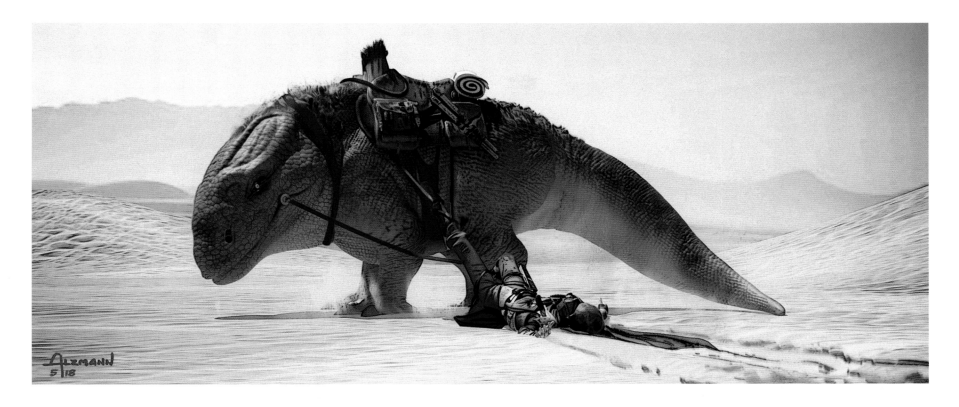

↑ **DEWBACK DISCOVERY VERSION 01** "We went through a little bit of a redesign on the dewback feet. Doug and I felt like the toes were a little too much. They didn't fit with the bluntness of all the other shapes. So, we just scaled them back, sixty percent toward an elephant foot. An elephant foot probably wouldn't do so well in sand, with that much weight. So, we needed some toe with a little bit of webbing." **Alzmann**

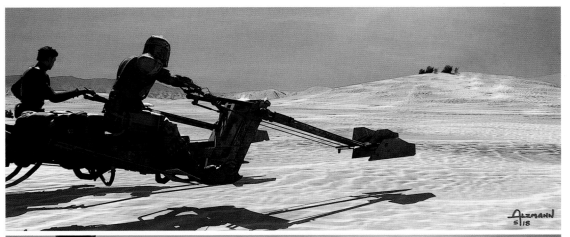

↑ **DEWBACK SKETCH** Filoni

↗ **TUSKEN ENCOUNTER VERSION 1A** Alzmann

→ **TUSKEN ENCOUNTER B VERSION 1A** "I'm imagining Mando saying [in sign language], 'Big!' [Laughs] And of course, Toro, being the young brash guy, has no idea why they're even bothering because he just wants to get there and get paid. I tried to show him being as impatient as I could." **Alzmann**

"Achieving the Dune Sea was one of the harder things we had to do all season because it's so minimalist. There's so little to trick your eye. We went round and round on it. I only had a small patch of sand to try to convince you that it's this whole desert. [Production designer] Andrew Jones had the same [Yuma, Arizona] sand from Tatooine flown in." **Filoni**

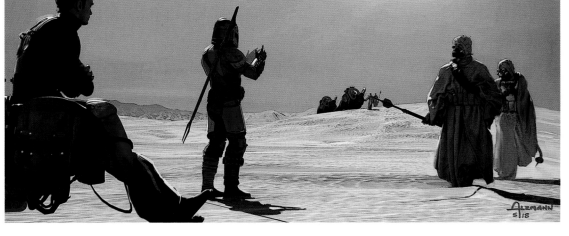

"I wanted a character like Fennec, an incredibly adept assassin, a top-tier character, for them to go after. Somebody that would immediately seem dangerous and be worth the risk for Mando to leave the Child with Peli." **Filoni**

← **FENNEC HELMET VERSION 01** "I was playing with eye shapes and I still want to explore that in the future. But for her character, it wasn't intimidating enough." **Matyas**

→ **FENNEC VERSION 02** "Fennec was super fun and one of those rare designs where you do one or two concepts and it's done. I wanted to go with a geometric, fashion-able, ninja-samurai-assassin [laughs]. She's a professional and uses her money to fund what she needs for her profession. For the helmet, I wanted something a little more Rocketeer, a little more retro, like a *Metropolis* kind of vibe." **Matyas**

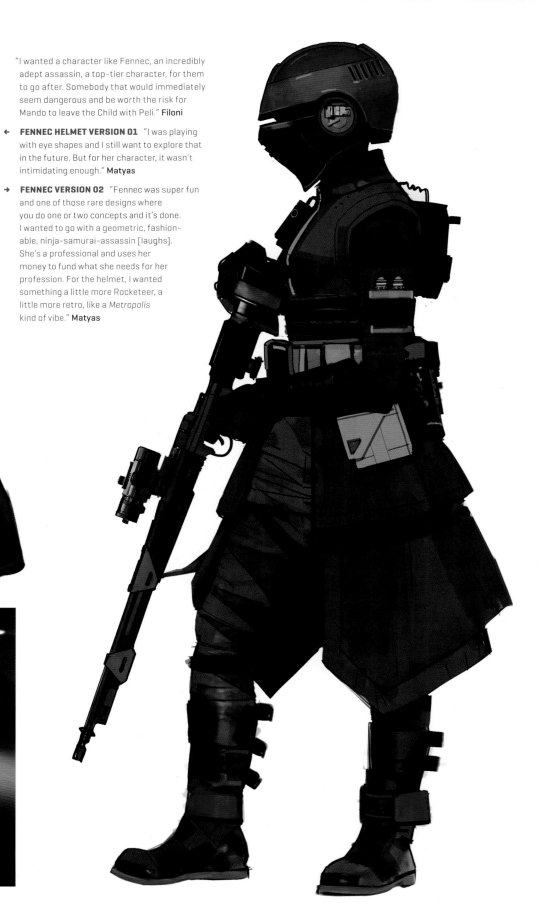

↓ **TATOOINE NIGHT RIDE VERSION 02** Jurabaev

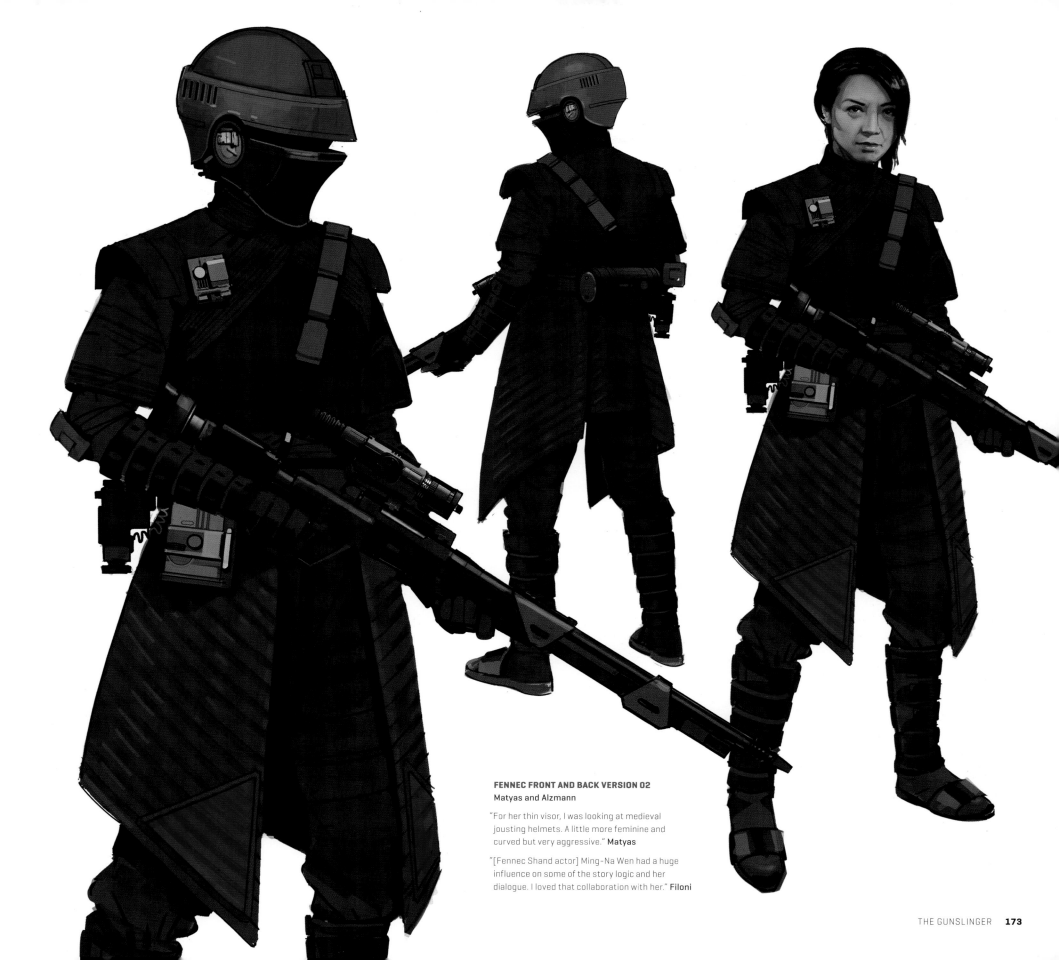

FENNEC FRONT AND BACK VERSION 02
Matyas and Alzmann

"For her thin visor, I was looking at medieval jousting helmets. A little more feminine and curved but very aggressive." **Matyas**

"[Fennec Shand actor] Ming-Na Wen had a huge influence on some of the story logic and her dialogue. I loved that collaboration with her." **Filoni**

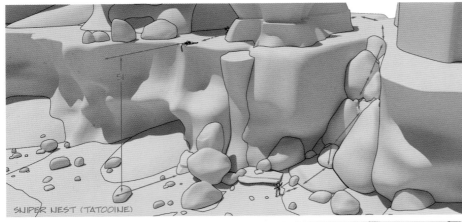

SNIPER NEST (TATOOINE)

SNIPER NEST (TATOOINE)

↑ **SNIPERS NEST VERSION 09**
"This was all about designing what type of rocks we would see and trying to get that canyon quality. It had to still feel like Tatooine." **Alzmann**

← **TATOOINE SNIPERS NEST COMP VERSION 11** "This was really about scale and proximity. We wanted to keep that ledge around fifty feet up. These diagrams are actually super fun to do because you really are helping design the set, which informs how you're going to shoot it." **Alzmann**

↓ **SNIPERS NEST VERSION 12** "We're going to have the Dune Sea up right against this rock. Is that going to look right? Do we need more of a bridge for that gap? It's actually OK. You just put a couple of rocks up there to help feather it out." **Alzmann**

"Once they captured Fennec, it wasn't ever going to be easy to get her back. The complication is that they only have one horse, or speeder, to ride. Everything becomes a choice. And who do you trust? Even Fennec, the wise assassin, underestimates the kid's disrespect and evil. Fennec has more in common with Mando than either of them do with Toro. And that was intentional." **Filoni**

→ **DOCKING BAY STANDOFF VERSION 02** "I really wanted to capture the jeopardy here. The story moment is, 'Do I or don't I draw my gun to take this guy out?' And the fact that Toro went this far? Dude, you just got to die now." **Alzmann**

→→ **DOCKING BAY STANDOFF VERSION 01** Alzmann

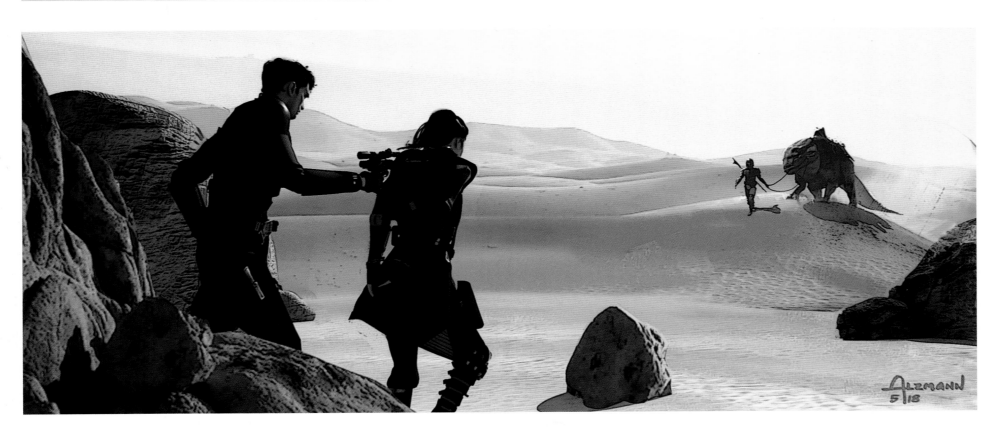

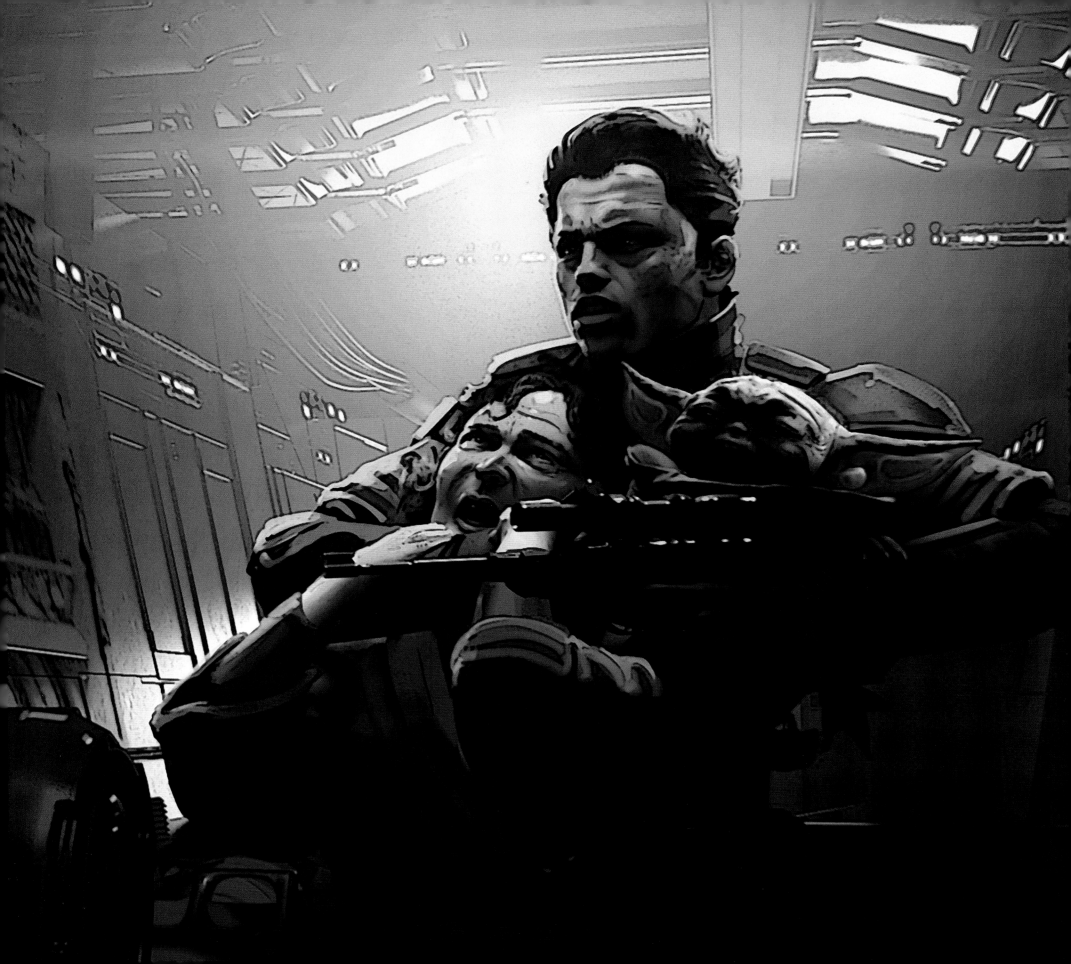

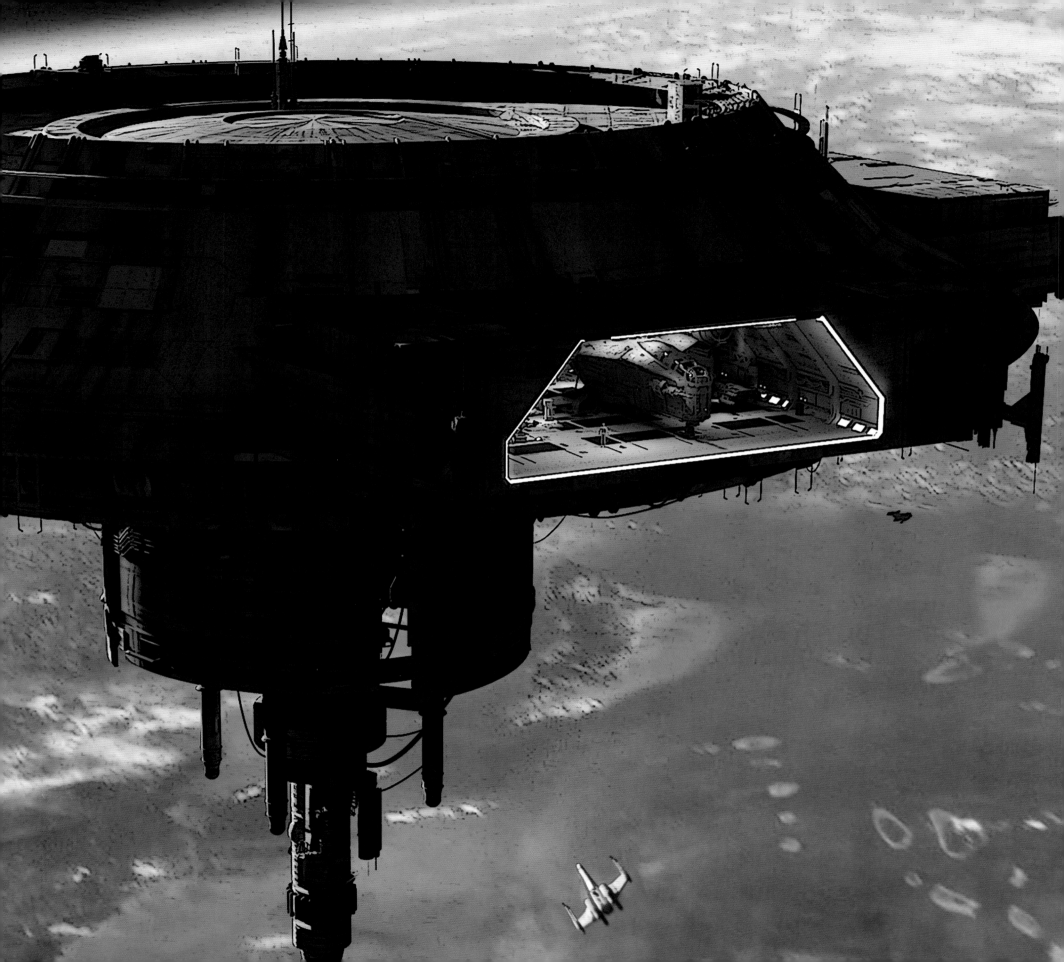

THE PRISONER

Despite its far-flung frontier appearances, *The Mandalorian* was the first *Star Wars* production to be shot entirely within the state of California. Enabling this achievement were technological leaps in the tradition of both *Star Wars* and Walt Disney Animation storytelling. "There's a relationship between what Walt did with animation and what George did with *Star Wars*," show creator Jon Favreau realized. "You're calling upon the old stories and bringing new technologies to bear to make them relevant for a new generation."

As Lucas did with Industrial Light & Magic (ILM) on his films, Favreau too pushed ILM to innovate. ILM VFX supervisor Richard Bluff and his team used similar LED (light-emitting diode) video screen walls to the ones used to project animated lighting through the cockpit windows of *Rogue One: A Star Wars Story* and *Solo: A Star Wars Story*, but in an entirely new and risky way: as fully rendered digital set extensions directly behind the actors, synchronized to physical camera movement. "Using her relationship with ILM, Kathy [Kennedy] supported my vision for incorporating technologies that I've worked with on previous projects (namely, real-time set extensions powered by video-game engine technology for *The Jungle Book* [2016] and moving cameras within virtual environments using consumer-facing virtual reality [VR] technology for *The Lion King* [2019]) with innovative in-camera visual effects," Favreau continued. "I don't think we could have done it without that collaboration, because *The Mandalorian* is a very challenging project."

Camera tests for this emerging technology began five months into pre-production, on May 14 and 15, 2018, at Illumination Dynamics, a film equipment supply house in Santa Clarita, California. There, director of photography Greig Fraser tested several cameras, shooting a stand-in (both in and out of a prototype chrome Mandalorian helmet) in front of preexisting and relatively small LED video walls projecting test patterns.

A month later, from June 11 to 15, at Manhattan Beach Studios, where a horseshoe of LED screens forty-five feet in diameter, plus two mechanical lift arms holding additional screens overhead, was assembled. More than a dozen test shots were filmed over the five days, with LED environments provided by production designer Andrew L. Jones's Virtual Art Department (or VAD, who also created rough 3D sets for virtual scouting, lighting, and filmmaker approval), Epic Games (utilizing Unreal video-game engine technology), and ILM, who employed custom panospheres

(360-degree panoramic photography or video) of real-world locations created for *Rogue One* and *Solo*. Those shots included the Mandalorian (a stand-in wearing prototype armor) on the ice planet boardwalk, appearing through the bar's irising doorway, inside the ice planet bar and Nevarro public house, in the back seat of a speeder taxi driven by a digital Trandoshan, and walking around Arvala-7's salt flats.

It wasn't until the final days of the June test that the crew was fully convinced that the technology could work. The Mandalorian walked in front of the video wall displaying ILM photogrammetry (three-dimensional environments fabricated from thousands of location photographs) of an abandoned building on San Francisco Bay's Angel Island. Fraser told Favreau, "My jaw is on the floor. I never thought it could look as good as this. For me, this is a complete and utter game-changer."

Ultimately, more than one half of *The Mandalorian*'s Season 1 environments would utilize the seventy-foot diameter LED wall horseshoe (casually referred to as "the volume"). Those environments included the ice planet exteriors, Nevarro's lava fields (utilizing ILM photogrammetry of Iceland), the Client's chamber, Arvala-7 and Tatooine's desert landscapes (ILM photogrammetry from outside Salt Lake City, Utah, and California's Harper Dry Lake, Dumont Dunes, and Death Valley), Sorgan's common house interior, and Chapter 6's chop shop hangar. "The barrier of entry for *Star Wars* TV for many years was simply the scope," Bluff said. "I don't think anybody would accept a *Star Wars* TV show where you didn't visit vastly different environments. This technology allows us to achieve that visual bar faster than you would expect to do through traditional movie techniques."

Preexisting visual effects techniques were also employed, including a scale model of the *Razor Crest* cast and assembled by John Goodson, with parts 3D-printed by Landis Fields, coupled with John Knoll's garage-built "K-flex" motion control system, and the virtual reality design-approval workflow that Favreau was already employing on *The Lion King*. "Virtually validating the designs allowed us to get our answers very quickly," Chiang said. "It was the only way we could achieve this amount of design in this short amount of time."

"Chapter 6: The Prisoner," written by episode director Rick Famuyiwa and *Star Wars Rebels*'s Christopher Yost, was the next-to-last Season 1 episode in production, shot from January 25 to February 8, 2019.

← **SPACE STATION EXTERIOR 1A** Hobbins

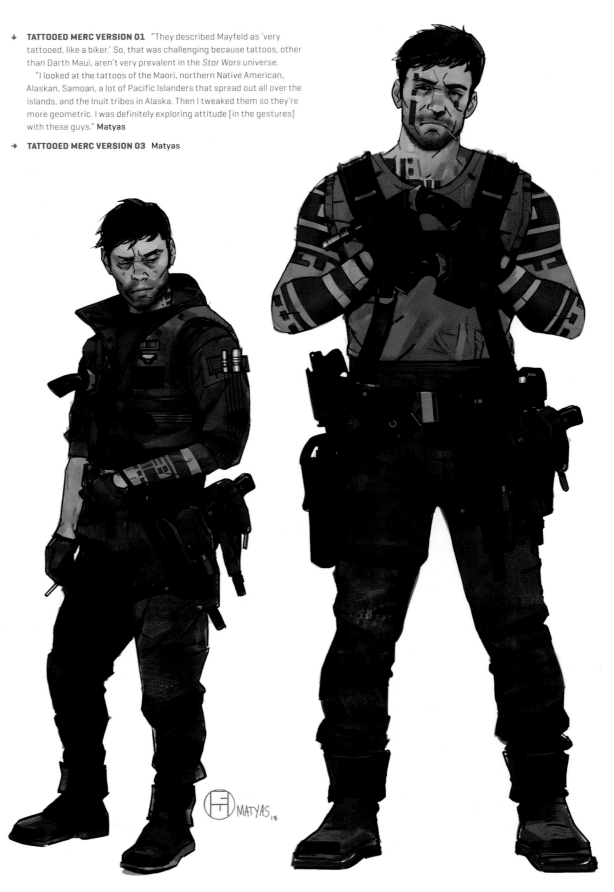

↓ **TATTOOED MERC VERSION 01** "They described Mayfeld as 'very tattooed, like a biker.' So, that was challenging because tattoos, other than Darth Maul, aren't very prevalent in the *Star Wars* universe.

"I looked at the tattoos of the Maori, northern Native American, Alaskan, Samoan, a lot of Pacific Islanders that spread out all over the islands, and the Inuit tribes in Alaska. Then I tweaked them so they're more geometric. I was definitely exploring attitude [in the gestures] with these guys." **Matyas**

→ **TATTOOED MERC VERSION 03** Matyas

↑ **RAN MALK VERSION 02** Kim and Porro

In an early iteration of the script, the eponymous prisoner of *The Mandalorian* "Chapter 6" was mercenary gang leader Ran Malk's brother Tyko instead of Twi'lek bounty hunter Xi'an's brother Qin.

↓ **MAYFELD PAGE VERSION 01** "He's a gun guy. So, he has a lot of pistols to the point where they're wrapping around to his back side. They described his robot arm as being like the Predator's gun. And I thought it would be cool if it could appear over his shoulder or under his arm, like a trick shot." **Matyas**

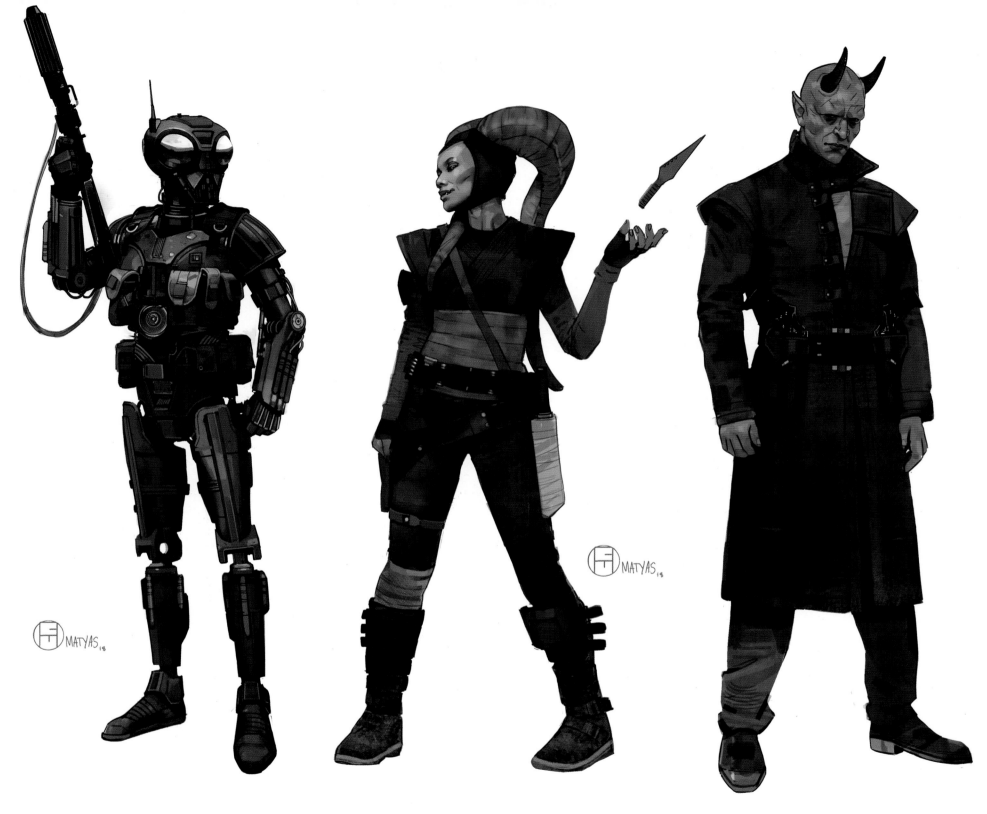

↑ **EVIL DROID VERSION 03** "The initial direction was only to try an evil 3PO-style droid. I looked at the RA-7 Death Star droids and 4-LOM, but my main inspiration was Ralph McQuarrie's Ovion sketches from *Battlestar Galactica*. I always liked the bug influences in his droid designs and this particular unused design had a very strong grasshopper/mantis vibe. I also wanted his eyes to be like mirrors, which really paid off when he jumps to hyperspace." Matyas

↑ **TWI'LEK MERC VERSION 01** "The brief was, 'She's crazy and she likes knives.' I'm like, 'OK. That's enough information.' The chop shop's a bit humid so they wanted really lightweight clothing. In the end, there wasn't much deviation from these initial designs [for the four mercs]." Matyas

↗ **DEVARONIAN MERC VERSION 01** "It's really hard not to think of *Hellboy* when it comes to Devaronians. There's quite a few characters, especially in Season 1, that are big brutes. So, my initial instinct was to do someone a little thinner, with a Clint Eastwood sort of physique and a Western duster. But there's some weird business-suit elements in there: the cuffs of his pants and the type of boots he's wearing. So, I thought that maybe he likes to wear decent clothing that reflects how much money he makes." Matyas

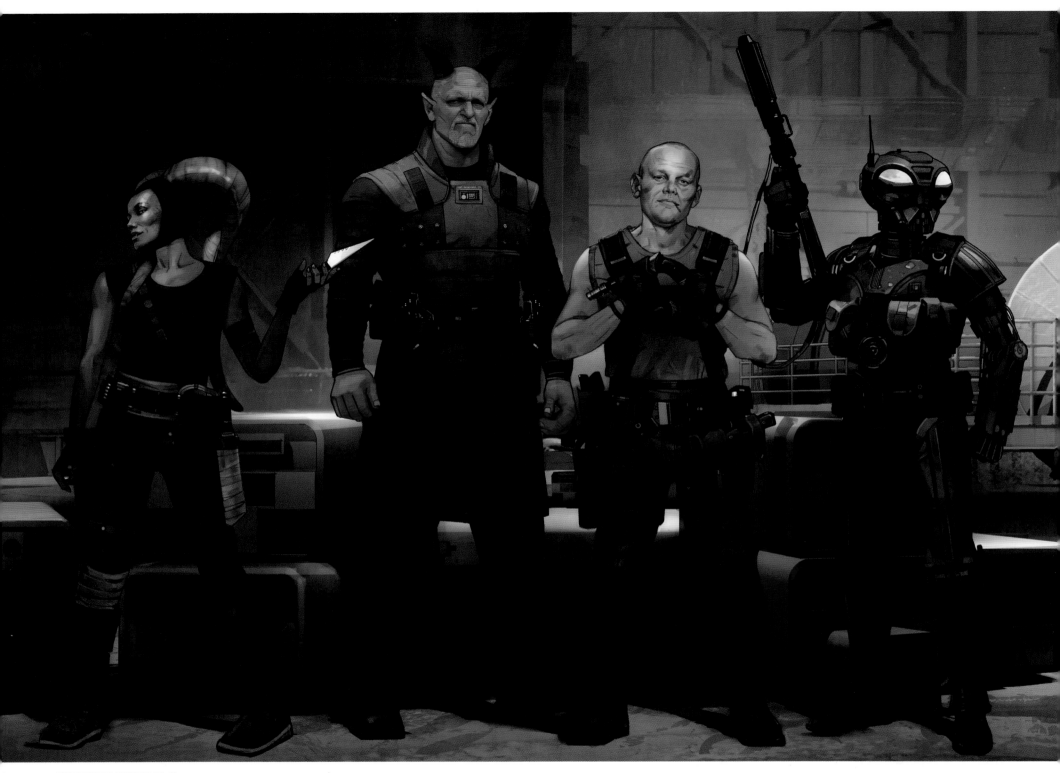

↑ **MERC LINEUP VERSION 06** Matyas

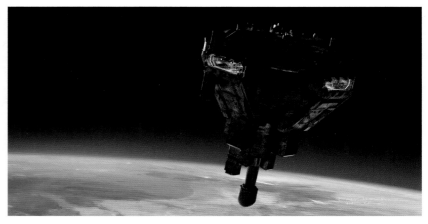

↑ CHOP SHOP STATION VERSION 02 Church

↑ **CHOP SHOP STATION VERSION 02** "I did so many that it might have confused Jon [laughs]. This is one of the pieces where I learned, 'Just do six separate pieces as opposed to a six-in-one piece.' And I liked the idea that it could almost be floating amid a bunch of other junk to help disguise its nature." **Alzmann**

↓ **CHOP SHOP STATION VIEW 3** Hobbins

"We played with a whole bunch of different ideas and ultimately landed on a very small, crude version of Cloud City, which works pretty well. The tall spindle makes a lot of sense because it could be attached to the power source, which may be radioactive. Plus, it very subliminally leans into a form that we've seen before, yet is a new interpretation." **Chiang**

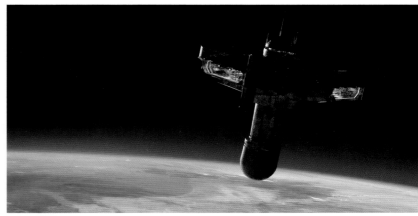

↑ **CHOP SHOP STATION VERSION 03** "Always, the first question is, 'Is this a round *Star Wars* thing or an angular *Star Wars* thing? Is it Imperial? Or is it good? Or is it third party?' That's the first slider you think of." **Church**

↓ **CHOP SHOP STATION VIEW 2** Hobbins

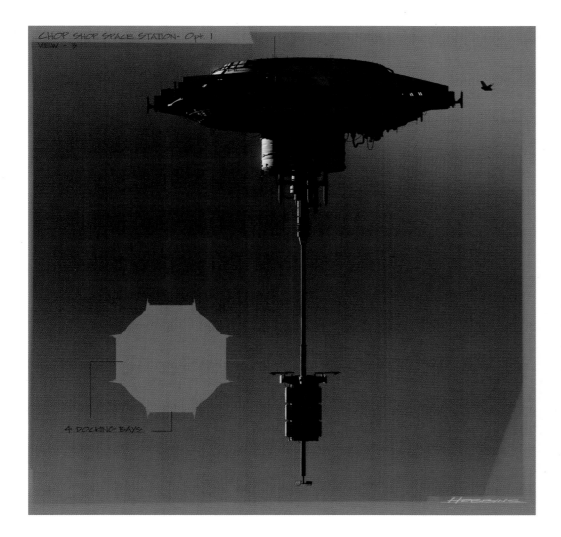

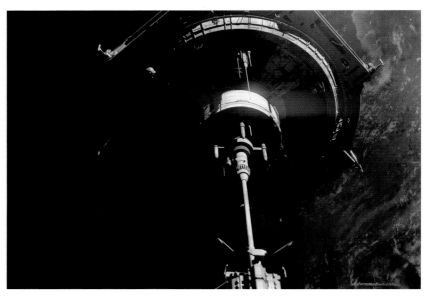

↑ **MESS HALL VERSION 1A** Alzmann

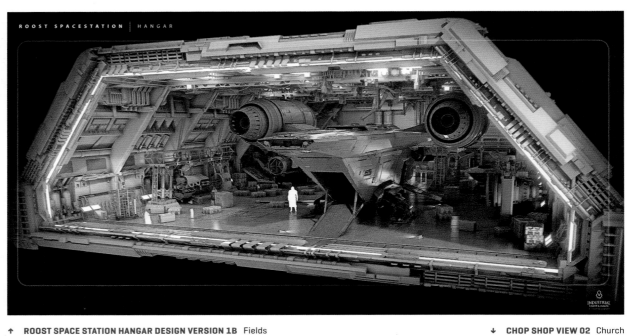

ROOST SPACESTATION | HANGAR

↑ **SPACE STATION INTERIOR WITH** *RAZOR CREST* **VIEW 2A** Hobbins ↑ **ROOST SPACE STATION HANGAR DESIGN VERSION 1B** Fields ↓ **CHOP SHOP VIEW 02** Church

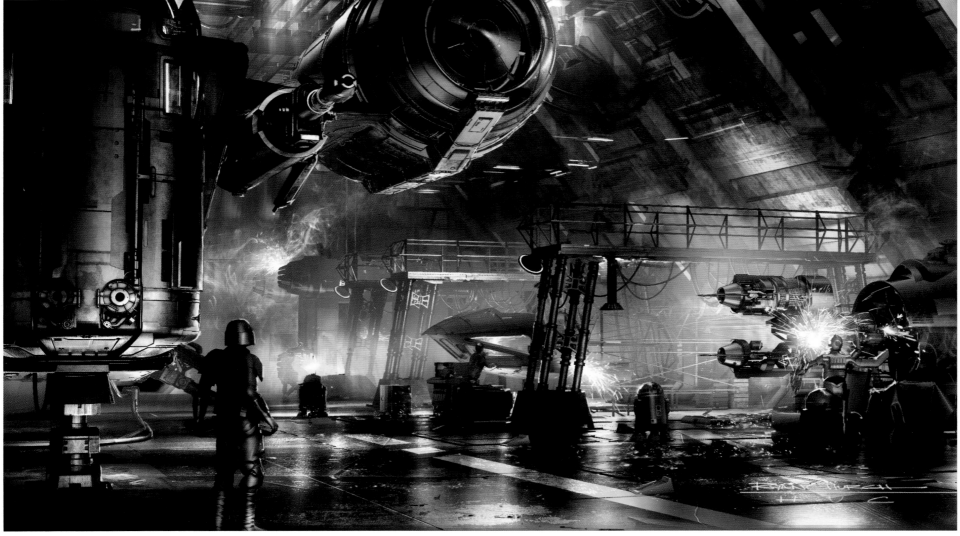

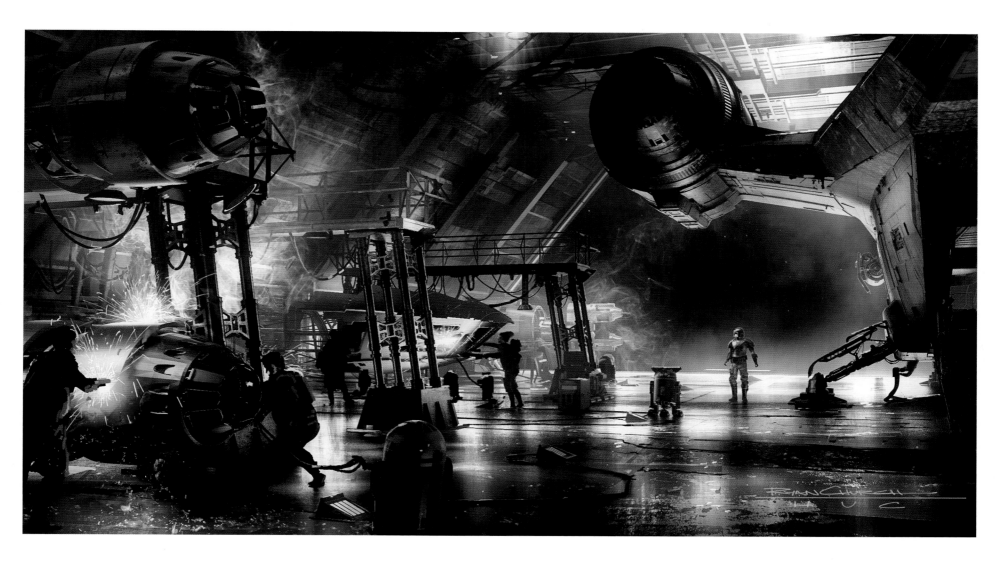

CHOP SHOP SHOT 02 "You look up images of chop shops and there's all kinds of different-colored gases and sparks. And you really want to be aware that the aperture to outer space (indicated by the glowing light around the opening to *Star Wars* hangars) is functioning. So, that's your cool color. Then everything else is warm." **Church**

"How do you take a hangar and make it into a real, functioning automotive chop shop, where there's a bunch of sweaty guys cutting up spaceships? We were also trying to make it gritty. We wanted sparks and to make it look like it smelled really bad. It was humid. It was uncomfortable. Like a real working space." **Chiang**

CHOP SHOP EXTERIOR VERSION 01 "We've seen a million hangars, and you don't want the aperture shape to read as an Imperial hangar." **Church**

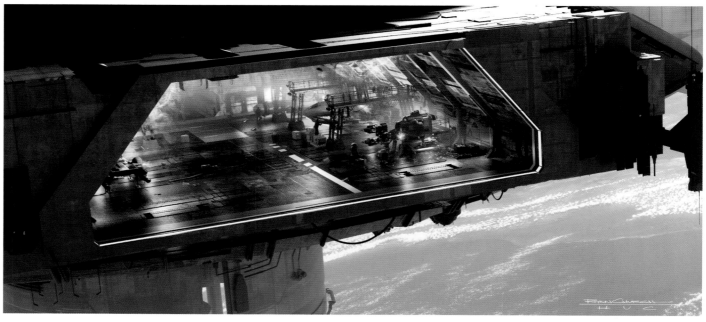

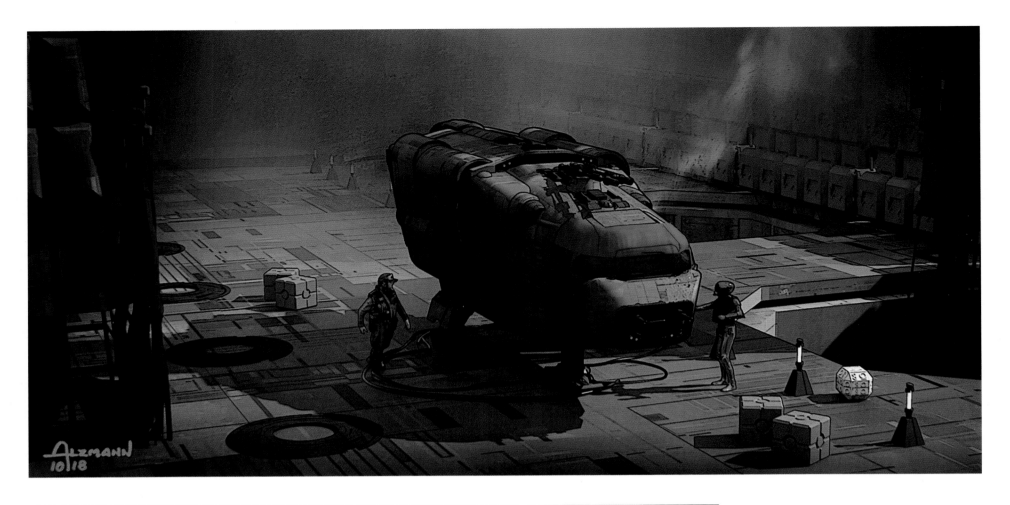

↑ **DELIVERY SHIP VERSION 28** Alzmann and Chiang

"Doug and Ryan do really great slick vehicle
designs. They look like they're moving when
they're parked. And Ryan also does great
utilitarian stuff. I love to do old Chevy clunkers
because, at least for *Star Wars*, that's such an
important ingredient. So I was trying to make it
look like a crappy '70s van." **Alzmann**

← **DELIVERY SHIP COCKPIT VERSION 01** Alzmann

Ran Malk's mercenary gang originally boarded
the New Republic prison ship via a small, truck-
like "delivery ship" called the *Malk-1*, which would
have utilized a redressed version of the *Razor
Crest* interior set.

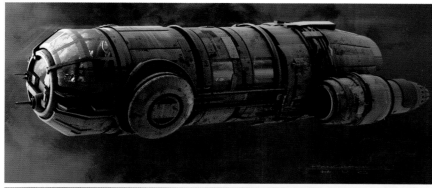

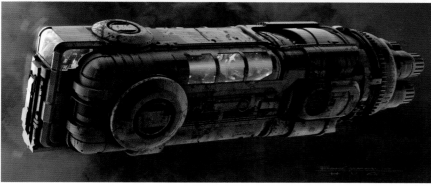

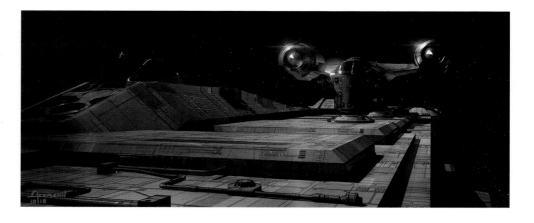

↑ **PRISON SHIP BOARDING VERSION 01** Alzmann

← **VAN SHIP VERSIONS 01 AND 02** "You'd think that when they want to build something cheap and throwaway, it would look like the Blockade Runner escape pod. So let's evoke that." **Church**

↓ **MAINTENANCE HALLWAY VERSION 01** "I added red lighting in this room, just so that it would hopefully feel different from the interior of the *Razor Crest* and that you're coming into a space you're not supposed to be in. And I wondered, 'How cool if he just vertically and literally spun 360 with his guns? And got pulled right back up and then they start coming down the ladders?'" **Alzmann**

→→ **PRISON SHOOTOUT VERSION 01** Gindraux

"At first, the prison droid was a guy in a suit. And then, it was black and menacing. 'No, no, these are New Republic, so it can't be black and menacing because that looks too Imperial.' It did keep changing. But badass droids? If you pay me by the hour, I'll do them for as long as you want [laughs]." **Alzmann**

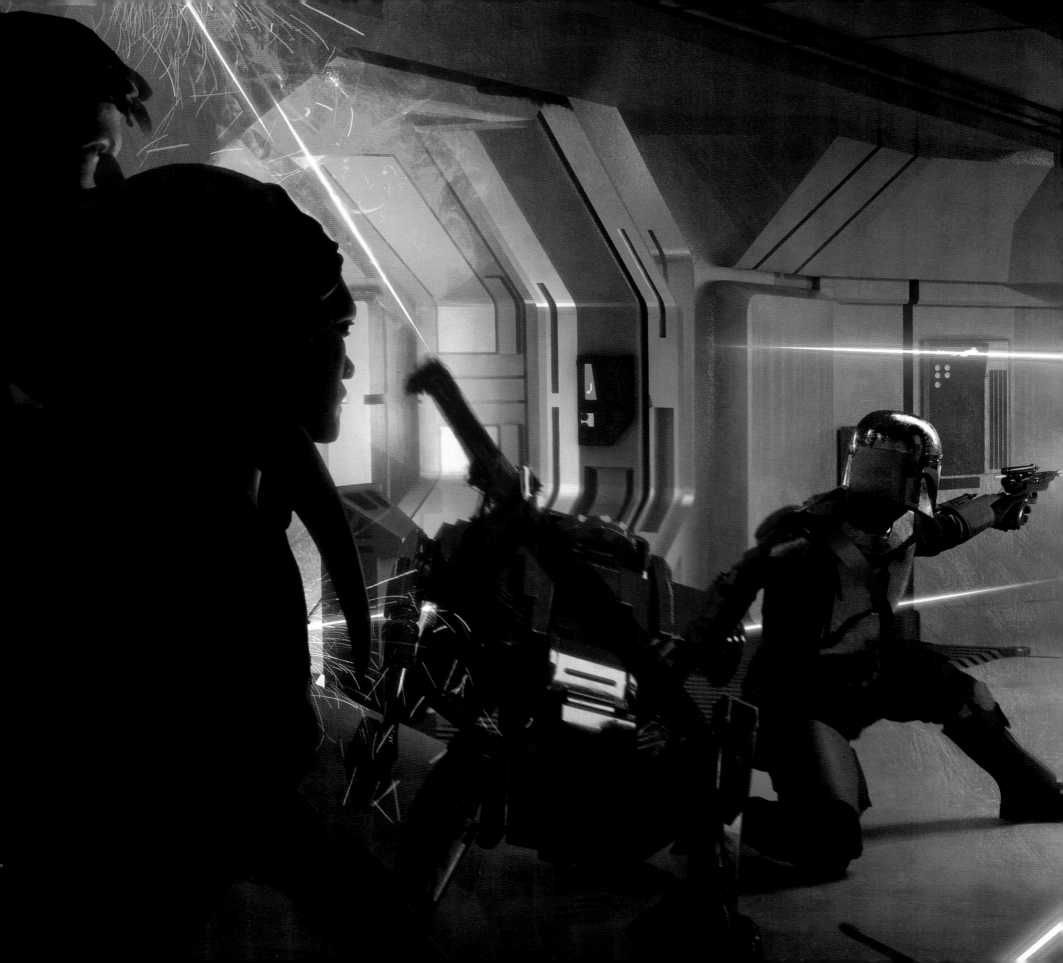

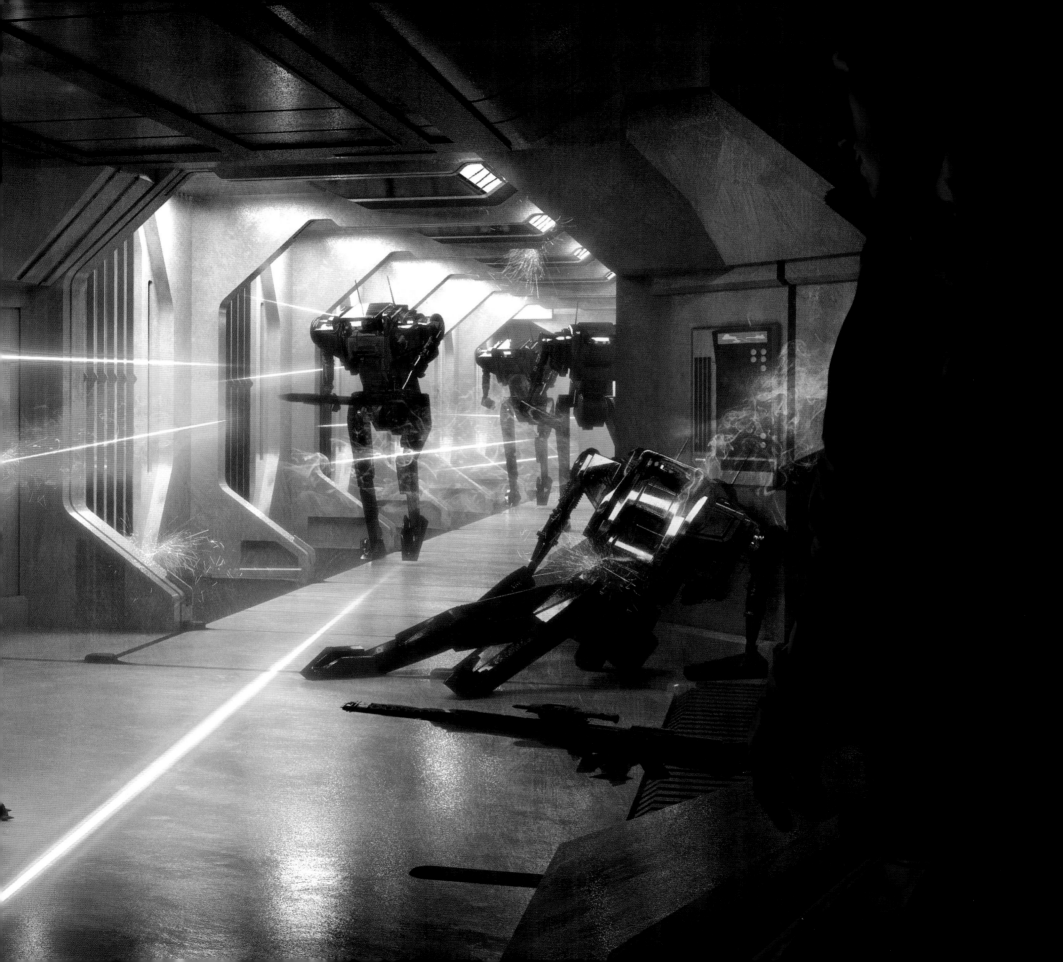

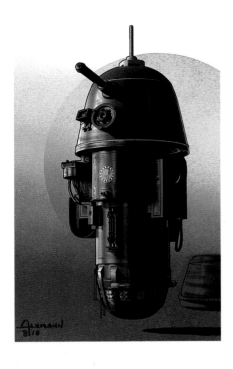

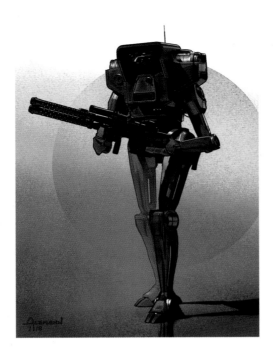

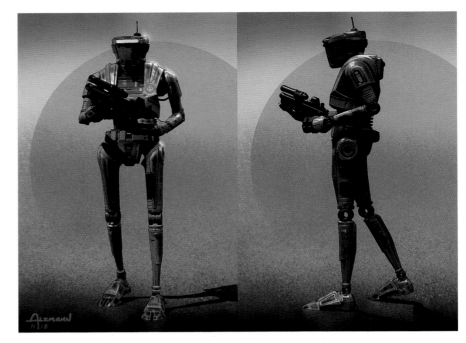

↑ **PRISON DROID VERSION 13** Alzmann

Floating versions of the R1-series astromech droid, glimpsed in the background of the Jawa droid sale in *Star Wars*: Episode IV *A New Hope*, were one of the New Republic prison droids designed by Christian Alzmann.

"I made it so they could have the base or not, depending on what they wanted. Or it could even dock in the base, where it recharges." **Alzmann**

↑ **PRISON DROID VERSION 08** "I thought it would be neat to have a very simple rotating head under there, so you could get different expressions. Remember the He-Man toy, Man-E-Faces [laughs]? To me, it doesn't get any better than the probe droid. Immediately, if it's an evil or bad droid, I'll probably try that first." **Alzmann**

↗ **SECURITY DROID VERSION 22** "We went back and forth on what logo to use for this era of the Republic, which was a fun exercise. There's a lot of K-2SO [from *Rogue One: A Star Wars Story*] in him. Doug likes the solidity of K-2. It was just about changing the chest and a little bit of the hips. And the hands are a lot clunkier, like they're only designed to grab and pull a trigger. One single eye makes something look simple-minded, like you can't reason with it. It just has a couple of tasks, where K-2SO, because he had two eyes, looked sentient. 'I don't even know which eye to look into, to try and talk you out of shooting me.' [Laughs]" **Alzmann**

↓ **PRISON BATTLE VERSION 04** "It was fun adding the windows with the bars and a few alien hands grabbing. If you were running down the hallway, you'd hear the shouts of, 'Hey, man, get me outta here! I know a person! I can pay you!'" **Alzmann**

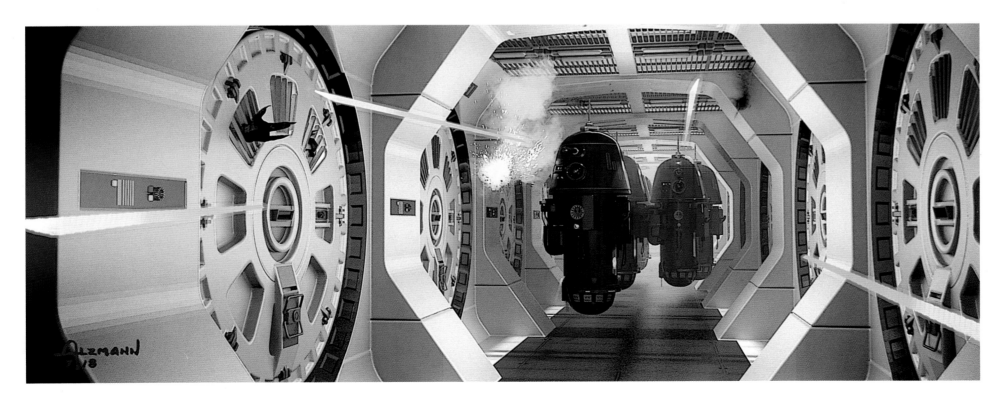

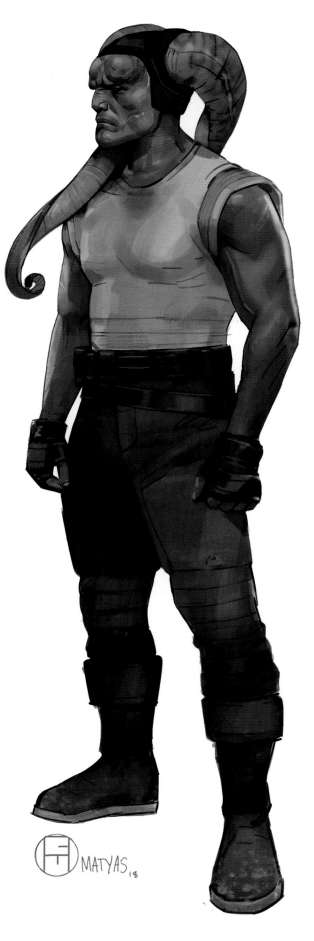

↑ **MERC TYLER VERSION 4B** "The only cinematic version of a male Twi'lek that I can think of is Bib Fortuna (from *Return of the Jedi* and *The Phantom Menace*), which is a very creepy, decrepit-feeling version. But they wanted Qin to feel strong, like a very fit and tough Twi'lek male." **Matyas**

→ **MERC TYLER VERSION 02** Matyas

↓ **MERC TWINS MEET VERSION 02** Matyas

MATYAS '18

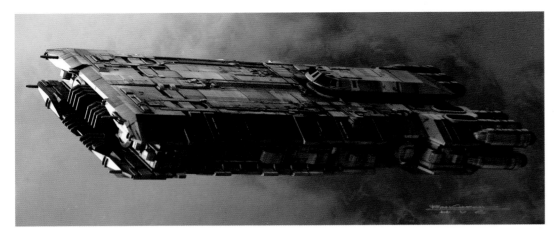

↑ **PRISON VERSION 01** Church

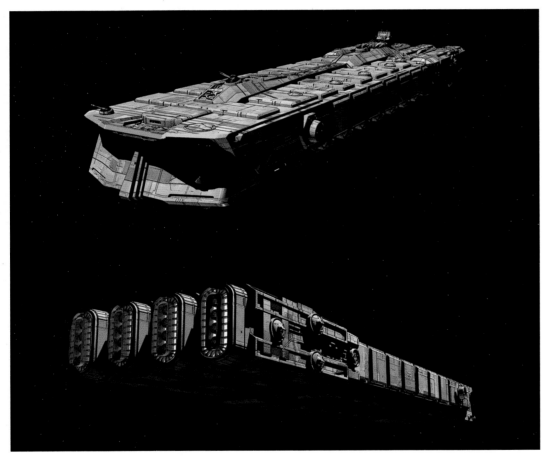

↑ **PRISON TRANSPORT VERSION 03** "I was thinking, 'OK, how can I make this feel like a train or stagecoach robbery from a Western?' They wanted it pretty boxy and simple. But I was just trying to make it feel like as much of a train as I could. Even with the angles on the front, I was trying to mimic a cow catcher. And then the boxes on the side, that repetition of a train." **Alzmann**

"It goes back to how George [Lucas] likes to design shapes. Keep it very geometric, very simple, and very easy to read. And this is as simple as you can get." **Chiang**

→ **NEW REPUBLIC POLICE VERSION 2C** Matyas and Chiang

"The costume is like the Alderaanian Fleet Troopers [from the opening scenes of *A New Hope*] but cleaner and more romanticized, because it's been a few years since their power takeover. Maybe they have a little bit better funding [laughs]." **Matyas**

Matt Lanter, the voice of Anakin Skywalker in the *Star Wars: The Clone Wars* animated series, makes a cameo appearance as a New Republic guard in "The Prisoner."

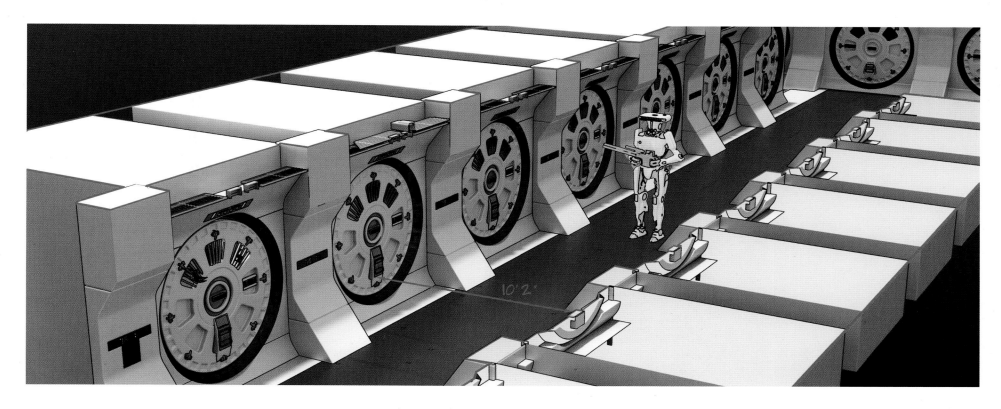

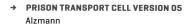

↑ **PRISON HALLWAY VERSION 04** Alzmann

"We thought, 'Maybe it's clean, white, and brightly lit, like the Blockade Runner [from *A New Hope*].' So, the task became keeping the visual texture and feel of that but changing the form language. It became very *2001: A Space Odyssey*, in contrast with all of the other gritty environments. But when the breakout happens, it turns red. I like the boldness of that, graphically." Chiang

"If we're trying to fit with that Western feel, a round door feels like we're robbing the big safe or bank vault door." Alzmann

→ **PRISON TRANSPORT CELL VERSION 05** Alzmann

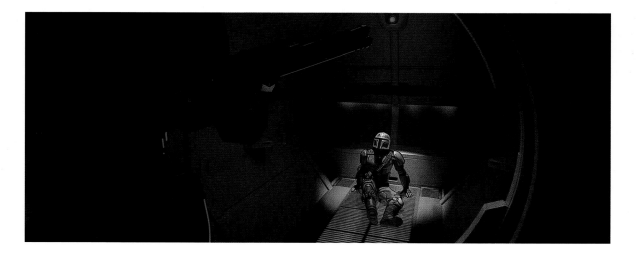

↑ **GETAWAY SHIP VERSION 01** Hobbins

← **PRISON TRANSPORT CELL VERSION 04** "I'm sure I looked at the cell block from the Death Star. Steps down are so important. You want it to feel like when someone's getting thrown in there, they're being thrown in the hole." Alzmann

→→ **X-WING ATTACK VERSION 01** Church

The Lucasfilm art department briefly considered using the split-wing T-70 X-wing starfighters, first seen in *Star Wars: The Force Awakens*, for the New Republic X-wings. Ultimately, classic T-65 X-wings from the original *Star Wars* trilogy were used, flown by directors Deborah Chow, Rick Famuyiwa, and Dave Filoni in cameo appearances.

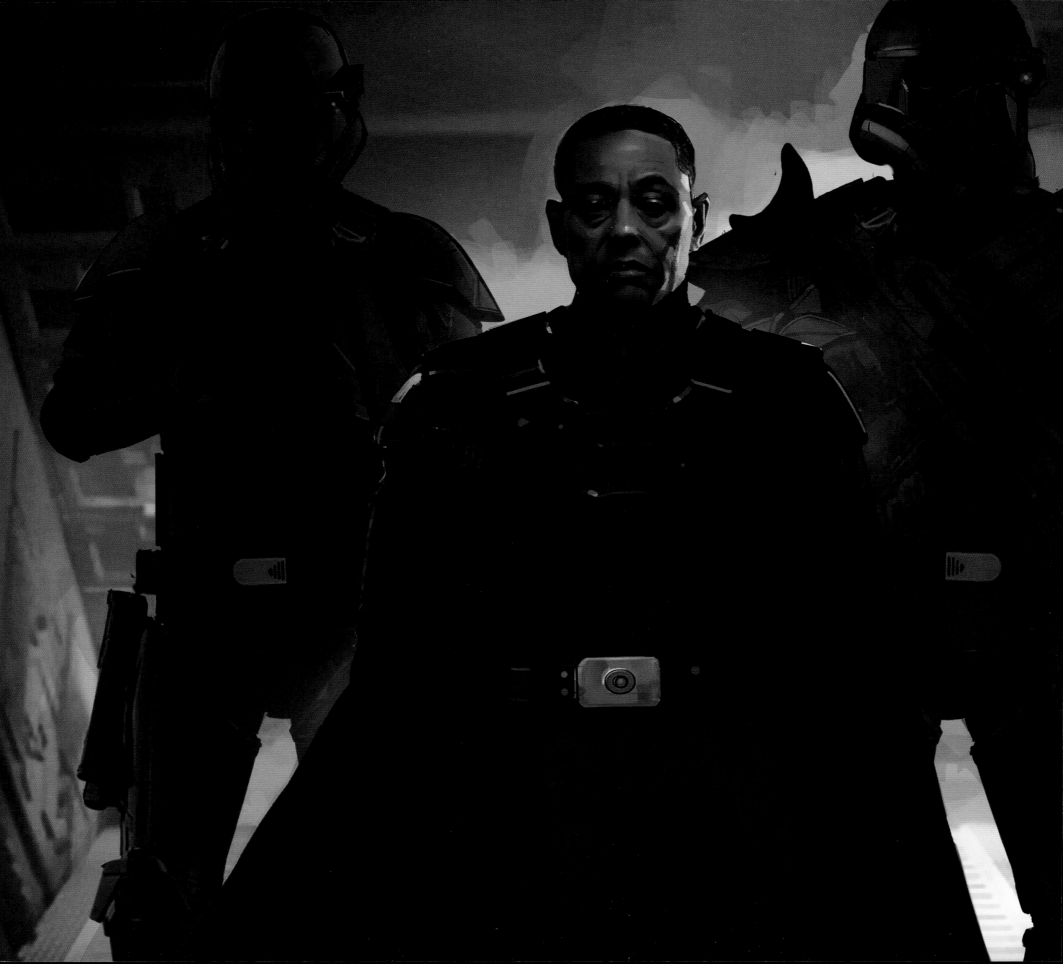

THE RECKONING

Doug Chiang's Lucasfilm art department completed the bulk of the design work for *The Mandalorian* Season 1 in September 2018, just prior to the start of production on October 4. "Normally, on our films, we take four to six months in the initial design phase," Chiang said. "Here, it was truncated to a month and a half and with a very small crew. Partly, the efficiency worked out because there was an urgency. And Jon and Dave, in terms of their feedback and comments, were so precise that we were able to hit and finalize ideas within one or two rounds, which is very unusual. Normally, directors like to explore and explore and then see where it goes. But Jon was very decisive. He was also very open to suggestions. So, sometimes we would leap ahead. If an idea was being talked about but not yet in a script, I would put something down visually, just to inspire Jon. This reminded me very much of how I worked with George [Lucas].

"*The Mandalorian* is definitely one of my career highlights," Chiang continued. "Working with a filmmaker like Jon, who loves to push the technology, the storytelling, and the art form, is a dream job. He likes to challenge us, and I love that challenge. Plus, timeline-wise, we have a very compelling reason to tie together the design language of the original trilogy, prequels, and sequels. It is the fulfillment of what George and I were establishing: a holistic *Star Wars* design timeline."

"It's really humbling that Doug gave me this much responsibility," Brian Matyas reflected. "My background is primarily in animation and video games. So, doing designs that are translatable for actual people has been a learning experience. *Star Wars* storytelling can be limiting if you see it through the narrow lens of the Jedi and the tropes that have already been told. But this is a perfect example of exploring smaller stories and expanding from there, while giving a nod to the inspirations for the original trilogy, like Akira Kurosawa, Sergio Leone, *Buck Rogers*, and *Flash Gordon*."

Christian Alzmann agreed. "Jon's taking a chance in moving away from the established scale and scope that *Star Wars* has been traditionally working in. And you know what? There's not one 'star war' in this. It's about people. *The Mandalorian* is my favorite project in the twenty years that I've been working. Jon has so much trust in us and such confidence in what he's doing."

"There's something really special about this project," Ryan Church said. "Work *can* be this fun. We're being trusted to do our thing. And the writing is great and not over-thought."

"*The Mandalorian* has been the opposite of agonizing," Erik Tiemens concurred. "It's been exuberance. The ultimate sandbox and inspired flow." Alzmann, Church, and Tiemens, the three concept supervisors and creative core of Chiang's Lucasfilm art department, would continue to do occasional shot paint-overs and designs of digital assets for Richard Bluff's ILM post-production team well into August 2019.

Summarizing his *Mandalorian* experience, Dave Filoni said, "[With *The Mandalorian*,] we try not to corner ourselves and want to see where the story takes us. But we always do have a plan. With *Rebels*, I would always harp on everybody, 'Where is this going? Why are we telling this story?' It can't just be another story about a kid that gets the ability to use the Force. It has to have a point and a purpose. Otherwise, I'm not comfortable with the telling of it."

After fifteen years of *Star Wars* storytelling, Filoni believes that "Ultimately, the Force is an ability that can be used selflessly or selfishly and how one chooses to wield it determines whether you stand on the dark side or light. The dark side of the Force is manifested in our greed, desire for power, and fears. And the light side of the Force is propagated by selfless action, by living in balance, by overcoming our fears. The Force naturally exists in balance; that balance is thrown out when someone chooses to give in to their fears and then spirals out of control making selfish choice after selfish choice. Fear leads to anger, anger leads to hate, hate leads to suffering.

"Our own ambitions can make the Force into something terrible even when our intentions might have been good. We do not always realize we are acting out of fear, or selfishness. Anakin believes he is trying to save his wife, he is afraid to lose her, he chooses to act out of his fears and try to control the situation. That moment of choice, how we act and react is so important. The choice between dark and light is often subtle and not limited to the Jedi and Sith. Everyone struggles with the balance between light and dark. The Mandalorian has a choice: do his job, find the Child and hand him over to the Empire, or take this lost child in and protect it, become it's guardian. It is a critical choice and one that greatly impacts both of their lives."

The Mandalorian "Chapter 7: The Reckoning," written by Favreau and the second episode directed by Deborah Chow, was shot from October 29 until November 12, 2018, immediately following "Chapter 3: The Sin" and "Chapter 1: The Mandalorian." All three episodes utilized many of the same actors and sets, including Carl Weathers's Greef Karga, Werner Herzog's "the Client," the soon-to-be destroyed Nevarro public house interior set, and the Nevarro city gate and courtyard sets.

← **GIDEON VERSION 7A** Matyas

"We wanted to give Moff Gideon armor but were careful not to give him a helmet, so he wouldn't become Darth Vader. Ultimately, it's this nice hybrid. He has the presence of a Darth Vader but didn't evoke the same thing." **Chiang**

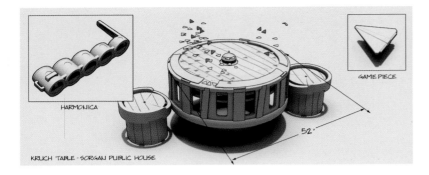

HARMONICA

GAME PIECE

KRUCH TABLE - SORGAN PUBLIC HOUSE

52"

↑ **KRUCH TABLE VERSION 03** Alzmann

In early iterations of the "Chapter 7: The Reckoning" script, Cara Dune competes in a strategy game called "kruch" in the Sorgan public house last seen in "Chapter 4: Sanctuary." Kruch is played using floating metallic arrowhead-like pieces (reminiscent of Imperial Star Destroyers) controlled by a small pitch pipe. Eventually, wrestling instead of a game was deemed a more dramatic and appropriate reintroduction to the warrior Dune, utilizing actress Gina Carano's background as a mixed martial arts champion to its fullest.

→ **KRUCH TABLE PIECES VERSION 01** Alzmann

↓ **KRUCH TABLE VERSION 04** Alzmann

↑ **CARA WRESTLING VERSION 01** "I designed these belts that are almost like the podracing binders. So, they're literally bound to each other and can't get too far away, creating a version of a boxing ring. It's totally [the] *West Side Story* [knife fight]." **Alzmann**

→→ **RECRUITING UGNAUGHT VERSION 1A** "A warm inviting homestead. I can't remember if they do some sort of formal greeting like this in the script, but it definitely seemed right." **Alzmann**

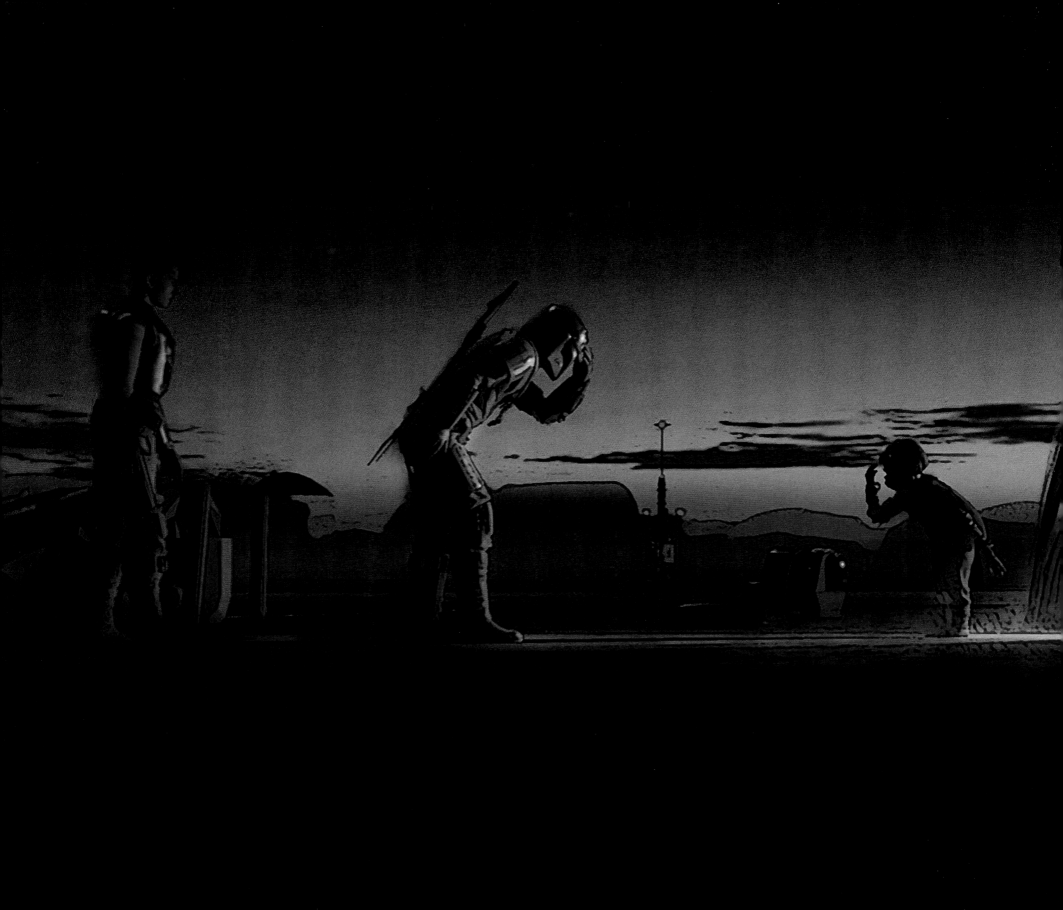

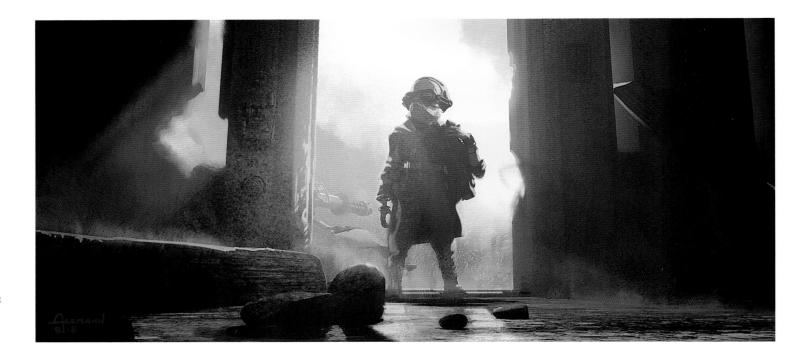

→ **UGNAUGHT SEARCH VERSION 01**
"How can we show an Ugnaught, this little quirky character, in a really heroic way? That odd juxtaposition is fun." **Alzmann**

↓ **UGNAUGHT IG-11 PIETÀ** "This is the pietà [Christian visual art depicting Mary holding the body of her son, Jesus] moment of the Ugnaught, in a way, cradling his future son. I think Doug might have gone in and added the negative space in IG's head, all the way through, to really make that sing." **Alzmann**

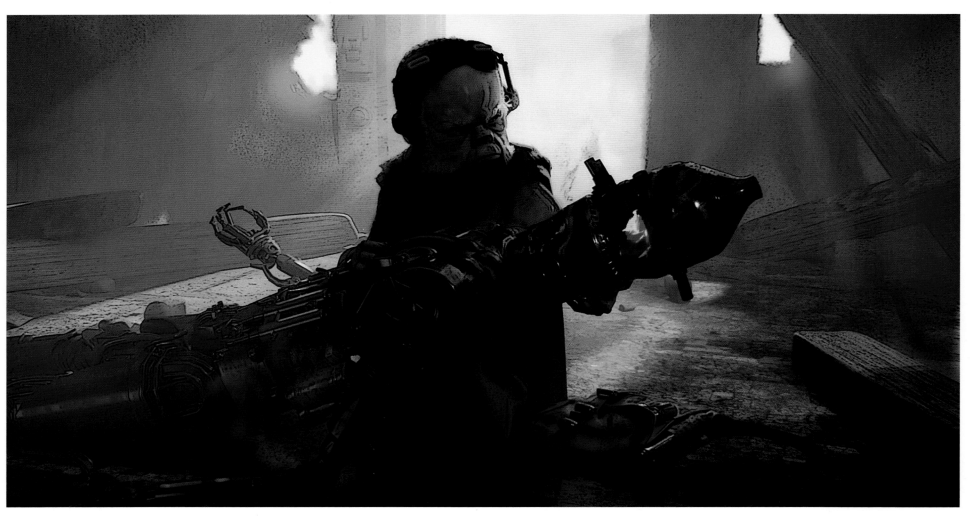

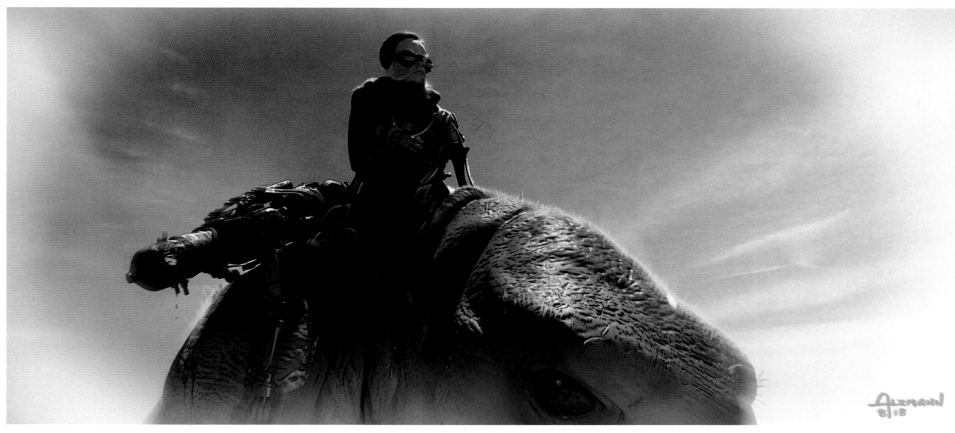

↑ **RIDING VERSION 01** Alzmann

↓ **BLURRG SUNSET VERSION 1A** Gindraux

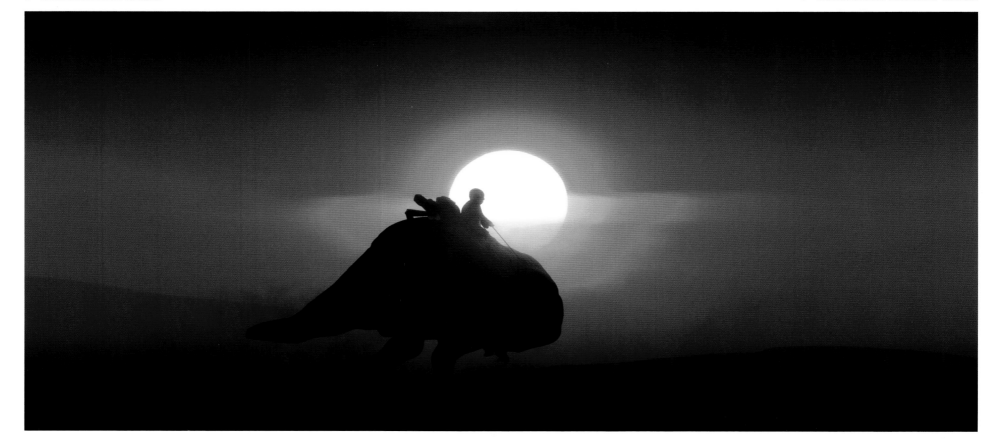

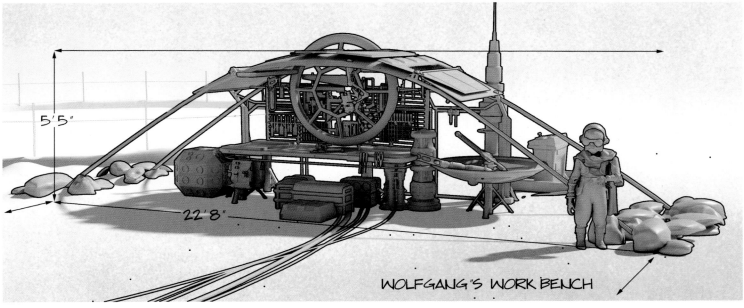

WOLFGANG'S WORK BENCH

5'5"

22'8"

↑ UGNAUGHT TOOL BENCH VERSION 01
"The TIE window was my idea. If he's using junk on his work bench, let's add a focal point to it. I even added a little step because he's short. One of my favorite days was visiting the set and they had just finished building the bench one-for-one. And I totally geeked out." **Alzmann**

← UGNAUGHT WORK BENCH VERSION 01
Alzmann

↑ **IG-11 REPAIR VERSION 1A** Gindraux and Chiang

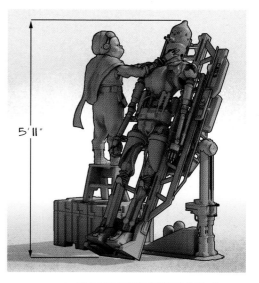

↑ **IG-11 SLEEP RACK VERSION 01** Alzmann

↑ **IG-11 SLEEP RACK VERSION 02** "This is a very *Frankenstein* moment. It was all about getting them eye-level with each other. He puts IG to bed. It's a very caring thing. This means more to Kuiil than just a mechanical project. I chose a high angle because it was the best way to link the two of them together and see that there was an emotional attachment." **Alzmann**

← **IG-11 TEA TRAY VERSION 6A** Alzmann and Chiang

"Everything was super easy to do on this piece except the teapot and the cups. Jon is so food oriented that he has very specific ideas." **Alzmann**

→→ **UGNAUGHT HOOKAH VERSION 01** "I love it because you're not spending any time explaining the hookah. But it adds so much to the character, 'I'm not getting on that ship without my hookah.' [Laughs] And this frightening monster of a thing is putting essence in the hookah with an oil can." **Alzmann**

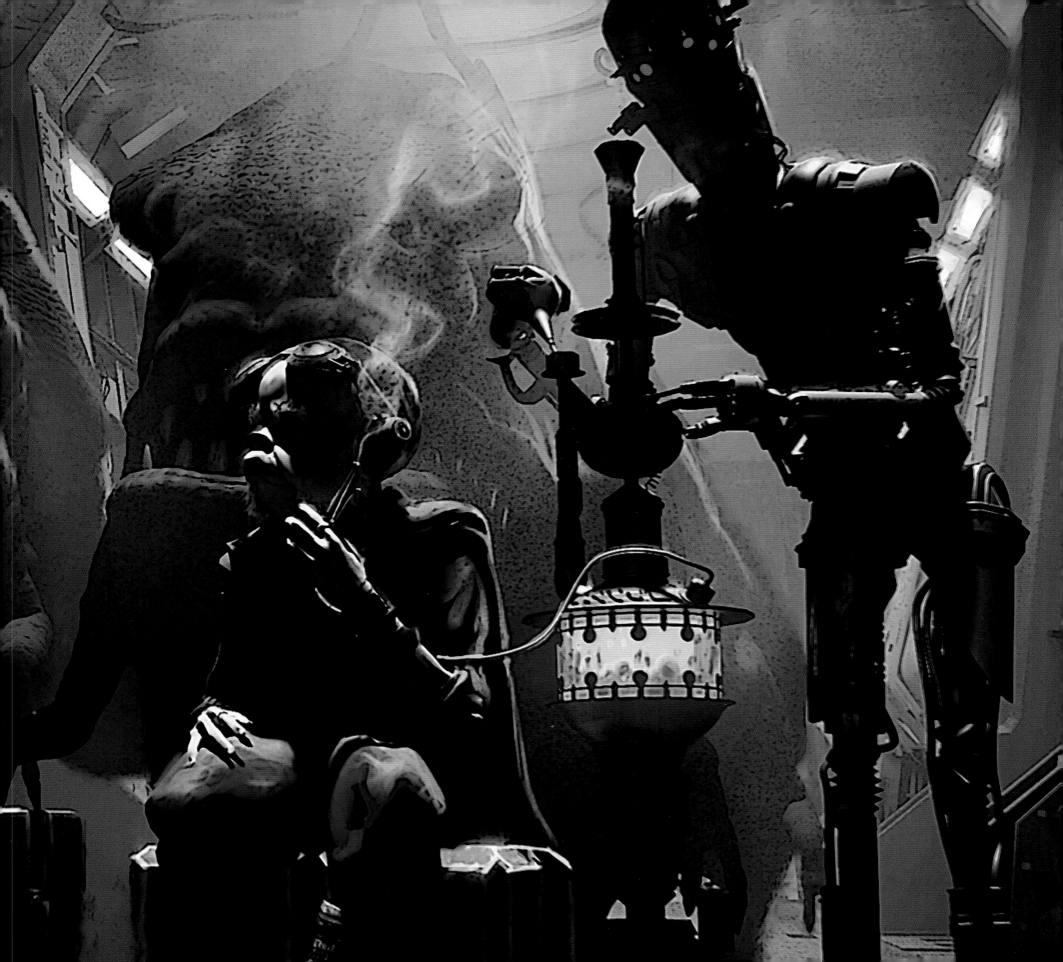

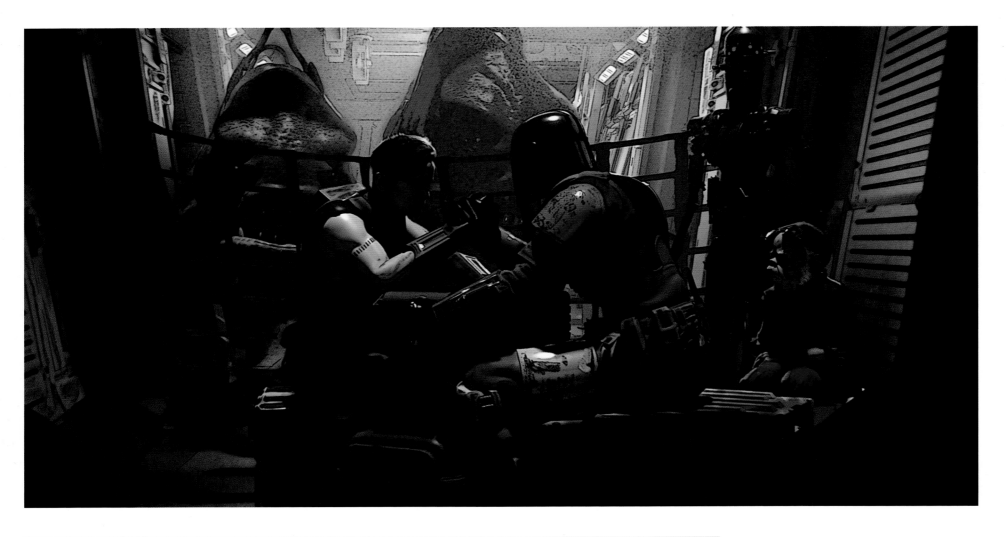

↑ **ARM WRESTLING VERSION 02** Alzmann

← **ARM WRESTLING CHOKE VERSION 02** "That is one serious Yoda pose. I found a frame of that [*The Empire Strikes Back*] scene when Yoda lifted the X-wing, because I wanted to get that pose, even the tilt of the head and everything, perfect. It has this really beautiful atmospheric blue lighting on him that makes it look like a magical moment, very much at odds with the fact that he's choking somebody." **Alzmann**

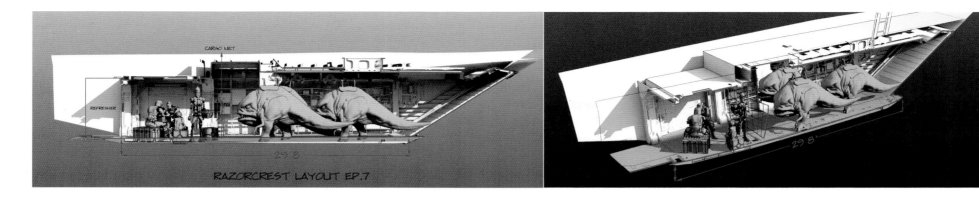

RAZORCREST LAYOUT EP.7

↑ **RAZOR CREST LAYOUT VERSION 02** Alzmann

"[When we designed the *Razor Crest*], we didn't account for whether three blurrgs could fit inside. But we did the math and they actually could fit. So, that was a nice surprise. It's one of those things: Jon wrote it and we made it work." **Chiang**

→ **UGNAUGHT BABY PRAM VERSION 02** "[This pram has] Corinthian leather. It's really beautiful. And I even made the dark slats up top as if he's got skylights. This was all about showing that the Ugnaught was no slouch. He could craft the hell out of stuff." **Alzmann**

↓ **UGNAUGHT PRAM BUILD VERSION 01** "I designed the new chrome or brushed-aluminum pram. And then we backed into, 'OK, what would it look like half built?' Sort of like the half-built Death Star." **Alzmann**

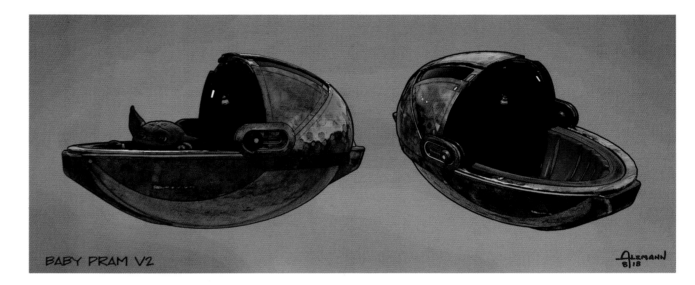

BABY PRAM V2

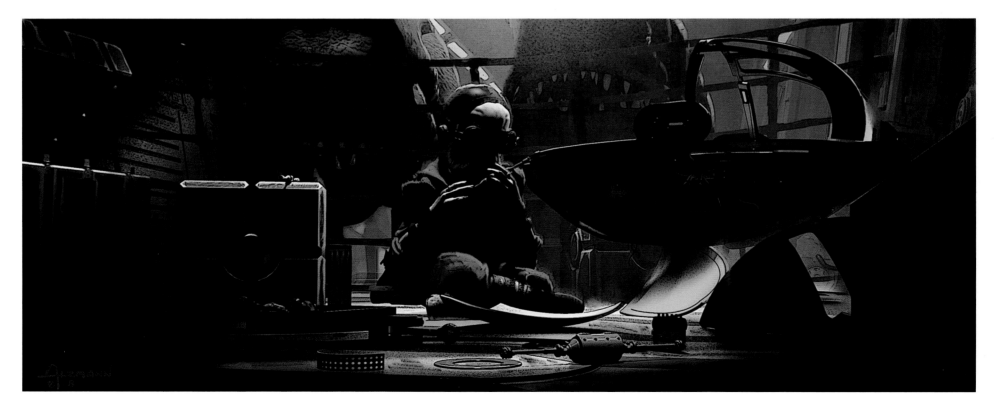

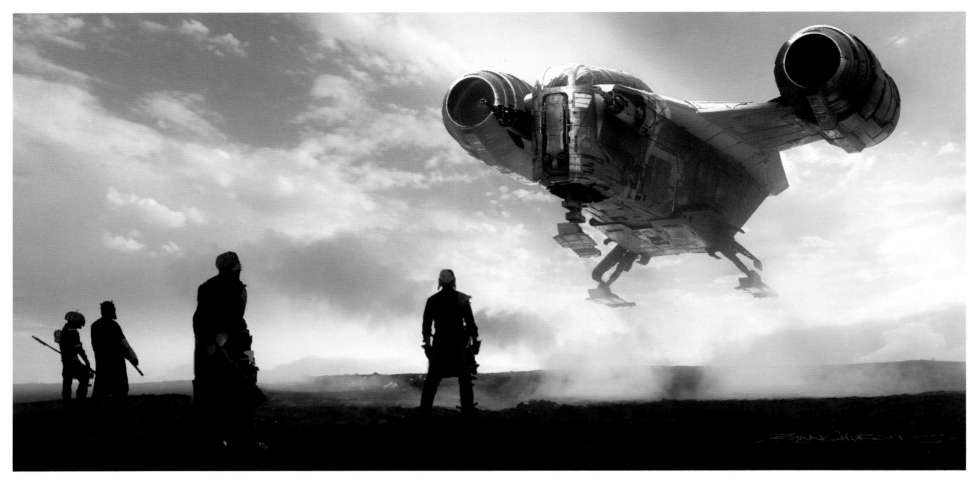

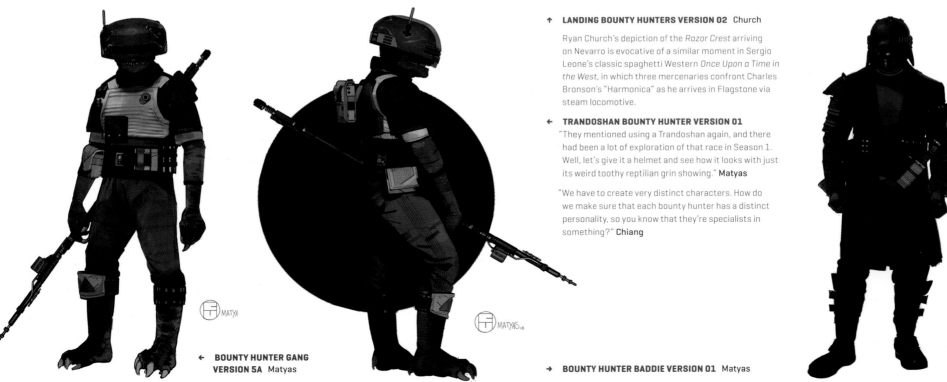

↑ **LANDING BOUNTY HUNTERS VERSION 02** Church

Ryan Church's depiction of the *Razor Crest* arriving on Nevarro is evocative of a similar moment in Sergio Leone's classic spaghetti Western *Once Upon a Time in the West*, in which three mercenaries confront Charles Bronson's "Harmonica" as he arrives in Flagstone via steam locomotive.

← **TRANDOSHAN BOUNTY HUNTER VERSION 01**

"They mentioned using a Trandoshan again, and there had been a lot of exploration of that race in Season 1. Well, let's give it a helmet and see how it looks with just its weird toothy reptilian grin showing." **Matyas**

"We have to create very distinct characters. How do we make sure that each bounty hunter has a distinct personality, so you know that they're specialists in something?" **Chiang**

← **BOUNTY HUNTER GANG VERSION 5A** Matyas

→ **BOUNTY HUNTER BADDIE VERSION 01** Matyas

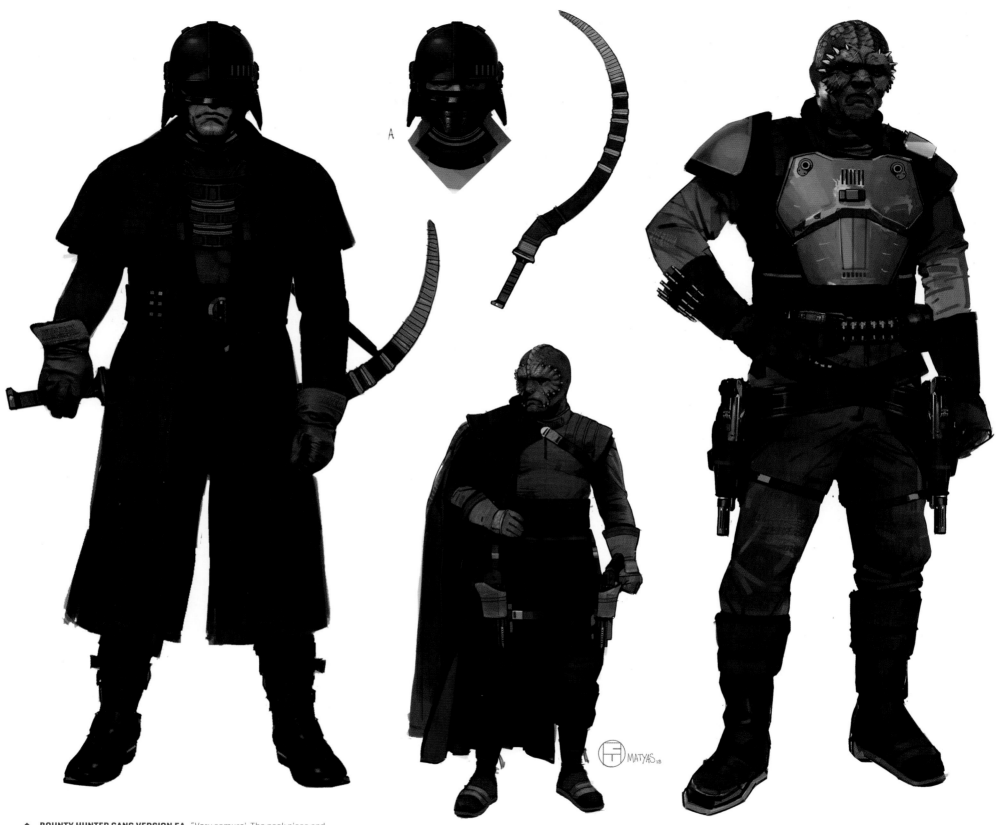

↑ **BOUNTY HUNTER GANG VERSION 5A** "Very samurai. The neck piece and the chest piece were definitely riffing off of that. You can give me these kind of assignments all day and I'll never get bored [laughs]." **Matyas**

↑ **NIKTO BOUNTY HUNTER VERSION 02** Matyas

↑ **BOUNTY HUNTER GANG VERSION 5A** Matyas

↑ BLURRG EXITING VERSION 1A
"It's a little bit of a cheat, trying to get the blurrgs to come down the ramp with riders. Cara would really have to lean forward to not hit her head." **Alzmann**

→ LAVA FALLS LANDSCAPE VERSION 2A Tiemens

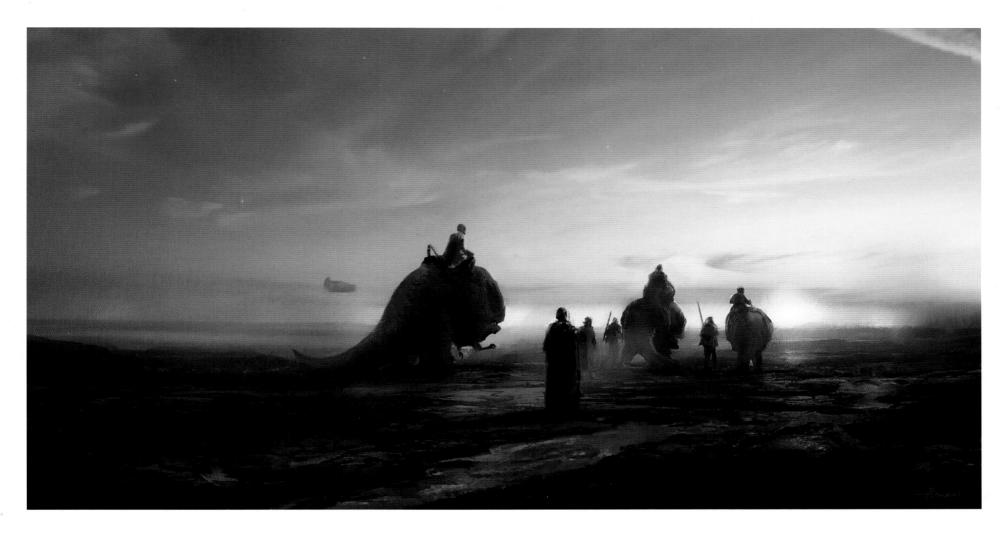

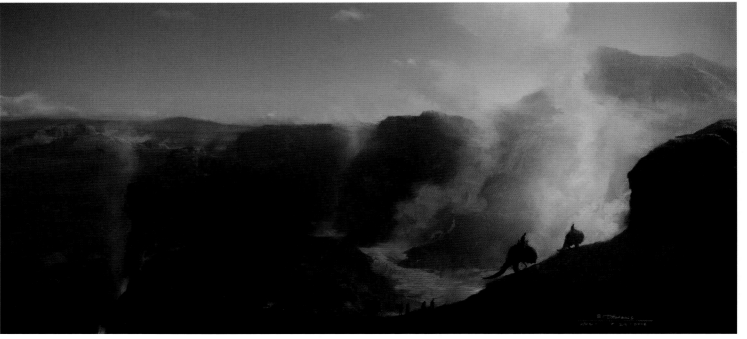

↑ **NEVARRO BLURRG SCENE VERSION 5A** "These remind me of old paintings of the near east, of camels going toward a horizon destination. Exploring mood, a sense of journey, and little hints of lava cracks on the right-hand side." **Tiemens**

→ **LAVA CLIFF SCENE VERSION 1B** "There might be natural bridges and volcanic lava tubes. Maybe they're near a volcanic cauldron. Anyway, it was too much shoe leather [laughs]. But my mind would wander off. I had worked on Mustafar stuff for *Episode III*. And so, it was flashbacks to that." **Tiemens**

→→ **CAMPFIRE VERSION 1A** Matyas

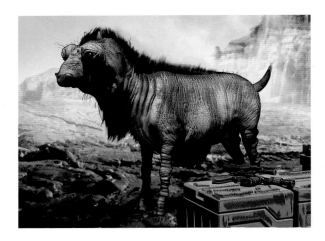

↑ **QARTUUMS VERSION 02** "Again, you ask yourself, 'What would Phil Tippett design for something like this?' He is so great at doing 'ugly-cute.'" **Alzmann**

→ **REPTAVIANS VERSION 01** Alzmann

Original *Star Wars* trilogy concept artist Ralph McQuarrie's designs for dragonsnakes on the swamp planet of Dagobah formed the basis for the reptavians that attack the Mandalorian and Greef Karga's ragtag squads in "Chapter 7: The Reckoning."

"The biggest issue was the scale. It had to be just big enough to grab a blurrg and carry it off into the night. They totally have a Pteranodon-style wing." **Alzmann**

↓ **REPTAVIAN ATTACK STORYBOARDS** Lowery, Norwood, and Duncan

Mando creates a protective perimeter of fire around Ug. and child

Reptavian drags Weeq. into frame over camera

A Reptavian grabs Mando's gauntlet

Mando points his flame thrower up at Reptavian

Mando brings blaster upward

Mando keeps blasting away at Reptavian

Tilt up with Reptavian

It slams into ground as Camera pulls back

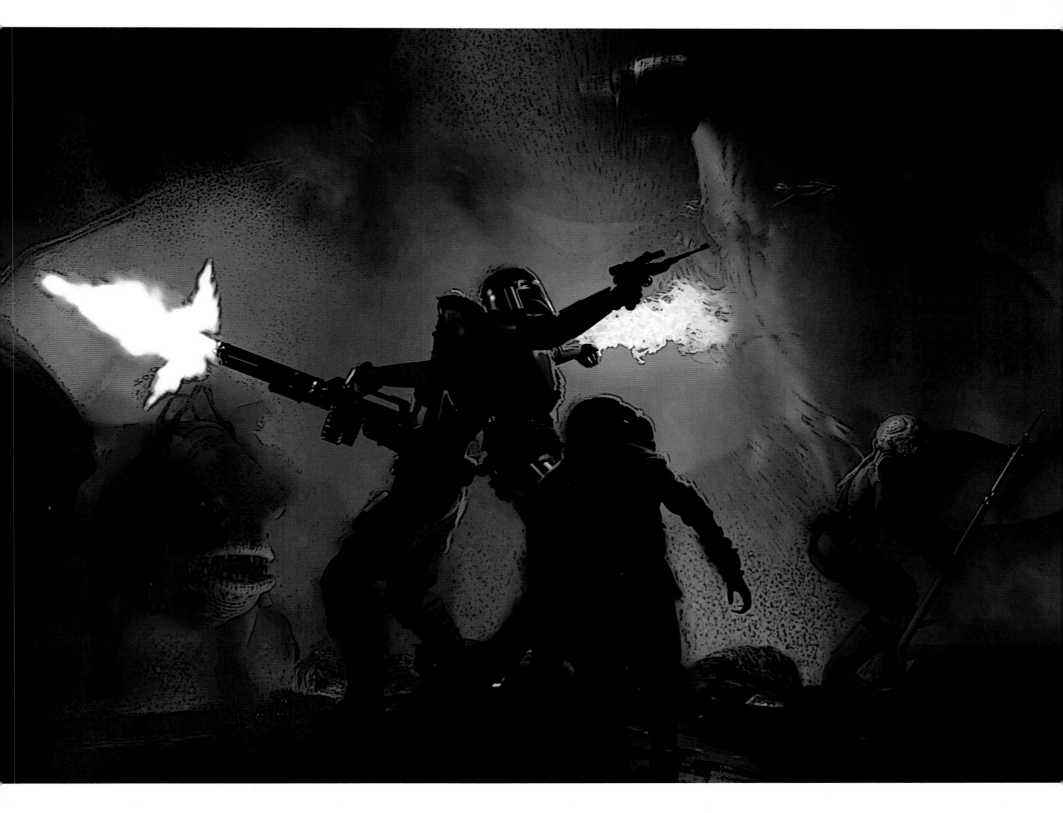

↑ **REPTAVIAN ATTACK VERSION 03** "I'm always thinking about movies that I grew up with, [in this case] the brides attacking around the fire in *Bram Stoker's Dracula* [1992]. *Pitch Black* [2000] had a really great version of that, as well. Not seeing them coming until that weak firelight hits them fifteen or twenty feet away." **Alzmann**

→→ **BABY HEALS GREEF VERSION 01** "In the script, they make it seem like the arm had to come off. So, I designed a medical cuff to go around his elbow, like what Luke had after he lost his hand [in *The Empire Strikes Back*]. Again, I use the Yoda lighting. And the [rictus setting in] was a way to visually explain that these creatures have venomous claws or maybe they're so dirty that the wound got infected right away." **Alzmann**

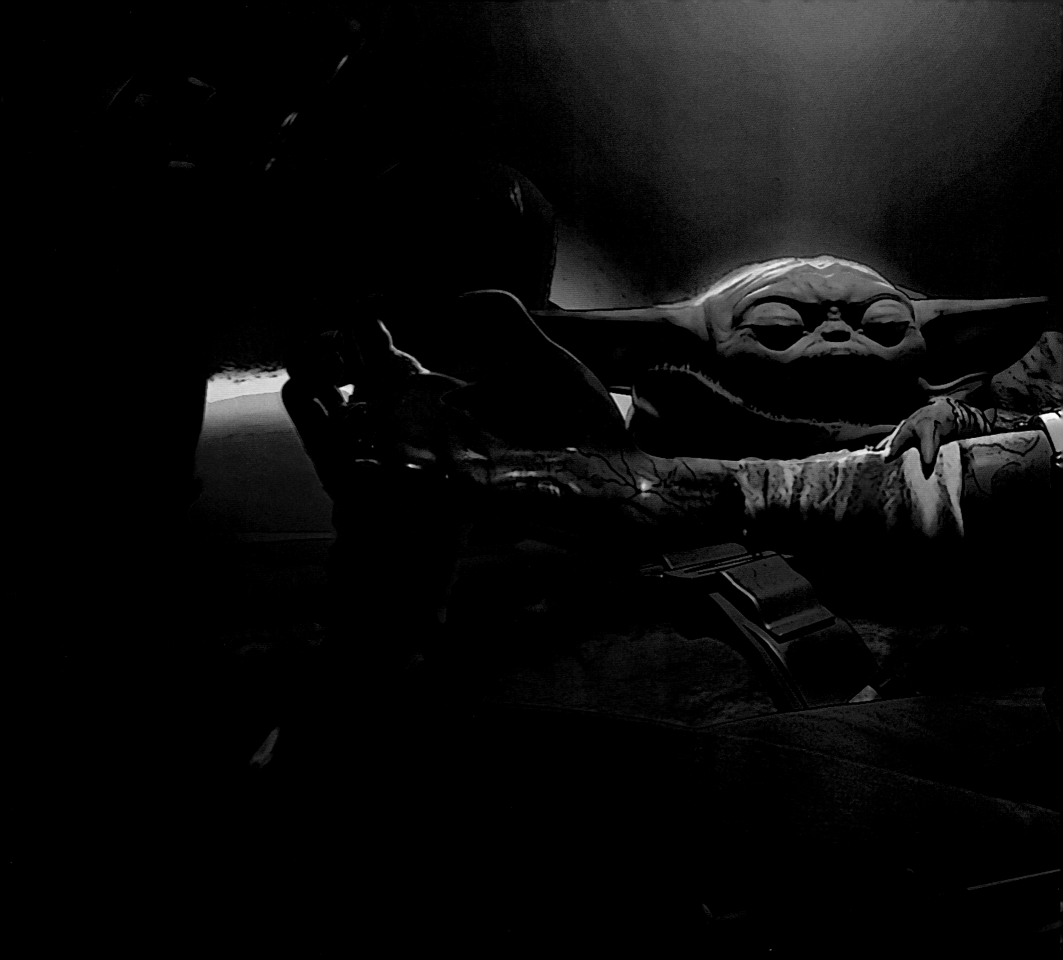

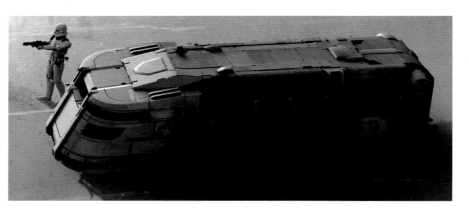

↑ **FRONT GATE VERSION 01** Church

"I was at Respawn Entertainment [video game developer of *Jedi: Fallen Order*] and I saw their speeder bike [replica]. They had painted it white and it was really nice. So I suggested to Jon that we should make ours white. He really liked that idea. We ultimately ended up borrowing Respawn's and then made our own." **Chiang**

↗ **KENNER VEHICLE REAR VERSION 02** Church

→ **KENNER VEHICLE VERSION 2A** Church

"Chapter 7: The Reckoning" marks the second canonical TV appearance of the Imperial Troop Transport (ITT), first seen in several episodes of *Star Wars Rebels*. Both iterations are based on the Imperial Troop Transporter vehicle created by Kenner Products and first released in 1979 as part of the original *Star Wars* toy line.

↓ **KENNER VEHICLE FRONT VERSION 02** "By the time the Kenner vehicle showed up, we were on a roll and totally got it. [Our task was to] do the real version, the version that you actually want to see." **Church**

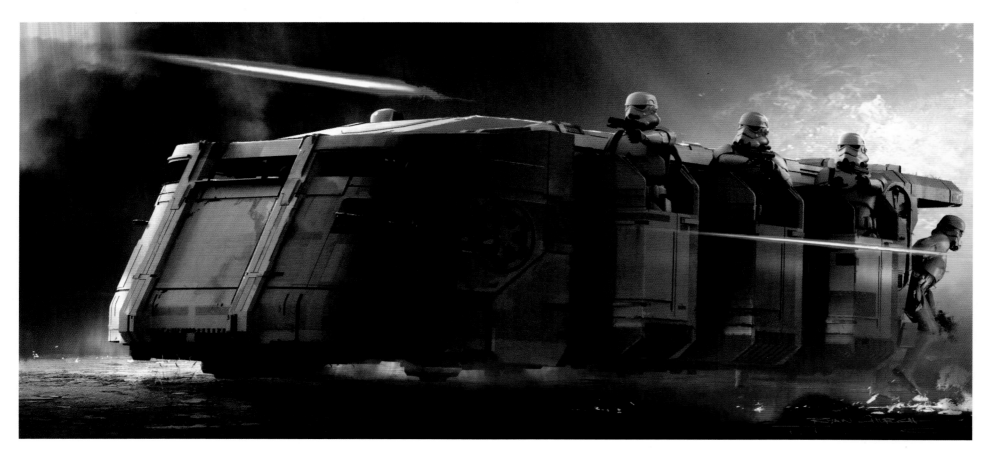

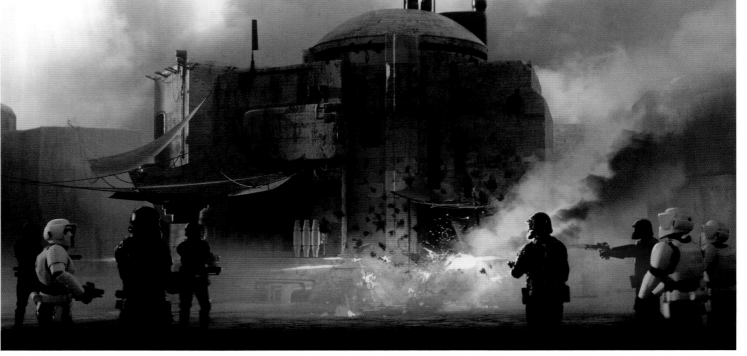

↑ **DESTRUCTION VERSION 1A** Gindraux and Chiang

→ **PUBLIC HOUSE SHOOTOUT VERSION 01** Church

The same death trooper costumes designed and fabricated by co-costume designer Glyn Dillon and David Crossman's team for 2016's *Rogue One: A Star Wars Story* were shipped to Los Angeles and reused for *The Mandalorian* "Chapter 7: The Reckoning" and "Chapter 8: Redemption."

← **TIE LANDING WINGS VERSION 01**

"Way back in [2013 for] Episode VII, I was trying to figure out how TIE fighters land. My solution was that the wings would fold. It didn't quite work but I'm glad that the idea stuck. And Jon and Dave really embraced it. It works technologically but also graphically, feeling very Vader's TIE-like in a subliminal way, with the wings angled out instead of in." **Chiang**

↓ **TIE LANDER TWIN FUSELAGE VERSION 01**

"I took a bunch of passes at giving Gideon [a unique TIE fighter] but it just never worked." **Church**

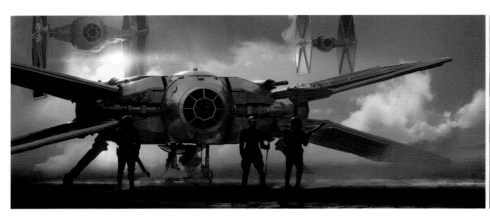

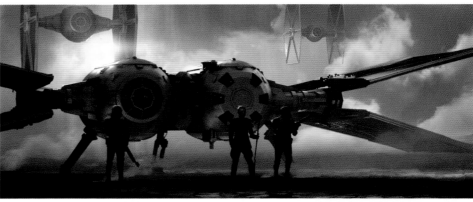

↑ **TIE LANDER BIG FUSELAGE VERSION 01** Church

↓ **NEVARRO COURTYARD VERSION 1A** Church

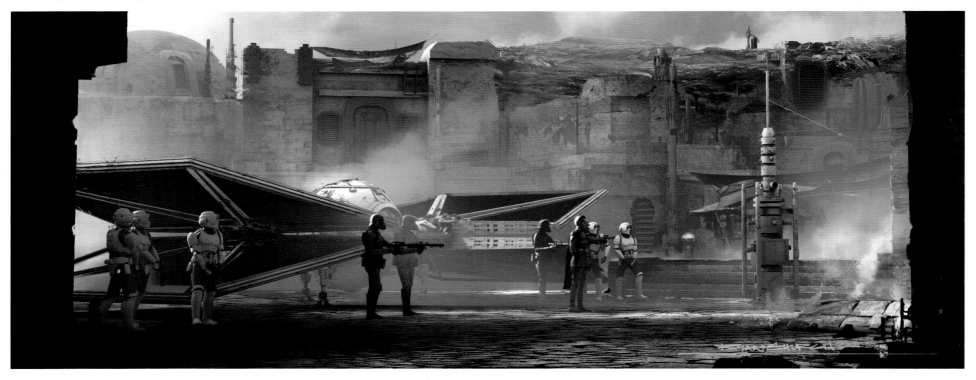

↑ **GIDEON VERSION 13** "There's something cool about taking that Imperial officer costume and giving them a bit of armor." Matyas

→→ **GIDEON VERSION 17** Matyas and Chiang

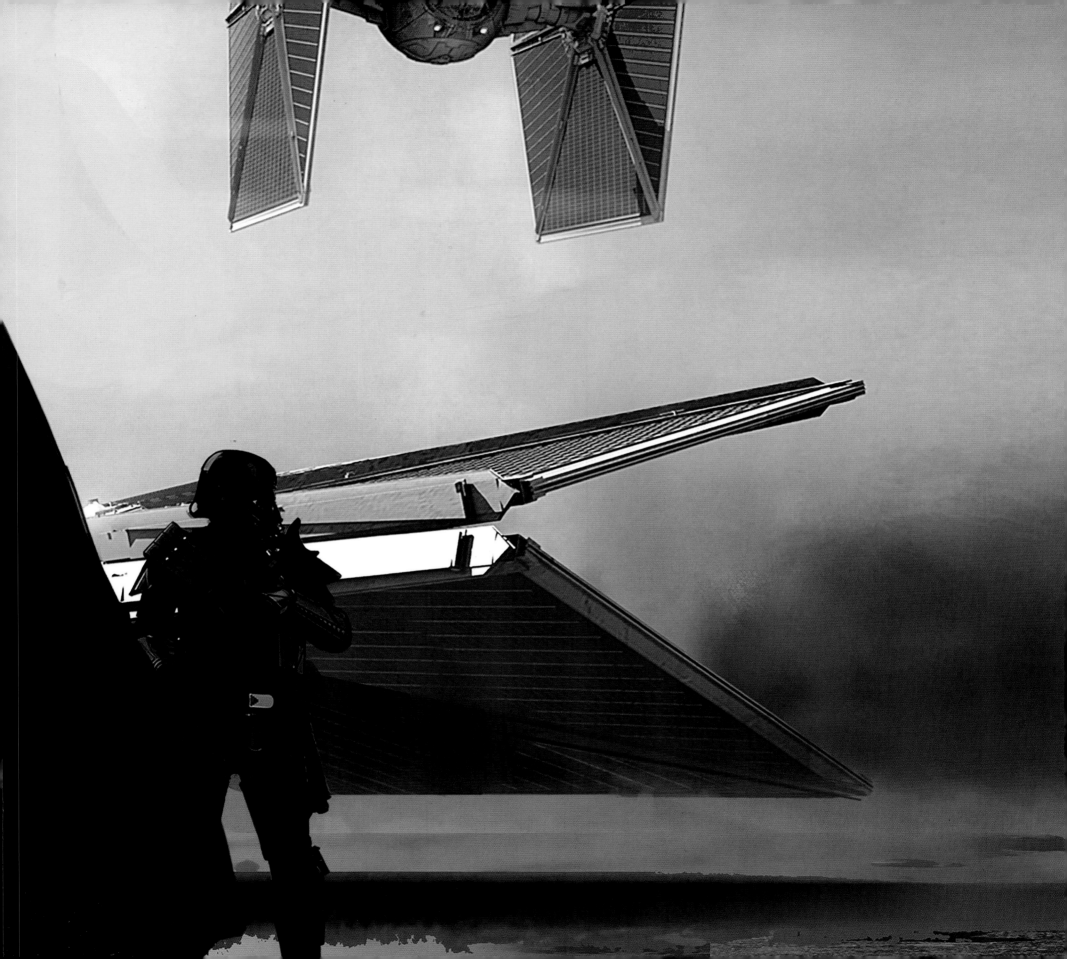

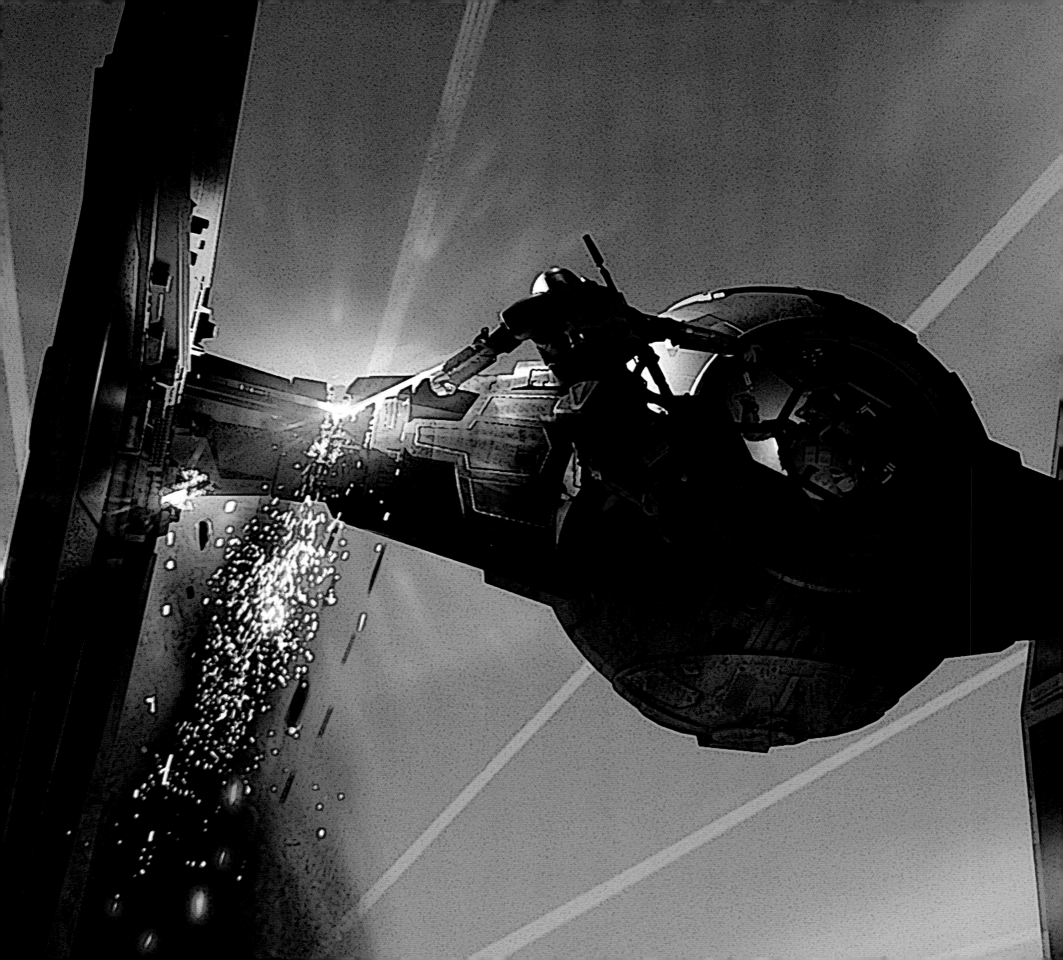

REDEMPTION

Reflecting on *The Mandalorian*, show creator Jon Favreau said, "The myth of the gunfighter is a dangerous person living in a dangerous world, who may have crossed certain lines morally in their life, but is redeemed through saving innocence, like Shane protecting the homesteaders or the Seven Samurai or the Magnificent Seven protecting the villagers. Preserving the innocence of others as a way to redeem oneself. There's something compelling to us as a species in that mythology. And I loved how *Star Wars* [1977] captured that. I appreciate people who hold *The Empire Strikes Back* on a pedestal above it. But, to me, the original *Star Wars* is everything. There's something about the grittiness, the edginess of that world, [like] *Mad Max* and *The Road Warrior*, other films that I liked.

"As a ten-year-old, it was brand new. But my father knew what was going to happen. There weren't too many surprises to somebody who's seen a lot of movies and read a lot of books. I didn't know what was going to happen next, but I knew it was satisfying. As a human being, these were stories that you yearned to hear. Even when you're familiar with the stories, you yearn to hear them again if they're told well and in an original way.

"When you're younger, Ralph McQuarrie's art is weird because it doesn't look like what's on the screen," Favreau continued. "But as you get older, you start to understand the creative process and the brilliance of these collaborators. You start to appreciate how things were kitbashed out of necessity, implying a reality and history because things were so authentic and tactile. I remember my dad leaning into me when we were watching the first film, pointing out oil stains on the fuselage of the X-wings parked in the hangar. What made this movie so cool was that lived-in quality. Then later, I realized it was combined with imagery from World War II movies. Those X-wings could have been B-17s parked on the runway. George [Lucas] was curating a collection of imagery, his baby boomer twist on the silent generation's films, movie stars, and archetypes: the Western, *Flash Gordon*, *Buck Rogers*, and even samurai films."

Favreau completed his shooting script draft of *The Mandalorian* "Chapter 8: Redemption" on November 8, 2018, shot by fellow MCU director Taika Waititi (also the voice of hunter-turned-nurse droid IG-11) from November 13 to 29. "The world [of *Star Wars*] is so crazy and, obviously, so far removed from Earth," Waititi said. "But the characters are very grounded. And you can recognize them in family members, teachers, or other people you know. That's what draws you in and makes you feel

like you're in safe hands when you're watching *Star Wars*." "Chapter 8," the fourth of eight episodes in production, was filmed immediately after Dave Filoni's "Chapter 1" and Deborah Chow's Chapters 3 and 7, as they all had cast and sets in common.

On Waititi's first day in the *Mandalorian* director's chair, Walt Disney Company chairman and CEO Bob Iger revealed the name for the company's direct-to-consumer streaming service, Disney+, during a live financial webcast. Iger also unveiled a Disney+ show centering on *Rogue One: A Star Wars Story*'s Cassian Andor, with actor Diego Luna reprising his role as the Rebel spy.

Upon completion of Dave Filoni's "Chapter 5: The Gunslinger," *The Mandalorian* wrapped its main production unit on February 12, 2019, three days prior to *Star Wars: The Rise of Skywalker*'s wrap at Pinewood Studios. In the midst of shooting that final episode, Doug Chiang's art department kicked off *The Mandalorian* Season 2 on January 10, 2019.

Four months later, cast and creatives, including Favreau and Filoni, convened at *Star Wars* Celebration 2019 in snowy Chicago, Illinois, to present the first footage from *The Mandalorian* to be seen by *Star Wars* fans. The initial trailer for *The Mandalorian* debuted on August 23 at Disney fan event D23 Expo in Anaheim, California, alongside news that actor Ewan McGregor would reprise the role of Obi-Wan Kenobi for another upcoming Disney+ series, helmed by *Mandalorian* alum Deborah Chow.

On November 12, Disney+ launched in the United States, Canada, and the Netherlands, *The Mandalorian* drawing near-universal critical and fan acclaim and tens of millions of the *Star Wars* faithful to the nascent streaming service. Almost immediately, the Child, popularly known as "Baby Yoda," became a viral sensation, permeating every strata and genre of popular culture around the globe.

"*Star Wars* must have been powerful, because it's dictated everything that I've explored and liked from a cinematic perspective since 1977," Favreau concluded. "As I peel back the onion over the years, going to samurai movies with my dad, learning more about Westerns and the movies and the myths that inspired *Star Wars*, it's opened me up to understanding the Hero's Journey, the monomyth, and Joseph Campbell. Also, that's been a gateway into learning about myths of other cultures and about religions and the archetypes that exist in storytelling. As I've learned more, it's refined my understanding of storytelling."

← **TIE TAKEDOWN VERSION 05** "In 'Chapter 3,' the Heavy Mando was going to take out a TIE fighter by flying up with his jetpack and plasma-cutting the wing off. I liked that they saved it for the end. A dude flying around on a jetpack taking out a TIE fighter? That's a spectacle you keep for your finale. Basically, I was just thinking of what we *haven't* seen before. I imagined the cutter being slightly liquid with welding sparks falling off, like it's a little less controllable than a lightsaber. My favorite part is the TIE fighter pilot: 'Wait, what?' [Laughs]" **Alzmann**

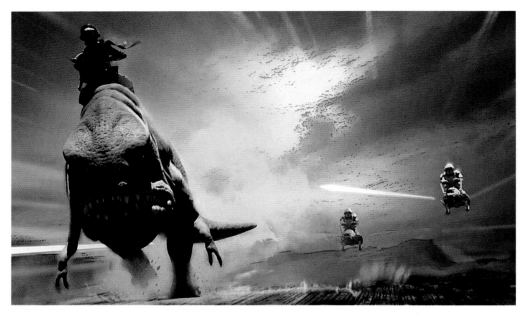

↑ **SPEEDER BIKE CHASE VERSION 3A** Alzmann

→ **SPEEDER BIKE CHASE VERSION 2A** Alzmann

↓ **BABY GRAB VERSION 1A** "One of the most important scenes in *A New Hope* is Uncle Owen and Aunt Beru dead and smoldering, because it creates a realism and a fear. And I figured this is that sort of moment. The threat is real. I had to have the tongue hanging out of the blurrg, because that's just such a *Star Wars* thing. I was trying to get the right pose out of Kuiil, still reaching for the baby with his last breath." **Alzmann**

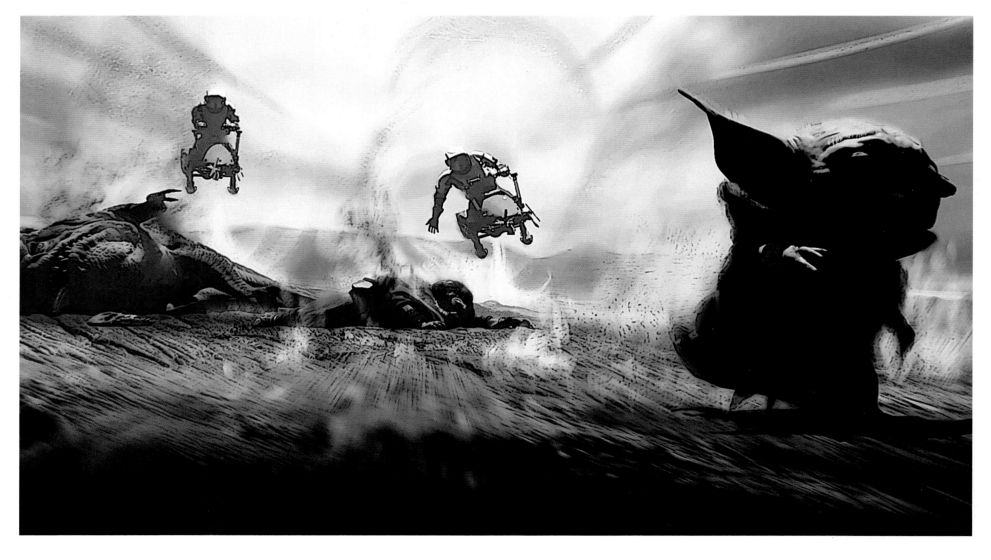

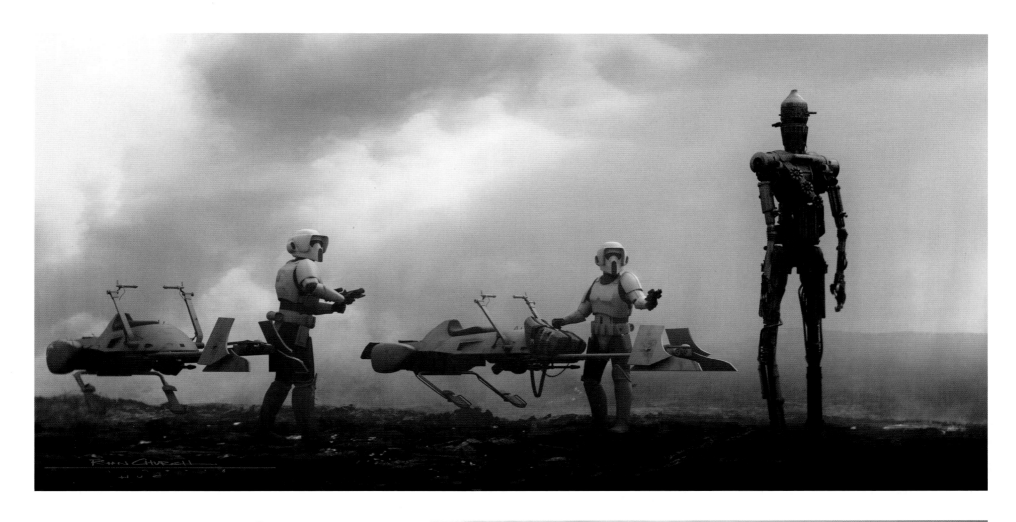

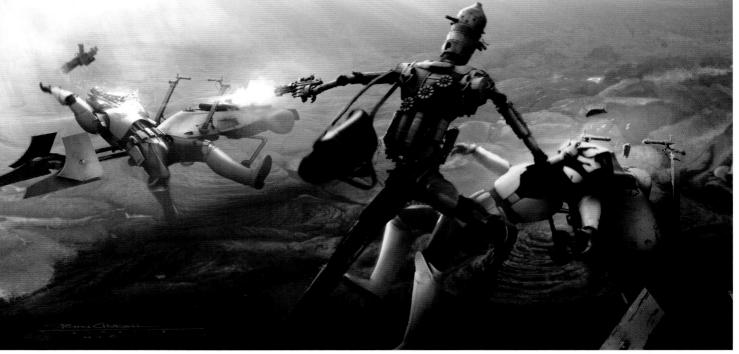

↑ **IG-11 SPEEDER BIKE VERSION 1A** Gindraux and Chiang

↓ **IG-11 SPEEDER BIKE** Gindraux

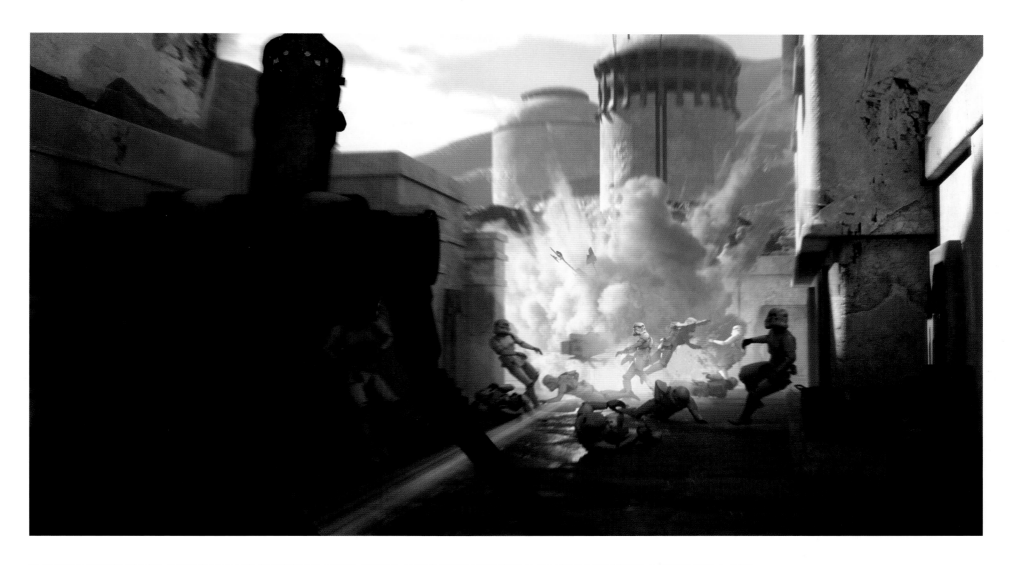

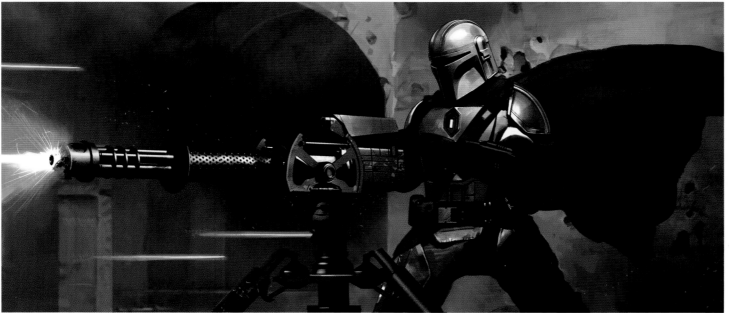

↑ **SPEEDER BIKE EXPLOSION VERSION 1A**
Gindraux

← **MANDO E-WEB VERSION 03** Matyas and
Chiang

→→ **MANDO WOUNDED VERSION 03** Matyas

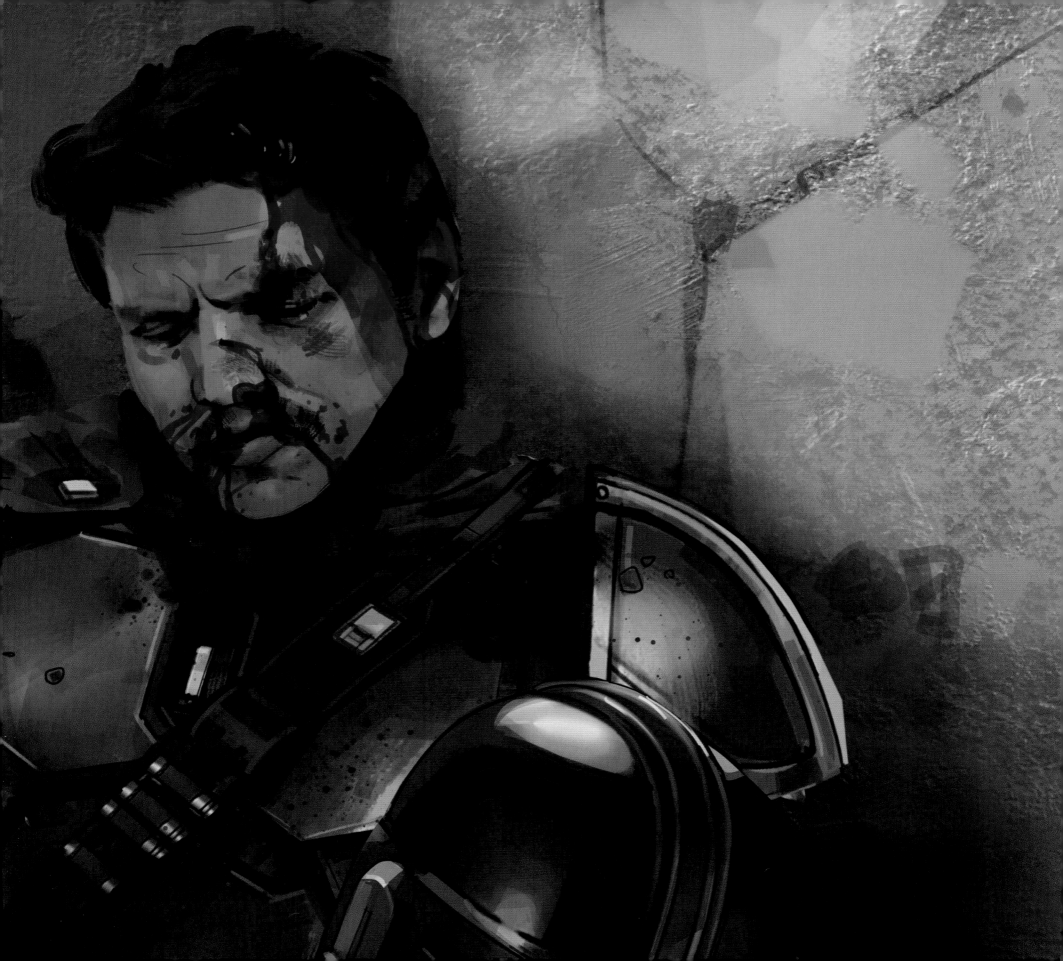

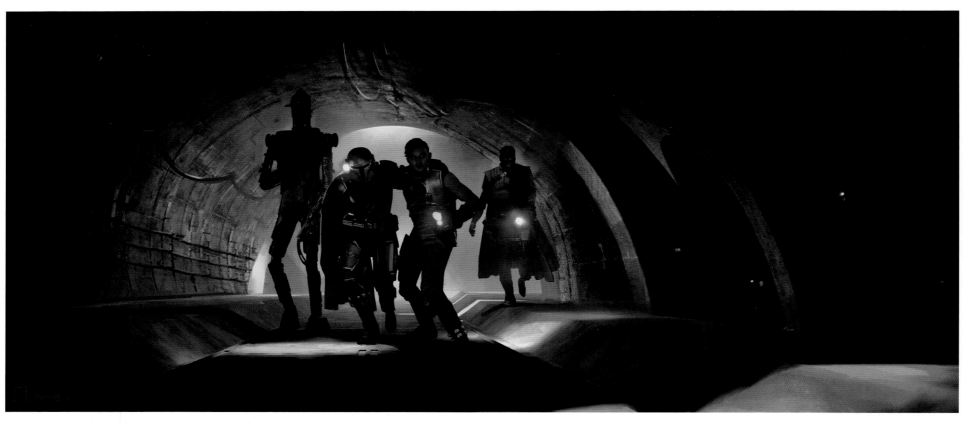

↑ **SEWER ESCAPE VERSION 2A** Matyas

↓ **ARMOR PILE VERSION 04** Matyas

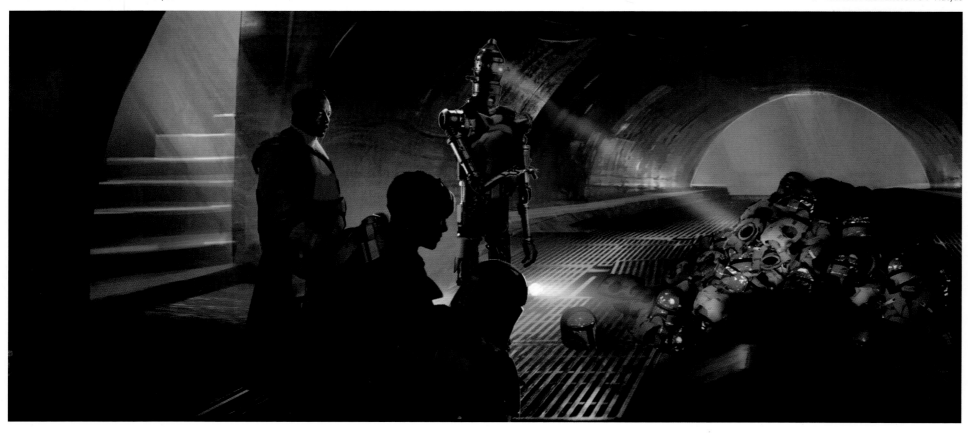

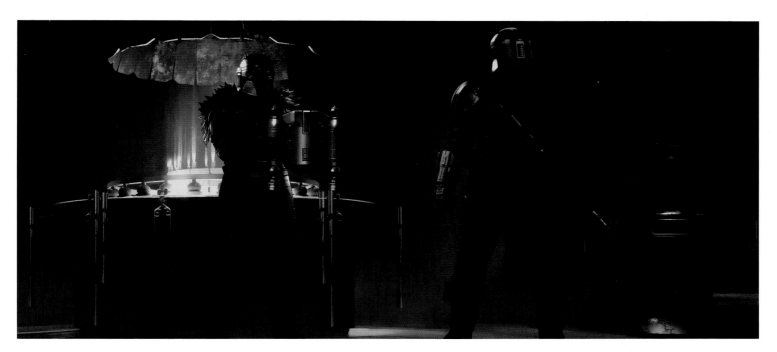

← **BLACKSMITH GIFT VERSION 2A** Matyas

"We were trying to update Boba's jetpack but make it even cooler, befitting the Mandalorians' new armor." **Chiang**

↙ **MANDO JETPACK VERSIONS 02 AND 05** Matyas

↓ **MANDO JETPACK VERSION 9A** Matyas and Chiang

"Mando's jetpack should look distinct, like it was made for him. I always liked Joe Johnston's *Rocketeer* jetpack. And I thought a hybrid between that and Boba Fett's with an art deco vibe would be really cool." **Matyas**

→→ **BLACKSMITH KNEELING VERSION 2A** Matyas

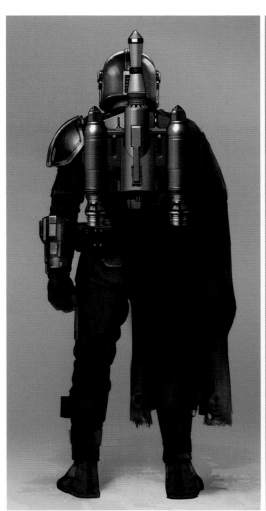

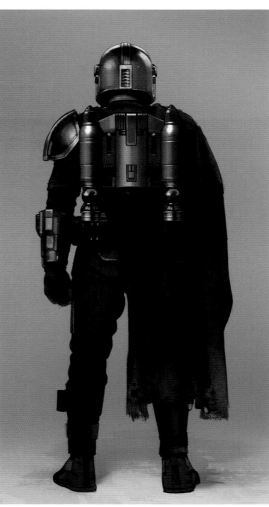

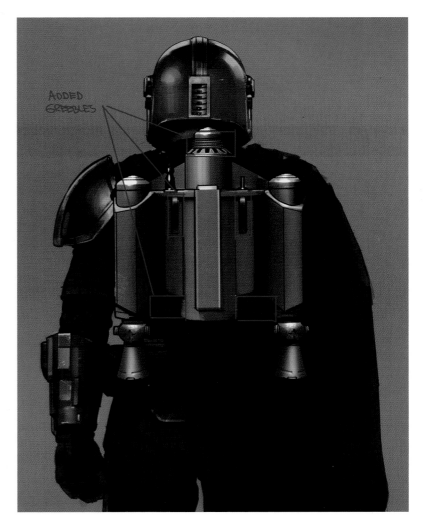

ADDED GREEBLES

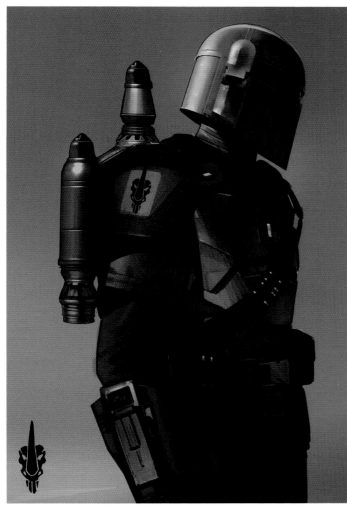

↑ **MANDO PAULDRON VERSION 02** Matyas and Chiang

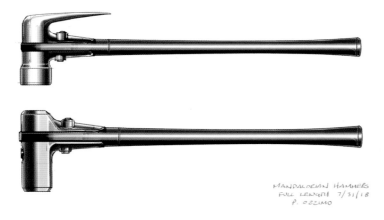

MANDALORIAN HAMMERS
FULL LENGTH 7/31/18
P. OZZIMO

↑ **ARMORER HAMMER FULL 01** Ozzimo

→ **MANDO PAULDRON VERSION 8A** Matyas and Chiang

← **BLACKSMITH ACTION VERSION 02** "She swings and the stormtrooper
helmets just shatter like porcelain. It just further reinforces how they're
completely incompetent and so is their armor." Matyas

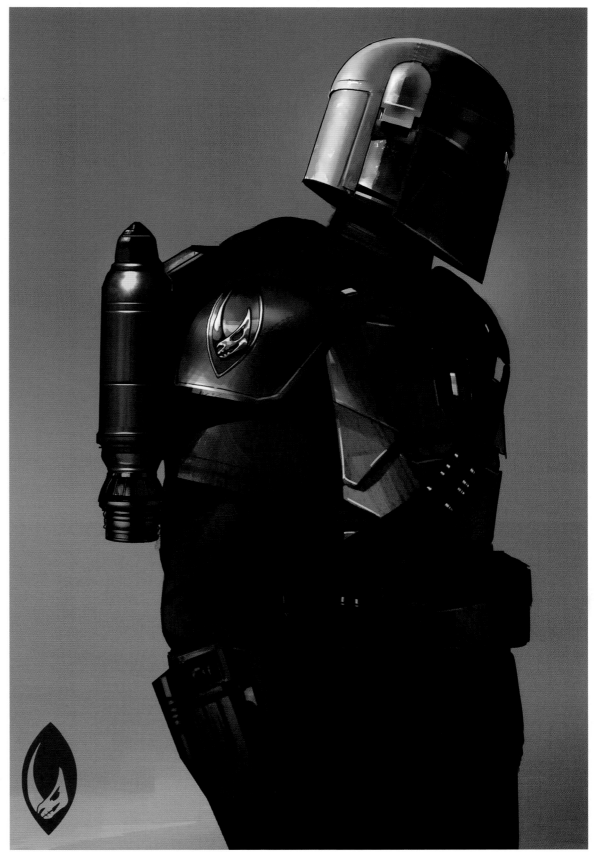

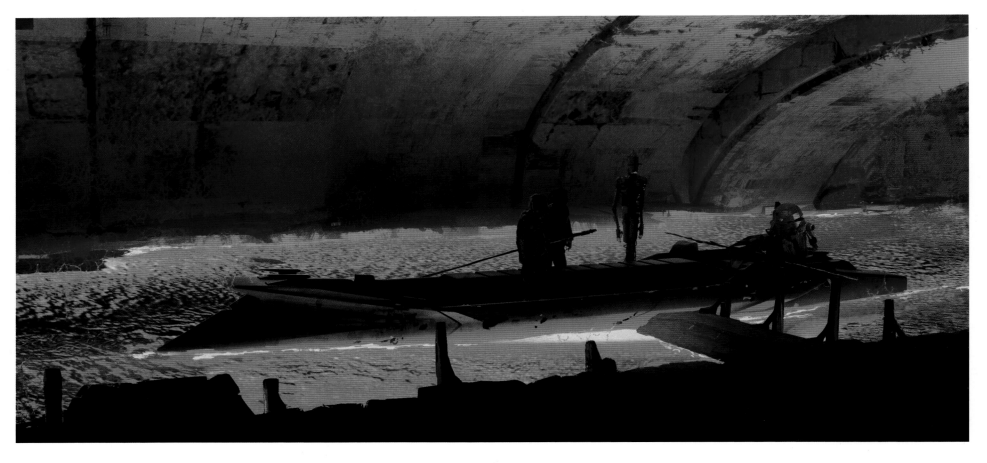

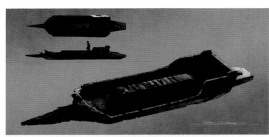

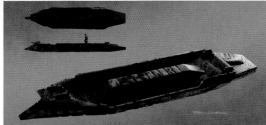

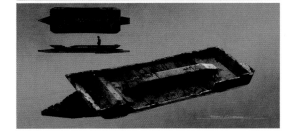

↑ **KEELBOAT VERSION 03** "I was thinking, 'What is this boat made of?' It better be really thick metal." **Church**

"The thinking here was that these were old transportation barges that were rarely used." **Chiang**

← **KEELBOAT VERSIONS 01–03** "Jabba's skiffs were in the back of my mind. And that [these lava barges] were crappily built, [so I wanted to make them] as basic as they could possibly be." **Church**

→ **SEWER DOCK VERSION 18** "It's like a classic subway platform but with a lava flow. And it seems incredible, right? Boats on lava? But I love that Favreau went there." **Tiemens**

"We wanted to capture the vibe of the sewer systems in London. But we had to be very careful that the lava didn't become so over-the-top, glowing too red. Jon wanted to make it feel very realistic. And so, we decided to tone it down. What does real lava look like when you have ambient light coming off of it? It's actually pretty dark, and there's always a crust on the surface because it cools very quickly." **Chiang**

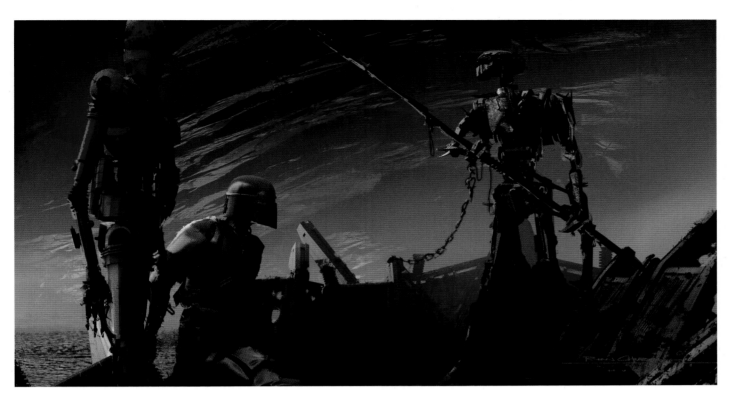

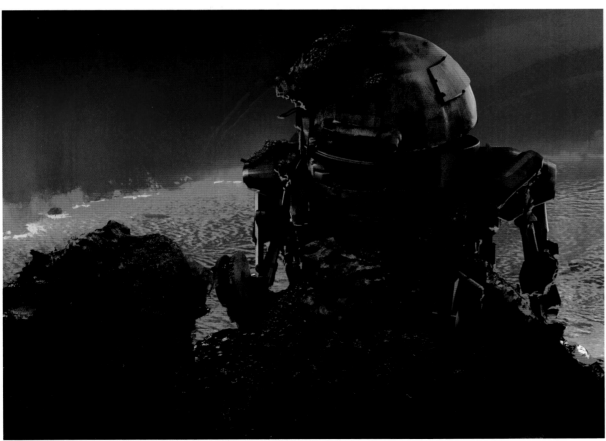

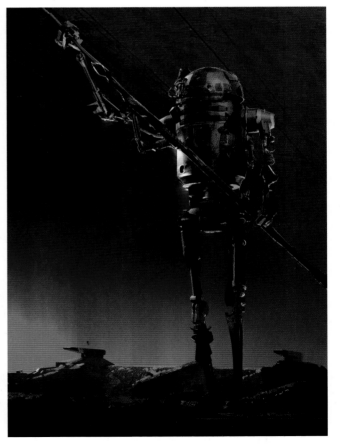

↑ **DROID RETRACTED VERSION 1A** Church

↑ **BOAT DROID VERSION 03** Church

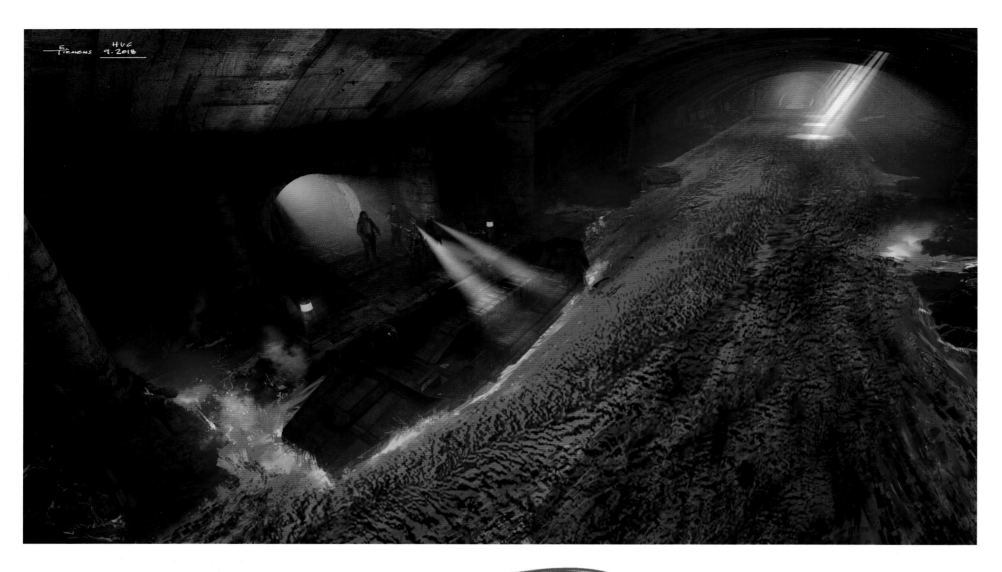

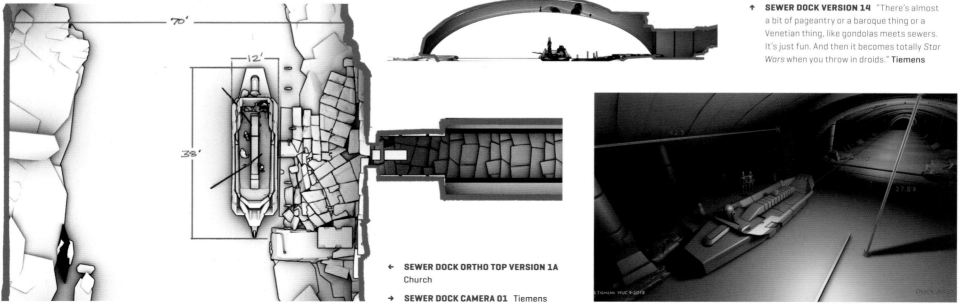

↑ **SEWER DOCK VERSION 14** "There's almost a bit of pageantry or a baroque thing or a Venetian thing, like gondolas meets sewers. It's just fun. And then it becomes totally *Star Wars* when you throw in droids." **Tiemens**

← **SEWER DOCK ORTHO TOP VERSION 1A** Church

→ **SEWER DOCK CAMERA 01** Tiemens

→ **SEWER DOCK CAMERA 05** "[Working with the scale of the LED 'volume' has] been a real learning process. Building things to scale [in 3D for our concept art] and the importance of the seventy-foot marker, which is the diameter of the volume. So, you get a little bit of weaving of set [design of physical set pieces] and set extension [for what's projected on the LED screens]." **Tiemens**

↓ **SEWER DOCK VERSION 18** Tiemens

"Graphically, I wanted it to have a shallow roof, instead of a circular tunnel, so that when you saw the end, it almost looked like an [oval] eye. That was your target to go toward. If you look in the reverse direction, you saw these two holes. This is a very subliminal thing, but that's like going into [the two bronchial tubes of] your lungs. You can tell very quickly whether you are going deeper into town or toward the escape, toward the light, toward the eye." **Chiang**

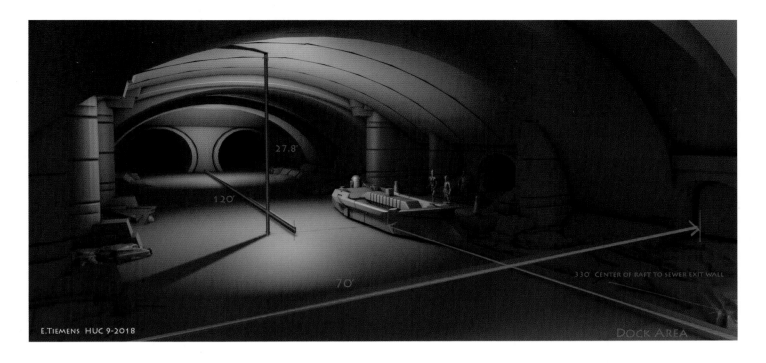

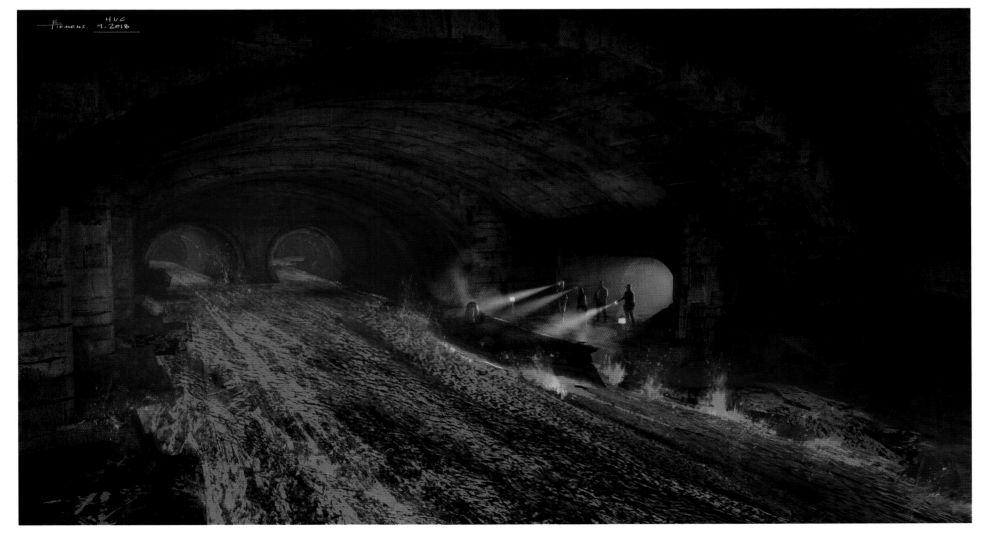

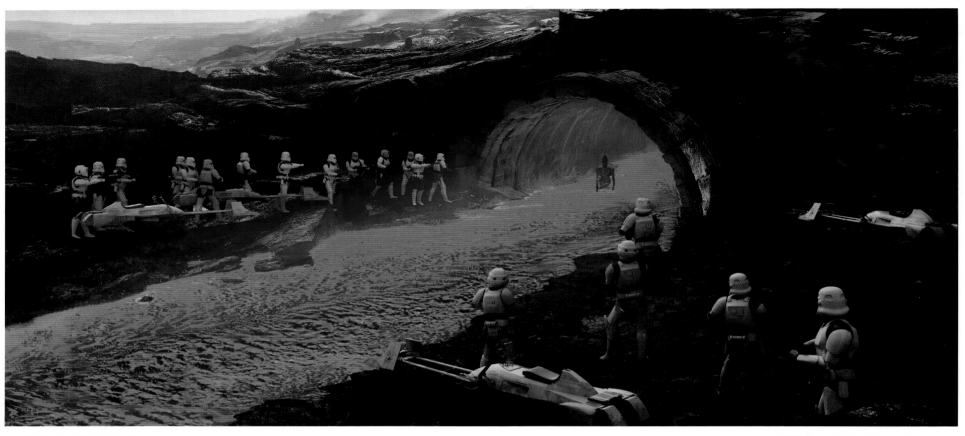

↑ **TUNNEL EXIT VERSION 1F** Church, Tiemens, and Chiang

↓ **LAVA RIVER EXPLOSION VERSION 1A** Church

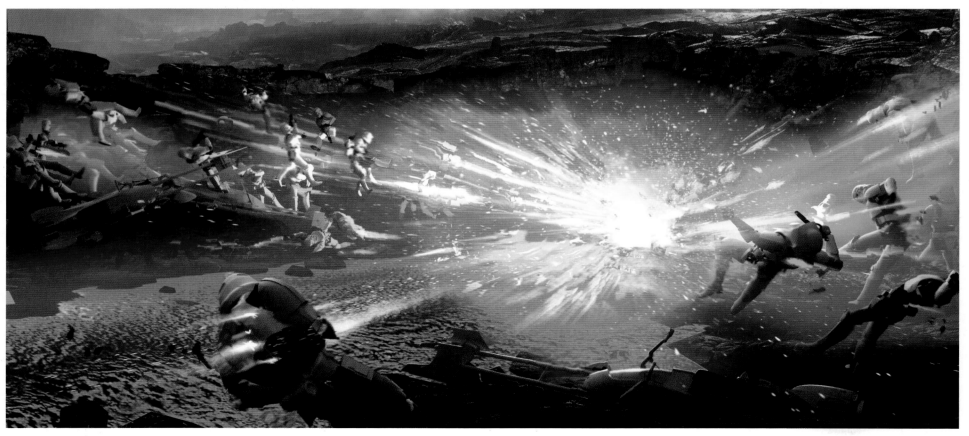

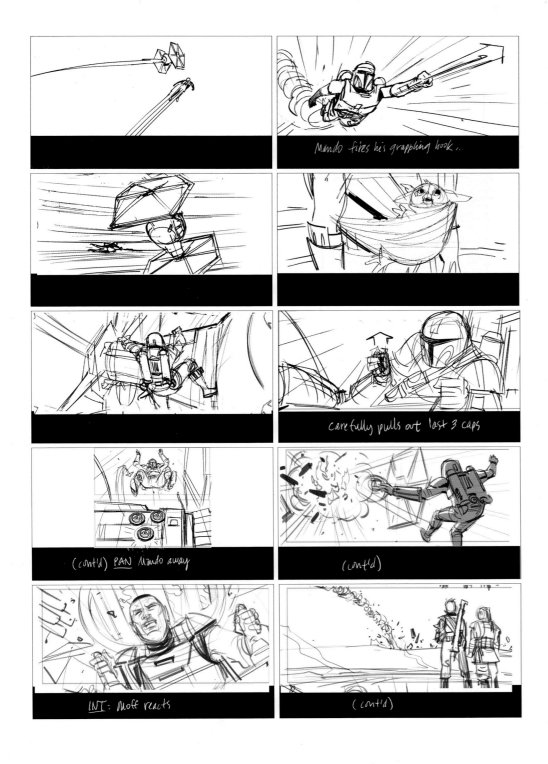

Mando fires his grappling hook...

carefully pulls out last 3 caps

(cont'd) PAN Mando away

(cont'd)

INT: Moff reacts

(cont'd)

↑ **TIE BATTLE STORYBOARDS** Lowery, Norwood, and Duncan

→ **MANDO STAGE 06** Matyas

→→ **BOAT ATTACK VERSION 02** Church

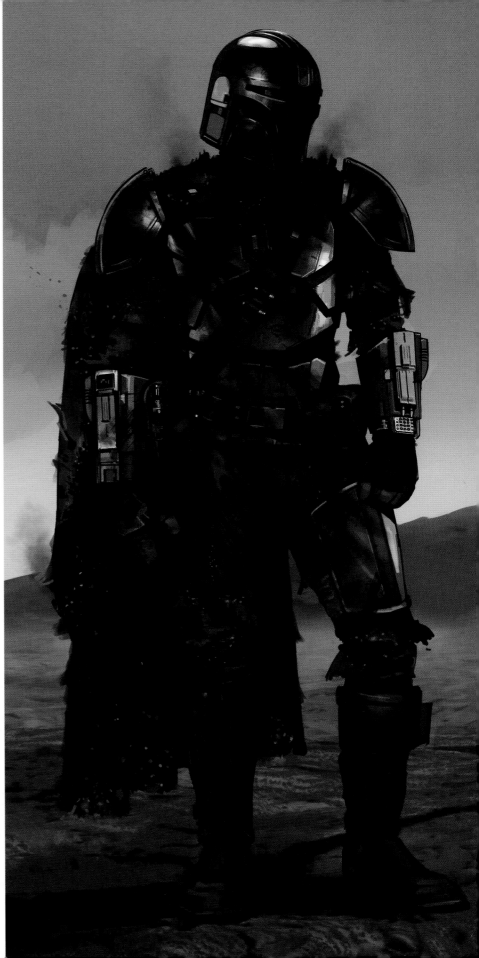

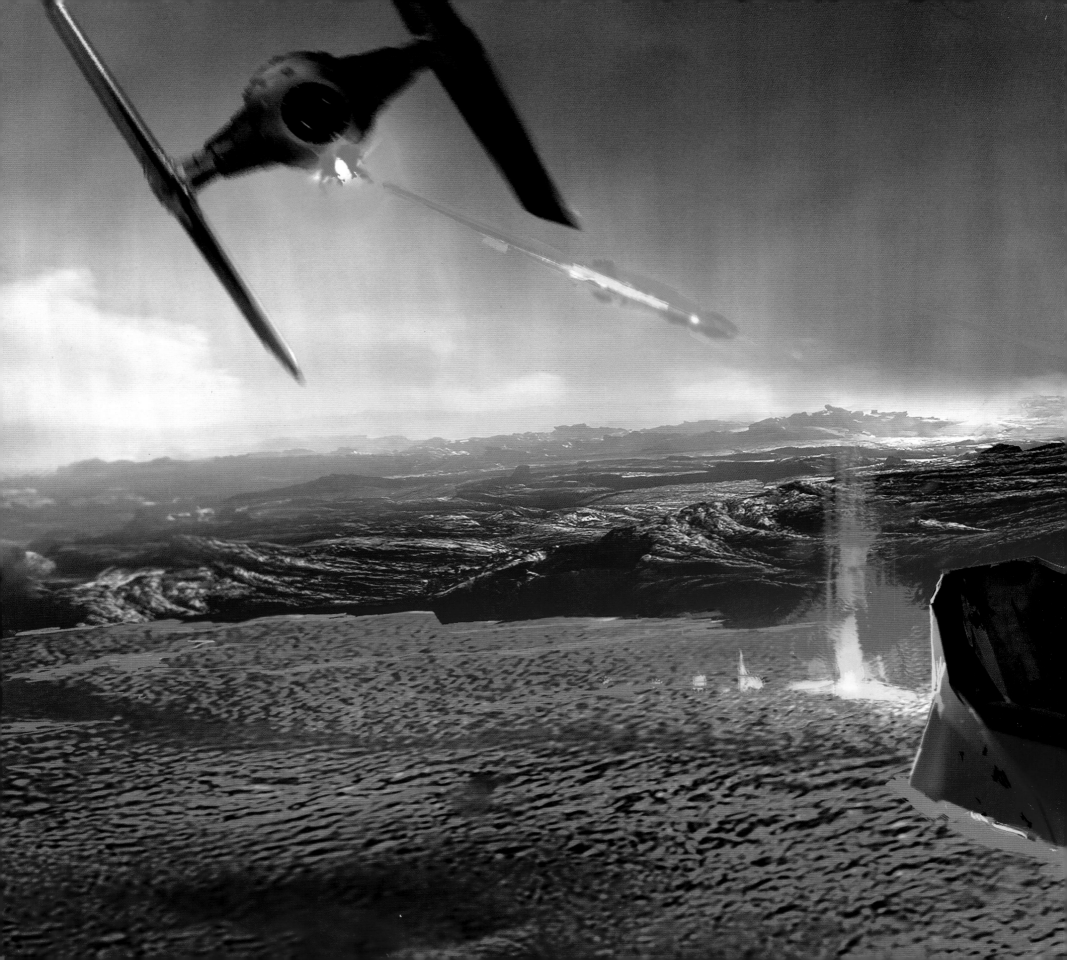

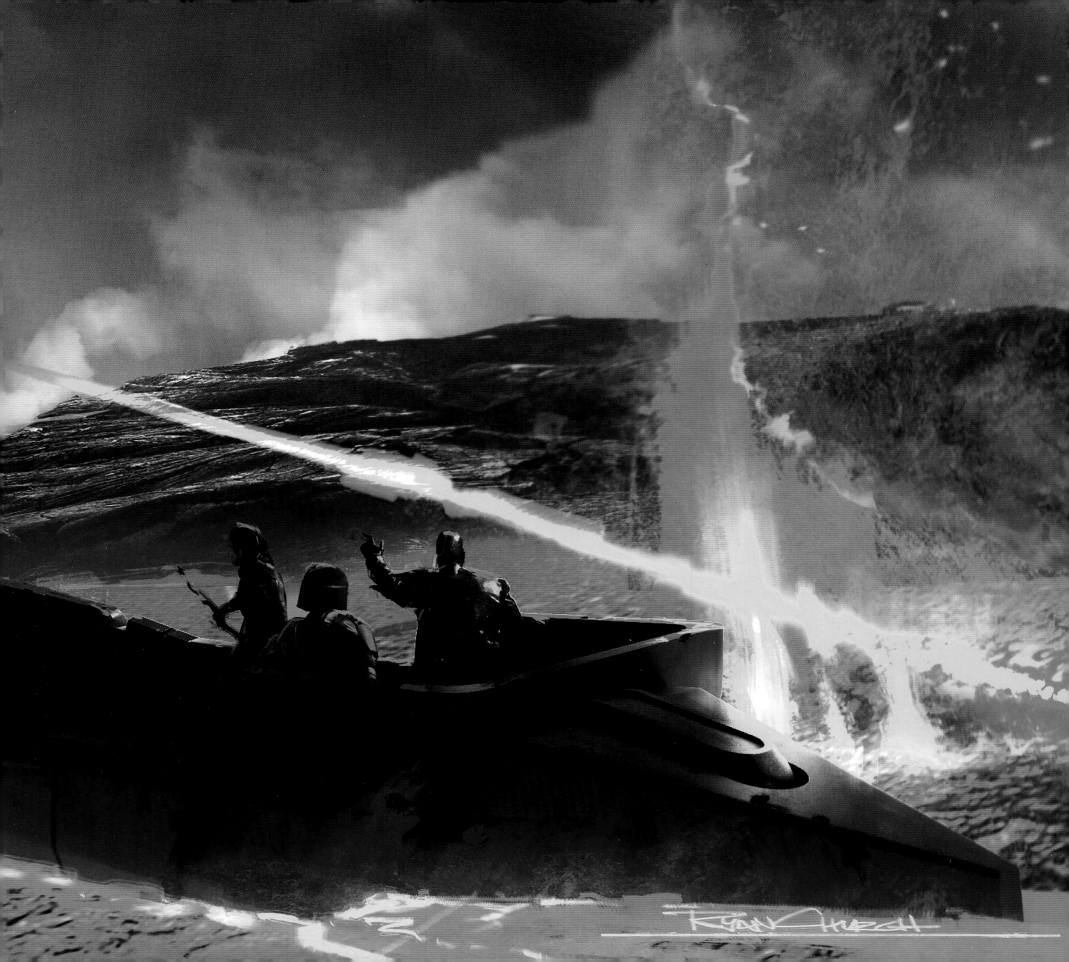

INDEX

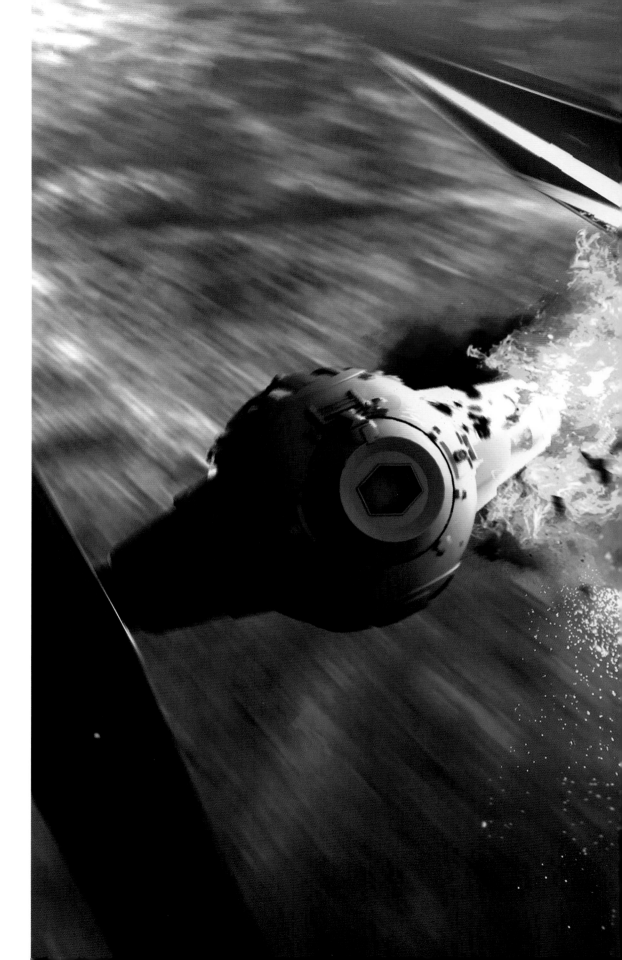

ACKNOWLEDGMENTS

To George Lucas and Kathleen Kennedy, for laying the foundation upon which all of this is built.

To Jon Favreau, Dave Filoni, Doug Chiang, Carrie Beck, Christian Alzmann, Ryan Church, Erik Tiemens, Brian Matyas, Tony McVey, and Landis Fields, for being so generous with your time in telling your stories.

To Noah Kloor, Anjali Iyer, and Claudia Ramirez, for facilitating my interviews with Jon and Dave.

To Eric Klopfer, Connor Leonard, Liam Flanagan, Mary O'Mara, Lisa Silverman, and Denise LaCongo at Abrams Books and Robert Simpson in Lucasfilm Publishing, for your continuous miracle work in editing and assembling the Art of *Star Wars* book series.

To Mike Siglain and Troy Alders in Lucasfilm Publishing; Pablo Hidalgo, Leland Chee, Matt Martin, Emily Shkoukani, and Kelsey Sharpe in the Lucasfilm Story Group; Tim Mapp, Gabrielle Levenson, Nicole LaCoursiere, Bryce Pinkos, and Erik Sanchez in Lucasfilm's Asset Team; Tracy Cannobbio in Lucasfilm Publicity; and Zack Bunker and the entire Atris Team.

To Genna Elkin, Jennifer Hsyu, and Madeleine Sandrolini in the Lucasfilm art department.

To Kristin Baver in Lucasfilm's Online Team, for your invaluable honesty and support.

Lastly, to my family, Joseph, Barbara, Martin, David, Grace, and Leo Szostak, and friends, Lila Atchison, Sean and Sarah Dicken, Mike and Lucy Bates, Matt Davis, Shawn Hunter, Chris Wales, and Tina Fossella.

→ **MANDO TIE VERSION 2A** Church

"How do we do a fresh version of a TIE crash, since we already did one for Episode VII? After Gideon's TIE fighter is disabled, it plows a groove but doesn't get totally destroyed. The inspiration for this was the meteor crash from *Superman* [1978]. I've always liked that scene and graphic of that path." **Chiang**

→→ **CRASHED TIE HIGH ANGLE VERSION 01** Church

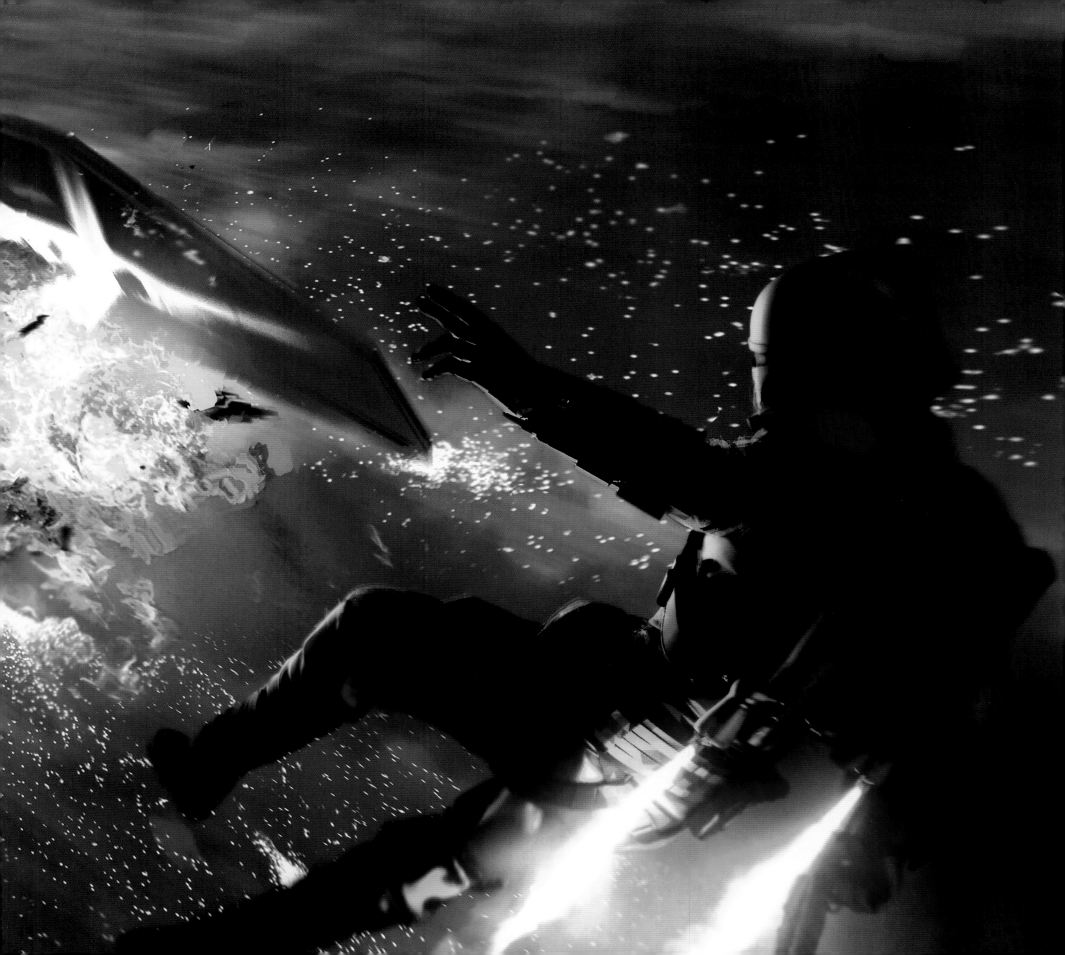

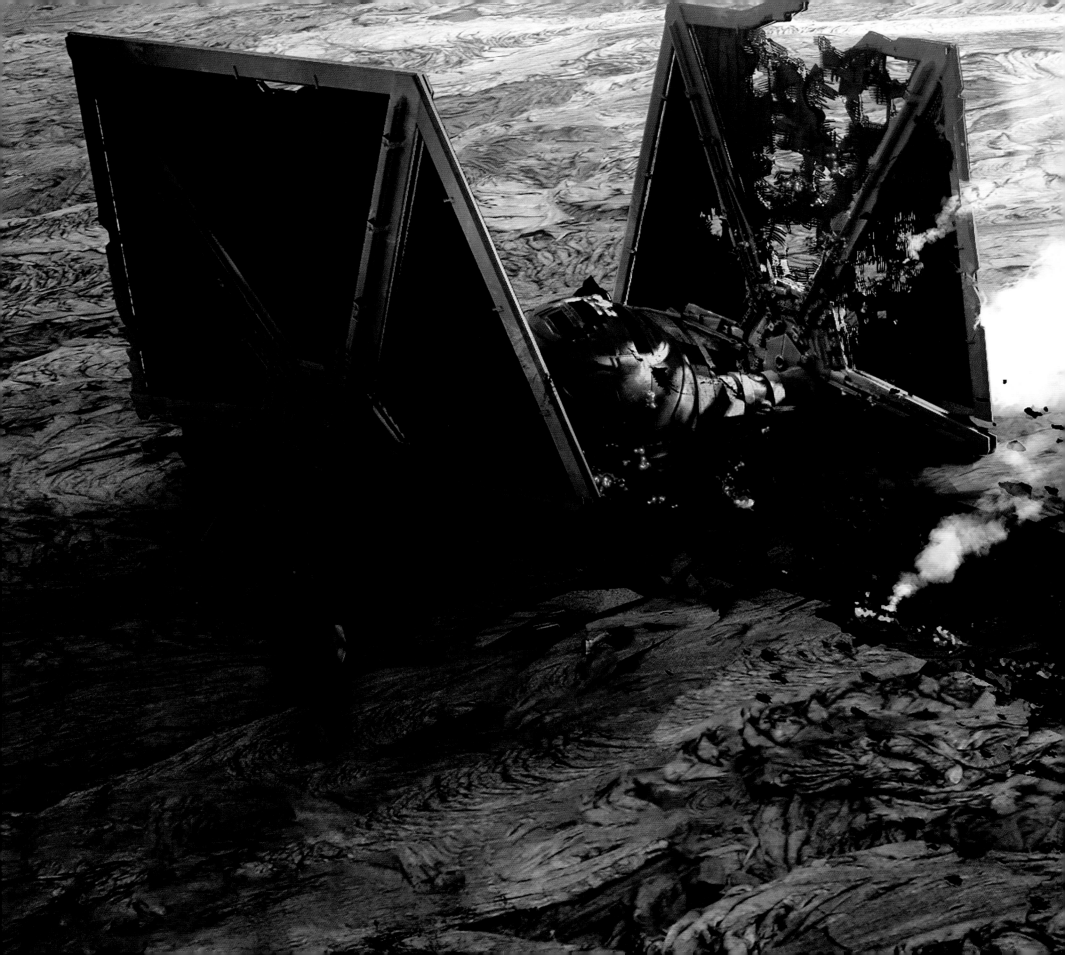

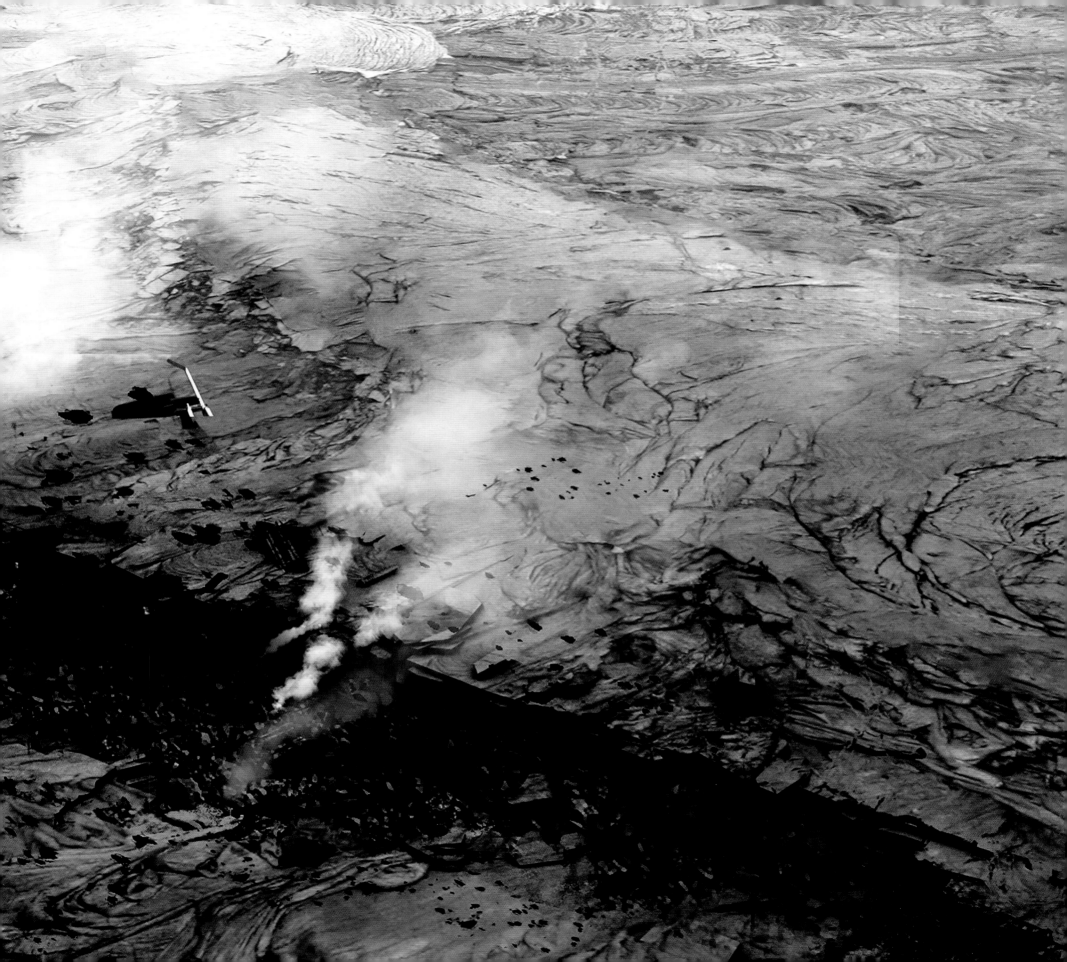

HUCKLEBERRY
DARK SABER
PAUL OZZIMO 8/2?/IX

↑ **DARK SABER 1B** Ozzimo

→ **CRASHED TIE LOW ANGLE VERSION 1A** "Finding the exact right angle and
then the exact right read on the Jawas, so you're looking at Gideon and then
you see that these Jawas are completely screwed. He's the darkest dark next
to the lightest light, right in the middle of the frame too, which I don't usually
do. But this is me just going for it. Everything is turned up all the way." **Church**

→→ **GIDEON WRECK VERSION 02** Matyas

Case **IG-11 SPEEDER BIKE VERSION 1A** Gindraux and Chiang

For Lucasfilm Ltd.

Senior Editor Robert Simpson
Creative Director Michael Siglain
Art Director Troy Alders
Asset Group Nicole LaCoursiere, Gabrielle Levenson, Tim Mapp,
Bryce Pinkos, and Erik Sanchez
Story Group Leland Chee, Pablo Hidalgo, and Matt Martin

For Abrams

Editor Connor Leonard
Designer Liam Flanagan
Production Manager Kathleen Gaffney

Library of Congress Control Number: 2020937106

ISBN: 978-1-4197-4870-7

Printed and bound in China
10 9 8 7 6 5 4 3

Abrams books are available at special discounts when purchased
in quantity for premiums and promotions as well as fundraising or
educational use. Special editions can also be created to specification.
For details, contact specialsales@abramsbooks.com or the address below.
Abrams® is a registered trademark of Harry N. Abrams, Inc.

ABRAMS The Art of Books
195 Broadway, New York, NY 10007
abramsbooks.com

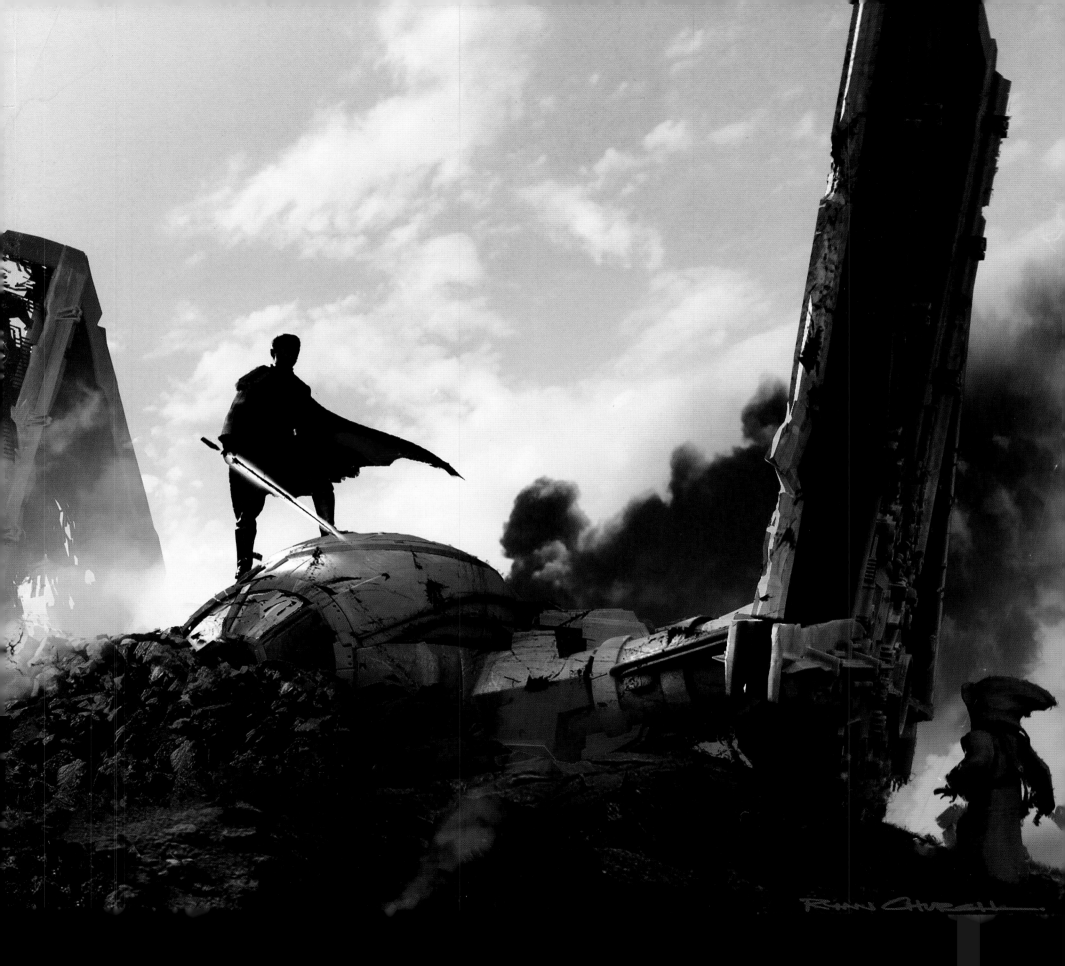

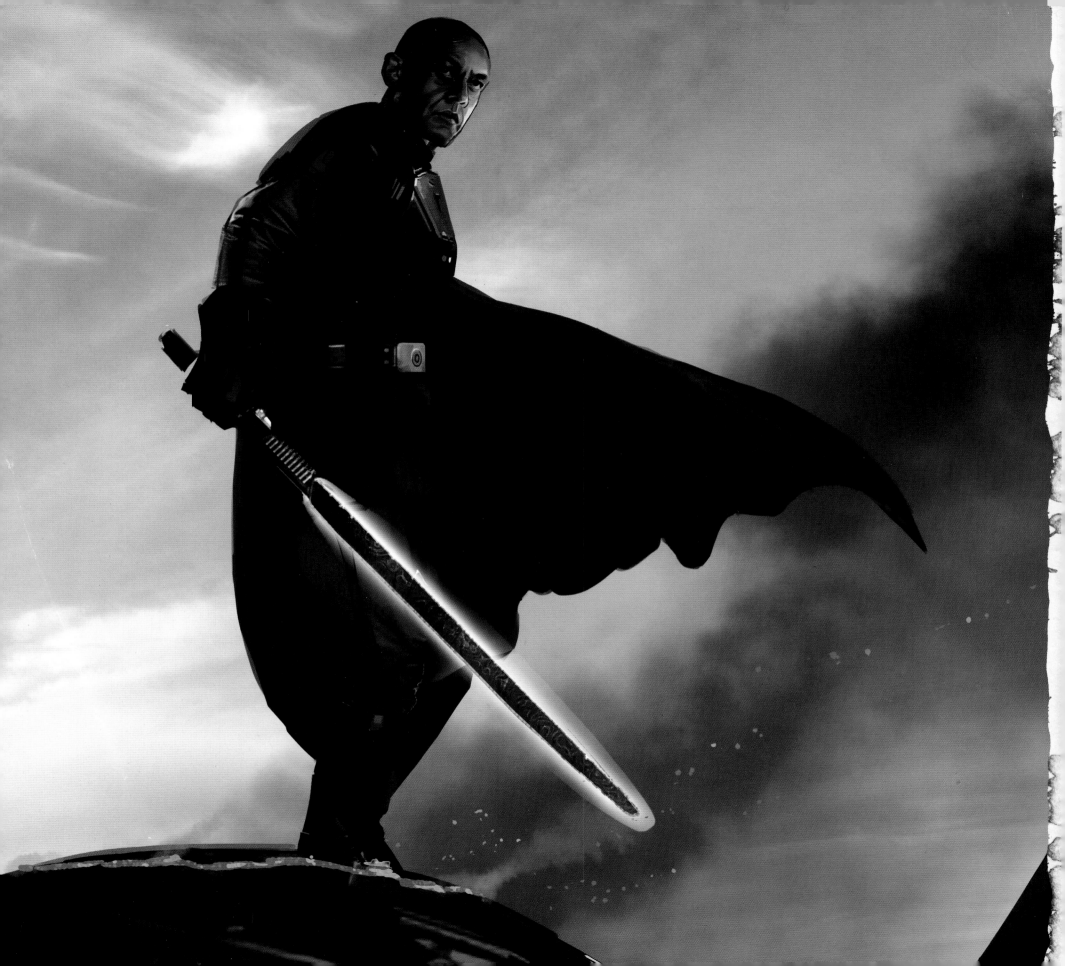